RENT

BOOK, MUSIC AND LYRICS BY JONATHAN LARSON
AS DIRECTED BY MICHAEL GREIF

Interviews and Text by Evelyn McDonnell with Katherine Silberger

Special Photography by Stewart Ferebee and Larry Fink
Designed by Spot Design
Edited by Kate Giel

Produced by Melcher Media, Inc.

Rob Weisbach Books
William Morrow and Company, Inc. New York

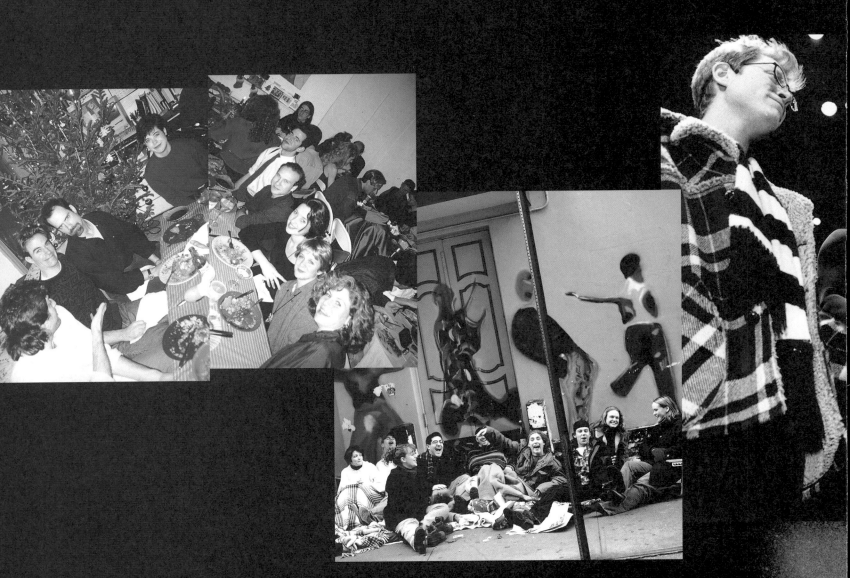

This book was produced by Melcher Media, Inc.

170 Fifth Avenue, New York, N.Y. 10010

An *original* publication of Rob Weisbach Books/
William Morrow/Melcher Media

Published by Rob Weisbach Books
An Imprint of William Morrow and Company, Inc.
1350 Avenue of the Americas
New York, N.Y. 10019

Book design by Spot Design

Library of Congress Cataloging-in-Publication Data

Larson, Jonathan
[Rent. Libretto]
Rent / book, music and lyrics by Jonathan Larson: text written by
Evelyn McDonnell with Kathy Silberger: special photography by
Larry Fink and Stewart Ferebee: edited by Kate Giel.—1st ed.
p. cm.
ISBN 0-688-15437-9 (hc)
1. Operas—Librettos. 2. Larson, Jonathan. Rent. I. McDonnell,
Evelyn. II. Silberger, Kathy. III. Fink, Larry. IV. Ferebee, Stewart.
V. Giel, Kate.
ML50.L334R46 1997<Case>
782.1'4—dc21 97 - 1171 CIP
Printed in Japan

First hardcover printing June 1997

10 9 8 7 6 5 4 3 2 1

CONTENTS

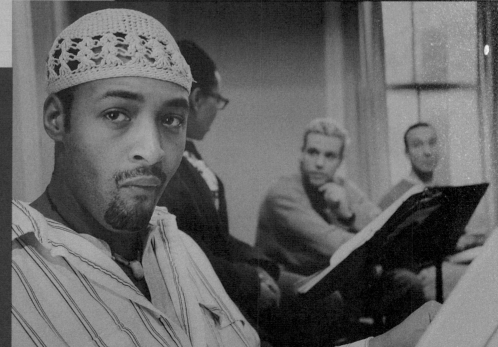

one song
glory one song
before I go
glory
one song to leave behind

find one song
one last refrain
glory
from the pretty boy front man
who wasted opportunity

one song
he had a world at his feet
glory
in the eyes of the young girls
the young girls

find
glory
beyond the cheap colored lights
one song
before the sun sets
glory
on another empty life

time flies
time dies

glory
one blaze of glory
one blaze of glory
glory

Stay true to
yourselves and
to your dreams
and know they
can come true

CBGB
OMFUG
315

It took my brother Jonnie fifteen years of really hard work to become an overnight sensation. So we'd like to dedicate this book to all those who are out there still working in restaurants, driving taxis, doing whatever they have to do to scrape by for their art.

Stay true to yourselves and to your dreams and know they can come true.

—Julie Larson McCollum

To create
to allow
to accept

Creation

"How do you document real life, when real life's getting more like fiction each day," Mark, the filmmaker narrator of *Rent,* asks at the start of the show's title song. It's one of many frighteningly prophetic lines playwright Jonathan Larson wrote before he died suddenly of an aortic aneurysm at age thirty-five—and before his show became the biggest theater story in two decades. Larson's death and *Rent*'s subsequent success are such epic tales of tragedy and triumph that it's no wonder they've already taken on mythic stature. "If we had written that scene together, of him dying at that point, I would never have let him put it in," says Eddie Rosenstein, himself a filmmaker, and one of the playwright's best friends. "It was perfect Jonathan: he was always over the top that way. Dramatically, it made sense. The dramatic question of his life was over."

The story of *Rent* has a strange trajectory. For seven years, Larson, a talented playwright, composer and pianist who was eager to remake the American musical and hungry for a career breakthrough, had worked on an update of the opera *La Bohème,* relocating Giacomo Puccini's tale of Parisian artists to New York City's East Village. The off-Broadway production of *Rent* was scheduled to go into previews January 25, 1996, at New York Theatre Workshop. The night before, at the final dress rehearsal, the play received a standing ovation. Larson then went home, put a pot of water on the stove for tea, collapsed and died alone on the floor of his apartment. Two weeks later, *Rent* opened to phenomenal acclaim. Within three months, the show moved to Broadway, its young cast became stars and Larson won a posthumous Pulitzer Prize. *Rent* swept the theater awards that spring, including the Tonys; the cast recording was nominated for a Grammy; and a film is in the works. *Rent* not only invigorated the moribund Broadway musical form; it offered a testament to lives lived on the edges of creation and death—a testament that struck a chord with thousands.

To those who discover *Rent* by being excited and moved by the performance, or by the CD or even by this book, Jonathan Larson's life is the finite chapter within the show's ongoing story. But for those who knew him, his absence is a painful reminder of a career that should still be evolving, works never seen that must be unfolding in some parallel universe. As Jonathan's friend Ann Egan says, "For us, when *Rent* began, Jonathan ended. For the actors, *Rent* catapulted their careers, and now they're bigger stars than Jonathan ever was in his lifetime." *Rent* is a moving show that has changed the lives of many of its participants and fans. Hopefully this book conveys some of that joyous, transforming spirit. Yet after talking to people who knew Jonathan and witnessing their

sadness and anger, it's hard not to think of this story as, ultimately, a tragedy. "As you wander on through life Bud, whatever be your goal/Keep your eye upon the donut, and not upon the hole." Jonathan's father, Al Larson, used to tell his children, quoting an old advertising slogan. Talk to Al now and he'll say, shaking his head, "*Rent* and its success to the world can be a consolation for the fact that Jonathan is not here, but as a parent, if I had a choice, I'd dump the whole thing and take Jonathan."

"The opposite of war isn't peace, it's creation," Mark sings in "La Vie Bohème." One of Jonathan's missions while writing *Rent* was to celebrate art and art-makers. "*Rent* also exalts 'Otherness,' glorifying artists and counterculture as necessary to a healthy civilization," he wrote in a 1992 statement of concept. The production of his play gathered together a group of people who embodied the creative spirit. "Jonathan spoke eloquently

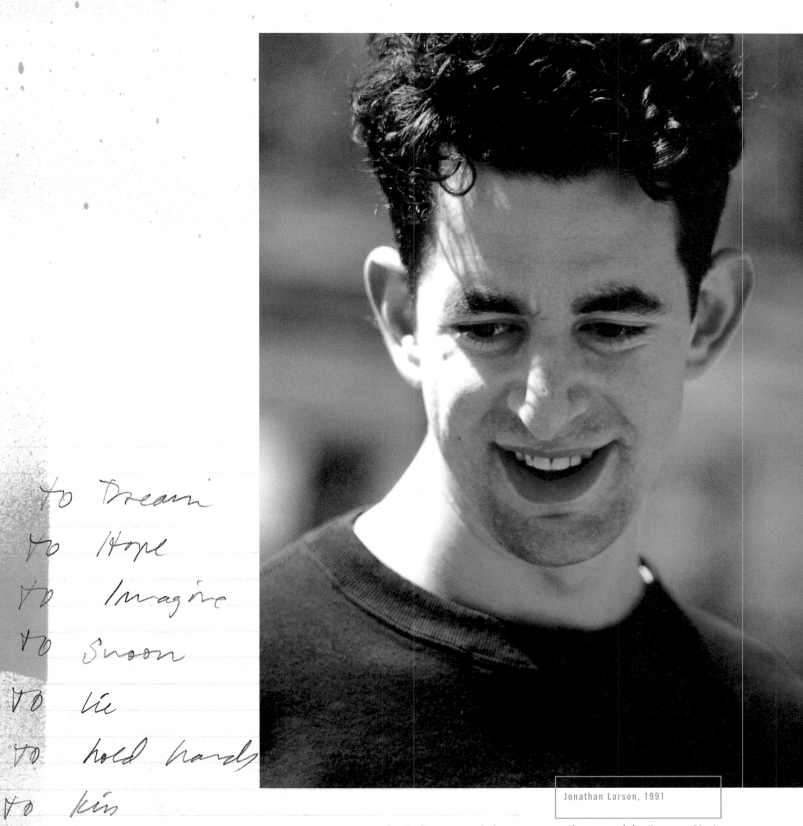

to Dream
to Hope
to Imagine
to Swoon
to lie
to hold hands
to kiss
to Create to allow
 to accept
 to be alive

 to be aware

 to be present. in my
 in the life I have

this is my life—
the one we're in
we're here to learn.
Meant to be.

about demons and fears surrounding creativity," says Mark Setlock, who played Angel in the 1994 workshop production of *Rent* and understudies on Broadway. "He speaks volumes to anyone who wants to make it as an artist in this society."

That faith in creative work helped drive the writers of this book. We never met Jonathan Larson. He's the hole in the donut we had to write around, which is why we interviewed more than seventy people, trying to capture as many curves as possible. This story of *Rent*'s creation is told in a *Rashomon* chorus of voices, as Al Larson puts it, where every point of view reveals the speaker as well as the subject. For Jonathan's voice, we're left with a few random quotes—and of course, the show's libretto. In it you'll find the bursting-with-love belief in life that characterized Jonathan Larson to those who knew him, and this gift to the rest of us known as *Rent*.

La Vie Bohème

Before *Rent,* theater was not a medium associated with people who had come of age after the age of Aquarius. Post-baby-boom generations had their grunge, rap, MTV, spoken word and tattoos, but plays were not their thing. Yet from the time Jonathan Larson first met with playwright Billy Aronson, on the former's downtown New York rooftop, to the day Larson died, on the morning of *Rent*'s first off-Broadway preview, he saw the show as a generational anthem, "a *Hair* for the '90s," as he put it. When he would tell people that he was the future of musical theater, he couldn't have seemed less hip, and for fifteen years he had trouble finding producers willing to back his claim. And yet Larson was so driven by his vision of a theater that spoke to his life and the lives of his friends that, seven years after he began, he succeeded where no one else had.

Theater is a distinctly collaborative art form. *Rent* was not originally Larson's idea, and it came to be shaped by a number of people. But it was Jonathan who seemed to will it into being, by the sheer obstinacy of his vision. To understand *Rent,* you have to understand that missing voice, the voice of a six-foot-tall book lover with a curly mass of dark brown hair and long arms destined to end at piano keyboards.

Jonathan Larson was born February 4, 1960, the younger of two children in a liberal Jewish family. He grew up in White Plains, New York, a pleasant middle-class suburb about thirty-five miles north of New York City.

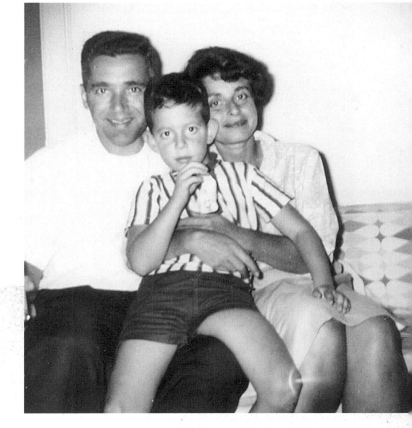

"Pursue

Al Larson, Jonathan's father: An early memory of Jonathan: I was changing his diaper, so he had to be pretty young, and he started singing "Yellow Bird." In tune.

Julie Larson McCollum, Jonathan's sister: I think music was just a part of him. He was innately very creative. My parents were huge supporters of the arts. Neither of them could sing or play an instrument—well, my dad played a little guitar—but they loved theater and they loved dance, so we were exposed from a young age to ballet, to Broadway, to all kinds of music. I was raised on Pete Seeger, the Weavers, Paul Robeson, labor songs of protest from the '30s. My dad would putter around, building bookshelves on the weekend and listening to whatever opera was on *Live at the Met,* and to musicals. They had every musical album, and we used to listen to those over and over again.

Nan Larson, Jonathan's mother: We took the kids to whatever theater was suitable. I love theater, and so does Allan. I love musical theater especially. We took them to *Fiddler on the Roof* and *1776.* We didn't go all that frequently; it was kind of a special event. There's a chemistry that happens in live theater that you don't get from television or movies. When a curtain goes up, I still have to catch my breath.

Julie Larson McCollum: We grew up with the two most loving, supportive parents. They raised us to do what we wanted to do. All our friends adore them. They could always come to them and talk about anything and know they weren't going to be judged.

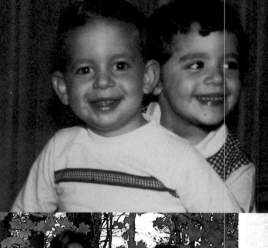
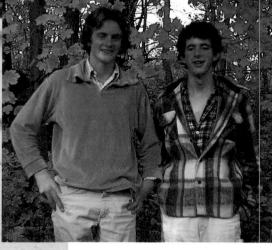

Al always said, your dreams."

Matthew O'Grady, Jonathan's friend since childhood:
It was a conventional suburb. We didn't have play dates, we just got
on our bicycles and rode around. We went away in the summer, to
camp or the beach. Jon said we were the *Speed-Racer* generation.
We weren't cutting-edge boomers, but we were influenced by the
political unrest of the '60s. I remember as a child that it felt like our
parents were the only people in White Plains who voted for
McGovern. It seemed like the entire world voted for Nixon except the
O'Gradys and the Larsons.

The Larsons were a very embracing family. Al always said,
"Pursue your dreams."

Al Larson: There was a big extended family. We had friends,
the Manesses and Deans, who were as close as any of our
blood relatives. From that, Jonathan learned that anyone could
be family.

Ann Egan, onetime roommate of Jonathan's: Jon was a
really positive person. You'd have to attribute that to his parents. He
saw them as his team. In his work, that love bursts out at you.

clockwise from far left:

Jonathan, age four, with his parents, Al and
Nan; Jonathan on his bicycle, age five; Jonathan
and his sister, Julie; childhood friend Matthew
O'Grady and Jonathan; Jonathan, age 21, with his
sister, Julie, and parents.

Jonathan showed talent at an early age. The Larson and Maness children would put on backyard productions of *The Wizard of Oz*, in which Jonathan evidenced a "flair for performing," his mother recalls. In third grade, he wrote a play that was produced by his class and photographed for the local newspaper. He played tuba in the high school band, played piano, and was a star of high school theater productions.

Al Larson: Jonathan took piano for two years, but he didn't like the structure, so he quit lessons. In high school, his trademark piece was Billy Joel's "Piano Man."

As far as I can remember, his first musical-theater performance was in *West Side Story*; I think it was in junior high. Throughout high school he was in all the shows. He was a damn good actor.

Julie Larson McCollum: In junior high it was Elton John and Billy Joel and all the keyboard players. He must have seen both those guys in concert about twenty times. In the band in high school he might not have been playing what was on the page, but he had such a good ear that he was improvising within what was musically correct. And it took the bandleader a long time to figure it out. One time he said, "Jon, play bar fifty-seven," and Jon said, "I can't, I've been faking it." Music was secondary. It was still very important, but everyone knew he was really talented as an actor. He was a very unassuming presence when you met him, kind of goofy and gawky. Yet he could totally command the stage.

Larson was a fairly typical teenage boy, more intellectual than athletic, but interested in girls, rock and roll, the New York Mets and mild acts of rebellion.

Matthew O'Grady: White Plains was very diverse: Jewish, Black, Hispanic, WASP. But only a mile away was the most affluent neighborhood in Westchester.

Julie Larson McCollum: He and Matt would take my dad's car, ring people's doorbells and, if they weren't home, go jump in their pool. That's about as rebellious as Jonathan got.

Matthew O'Grady: We were inseparable in junior high and high school. In junior high, whenever there were tickets to go into the city to see *Godspell* or *Jesus Christ Superstar*, we would do that. In high school we'd go to rock and roll shows, but he still dragged me to Sondheim musicals. To me they were horrible. Those singsong rhymes over and over again. I remember thinking, "We're in New York, we're supposed to be in a bar!" One time I sent him to get us tickets for Peter Frampton. So Jon went down to Ticketron and came back with tickets for *Sweeney Todd*. Or *Pippin*. One of those. "Well, Peter Frampton was sold out," he said.

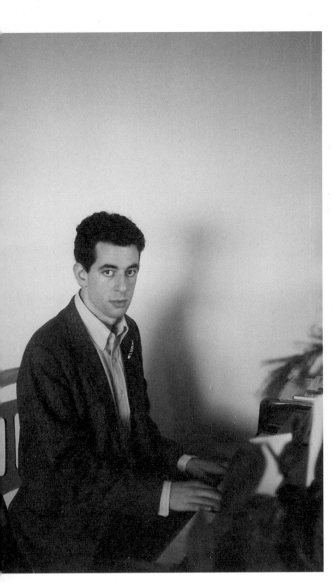

clockwise from above:

Jonathan, age 23, at the piano; exterior of Jonathan's Greenwich Street apartment; close friend Lisa Hubbard, with Jonathan's cats, Finster and Lucy, at his apartment; Jonathan, standing, and classmates in an Adelphi University production of "Moonchildren," 1981.

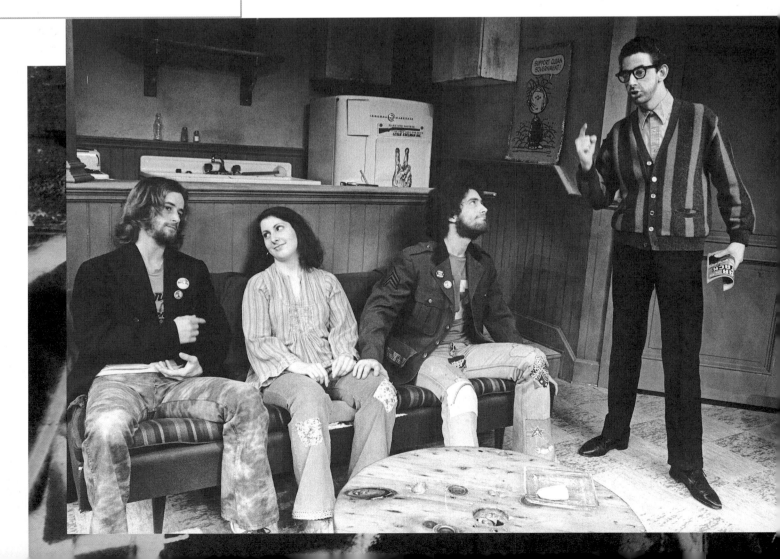

When they were seniors in high school, O'Grady told Jonathan he was gay. Their lifelong friendship had a profound impact on both men, and on *Rent*.

Matthew O'Grady: I didn't let people in high school know I was gay; it was a big secret. I just hoped that it would go away. When I told Jonathan, I don't think he ever thought twice about it. And it never changed our relationship.

In 1978 Jonathan graduated high school and received a four-year acting scholarship to Adelphi University, on Long Island. There, working with professors including Jacques Burdick and Nick Petron, he began writing songs and skits for the school's cabarets. Gradually his focus changed from acting to composing.

Jacques Burdick: When Jonathan first arrived, he told us he wanted to learn as much as possible about writing topical material into presentations. He was interested in what makes a lyric work. We used to examine a song's rhyme scheme and write other lyrics to it. In a course on radical theater techniques, we took topical material and recast it in a way that's presentable through skits and cabaret songs. Jonathan especially liked that.

He was a powerhouse of cheerful inventiveness. That quality, that way of seeing the world, seems somewhat innate; it's like an intuition about theater. You can work at your craft, you can be very skillful, but if you don't have that intuition, you never really achieve an authenticity.

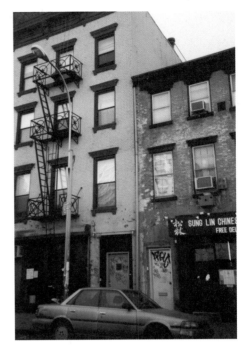

In 1982 Larson received his B.A. from Adelphi and moved to New York City. By now, his focus had started to change from acting to composing; he was torn between whether he should be going to auditions or writing music. While at Adelphi, he had met Stephen Sondheim, whose plays he adored. He went back to Sondheim for advice.

Al Larson: Sondheim commented that there were more working pianists than actors, and told Jon he had to make a choice, to concentrate on one of the two. He quit going to auditions.

Julie Larson McCollum: He told me once, I guess about the time he decided to focus more on music, that it was something he had always loved and had always quietly wondered about. Everyone else saw him as the actor in high school, but even then, he said, "I kind of knew."

He quickly settled into the life of a struggling artist, living in a notoriously run-down apartment on Greenwich Street with an ever-rotating cast of roommates.

Jonathan Burkhart, Jonathan's friend and onetime roommate: If you look on any map of Manhattan, there's SoHo, Tribeca, the Village and a grayed-out area of streets in between them, with no name. So we called it Assho. In the apartment, there was a kitchen with a bathtub. Then you went into one giant room, where I had built a wall creating two bedrooms, though one had no windows. The next room was the living room, where Jon kept his keyboard and computer and couch and a crappy TV.

Ann Egan: It was a real neighborhood situation. Jonathan's high school girlfriend Michelle Weinberg lived next door, and we used to jump across the roofs! Our friend Mitch built a bridge across the buildings, from our apartment to Michelle's. We were completely taking everything into our own hands. I'd be in front painting and Jonathan would be in his room pounding at the keys; everything would just flow back and forth. It had a very postcollege atmosphere. It felt like home. It was open—open to friends, lovers, creativity. When I decided to raise kids, my life had to go a different direction. Jon, if anything, stayed truer. He sacrificed everything for his art. Most of our friends, we did what we had to do to upgrade. But Jon had a nice lifestyle—not in poverty, but an artist's lifestyle. He was as poor as we all were when we decided our art came first.

Al Larson: The apartment had seen better days. After tromping up four flights of worn old steps, you'd walk into the kitchen, and there was the bathtub. But he was happy there. I could get into a debate about what is "bohemian," but he was certainly a starving artist. He worked his butt off from the time he got out of college. He was not a dilettante. He didn't have the idea the world owed him a living. He was doing what he wanted to do, and he was essentially self-supporting. He was deeply in hock. One of my major regrets is that I never knew just how tight things were for him.

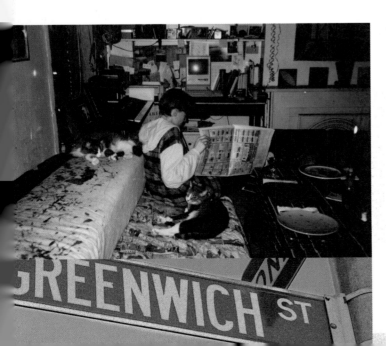

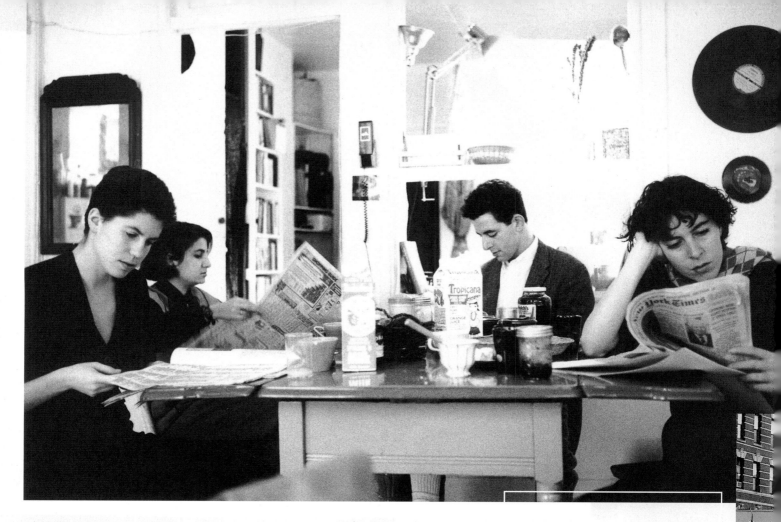

For nine and a half years, Larson waited tables at the Moondance Diner, a renovated railway car on Sixth Avenue in SoHo. He worked a couple days a week, just enough to keep him afloat and leave plenty of time for writing. Jonathan developed friendships with many regular customers: the architect up the street, the taxi dispatcher next door.

Hernan Valderrama, Moondance chef: He would always talk about his difficulty paying the bills. I used to joke with him about his sneakers, because they were filthy and falling apart.

Larry Panish, Moondance owner: Many customers came into the diner just to see him. He held court at the Moondance, and a lot of people loved him. This was not just a place for him to make a buck, but a place to share himself as well.

For fifteen years, Larson lived in an apartment that always needed painting and wore hand-me-down clothes and falling-apart sneakers. He got around town in Rusty, his notoriously run-down car, or on a barely more operative bike, while many of his friends were making good money filming commercials or working with computers. Yet with his creative skills, his family of friends and his *joie de vivre*, Jonathan's existence seemed rich, not poor.

Matthew O'Grady: For somebody who had no money, he had a great life. He could get the most out of the littlest things.

Lisa Hubbard, a close friend: Jonathan had a romantic idea about doing your work and what you love. He was able to take nothing and make it feel like a celebration. When it snowed, he would always call friends to go for a walk in Central Park. I remember a breakfast we had when we were staying on Long Island, and how he picked flowers and made everything festive. Jonathan was extremely unhip, but he was also hip, in his own way.

Jonathan Burkhart: In *Rent,* he talks about riding his bike past the three-piece suits. We did that all the time. Sometimes he'd call me and say, "That's it, we're not doing anything today, we're going to the Hamptons." We'd leave at about nine-thirty and get coffee and bagels and be at the beach by noon and spend the day. But he'd always have a pen and paper with him. He had a much greater sensitivity and appreciation of things than anybody I will ever meet. And that was what impressed the people who met him. Because he was so well-educated and so well-spoken, when we'd stand around and talk about how things affected us, it always seemed to me that it affected him more. But that might have been because he was so eloquent.

Larson was a romantic—a sentimental lover of sunsets, candles, beaches and cats who, from high school on, always had a girlfriend.

Matthew O'Grady: Women loved Jonathan, and he was so romantic and sincere. He romanced the day. He was very charming to date, sending notes and letters. Doing the little things that mean a lot.

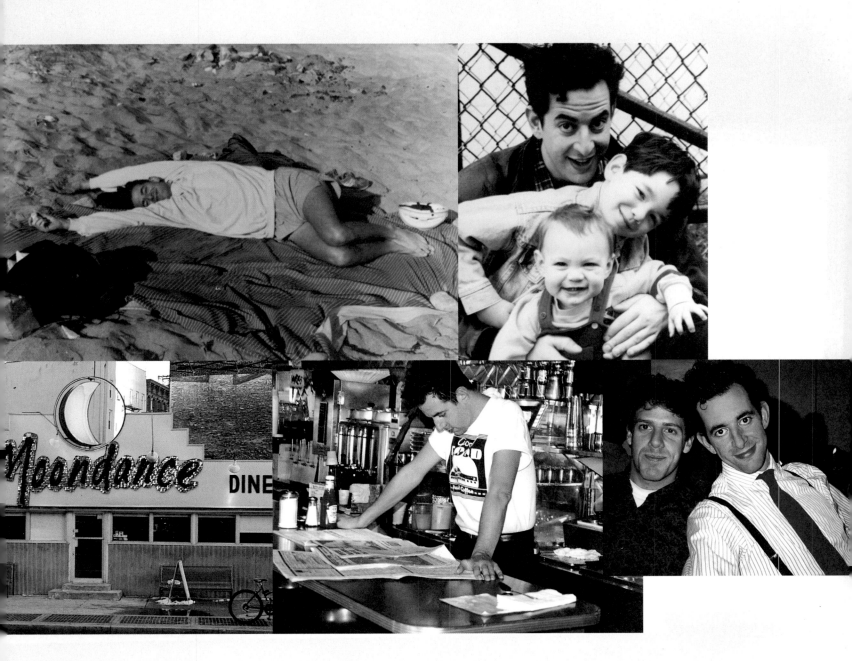

Janet Charleston, Jonathan's longtime girlfriend: Part of Jonathan is in Angel—the romantic part, that belief in love in an idealistic way. Like the lyrics to "I'll Cover You:" especially in the first couple of years we were going out, that's really how he was.

Julie Larson McCollum: He was not a saint. He could be annoying and frustrating and pigheaded. But I can't think of any unpleasant moments with him as an adult. If "Uncky" was coming, which is what my sons called him, it was pure magic. Everything felt complete, and peaceful. As frustrated as he would get, he was still a joyful person and could find wonderment in sitting and watching a sunset or smelling the roses. He gave a toast at my wedding. There was a long litany of the memories that we shared, and then he quoted Thornton Wilder's *Our Town:* "Does anyone really appreciate life when they're living it?" He was one of the few people I know who actually did that. He could take nothing and make it into something fun.

Jonathan was at the center of a circle of artistic friends. With them he developed the expansive vision of family that he had learned from his parents and that he put onstage with *Rent*. Many particulars of the play come from his own life—Jonathan really did have to throw keys down from his window to visitors on the street.

Jonathan Burkhart: Most of *Rent* is real. Most of the events he and I went through, or he went through. He put his ass on the line.

Nan Larson: The concept of Roger looking for one great song, for a breakthrough in his career—that certainly was Jonathan. And Mark is Jonathan to a certain extent: obsessed with work and everything else. There's a little bit of Jon all over the place.

Matthew O'Grady: He could take different elements of people's personalities and put them into one body. I see myself in Angel, and I'm so honored by that. You see some of Jonathan Burkhart and Jonathan Larson in Mark. And you see what they wanted to be in Roger: sexy, raw talent. He was a curious person in general. That was why he was able to take everybody's lives around him and put it into such a beautiful context.

Eddie Rosenstein, a close friend: I think the characters seem organic—like they really would exist—because of their nuances. The nuances are there because he worked so hard. He didn't leave his house much. He'd sit around in a room full of shelves and books, and write. It was a very sheltered world. Those nuances came from when he would leave and appreciate things. A lot of the characters are modeled on the characteristics of the people around him. But if he had lived in the world so fully, I don't think he would have been able to write it.

Beginning in 1985, Jonathan poured his creative talents, his enthusiasm for living and his love of community into an annual holiday potluck supper he called the Peasant Feast.

Al Larson: Jonathan surrounded himself with terrific people, caring people. The Peasant Feast: that's part of his legacy.

Matthew O'Grady: The Peasant Feast was started by Ann Egan and Jonathan. There was gravy at every table and stuffing and turkey and assorted vegetables. We would read or recite something. It was usually Sunday night and Jon had the Charlie Brown Christmas tree up in the corner. It was the tallest, skinniest thing, but he always had great ornaments: a spatula, other kitchen utensils. The room was packed. And we'd always dance.

Ann Egan: You'd invite everyone, from close friends and people in the neighborhood to someone you'd just met on the way home from the supermarket. It was like theater itself; the ambience of festivity covered all the dinginess. We transformed our ratty apartment into a great-looking bistro, with lit candles everywhere.

At some point in their lives, most creative people have to decide whether to apply their talents to a moneymaking career or pour them purely into artistic endeavors and pay their bills with a day job. Jonathan chose the latter.

Matthew O'Grady: He never lived there, but his life was very much an East Village life. He was supporting himself and supporting his art and not complaining about it.

Jonathan Burkhart: Jonathan spent nine years in the diner, serving eggs and complaining about it. And I'd say, "Go write jingles, go score someone's show; at least you'd be writing music for a living and have more of an influence and learn collaboration skills." He'd say, "No, fuck it, I'm just going to have all this time to myself and write my own stuff." I don't know if he'd say he was a bohemian, but he was. The entire time I knew him, he made maybe twenty, twenty-five thousand a year.

One of the things that amazed me was how diligent he was. We would be at a party or out doing something and he would say, "I think I'm going to go home now." I think he was going home to listen to his music.

If he were here right now, he could write a song about our last twenty minutes of conversation. Sit at the piano, crank out music you've never heard before and put the words together. He could write a song instantly.

Eddie Rosenstein: I got him a few jobs writing music for industrials, and he never turned those down. But he didn't pursue them. He always said, "The problem with easy money is that it is never easy." He could have pursued it, but why do that when what you're interested in is so consuming?

He didn't waste moments. He was entirely focused on his goals. In his time off, he would work on side projects. He could spend four years on something. His staying power blows away anyone I've ever met. That's another example of him being a throwback; he was not a fast-moving, commercial-marketing kind of guy. Most of his habits, values and ethics were rooted in traditions of another era.

My deepest conversations of the last ten years have been with Jonathan. We talked about every issue. We had huge battles, where he talked about his right as an artist. I said, "That is pretentious shit. You can't call yourself an artist. Let other people call you an artist; it sounds better." He said, "I can call myself an artist." I

guess I come from a blue-collar sensibility; my dad was an insurance salesman in Pittsburgh. I didn't grow up in Westchester. So the next morning, I wake up, and in my fax machine is this dictionary definition of an artist.

Jonathan, in notes for a 1992 script for *Rent:* Art is about love—the love you never got as a child—the love you can't give as an adult—the love you can only give your work.

Larson had a vision for musical theater that was both political and aesthetic, and he pursued it with incredible determination and drive. At the time, Broadway was clogged with big-budget productions that offered sensational pyrotechnics but uninspired content and music.

Julie Larson McCollum: He was influenced not just by musicals but by the sense of wanting to say something more than just fluff, and then have it be modern, accessible. I guess *Jesus Christ Superstar* was one of the first and major influences. He listened to it a few times and then sat down and played it. And my parents took us to *Hair;* he must have been so young. But he felt that what was out there then was meaningless and had no relevance for anybody.

Jonathan Burkhart: Jonathan said this: "It's the 1990s, it's time for a change." He was very clear about the evolution of theater. You cannot continue to write Stephen Sondheim, Andrew Lloyd Webber and Lerner and Loewe musicals and survive.

Anthony Tommasini, *New York Times* critic: Jonathan was trying to do something very difficult: he was trying to combine the tradition of Broadway—the song tradition, the words and music tradition, where words really

American Heritage Dictionary: artist *n.* 1. One, such as a painter or composer, who is able by virtue of imagination and talent to create works of aesthetic value. 2. A person whose work shows exceptional creative ability or skill: *you are an artist in the kitchen.* 3. One who works in the performing arts.

matter—with rock. Words don't carry in rock; rock is visceral, organic. It's a hard thing to combine; he did it as well as I can imagine it being done.

Eddie Rosenstein: In 1986 or 1987 I went to a fancy dinner party. Jonathan was there, and after dinner he said he wanted to play something. We retired to a room and he put on a tape and it was him. I was shocked by the gall of this guy. It was *Superbia.* We were glued to it. He played it for forty minutes, and we were all just watching the tape player. About a week or two later, he and I were hanging out, and I said, "What do you do?" And he said, "I'm the future of the American musical."

Al Larson: Jon had confidence that he was going to marry the MTV generation with theater. That was his goal, and he was confident that he could do it. But he wasn't cocky about it.

Changing musical theater was easier said than done. The costs of producing a musical—paying for musicians, conductor, choreographer, in addition to the cast—are prohibitive. Larson had trouble even putting together a musical system with which to compose. One day, Jonathan Burkhart asked Larson, as a favor, to drive to a music store in New Jersey and pick up something for him. Ever-obliging, Larson did, and discovered the "something" was a state-of-the-art keyboard to replace his rinky-dink Casio. With that, a digital processor and a computer, Burkhart says, "he could produce any sound in the world."

Larson did most of his recording at a digital studio owned by future *Rent* musical arranger Steve Skinner, an engineer who, like Jonathan, was interested in both pop and theater.

Steve Skinner: He would put together basic arrangements and bring the disc in here to me, and I would elaborate on the arrangement. He would bring his musical intuition and I would bring my music degree. I'm sure he heard those chords in his head and worked by trial and error. My job was to help make up for his lack of musical training. He would describe to me, say, a particular drumbeat that he wanted, and I would add a technically sophisticated thing to his intuitive approach, and they complemented each other. I think it was a good marriage.

One of the reasons he was attracted to me was because I would do synthesizer sounds. All of *Rent* evolved on disc and computer. He would use the technology, but was concerned with people preserving their humanity in whatever way, whether it was technology taking it away or something else.

Jonathan Burkhart: For many—ten to twelve—years, Steve did most of Jonathan's recording, 95 percent of anything Jonathan ever did outside of his apartment. Steve is a very, very pleasant man, a technical genius, very good at arranging. He and Jonathan got along famously, and he was very generous with Jonathan in terms of recording time and paying bills.

Steve Skinner: He was really like a little kid—always had this vibe like, "Gee, my dad's got this barn, let's put on a show." He wasn't too concerned with whether something was hip or current, he just did it because he liked it. Sometimes with corny results, sometimes with brilliant results. Jonathan was not a rock person doing a musical. He was first and foremost a musical person interested in rock.

Larson had written his first musical, *Sacrimoralimmorality,* with David Armstrong while at Adelphi. About the new Christian Right, the show was rechristened *Saved* and played on Forty-Second Street for two weeks.

Victoria Leacock, a close friend and producer: It was very hush-hush; no one could see it, because it was so scathing against the Moral Majority. Their cross turned into a swastika. There was an abortion comedy musical number; it was pretty wild. Some of us knew from that show on that Jonathan had tremendous intellect in his writing.

In 1982 Larson began writing a musical based on George Orwell's *1984.* When he was unable to get the rights from Orwell's estate, he converted some of the material into his own futuristic parable, *Superbia,* which opened with a satire of "We Are the World" pop-star benefits and went on to offer a scathing critique of the mindless, conformist, totalitarian culture of a media-controlled society.

Victoria Leacock: He was terrified that there was this bottom-line mentality that was going to destroy the planet and life as we know it. In *Superbia* everybody's going to be "delimbinated," which is the removal of the arms, legs and upper torso so that everyone's heads can be put in a box with a thirty-two-inch color monitor.

The way he'd develop stuff is that he'd play it to you in his living room, put the speakers facing you and literally play you the whole musical. You weren't allowed to get up, walk around, ask questions, pee. It was dead serious. He developed a lot of *Superbia* that way.

Unfortunately Jonathan had trouble developing the show in more public venues. In 1988 he did win a Richard Rodgers Production Award, chaired by Stephen Sondheim, which paid for a staged reading at Playwrights Horizons.

Victoria Leacock: That was a terrible production. By the time he did it, he didn't have the people and the music he wanted, and they forced him to make changes he wasn't comfortable with. Then Sondheim came. At intermission, Sondheim put his hand on Jonathan's shoulder and said, "Nice work; I've got to be on *Good Morning America* tomorrow morning, so I'd better go." Jonathan was devastated.

Stephen Sondheim: I thought the show was interesting, and that what he was trying to do was interesting. What was wrong with it had to do with the story and how the story was told. Some of the songs were good and others not. He was still finding a voice, and I think he still would be, but he had a voice, and that was the important thing.

Driven by his own belief in his work, and supported by Leacock, Larson continued to work on *Superbia.* In 1989 they produced the show as a rock concert at the Village Gate, a nightclub in Greenwich Village.

Victoria Leacock: It was free, and more than two hundred people came. Everybody said it was fabulous. We were two thousand dollars in debt, and nothing came of it. So Jonathan gave up on *Superbia.* They were always saying it was too big, there were too many people in it, it was too expensive to do. So around that time, Jonathan decided to do his monologue.

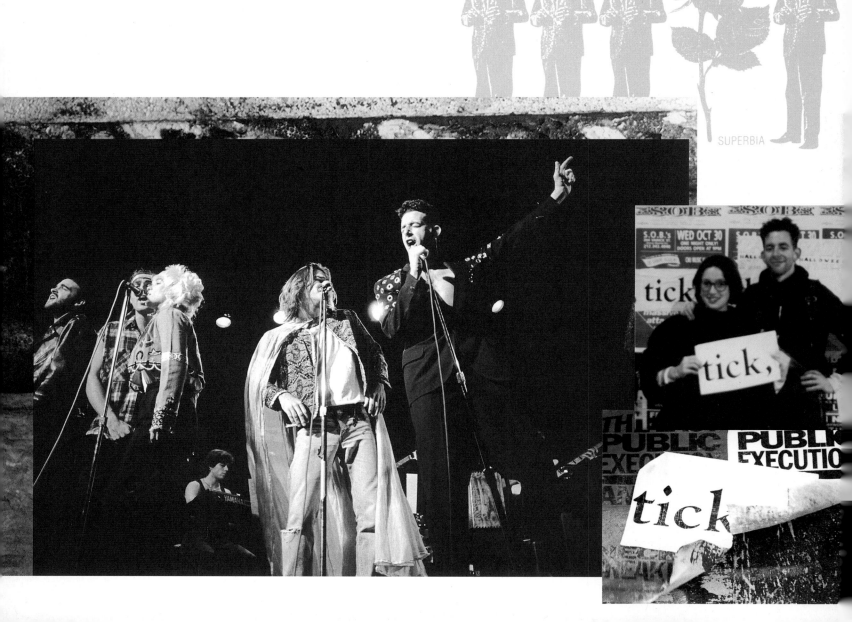

By this point, Larson had been out of school seven years and still had not had a show of his own fully produced. Frustrated, tired of waiting tables, he was questioning his own commitment to his art. He began writing a show about his fears and doubts—and how they run up against a colder reality when his best friend tells him he's HIV-positive. Originally called *30/90*, because he was turning thirty in 1990, the show went through a number of versions and titles, including *Boho Days* and ultimately, *tick, tick...BOOM!*

Victoria Leacock: *tick, tick...BOOM!* was a one-man show that he could do himself, with his own music, about all the shit he went through trying to reinvent American musical theater.

Matthew O'Grady: I'll never forget it: it was like we were on the edge of an exploding society. In addition to being musically talented, he was a pop sociologist. He loved tracking social and political trends. He had a very strongly developed political ideology. He really kept up with current events and their sociological implications.

Eddie Rosenstein: He came from a suburban community where everybody else was doing pretty damn good. I don't think he expected to become bohemian. That snuck up on him. Then he realized he was poor. And he was afraid. He thought *tick, tick...BOOM!* was about being a bohemian artist. My argument with him, even the week he died, was that it was about suburban angst and fear of not being successful. Jonathan was a kid from White Plains who wanted to be successful and had the tools and was working in a diner. It was about overcoming that.

Among those who saw *tick, tick...BOOM!* and were impressed by its music and Larson's intensity was a young booking agent named Jeffrey Seller. Larson convinced Seller to try to produce the show.

Jeffrey Seller: In 1990 a friend invited me to see something called a rock monologue. *Rock monologue* seemed like a weird juxtaposition. So we went, and there was a piano and rock band onstage. It was all about this composer struggling at his surprise thirtieth birthday with whether he should continue composing or just throw in the towel and take a job as an ad copywriter.

Through a cycle of songs, Jonathan really depicted what it's like to be thirty (or twenty-five, as I was that night) and be at a crossroads. Who am I? What am I made up of? What do I want to do and how do I do it when everybody else is making it so difficult? I was bawling my eyes out. He was capturing what my generation was going through better than anybody else I had come in contact with, be it song, book, movie, television or theater. He had his finger right on the pulse.

The next day, I wrote him a letter saying: "Dear Jonathan, my name is Jeffrey Seller. I'm a young theater person, and I want to produce shows, and I think you're amazing."

He immediately started selling me on why I should produce *tick, tick...BOOM!* We had a great talk, and I felt very in touch with him in terms of our theatrical values. It was back then that he said, "Nobody goes uptown. Those aren't our stories, those aren't our values, those aren't our people. That's why no one our age goes to the theater, because there's nothing for them."

I wanted to be around him, but I knew in my heart that *tick, tick...BOOM!* was never going to be commercial. I knew it was self-indulgent and self-pitying. We did two readings of it for people who would help me raise money, and it fell flat on its face. That was upsetting to me, because I was afraid I was going to lose him as a friend and as a theatrical collaborator.

Eddie Rosenstein: Jeffrey was interested in producing, but they wanted someone else to perform it, and Jonathan had grown so attached to it that he couldn't let go. We had a huge battle, because I felt at that point that he was making problems. He was unable to collaborate and invited disasters, making excuses through his inability to work with other people, taking on so much that he was blocking people out. That was his escape mechanism for failure, saying, "Look at everything I'm doing, I'm doing all I can," instead of inviting people to work with him. Then, about a month later, he started a whole new thing, where he wanted to work with everyone.

Larson was having some success with his music. In 1989 he won the Stephen Sondheim Award from the American Music Theater Festival. He wrote scores for kids' books on tape and videos, including *Sesame Street* and *Away We Go!* He wrote music for home movies put together by Leacock for Jann Wenner, the publisher of *Rolling Stone*. And he composed scores for dance concerts, including some for his girlfriend of several years, Brenda Daniels.

Nan Larson: I would have loved to see good things happen to him. I wondered, "How long is it going to take?" Each step was a step up. It was a slow process, and obviously we would have loved to see him settled, to get some recognition for what he was doing.

Julie Larson McCollum: I was his cheerleader. I always said he was creating the building blocks. Little by little, more and more of his time and income was from doing what he loved, his music—getting awards, grants, commissions. People outside the theater community didn't know him yet, but he was building the contacts and relationships that were going to last a lifetime.

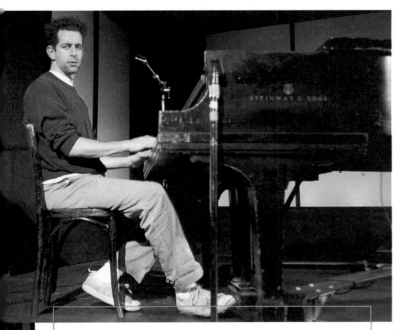

clockwise from left:

detail from *Superbia* playbill; performance of *tick, tick...Boom!*; *tick, tick...Boom!* poster; Victoria Leacock and Jonathan putting up posters at 3 A.M.; Jonathan performing in *Superbia* at the Village Gate, 1989.

Leap of Faith

The story of *Rent*'s creation is the story of Jonathan Larson's singular vision and drive. But it's also the story of a group of people working together to create a work of art. *Rent* started as a collaboration, conceived by another playwright, Billy Aronson. While a young writer, Aronson found refuge from the chaotic life of New York at the Metropolitan Opera. There he discovered Puccini's *La Bohème,* which depicted artists' struggles to live and create in turn-of-the-century Paris—struggles that resonated with Aronson.

Billy Aronson: I was living in Hell's Kitchen in a tiny apartment with no place to think. So I would go to the Met a lot and get standing room and solitude. Over the course of that time, I became infatuated with opera. I really fell in love with *La Bohème.* The similarity between these artists and their poverty and New York in the late '80s struck me. The numbers of homeless people were shooting up, and people were dying all around us. There was AIDS and lack of government support for the arts. I wanted to rework the plot of the opera, which is very choppy and reads like a Samuel Beckett play—they fall in love, everything's different, they go to a party, they can't stand each other anymore, they fight, they can't live together, she's dying, she dies. Where I differed from *La Bohème* was that the characters were so eloquent about their feelings. I wanted, in part because of the way I write, to take the plot but have things be so overwhelming and peculiar that they have trouble speaking, that it be hard to express tenderness.

In the spring of 1989, I asked Playwrights Horizons to recommend a composer, and artistic director Ira Weitzman gave me two names, one of which was Jonathan's. I got in touch with him, and he was very excited by the idea. I loved his music—it was so clear and accessible and fun. I thought maybe we would do something other than *La Bohème,* something funnier, but he really wanted to do this. One thing that excited him about the idea was that it was both highbrow and lowbrow.

Although some of the themes I was interested in were interesting to him, too, some went against the grain of his music. His music is so expressive, and in that way *Rent* is more like *La Bohème.* So even though there were differences, I wanted to work with him and see what would happen.

Al Larson: When Jonnie was no more than eight, we were in Chicago. It was at the time of the election, 1968. We went to a Swedish restaurant because they had a Punch-and-Judy show, and they did *La Bohème,* with puppets.

Eddie Rosenstein: Jonathan's idea was that you have to look at the classics. He was a student of Aristotelian dramaturgy and felt that you structured everything after the classics. Once that was complete, you departed. So it was no surprise he chose Puccini.

Billy Aronson: He was not much of an opera fan when we started. In fact, I couldn't get him to go to the opera with me. That certainly changed when we parted company, and he obviously became a great student of it. We were both in the Village at that time, and we met on his roof. I had a choice of plastic crate or wood. Right off the bat, he said, "It's time for a new *Hair.*"

Aronson and Larson decided that the characters who had tuberculosis in *La Bohème* would have AIDS in *Rent.* And instead of living in Parisian garrets, they'd live in New York's East Village, a mecca for the modern bohemians. The particulars changed, but the plot stuck closely to *La Bohème.*

"...they fall in love, everything's different, they go to a party, they can't stand each other any more, they fight, they can't live together...."

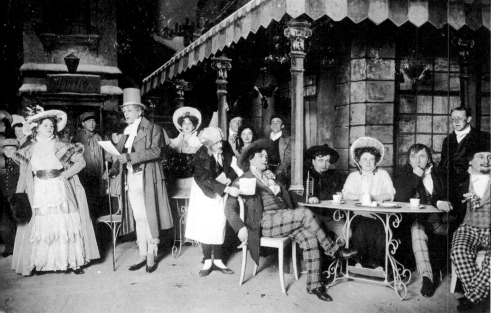

from top:

A kiss on St. Marks Place, in the East Village; café scene from a Berlin production of *La Bohème*, 1910.

Billy Aronson: He wanted the East Village. I tend not to write about a generation or a neighborhood. He wanted *Rent* to be the title. I didn't know what to call it. I said that it didn't seem to work on enough levels, and he reminded me that *Rent* also means torn apart.

From July through September, I wrote the first draft. *Rent* began with two artists, a playwright and a painter. It's Christmas Eve, the heat is broken and they're wrapped in blankets. I tried very hard to make my characters speak in a way that would be right for his music: more straightforward, earnest, on the surface. I wrote three songs: in my beginning you had the "Rent" song, of

which the lyrics have been completely changed; "Santa Fe," where the third roommate wants to leave, followed, and those lyrics were pretty much as they are now; the final song in what would have been the first scene is where Roger meets Mimi, falls in love and sings, "I Should Tell You," which again is as it was, except that the verse about how diseases spread was changed. In those lyrics, you can see the awkwardness I was talking about: they can hardly finish a sentence.

Victoria Leacock: Those three songs remained the same for years. Jonathan was happy with them and stuck with them through thick and thin.

Billy Aronson: For both of us, collaboration was new. We each had the same problem: how to say what we felt without being antagonistic. Therefore, both of us would wait too long to say something. He tended to have impulsive reactions: he'd love something or not like it. Rational discussion got combined with emotional stuff. It was hard, because I didn't know exactly what I wanted. He was headstrong—it's gotta be exactly how he thinks it should be. I have an impulse to want to please everyone in the room. Some of the weirdest and most daring stuff he did was some of the best. What he had more than just about anybody was that desperate desire to be out there. Even if some of the songs were trite, they were his. When it wasn't working out, he wouldn't let it sit there.

October 4, 1991

Bill Aronson
394 First Street #4L
Brooklyn, NY 11215

Bill:

As per our phone conversation, I'm planning , with your permission, to go ahead and continue working on RENT. If any such miracle as a production happens, I'll give you credit for original concept and any lyrics of yours that I use.

At such time, we'll obviously draw up a more official agreement so you'll be fairly compensated for your work.

Thanks for the green light.

Best,

Jonathan

Jonathan Larson

When the draft of the four scenes was complete, somehow it wasn't done. It wasn't vivid. So we recorded the three songs at Steve Skinner's towards the end of 1989, beginning of 1990. I just loved those songs. I remember listening to them the first time and thinking that he was already better than what he had given me. He was in touch with something. But we weren't sure what to do next. The major characters were heroin addicts. I told him I would have trouble writing that from the inside. So he got busy with *tick, tick...BOOM!* and I got busy with some other plays. After a couple of years, maybe 1991, he called me and asked if he could go ahead on his own.

I was creating the characters, really. He wanted them to be like his friends, but it wasn't until we separated that he made them what they are. I got the feeling that he wanted them to experience things that he experienced, literally, actually. There was a scene in which the playwright was having an argument about the theater. Jonathan wanted that to be what he would have said to the producers who weren't doing his plays. He wanted to get his gang up there. Jonathan felt a very personal connection to *Rent*. Right from the beginning, it was as if he didn't hear what I was saying. He had a vision for it, and you couldn't vary from that. He did discover things: "I Should Tell You" is a strange lyric for him, but he liked it. But his music was going to go where it was going to go, and I don't think anybody could get him to compromise.

One reason Jonathan returned to *Rent* was that AIDS had became a major concern in his own life. In 1987, Matthew O'Grady had told Jonathan he was HIV-positive.

Matthew O'Grady: At age twenty-five, they told me to go home and get my things in order. In some ways he took it harder than I did. He saw what was going on, and I didn't. I didn't want to. But I gave him unspoken liberty to write about it.

Larson began volunteering at the now defunct Manhattan Center for Living, an organization that offered counseling and support for people with AIDS. When O'Grady started going to group meetings at Friends in Deed, an organization that spun off from the Manhattan Center, Jonathan sometimes went with him. There, O'Grady began coping with his status. Friends in Deed's philosophy of learning to live with the disease had a profound impact on *Rent*.

Cynthia O'Neal, director of Friends in Deed: Jonathan came here to support his great friend. He was a wonderful, alive, absolutely interested, absolutely present person. How glad Matt was that he was here, too—you could see all the love between those two men.

Matthew O'Grady: I definitely picked up from Friends in Deed that you don't have to choose fear. My life may not be as long as I want it to be, but it's a really good life. Jonathan saw me evolving towards that. I didn't have lofty intellectual or spiritual aspirations, but when you're confronted with the fact that you're going to die, you get your shit together pretty quickly, because you want your time here to be good. It's not about having HIV, it's about having a good life. It's about love. I'm so honored that he took all that and put it together.

"Excuse me

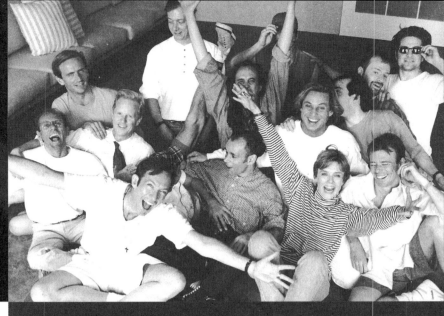

By this time, AIDS had been diagnosed in three more of Jonathan's friends: Ali Gertz, Pam Shaw and Gordon Rogers (all three had died by the time *Rent* went into rehearsals and appear by name in the "Life Support" scene). Shaw and Rogers, however, were less appreciative than O'Grady of the way *Rent* depicted people with AIDS.

Victoria Leacock: Jonathan did a big living room read-through of it for fifteen of us, including Gordon and Pam. He played the tapes, and everyone loved it. But Gordon and Pam were just enraged. Jonathan's message was love, love, love, and Gordon and Pam were like, "Fuck you, you don't have AIDS." In the original "Life Support" scene, Mimi was doing the whole support group, and Pam said, "How can you have her up there when she's still a drug addict? It's like having someone spout AA who's drunk." So that fight with Roger came directly out of what Pam was saying. The Gordon part was like, "You don't have AIDS, so you can't just say that at the end of the day all that matters is love." That's why Gordon is the voice coming out of the support group saying, "Excuse me, my T-cells suck."

Larson had rewritten Aronson's script drastically, going back to Henri Murger's *Scènes de la Vie Bohème*, on which *La Bohème* is based, and increasingly deviating from Puccini's structure. Collins and Angel (Colline and Schaunard in *La Bohème*) became gay men, Maureen (Musetta) became bisexual and Alcindoro became Maureen's lover, Joanne. All the characters except Mark had HIV. And Mimi didn't die.

Gilles Chiasson, *Rent* **cast member:** Jonathan and I had a whole discussion about why Mimi didn't die. He was adamant. He said, "It's a play about life, not about death."

Jonathan Larson in a 1992 statement of concept for *Rent:* Inspired, in part, by Susan Sontag's *AIDS and Its Metaphors,* the aim is to quash the already clichéd "AIDS victim" stereotypes and point out that A. People with AIDS can live full lives; B. AIDS affects everyone—not just homosexuals and drug abusers; C. In our desensitized culture, the ones grappling with life-and-death issues often live more fully than members of the so-called "mainstream."

Billy Aronson: What was so unique about *Rent* is that Jonathan could translate his love for his friends into music. He wanted you to feel what he felt about having friends who were dying, and living.

FRIENDS IN DEED

The support group for people with HIV depicted in the *Rent* song "Life Support" is based on gatherings that take place several times a week at Friends in Deed, a social-services agency dedicated to helping anyone affected by HIV and other life-threatening illnesses.

The corridors of Friends in Deed are lined with photographs of members: a trio of smiling sisters; five men lounging and laughing on a couch; a young man's proud face as his parents embrace him. Some of those pictured still participate in the organization's activities. Others have passed on.

Each week, 700 or 800 people visit a 6,500-square-foot SoHo loft to meet with friends, speak with crisis counselors, attend writing workshops and yoga and movement classes, or participate in discussion groups. Friends in Deed is where Matthew O'Grady went for spiritual and emotional support when he discovered he was HIV-positive. Several times he brought Jonathan Larson with him.

Cynthia O'Neal, a former actor and clothing designer, cofounded Friends in Deed with her longtime friend filmmaker Mike Nichols. She recalls Jonathan's first visit: "When he came here with O'Grady, I didn't know if he was gay or straight, positive or negative—he just participated in the discussion along with everyone else. Then in January of 1995 I got a letter from Jonathan saying he was writing a musical and AIDS was one of the things in it, that there was a support group in it that this was the model for. He asked if I would come speak to the cast."

One cold winter afternoon, Cynthia led a discussion with the *Rent* cast at New York Theatre Workshop. A couple of days later, she received a thank-you note from Jonathan. Three days after that, she got a message from Anthony Rapp, a *Rent* cast member, that Jonathan had died.

The principles of Friends in Deed resonate in several *Rent* songs. During one of Jonathan's visits, a man in a discussion group asked, "Will I lose my dignity?" inspiring the song "Will I?" "The main precept of our work here is that the quality of your life is not based on circumstances," O'Neal says. "It's never outside of yourself. How you perceive life is entirely up to you. We do not view anything as a tragedy." O'Neal finds much common ground in the messages of Friends in Deed and *Rent*. "We're about love, not fear, which is what I think the show is about. It's such a source of joy for a lot of us here, that connection of the heart we have with that show. 'No day but today'—in truth, that's all there is."

above: Friends in Deed director Cynthia O'Neal, with Matthew O'Grady (top left) and friends

my T-cells suck."

Larson began looking for a place to produce *Rent* and ran up against many of the old barriers. One day, in the summer of 1992, he rode his bike down East Fourth Street, past a theater under renovation. He walked in and discovered the new home for New York Theatre Workshop (NYTW), a growing nonprofit theater company. Shortly thereafter, he dropped off a tape and script of *Rent* for artistic director Jim Nicola. Because it was the off-season, Nicola responded to the materials unusually quickly.

Victoria Leacock: No one was doing new musicals. Jonathan courted people like Cameron Mackintosh, Des McAnuff, David Geffen. They were people he wanted to work with, people he wrote to over and over again. By the time *Rent* got to New York Theatre Workshop, he was so grateful that he had found his home. He called us up right away: "You should see this new space. It'd be perfect for *Rent*." NYTW really bit the bullet and said, "We will develop your musical." But they also said, "We want changes."

Jim Nicola: What was unusual is that it normally takes us a while to read a script and connect with the writer. But by the fall, we were under way on *Rent*. The real bond occurred over the idea of popular music in the theater. Musical theater had stayed in a particular style and form while popular music has progressed. I thought that this composer had the potential to write music which would fulfill the integrity of the pop song and the integrity of a theater song. The song that stuck in my head was "Light My Candle." It was a wonderful pop song, but it was also a complete theatrical scene, a wonderful piece of dramaturgy that took place in pop form.

The description was interesting: *La Bohème* in the East Village. We had just moved to the East Village and were looking for material representative of the community. It struck me that Jonathan and the workshop would be a good match, because he

had a great ability as a composer/songwriter, but he wasn't as sure as a dramatist, as a storyteller. That's what we talked about every day: dramaturgy and storytelling.

Rent was a great challenge for us. If we were to produce it, it would be two or three times bigger than anything we'd produced. If we were to grow and truly live up to our mission, which is to support artists, their work and their growth, here was a new kind of work and a new kind of artist that we should welcome into the fold and be able to respond to.

The process we started with was to invite Jonathan to be a member of our community of artists, which is called the Usual Suspects. He always told me it was very significant for him to feel a part of a group of artists. Although—very much like Mark in *Rent*, who needs and yearns to feel part of a community but has an equally strong impulse to be separate—Jonathan participated fully in the life of this community, he was also shy and a bit isolated. The kind of theater it was—not just a producing entity; it had a dimension of support—was important for what the essence of *Rent* was.

Nicola still needed some convincing to produce *Rent*. On June 17, 1993, Larson put together a staged reading at NYTW to lure investors.

Martha Banta, assistant director at NYTW: That reading, I completely remember the talk-back discussion afterward. There were lots of plotlines and problems. A lot of it was politically incorrect, out of Jonathan's naïveté. I said during the discussion that while the story line is a problem, nobody's talking about the music, and I think the music's really powerful. Basically, from that day on, I became a fan.

Jeffrey Seller: I took three friends down to see the reading. It started off with a great number, "Rent," but turned into this endless collage of songs. It made no narrative sense whatsoever. It went on for three hours; two of the people I was with left at intermission. The third said that this couldn't be saved and that Jonathan should get on with his life. I loved the songs, but I didn't know what Jonathan was

doing. A week later we went to dinner. I said, "Jonathan, are you trying to do a concert of songs or are you trying to tell a story?" He expressed some ambivalence. I said that it was my belief that he had to write a play into this.

Jim Nicola: The strongest response from the artistic community here was that you can't put actors onstage and use them as a chorus of cute homeless people. It's demeaning, it's insulting. At first he was defensive. Which was a pattern with him. Then he would go away, quietly think about it and realize what he could take from it.

Part of the learning curve for this operation was what it takes to support a musical theater artist. I knew at the time that we would have to find special funding to even do another reading. So we invited a lot of people, off-Broadway producers, people in the funding community. And nobody was interested. There were some people who said, "Well, he's promising, a good songwriter, but it's a big chaotic mess." Some people were very passionate about it, but most didn't think it would amount to anything. We were left with no money to proceed. That was the hardest period for Jonathan and us.

We did come to the point of saying, "Maybe we're not the right theater. Maybe we can't respond to what you need most: financial support." We did agree that if he wanted to show it around, he was free to do so. And he did. It was important for him to do, to wander away, look around and see what he could find.

Martha Banta: There were a lot of struggles between Jonathan and Jim and us at the workshop. He took this project to other theaters, and they started it and dropped it because he was difficult to deal with. Jim was really great in teaching him how to be patient and how to collaborate. Jonathan just didn't trust us and needed us to say in writing that "you will produce my play by such and such a date." Jim said, "No, we'll see how it goes and keep working until it's ready to be produced."

In the spring of 1994, Larson received a prestigious Richard Rodgers Development Grant of $45,000 that paid for a workshop performance of *Rent*. After a search for directors, Nicola and Larson agreed on Michael Greif, a young up-and-coming director whom they both knew and who had recently been widely praised for his direction of Sophie Treadwell's *Machinal* at the New York Shakespeare Festival.

Jim Nicola: I knew him and loved him, and we had a very strong connection. I feel like I could say anything to Michael without worrying about how to put it. The biggest problem for a director is that they are theoretically open to feedback, but when they're in the thick of it, it's very hard to hear anything but "You're a genius, it's wonderful." Michael and I seem to have gotten past the need for that, because he knows I trust him, and he trusts me.

Michael Greif: My first exposure to *Rent* was listening to the tape and reading along. I had questions, but they were things to deal with rather than run from. As soon as I talked to Jonathan, I knew he was interested in dealing with them, too. He didn't say, "This is ideal and this is how I want it." It was always, "Tell me more about what you want," and, "What do you mean?" and, "Tell me why that is better than this." When I did have concerns, I felt very good that Jim would stand by it and be there to really help it and me along. I think the workshop as a producing organization is really extraordinary, and I think Jim is really extraordinary, and that had a lot to do with my doing the project.

September 29, 1992

Jim Nicola
New York Theater Workshop
220 West 42nd Street
New York, NY 10036

Dear Jim:

After George Xenos gave me the tour of your new theater, I decided to finally make contact with you— as Tom Ross, Melia Bensussen and Morgan Jeness had recommended.

I write rock musicals. I've won the Richard Rodgers and Stephen Sondheim Awards and was Sondheim's observer during INTO THE WOODS. (where I met another NYTW alumni, R.J. Cutler) My current project is RENT— a rock opera based on La Boheme, set in the East Village.

I've been a fan of your productions for a while now, and the location of your new space confirms what I've always felt— that you're one of the only producers courageous enough to cultivate younger, hipper, downtown artists and audiences. This is exactly my brand of theater. RENT, for instance, deals in musical and esthetic language that audiences aren't finding uptown.

I'd love the opportunity to meet and discuss and/or show it to you.

Break a leg on your first production. Hope to hear from you.

Best,

Jonathan Larson

Jonathan Larson
508 Greenwich Street #4
New York, NY 10013
212-966-6011

A workshop production of *Rent* was scheduled for fall 1994. But everyone agreed the script needed work. While people loved Jonathan's music, they were concerned about the story, which was packed with ideas from the author's voracious reading but weak on plot and characterization.

Jim Nicola: A key moment was in May of 1994. We spent a week in Jonathan's apartment, Michael and Jonathan and I, listening from beginning to end. We would listen to one song, stop and argue for three hours and then listen to the next song. We came up with a new outline for a draft that was to be what we went into the workshop with.

It is to Jonathan's credit that he was so able and willing to throw something out, do something new. The primary focus was always on the storytelling: who are these people, what do they want? The elements were all there, but it was not structured right. The thing I proposed to him, a challenge he took on, was to come up with a sentence—it didn't have to be simple—that would be a touchstone for containing the whole story. That was the guideline right through to when he died.

Jonathan was really tired of working in the diner and doing all the half-baked jobs he had to do. He wanted, rightly so, to be paid for the work he was doing. What I never seemed to be able to make him comprehend was that I had lots of playwrights and directors and composers and designers who were working here in the same way. We don't have money to commission, to give five thousand dollars to an artist so he doesn't have to work in a diner. That was a real line of conflict which was not often spoken but was definitely there. One of Michael's great gifts was that he was able to defuse a lot of that between us and keep it on a happier and more constructive level.

Ultimately I understood Jonathan's difficultness to be insecurity. That week in the apartment, when we had actually made a move to hire a director, Jonathan felt, "Well, they're really going to produce my play; okay, now I can listen." Once he reached that point, he was wonderfully open and available. Then the kind of argument, discussion and conflict was in a much better dimension, because it was about the things that were actually on the table.

Michael Greif: Jonathan loved dialogue. He would come in with tons of material and say, "Here's a great thing, here's a great thing." The thing was, some of it was great and some of it wasn't. He was very prolific, and not shoddy-prolific. There was a very good synthesis of hearts and minds in this group to weed out the great from the not-so-great. He wrote on his own, but he loved getting inspiration from discussions.

The main structure, characters and music were already in place. But Nicola and Greif felt that some of the subplots were confusing and the characters cardboard. Larson's efforts to be multicultural and inclusive could be clumsily executed; sometimes his own intellect and earnestness got in his characters' way. At points, he adhered too much to *La Bohème,* or to his own experience, and didn't give the show space to grow. The relationship between Maureen and Joanne, for instance, was problematic: in early versions, Maureen gets back together with Mark in a plot twist that does parallel *La Bohème,* but that comes across as wishful thinking on a straight man's part. In fact, Jonathan had had a girlfriend who left him for a woman.

Michael Greif: Until late in rehearsal, there were a lot of dyke issues. It was my point of view that they were the characters Jonathan

Rudolpho — writes *musical plays.*

Mimi — a dancer

Schunard — jazz philosopher

Collins — his street musician homeless black male lover

Marcello — a filmmaker "insane" (like mary musican)

Musetta — a lesbian performance artist

An... — her activist lover

Benoit — a yuppie scum landlord.

The time — now,

The place — the East Village.

The story — In/a crumbling racial → in a world where art is shunned war zone — two artists, both w/ HIV+ blood, fall in love.

Rent

love, art, disease, new york.

~~la bohème 1994~~

an east village la bohème.

had the most distance from, or the least handle on. He wasn't seeing what Jim and I were seeing very clearly, which was that if you're writing a piece that celebrates queer life, then let the women be queer.

Lisa Hubbard: I talked to him a lot about the lesbian characters. I felt at first that he didn't know how pat they were. They didn't feel like they were people, you didn't feel like they were relating to each other, in the same way those kinds of characters often come across in movies—as if they were written by straight men. At first you felt Maureen's connection with Mark more than with Joanne. It was almost like a joke that she'd turned gay. Jonathan needed a little kick in the butt. But we never argued about it. He wanted it to be good. Jonathan was very different; he wasn't like most straight guys. Two of his very closest friends were gay—Matt and me. So he knew a lot about gay life.

Shelley Dickinson, a Broadway understudy who played Joanne in the 1994 workshop: He made Maureen seem bitchy, period. There were no balls in the air that made you think, "She's got this going on and this going on—maybe she's a bit neurotic." Joanne seemed like she was nothing better than a lapdog. At least in the final incarnation she has an identity: she's an attorney; she has parents who are well-to-do; you understand she's an intelligent person who is a lesbian, who fell in love with this woman who's maybe just a little bit kooky and different from anything Joanne's probably seen in her life. During

the workshop, they would give me changes. One change had to do with making her even more a "slave" to Maureen. I hated that it made her weak. I think she's bright and intelligent—uncomfortable and out of her element, but never weak. I told them that. At one point Jonathan looked at Michael and said, "She's right. Let's leave it the way it is."

Jim Nicola: A big struggle was how much do you stay true to *La Bohème* and how much do you veer from that? That libretto itself is hardly a model of good dramaturgy. I kept saying, "Don't cling to that. Take what you need and let go of the rest."

Michael Greif: We all knew that we never wanted to create a piece that relied on a knowledge of *La Bohème* for enjoyment.

Even before Greif came on board, Larson began condensing and excising *Rent*'s peripheral characters. Street people Rudy, Mrs. Chance and Dogman were folded into the chorus, becoming generalized voices of conscience instead of stereotyped characters.

Michael Greif: Another aspect of the play which continues to be tricky: the presence of homeless people. Out of a conversation we had about my concerns that they not be depicted simply as a group, Jonathan wrote "Who the fuck do you think you are?" which I think is a wonderful collision. He was really great about responding to issues like that with material.

A lot of the tone of our early conversations was to think about how to humanize the artist-heroes, to depict them as people who could also make mistakes, could be self-deluded, who were not in the right all the time. There was a bit of a tendency to be self-loving on the part of Roger and Mark. There was a lot of material in "La Vie Bohème" which I found to be dangerously self-congratulatory.

I think the issue has always been preserving authenticity and preserving real integrity in the way we present these characters, and also presenting them in ways that make them very identifiable and sympathetic and human. Not a group of smug, obnoxious, above-it artists, but instead young, struggling, sometimes obnoxious, sometimes endearing, but always very human people who are subject to lots and lots of extremes of every kind.

That's always been its attempt, to be a validation. My greatest concern has been that the people we were writing about would like it and would not either be insulted by it or feel that it was untrue, or a distant, weird and dumb depiction of their lives.

Anthony Rapp, cast member from the 1994 workshop to Broadway: I think Jonathan had a romanticized view of himself as an artist. He was very serious, not gloomy but intense. He had very strong ideas about the way things should be. You could say self-righteous, but he was never obnoxious—sanctimonious, perhaps, which is probably a lot of where he and Michael clashed.

LA BOHÈME

the original " goodbye kiss"

By the time Giacomo Puccini wrote *La Bohème*, in 1895, he was already a leader of Italy's younger musical generation. His fourth and most celebrated opera was based on Henri Murger's *Scènes de la Vie de Bohème*, a loosely linked series of autobiographical episodes published in 1848.

La Bohème depicts a group of artists, composers and their friends who live lives of romanticized poverty, searching for love and connection despite jealousy and hardship. This was a highly unorthodox choice of operatic subject for that time. Bohemian life existed in northern Italy (in the 1860s, a group of Milanese writers, composers and painters called themselves the *Scapigliatura*, or "Disorderly Ones"). But most popular operas traded in stylized artificiality, with larger-than-life characters and happy endings.

La Bohème had its world premiere at the Teatro Regio in Turin in 1896. The opera debuted in the U.S. a year later, at the Los Angeles Theatre. Many early audiences did not know what to make of the tragicomic libretto and the "ordinary" milieu it depicted. When it was first introduced at New York's Metropolitan Opera House, one reviewer dismissed it as "foul in subject." The opera nearly failed in its first few weeks but went on to become Puccini's most popular work.

Jonathan Larson liberally adapted Puccini's opera. Paris' Latin Quarter of the 1830s became the present-day Lower East Side. Rodolfo, the dramatist riven by jealousy, became Roger, a musician recovering from heroin addiction who is paralyzed by fear. Colline the philosopher became Tom Collins, a New York University philosophy professor who falls for a transvestite

named Angel. In Puccini's version, Mimi is a sweet, tubercular seamstress; Larson's Mimi is a sassy, HIV-positive dancer at an S&M club. Musetta, the coquette who takes advantage of the rich, elderly Alcindoro, becomes ditsy diva Maureen, who dumps Mark for Joanne, a lawyer from a socially prominent family.

Larson also took license with Puccini's plot twists. In *La Bohème*, Colline pawns his overcoat in the fourth act to pay for a doctor for Mimi; in the first act of *Rent*, Tom Collins loses his to muggers. Puccini's bohemians gather at Momus Tavern at the rue d'Enfer; the New York crew gathers at the Life Cafe in the East Village.

Although Larson borrowed loosely from Puccini, *Rent* reflects his own struggles, as well as those of his contemporaries. Poverty unites the characters in *La Bohème*; in *Rent*, they also struggle for their art and with HIV. But Larson's and Puccini's bohemians have more in common than hardship: they share spirit, youth, hope, delight in one another's companionship and, above all, a willingness to fight for love.

above: Jonathan's inspirational color Xerox of a scene from *La Bohème*

In September 1994, casting for the workshop began—a distinctive process of shaking the trees that has become crucial to the show's success. Some of the original cast had theater backgrounds: Anthony Rapp appeared in his first professional play when he was nine. Others came from the downtown music and art scenes: Daphne Rubin-Vega was singing in the dance-music band the Pajama Party, and Pat Briggs, who played Tom Collins, had been a performance artist. Among those picked for the 1994 workshop were current Broadway cast member Gilles Chiasson and Broadway understudies Shelley Dickinson and Mark Setlock.

Martha Banta: We hired an outside casting director, Wendy Ettinger, whom I worked with. We did all sorts of things to cast it. We literally went across the street to a gay bar to see if anyone knew any drag queens who wanted to be in a play. It was really fun, and we came up with a pretty terrific cast.

Michael Greif: I was looking for compelling, rough, intelligent actors-singers. I thought that we really needed some sort of kooky, authentic folks to pull it off, to teach me and Jonathan things. I wanted to see how the real thing responded to the material. And we learned that those authentic presences really, really, really made it exciting. The audience could tell the difference between someone who'd lived in that world and someone who hadn't. One of the reasons we all loved Daphne so much is that she found a way to seem like she really lived in that world—not in the world of musical theater, but in the world of *Rent*. And Anthony seemed to be a wonderful bridge, because here was someone with real theater experience, and Mark is the one who has the most sane distance from the exoticness of the play's world.

Daphne Rubin-Vega: I think that part of the reason I got the part was that I didn't want to do a fucking rock opera. I was a singer and an actress, and I wanted to keep them apart, to legitimize myself. When I heard that Mimi was this dope fiend AIDS stripper, I thought, "That's kind of interesting." I went in and belted out "Roxanne." That sparked interest, because Mimi has that physical and moral abandon, Mimi doesn't care. When Jonathan saw that, he saw something he could work with.

clockwise from above:
Gilles Chiasson backstage at NYTW, 1994; Shelley Dickinson in NYTW's dressing room, 1994; Daphne Rubin-Vega and Erin Hill in NYTW's dressing room, 1994; Mark Setlock as Angel, 1994.

sort

Anthony Rapp: The fall of '94 I was really broke and got a job at Starbucks, my first-ever job outside of acting since I moved to New York. Soon after that, my agent told me I had an audition for a new rock opera called *Rent*. I went in and sang "Losing My Religion" for the audition. R.E.M. is one of my all-time favorite bands, and singer-songwriters are among my biggest heroes, so I was really excited by the opportunity to express that kind of passion and joy myself. I screwed up a little bit and skipped a verse. They asked me to come back and gave me a song to learn, which was "Rent." I've had a lot of auditions, and oftentimes, even though they don't offer the part at the audition, it's clear that it's going to work out. I felt good about it, and they seemed to like what I did. I think I found out right away.

Shelley Dickinson: What I remember from the first audition is that we really did chat a bit. They need to know personality types. It does often come down to how people interact.

Gilles Chiasson: I got involved because I love musicals; I'm one of the few in the cast who does musical theater. Martha is a good friend of mine and she was working at NYTW. She told me they were doing this musical. So I left the Upper West Side in my grungiest clothes and went down to the East Village and sang and got cast as the squeegee man, that memorable member of the ensemble. I sang this Billy Joel song called "Goodnight Saigon," and then they gave me music to learn from the show for my callback. I sang "Rent." I was auditioning for the part of Mark and didn't get it. So I had to decide if I wanted to be in the chorus, which is something I hadn't done in years. I decided to do it for two reasons: one, because it would allow me to work at home, and I loved NYTW—it's my favorite theater in the city. Also because I totally dug the music that I learned for the callback.

"I thought that we really needed some of kooky, authentic folks to pull it off"

Shelley

Shortly before workshop rehearsals, Tim Weil, who had been the audition pianist, was hired to be the musical director. Under his auspices, the music began to change from the synthesizer-heavy tracks Larson and Steve Skinner had recorded—at one point, Jonathan envisioned all the music being performed by computers—to music played by a rock-and-roll band.

Jonathan, in musical notes to the workshop script: Ideally, *Rent* should be performed with a full orchestra as well as a complete rock band. If necessary, synthesizers can fill in string and brass sounds. The sound mix should blend the best worlds of live rock concerts with Broadway sound. Lyrics should be able to be heard at all times—BUT that in no way negates the need to "feel" the drums, bass and electric guitars.

[Handwritten note:]

1 year
4 seasons
12 months
52 weeks
365 days
1095 meals
8760 hours
525,600 minutes
31,536,000 seconds

thoughts
ideas dreams
breaths
memories
moments that count
how long is a moment?
what makes an event memorable?
awareness

Tim Weil: We wanted to make good theater, melding popular culture and popular music with a theatrical sensibility. What Jonathan liked about musical theater was that songs there reveal character and push the plot forward, as opposed to "How do I feel?" That's very passive. Songs being active was a very compelling idea to both of us, and we wanted to learn how to master that. We also knew that there was an inherent problem in pop music, that once you start putting in the backbeat, it evens everything out, and there is nothing dramatic in that. If you have enough lyrics and enough theatricality and enough stuff to push that through, the beat becomes secondary. We were both talking about how to marry that stuff peacefully. I thought there was an obligation to make it as musician-friendly as possible. If you want rock guitar, let's treat the thing like rock guitar. You play into the strengths of the band. As it turned out, Jonathan became very trusting of me. He would bring something in and say, "Tim, I know you'll make this sound good, just go...." And I would kind of arrange it, or help arrange it—continue along the path that he had begun. Jonathan and I were a great mix. We listened to a lot of the same records, we both liked Pearl Jam as much as Sondheim. I think it was amazing to find that the two of us felt that way.

Michael Greif: Tim's work on this project was so substantial. Throughout, he was the most extraordinary musical director. He knows how to get the absolute best from people musically and vocally. His gifts for that help account for how vibrant and individual and full-blooded the characters are—he really helped them in their musical and vocal expression. He's able to give someone real structure and real permission at the same time, to set a viable foundation and let people fly off of that. Like the "I'll Cover You: Reprise," which needed a lot of structure before it could fly: now it soars all over the place. He knows how to fashion the musical expression to the individual. He was just a wonderful presence, too. He was involved in the orchestration, for which he got no credit whatsoever. He was really, really involved with Jonathan, and they talked every night.

Tim Weil: I just showed up the first day and I taught the music well. I called Jonathan the night before and said, "I've got an idea of how to do 'Seasons of Love'—would you mind just listening while I give it a shot?"

Anthony Rapp: The first day of rehearsal, we gathered at NYTW, to have a meet and greet, and the very first thing we did was learn "Seasons of Love." It was evident to me right away that this was something extraordinary. I think all of us in the room realized that this was really special. Michael said that the song takes place at a funeral, but that it's about joy. So the whole thing started out in this careful, loving way.

They rehearsed for two weeks, and then the workshop ran for ten performances, from October 29 to November 6. Audiences loved the show, and by the last weekend, *Rent* tickets had sold out.

Anthony Rapp: It was a mess, but the response was so strong. All of us had such an amazing time. I didn't know when, but knowing that in the future I would get the chance to do this again was so exciting. I would tell my friends about this rock opera I was doing. The word I remember using was that it was going to be an *event*.

Gilles Chiasson: When we were doing the workshop in 1994, I said to Jonathan, "I think you're going to change the American musical theater." And he whispered, "I know," and smiled really big.

Jim Nicola: As we got through the workshop, and we were excited and wanted to continue past that point with it, that was the terrifying part. It is the kind of piece that can close a theater. That's what pushed us over the edge to say, "We have got to take on this challenge, or else what are we here for?"

Still a believer in Larson, Seller brought his booking partner, Kevin McCollum (no relation to Julie Larson McCollum and Chuck McCollum), to see the workshop production. A couple of nights later, the two of them returned with Allan Gordon, with whom they had produced the national tour of *The Real Live Brady Bunch*.

Jeffrey Seller: Kevin never liked anything we ever went to. Not even our own shows. He's a perfectionist. We got to the theater, and there were these two tables there, and there was the band upstage right. I was wondering if this was just going to be another reading or what. I turned to him and said, "This is either going to be brilliant or a piece of shit."

Kevin McCollum: We went down to NYTW, and the first thing I was struck by was what a wonderful space it was. The first thirty minutes was just a collage of people running around. Then all of a sudden, "Light My Candle" happened. Immediately, it was the most brilliant piece of writing I had ever seen—followed by these melodies that just kept coming at you. After the first act, I said to Jeffrey, "I'm loving this, let's get out the checkbook."

Jeffrey Seller: So the next day, I'm calling Jonathan: "I need six seats for Sunday night, 'cause I'm bringing a bunch of people." He's only too thrilled. We go back: Kevin, me, Allan, a few of our employees, colleagues. Allan is thrilled by the music, the whole experience.

Allan Gordon: We saw the show and heard the music and decided then and there to do the deal. It was without hesitation; I loved the show. It seemed so simple. It was an artistic decision by the three of us, and we each put up money on the same terms. This was a verbal agreement, all verbal, and it went on for a year before

we got anything in writing. The interesting thing was that no one else walked in in the interim.

Jeffrey Seller: Jonathan put us in touch with Jim Nicola. There were two tracks: one, we were agreed that the show was only on second base. Two, we wanted to become producers of this show. So we said, "You're in charge; you're the artistic leader. Michael is obviously the perfect director. Given that creative team, you keep doing what you do and we'll help finance it." In return we got the commercial rights to produce the show.

Jim Nicola: We were a little nervous, as we always are when we take money from a commercial producer. Are they going to mess up the process? We had a meeting with our board and said, "We've got this offer, they're willing to make that commitment, but it really would be better if we could come up with the money ourselves. That will put us in a better position, should it be successful, to really benefit." They as a group had seen the workshop and were not convinced of its potential, and they didn't want to make the commitment: "If these guys are willing to give you that kind of money, let's take it."

Then, I have to say, they were dream partners, in the sense that they wrote the checks and they were quiet. I said to them, "The only thing I ask is that the communication feed through me. We'll invite you to readings and anything along the way you'd be interested in. But if you have responses, talk to me first. I will filter it through to the artists."

Jeffrey Seller: After the workshop, Kevin and I put together a set of notes that emphasized that this is a brilliant collage that needs to be focused. We asked a whole bunch of questions about things that did not make sense to us, without proposed solutions, because we didn't know what they were and because that's the playwright's job. We gave those notes to Jim. He was the funnel. Then Jim and Michael and Jonathan all worked on where they were going next.

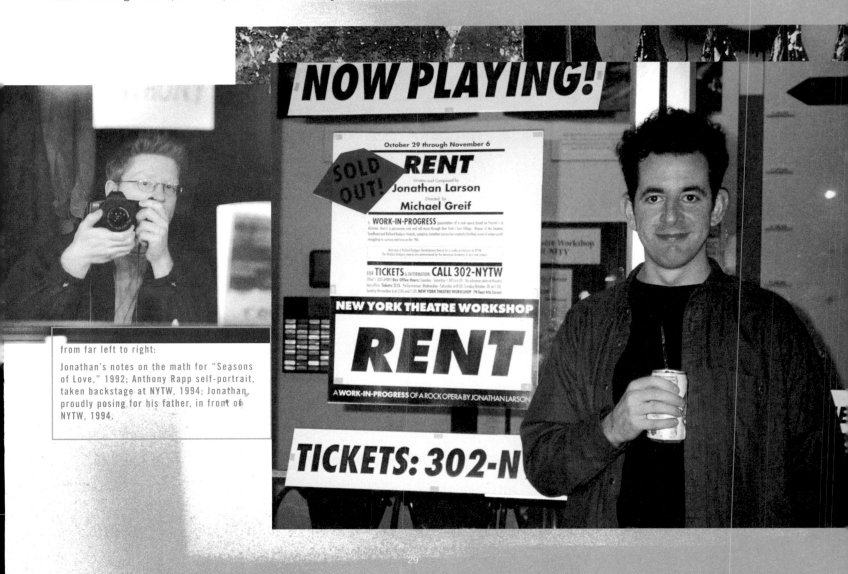

from far left to right:

Jonathan's notes on the math for "Seasons of Love," 1992; Anthony Rapp self-portrait, taken backstage at NYTW, 1994; Jonathan, proudly posing for his father, in front of NYTW, 1994.

With a budget of $200,000, *Rent* was ready to go. However, Greif had been hired as artistic director for La Jolla Playhouse, in San Diego, so beginning in January 1995, he wasn't available to work closely with Jonathan. Nicola was worried about Larson's ability to shape the structure on his own. In May 1995, Lynn Thomson, a professor at New York University and a theater veteran, was hired as a dramaturg, a common position in nonprofit theaters. She and Jonathan spent two and a half weeks at NYTW's Dartmouth program, addressing the critiques made by the producers, Nicola, Greif and others. In Thomson, Jonathan found someone who was sympathetic to his political ideas and aesthetic aims and who could help him articulate them.

Jeffrey Seller: Jonathan told me what a wonderful dramaturg she was and how she was helping to open his mind up to new things and that the play was getting better.

Eddie Rosenstein: Michael was a real boon to him, and Lynn was a blessing. She just started smacking him around and making him change shit. And he was thrilled.

Jim Nicola: He was a voracious reader, moviegoer, playgoer. One of the things that Lynn Thomson did for Jonathan is really get him excited about the structure of storytelling. I remember a number of conversations we had where he said, "I saw this movie, I saw that play, and it was amazing how Shakespeare tells this story." You could see the excitement he could feel about learning a whole new thing artistically in his life: how to tell a story like he hadn't been able to do before.

Larson had written short biographies for each of his characters years before, but Thomson convinced him to rewrite them in far greater detail. In the biographies, we learn that Mark and Benny were roommates at Brown University, that Roger's band was called the Well Hungarians, that Mimi left home when she was fifteen, that in high school Maureen dreamed of being Patti Smith. Lynn also had Jonathan analyze the show from each character's perspective. With the help of these exercises, Larson breathed life into his characters. Benny became more complicated; Roger's emotional journey was clarified; Maureen and Joanne's relationship became sexy and warm.

Janet Charleston: For me, Jonathan's talent was always the music. His music was so moving, but I felt like the book writing was not as strong. It seemed more surface, like he didn't get down as far as he needed to. He would present these major profound subjects, but they didn't go deep enough in the writing. In 1995 he talked about learning to write as he would approach the character as an actor.

Eddie Rosenstein: Lynn said to him, "You've written a cartoon, now let's make it a drama." Before it was a polemic. Real people don't deal with polemics, they deal with feeding themselves and falling in love. They deal with surviving and trying to do the best that they can. That's the point that Jonathan got to. Until then he was just talking the game. After a certain while he became the game.

Between the 1994 studio production and the 1995 production script, Jonathan wrote a flurry of new songs: "Tango: Maureen," "You'll See, Boys," "Life Support," "Halloween," "Happy New Year," "Your Eyes" and "What You Own." He revised others. The lyrics from "Rent," left over from Billy Aronson, had been full of mock suicidal images, wherein Mark and Roger imagined throwing themselves out the window rather than paying the rent. Larson made the song more philosophical, introducing the play's theme of connectedness amid millennial fears. "Right Brain" was transformed into "Glory," which had the same melody but more emotionally powerful, rather than cumbersomely clever, words.

Right Brain

problem

conflict
puzzle
completion
concentration
discipline

frustration
through line

trance
half sleep
time stands still
while time runs away

what do I want to say?

when

hospital
she was too young
bathroom
locked door

Listen to the chord
The notes

she left no note

from left to right:
"The Usual Suspects," in front of the Hopkins Center for the Arts at Dartmouth, 1995; 1995 notes for the song "Right Brain;" Jonathan and friends at Dartmouth.

> "Real people don't deal with polemics, they deal with feeding themselves and falling in love. They deal with surviving and trying to do the best that they can."

Kevin McCollum: "Right Brain" was about finding the right side of your brain, which was very esoteric. Jonathan was saying, "Got to get the right side of my brain going," but what he was really thinking was, "I've got to write a great musical." I think Michael said, "That's great, but get past the poetry; what is the intent?" "To write a great song." "So write that."

Jim Nicola: I'd say the big step forward from the workshop to the production script in terms of his growth as an artist was a song like "Happy New Year." "Light My Candle" was a complete dramatic scene and a pop song. "Happy New Year" is a pop song and a complete dramatic scene with seven people in it.

Pop song formula is very demanding. It's a little like haiku, in that it's a rigid form, especially for something messy like theater. So to be able to do these two things in one breath is an astonishing achievement.

Larson's discussions with his collaborators were often about philosophical as well as dramaturgical issues, and sometimes both sides learned from each other. *Rent*'s depiction of people with AIDS continued to be a center of debate, until the argument Jonathan had with Gordon at the living room read-through years earlier was incorporated into the script.

Michael Greif: A real go-round we had was over this "no day but today" philosophy. I've come around in a lot of ways, mostly because I've spent some time now with Cynthia O'Neal and I know what Friends in Deed does, but I also was very much aware that you need to present the other side of "If you just live peacefully with your illness, your illness will be peaceful." I was immersed in different kinds of philosophy. I remember showing Jonathan *Spontaneous Combustion,* a book by David Feinberg, who was dying of AIDS. He was a guy living with real rage. He had an incredible three-page list of "I regret." I was very hooked into the fact that this is also a part of the experience of living with HIV infection. It isn't just going to these meetings and cleansing your soul and learning to be a community. One of the ways Jonathan responded was that he beefed up Roger's anger and rage and he wrote into the support-group scene a bit where Gordon addresses that issue. It's so disarming to me, that Gordon material, as disarming as Cynthia O'Neal is when she counsels. She's come and talked to the various *Rent* companies, and she's quite spectacular in terms of not negating the rage, but being able to talk about something else, too.

Anthony Rapp: Michael gave Jonathan edge, irony, complexity, and Jonathan gave Michael more spirit.

In keeping with the show's holiday setting, *Rent* was originally scheduled to open in December 1995. But Greif's position at La Jolla made that schedule impossible, and the show was postponed to January 1996—a delay that irritated Jonathan. He was supposed to hand in his rewrite in September. But in the spring, he received a last-minute commission to write the score for *J.P. Morgan Saves the Nation,* a production by the reputable En Garde Arts company. The work garnered him his first review in *The New York Times*—a favorable one. By September, the *Rent* script was still not done.

Jim Nicola: It was a scary time. We'd seen a couple of things like the "hepatitis in your clam" song ["Love of My Life," a famously bad number between Joanne and Maureen that was replaced by "Take Me or Leave Me"]. I was looking at the funds for the season and we were in precarious shape. I said to Michael, "I'm not sure we can go ahead with this. If we're going to risk all we're risking, I need to feel more confidence in where the text is." We talked about contingency plans if we couldn't go ahead. We never told Jonathan this, ever. He had enough of his own angst.

In late October the rewrite was finally finished and a reading scheduled. To everyone's surprise, the show had been radically restructured and was now told as a flashback from Angel's funeral.

Martha Banta: This draft had gone in a lot of different directions and gotten really complicated. Mimi had gone on drugs and off drugs a lot more. Joanne and Maureen were fighting and making up more. There was a lot of back and forth. It was difficult to follow. He had written some new songs and some we liked and some we didn't. After that, there was a big powwow.

Jim Nicola: Jeffrey was really scared, too. He gave me some notes that were harsh for a fragile playwright, and they weren't meant for Jonathan, they were for me. And somehow Jonathan found out that these notes existed and wouldn't stop until I shared them with him. Then he was wounded by them. On the other hand, he got his ass in gear.

Jeffrey Seller: There was a feeling that we needed to postpone. I phoned one mentor in the business, and he said that if it's not ready, don't do it. But I felt that if we don't do this show, Jonathan's going to die. I know it sounds dramatic, but the guy's been in New York for thirteen years, he's thirty-five, and he's never had a show produced. I didn't know if I could call him and say, "Jonathan, I'm not doing it." And Jonathan *did* have a life-or-death quality about him: "If this show doesn't happen, I'm going to explode."

He called me up and said, "Thank you for the precision of your notes. They were very helpful to me, and I'm rewriting." We went to dinner the next night. He said to me, "I was hurt by your notes, but I realize that there were a lot of good points. So we're going to do the show. Let's go."

Victoria Leacock: It was funny, we didn't talk about *Rent* much in the fall. He was finishing the rewrites, going into rehearsal. Gordon died September 5. Four weeks later my godmother died; four and a half weeks after that, Pam died. Jonathan was like a rock, came

F.Y.I.
RENT runs at N.Y. Theatre Wkshop
Jan. 25 - March 3. Seating is limited.
to order tix: 212-460-5475

from bottom left:
Jonathan's note to Victoria Leacock; Jonathan with his mentor Steven Sondheim; Jonathan's notes from 1995.

new

✓ opening
Support group scene
Joanne calls
New Year
Mimi/Roger Drug Break
Wear the Pants
Mark Song
Roger Song

Revise

Rent
R-Brain /glory
Collins/Angel meet
Over It
Over the Moon
La Vie Intro
La Vie Coda
g'bye Love
trial Intro

Keep
Light candle
Today 4 You
out tonight
Another Day
will I
X-mo #2
Santa Fe
I'll Cover You
X-mo Bells
I Should Tell
Seasons A+B

Darling Vic—

greetings!
May 96
be our year
(+ no funerals!)
Kisses + Hugs,
Jonathan

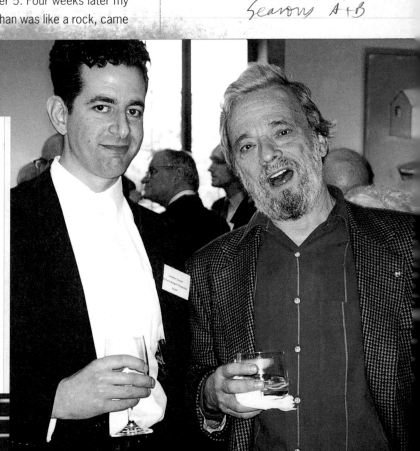

to all the memorials, videotaped my godmother's funeral, spoke at Pam's, spoke at Gordon's memorial. The only things he talked about with *Rent* was that he was having problems with Michael and Jim and money. I remember they had a very bad meeting and it was brought up that they might postpone it again. Jonathan had decided to frame *Rent*, open it with a funeral, and have it all be a flashback. He was talking to me very adamantly: "They don't like it, they want me to change it, they're wrong." He looked at me and I said, "I'm sorry, I can't support you. I hate things that start at the end. And you need to collaborate."

Michael Greif: There was discussion of the show not happening, and probably an ultimatum made to Jonathan that if he didn't continue reworking, there was a possibility it wouldn't get done. This really bummed him out. I said to Jonathan—it was while we were still casting, and I think Tim was there—I said to him, "Look, if you have to postpone this thing, you should feel free to go on." Jonathan got very upset at me, more than furious, and said—wept—"You can just leave this? You could walk away?" That was an indication of his love for this material and how completely shocked he was that I was not in the same place.

Lisa Hubbard: He got really discouraged just before the show downtown. He had to rewrite it, which he didn't want to do. They were fucking him over about giving him money. For a long time, they said they wanted to do a production, but they weren't contacting him. He felt like they were stringing him along. There were some really dark days around that. That was the most discouraged I ever saw him. Whenever he was working on something, he was happy. Not knowing whether he was working on it or not was driving him nuts.

Jim Nicola: I felt at the time that he was tired and emotional and feeling really pressed and running as fast as he could run. He was definitely in the place where he only wanted to hear that it was great. It was hard for him to hear, "Maybe that's not right, maybe what you're working so hard to do isn't the right thing to be doing and you've got to go do it again." Yet it had to be said.

Frustrated at the prospect of rewriting his show yet again, Jonathan turned to other writers for advice: his brother-in-law, Chuck McCollum, a screenwriter who lives in Los Angeles; and Stephen Sondheim.

Chuck McCollum: He was having problems with the development process. He didn't know how to deal with disagreements among the producers and financiers. He could collaborate with other writers beautifully, but he wasn't used to collaborating on that level, with the people whom you perceive as determining whether or not your show gets produced.

He had a kind of us-versus-them mentality. I said, "You've got to not be defensive, you've got to not assume that everything they say is totally stupid. People look at this house that you've built and they say, "Oh, you've got to lose this entire wing, this is terrible." You have to nicely guide them towards figuring out what it is about that wing that they don't like. As it turns out, it's a door, and if you replace that door, they're fine. You've got to help them discover these things and try to put into your own words what you believe their problems are so that they know they're being understood and that you are going to address them. Because it's frustrating for people in their position to work with someone who considers himself the artist and them just the money people, that they don't know what they're talking about. I told Jonathan, "Look and see if

you can come up with solutions that satisfy both of you, rather than just dig your heels in. And also, don't operate out of fear of whether or not they're going to pull the money." I doubt they were going to pull the money. It wasn't that melodramatic; it was just a point in the rehearsal process where everybody got a little hot under the collar because it was the final stretch. When I talked to him the next week, he was very happy; he said it worked out just great. He told me that when Stephen Sondheim told him that in all the years that he'd worked he'd never had an investor pull out of a show, that was the biggest help to him. Once you eliminated his fear, he was able to deal with people.

Stephen Sondheim: Producers and directors don't know, and writers do. I would rather have seen Jonathan do what he was doing, but he had chosen to work with these people. You can't change horses midstream once you've agreed that those are the horses. I said, "You've chosen your collaborators, and now you have to learn to collaborate." He learned. He called me back a few days later and said, "Well, you were right. I'm learning to collaborate."

Tim Weil: He knew what to do, but I think Stephen sort of reaffirmed it. Jonathan had really good instincts. That's the other thing: he didn't have a collaborator. And I said this to Jonathan, "The amazing thing is, when there's a problem with the music, when there's a problem with the book, when there's a problem with the lyrics, you're all three, so you don't have other collaborators to spread the criticism with; it all comes down to you." He had to do it all himself. And the pressure certainly mounted.

Michael Greif: We went back again to create the draft we went into rehearsal with, which essentially placed "Halloween" where it is now. It allowed "Halloween" to be more exuberant in nature, rather than elegiac. I think Jon was planning an entire elegiac evening, and after some duress, he got excited about the difference in tone between the two acts. We had some good healthy debates about tone, surprise, revelation, in an evening, as opposed to an elegy like *Romeo and Juliet*. We restored some stuff from the workshop that had been cut: Collins, coming back to the apartment and singing the lines "Bustelo Marlboro." That sort of lightness was not in the October draft and was reinstated.

Gilles Chiasson: One of the things I admired about Jonathan was that when he rewrote something, he went there. It wasn't tweaking. I've been in shows where there were three-hour production meetings and they would come out and change three words. He rewrote a third of the play from the workshop to the reading. It was a huge monster tamed over time.

Anthony Rapp: The rewrites were so much better, and to see that transformation—it seemed like something had cracked open. I never would have thought of the things he came up with to solve problems with the help of everyone he had. And it took this giant leap. It felt to me like Jonathan had to dig deeper into himself. Rather than painting the picture, he had to become a part of it.

Victoria Leacock: Those changes came from seven years of hard work. He was maturing as an artist, there was a natural growth.

Stephen Sondheim: The last time I spoke to him was in December. He was learning how to swallow his artistic pride and collaborate. He felt mixed about the show because of the compromises he'd made. He felt pleased with himself for growing up. He sounded the way any author does in the middle of rehearsals: "This is terrible, this is wonderful, I'm ashamed of it, isn't it great?"

On October 21, 1995, nine and a half years after he began working at the Moondance Diner, Jonathan gave notice. For years, Jonathan and his dad had a running gag they borrowed from radio comedians Bob and Ray. They would end each phone call with Al saying, "Write when you get work," and Jonathan replying, "Hang by your thumbs."

Al Larson: In spring, when Jonathan got word that NYTW would definitely be producing *Rent* that year, I changed it to, "Write when you quit work." And on October 21, even though he'd told me about it over the phone, Jon sent me a note that said, I quit work. He was so looking forward to not waiting tables anymore. It was a monumental day for him.

> 10/21/95
>
> Dear Dad,
>
> I quit work.
>
> Love,
>
> Jon

Meanwhile, auditions for the full production began in late August. NYTW hired casting agent Bernard Telsey, who had recently cast shows for Peter Sellars and John Adams. Again the goal was to hire not just actors but "the real thing."

Bernard Telsey: Casting *Rent* was an incredible challenge. The roles are really tricky. On the singing level, they're demanding, because they all have to sing five songs or more, and they have to have incredible voices, because it's also the smallest cast for a Broadway musical. Most agents and their musical theater clientele will not do a not-for-profit short run. They're going to hold out, because if they can really sing, they'll get cast, even if it's the chorus of *Victor/Victoria*.

Jonathan and Michael were very specific that they did not want a musical theater sound; they wanted rock and roll or raw or real street sound in the voice. But when you do all these musical theater shows, you start to have a musical theater sound. Your muscles do that, just like if you go to the gym all the time. How do you find those incredibly talented voices who've never worked before? And who are still twenty years old? Jonathan was so *about* this project that he said, "You know, I'll come with you to the prescreening." Everyone always wants the real thing. It wasn't until we got into auditions and I started collaborating with Jonathan that I realized, "Oh, he *reeeeally* wants the real thing."

Michael Greif: The play is about a very fresh and vibrant group of people, and we were looking for a very fresh and vibrant group of people to portray them. And some of those people, as it turns out, have lots of experience, and some have very little. But certainly there was a level of skill necessary. What Adam Pascal and other people were able to prove to me in an audition process was that they had some chops and some instincts to be very good actors. And we had an audition process by which we could gauge that. Bernie did a great job of beating the bushes. A lot of it had to do with who was compelling. If someone came in the room and I didn't want to get to know them better, that was a real issue. We all had similar feelings about who we dug. There was consensus.

Tim Weil: We didn't want *Phantom of the Opera*. That's a lot of training and it's something that doesn't come from as direct a place. All we were looking for was just a real direct, honest communication of what's going on. The other thing we required vocally is a sense of rhythm—that they have good time. I'm interested in what records you listen to. Did you wear out your Mary Martin *Sound of Music* record, or did you wear out your Aretha Franklin *Live at the Fillmore* record? That tells me a lot.

A couple of actors from the 1994 workshop were offered their roles again; others had to reaudition.

Daphne Rubin-Vega: I knew I was going to get it or die trying. I knew that in my lifetime I would be lucky if I would get five roles like this, roles that have this charged and generous an array of emotionality and intensity. In the 1994 version, the lesbians sang "Without You," but now I had to be able to sing it. It symbolized a certain point in the play. Jonathan said, "I want you to sing it to Roger." He said, "Make me cry."

Some members of the cast—Anthony Rapp, Taye Diggs, Timothy Britten Parker, Gwen Stewart, Jesse L. Martin—had solid acting résumés, but others were unproven talent. Although she had majored in theater at NYU, Idina Menzel was a rock-and-roll singer, not an actress.

Bernard Telsey: Idina was one of the first people we hired. And in one sense she wasn't at all what Jonathan first described. If anything, what he described for Maureen was more like Holly Hughes. When Idina came in, her exuberance, her talent and her voice were so special and so real and untapped, we said, "Let's create it around her." He was looking for individual personalities that he would mold the show around.

Idina Menzel: When I went in to my first audition, I sang "Something to Talk About," by Bonnie Raitt. Then I sang "When a Man Loves a Woman" like I was kicking the shit out of it. To me

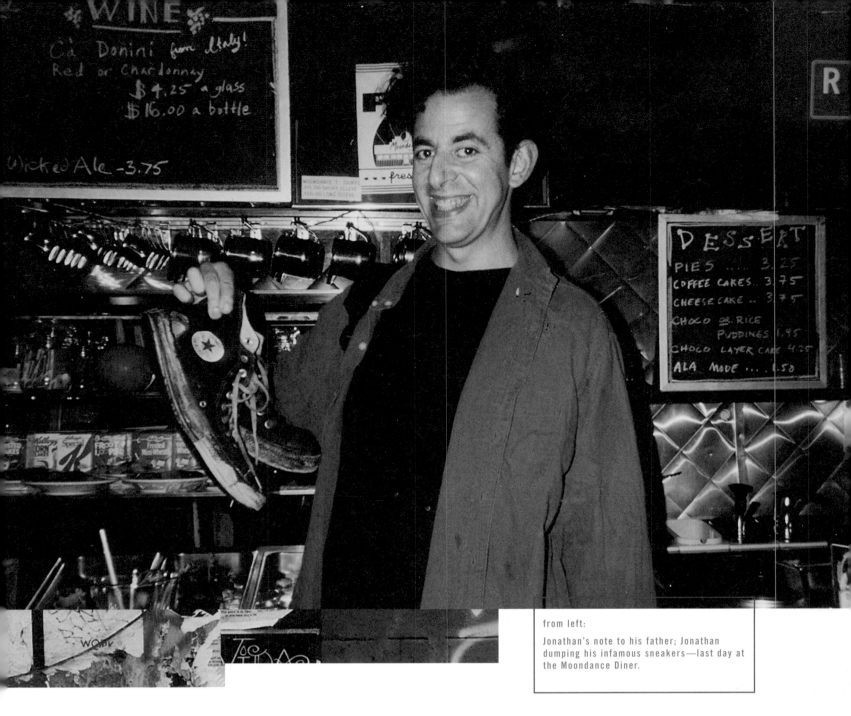

from left:
Jonathan's note to his father; Jonathan dumping his infamous sneakers—last day at the Moondance Diner.

it's a ballad, but it's not a pretty ballad. Jonathan said, "Do you have anything in a ballad?" I copped so much attitude! "That is a ballad," I said. He replied, "Oh, yeah, you're right." I felt like he really got me then.

Wilson Jermaine Heredia was working as a dispatcher of emergency maintenance crews and trying to decide whether to stay in theater.

Wilson Jermaine Heredia: My life was hell, my only concern was earning money. I was really depressed, because I wasn't doing anything artistically. I was living in my parents' house. I was scared and stagnant. My manager said, "Are you crazy? Are you an actor or a dispatcher?" I took the leap of faith and took the role.

Bernard Telsey: Wilson would come in dressed almost like Benny in his big grungy pants. Nothing at all about him said Angel, except he was young and beautifully simple and sang like an angel.

Since the nearly all-white first NYTW reading, the cast had become increasingly racially diverse. That process continued during auditions. In the workshop, Tom Collins had been a white Tom Waits–type character, but in the middle of the casting call, they began auditioning black actors for the part.

Bernard Telsey: We weren't finding any white Collins that we liked. Then the minute we tried it, before even seeing Jesse Martin, everyone was loving it.

I knew Jesse. I cast him in a play in Hartford and in two other plays before that. Once we decided that the part could be black, I called him up. He'd never done a musical before, but I knew he could sing. But he kept canceling every audition. I said, "Jesse, you can do this part. I know what they want and I've heard you. They don't want singers. You are this. Any day you're willing, we'll do the audition." I had a history with him, but still he was not listening to me. When he came in, they went nuts.

Jesse L. Martin: The reason I don't like to do musicals is because you end up working in this world where you don't really fit. You're only there because they need some kind of color. You put on this white powdered wig and do this 17th-century dance. But why would I be here? We can't make you a slave, because people get mad. This play it doesn't matter.

Taye Diggs: If you're not in a stupid musical, you're playing a black guy in a play, and you're a Black Guy. It's about black issues. But this play, literally, is just about people.

Jesse L. Martin: It's also minority heaven. There's more minorities than anything else. That never happens, unless you're doing *Smokey Joe's* or *Ain't Misbehavin'*, unless you're singing the black songs.

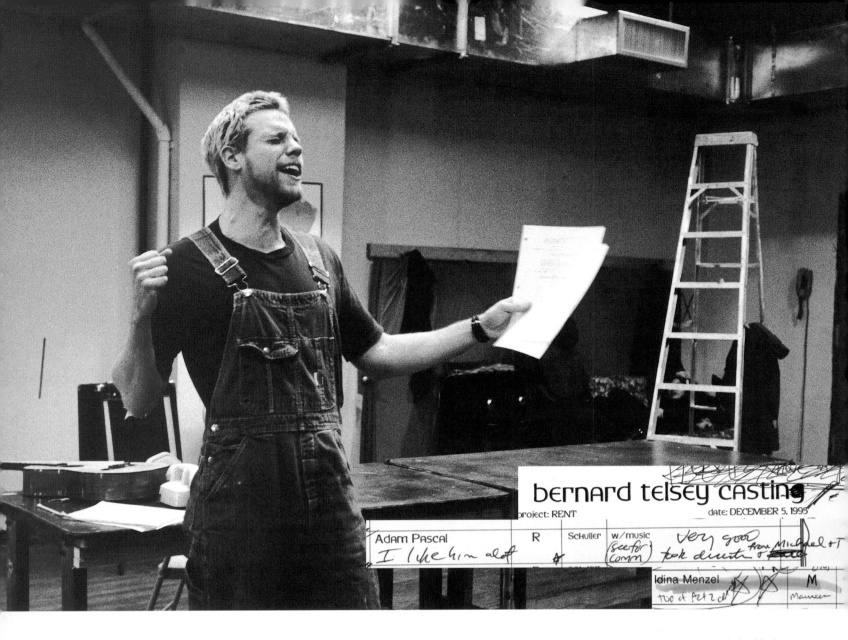

bernard telsey casting

project: RENT date: DECEMBER 5, 1995

Adam Pascal	R	Schuller	w/music (see for Comm)	very good took direction from Michael + T
I like him alot		#		
Idina Menzel				M
too of Act 2 ch				Maureen

The most arduous casting search was for someone to play Roger.

Bernard Telsey: For Roger we tested every good actor who wasn't too Broadway sounding and yet ultimately did have enough voice to hit those goddamn notes. We tried the rock and roll clubs, but no one at CBGB's is going to listen to some guy from NYTW. Even when we did get someone to listen, the average guy wasn't going to give up his band.

In desperation, Telsey's assistant David Vaccari looked in the classifieds in *The Village Voice* and called the rock and roll singing teachers who advertised there, asking them for names of students. On one of those lists was Adam Pascal, a singer who had just broken up his hard-rock band. Simultaneously, an agent friend of Pascal's told him about the *Rent* auditions, and Pascal, who had never acted before, decided to check it out.

Bernard Telsey: We called all the names and decided to just see whoever shows up. I remember walking with David through the lobby, and we got into the studio and I said, "Did you see that?" Like a needle in a haystack: all Alice Cooper and Kiss, and there was this guy who was great-looking. He came in and sang his own song on a guitar. I said, "David, get back in here and tell me I'm not crazy."

I remember calling Michael and Jonathan and saying, "We got one." Adam came in, and in all honesty, they did not have the reaction I did. At this point, everyone was so freaked and nervous that we hadn't cast Roger, and they warned, "If the guy's singing with his eyes closed on opening night...." He went out of the room and I had to remind them, "You want the real thing. This is the real thing now." Michael got it right away. Jonathan was still a little nervous. "How can the lead not open his eyes?" Michael said, "I'll teach him to open his eyes." Everyone loved him right away; it was just a shock, because now the real thing had walked in. How do we make that theater? The joke was, "We've got three weeks to get him to open his eyes."

Adam Pascal: It was my last audition, and I didn't want to go. "Fuck these guys, they can make up their mind, they've seen me three times." Bernie said, "Things are going great, they really like you, but you gotta open your eyes when you're singing." I said, "What are you talking about?" It was partly out of nerves and partly because when I was singing with my band I closed my eyes, like lots of people do. So at the last audition, they had me sing "Your Eyes" to Bernie Telsey—who was sitting there staring at me—as if I were singing to Daphne. That was the moment when I said, "I know what I have to do, just do it. Don't be a wuss." So I did it. That one experience taught me so much.

The last person cast was Gwen Stewart, the ensemble member with the solo in "Seasons of Love."

Bernard Telsey: No one wants to do ensemble; it means chorus. "Three hundred dollars a week for chorus?!" Jonathan said, "'Seasons of Love,' I want it to be a showstopping verse; they have to bring the house down." I wanted to say, "Jonathan, if somebody had a voice that could bring the house down then they should be playing Joanne or a lead—they're not going to want to be in the chorus." There were some people we liked early on in the process but they wouldn't do it. First off we offered Fredi the part. We said to her agent, "We want her to be in the ensemble, and she's going to have a verse in a great song." Meant absolutely nothing. She was offered a lead part in another not-for-profit theater, so she ended up getting Joanne's role. One woman turned it down for *Ain't Misbehavin'* in Lexington, Virginia. This was New York at least! A new play! Michael Greif, artistic director at La Jolla Playhouse, is directing! They didn't know. A musical theater person doesn't know La Jolla; it's such a different mind-set. We had people who were

In December 1995, Larson handed in the revised script and his final one-sentence summary of the story: "*Rent* is about a community celebrating life, in the face of death and AIDS, at the turn of the century."

The night before rehearsals started, he invited the cast to the Peasant Feast.

Fredi Walker, cast member: It was very sentimental. I was like, "Oh, God, how showbizzy this is." I was being jaded that night: "This is a job, you don't necessarily like the people you work with." So Jonathan gave his speech. He was talking about how this piece was a part of his life and how we all represented parts of his life, that it was immortalizing him in a way. He wanted us to understand that. He felt this was it. This was the group of people who were going to come together and breathe life into his show.

Anthony Rapp: Jonathan gave a beautiful toast. Very shy. "This is the best thing that ever happened to me." He was crying, and it was really, really touching. "This is a show about my friends, so you're all playing my friends."

Timothy Britten Parker: He was absolutely delighted that night. When I got there, I asked him how he was doing. "I am so happy," he said. "I finally have a life in the theater." I think he knew on some level that this was the beginning of what he'd always wanted to do, that he'd moved on to the next phase in his life.

Wilson Heredia		AC	WRIG	cb so good so sexy so it. dances to

so good sexy, fn, good read.

"This is a show about my friends, so you're all playing **my friends.**"

	1:00	Daphne Ruben Vega	CAST MI	WRIG	cb the real thing.

great and willing to do it, but Jonathan said, "No, has to be a showstopper." Then David started calling the churches. "We're looking for a twenty-year-old who sings and doesn't know she wants to be in theater." For four lines, a chorus part! We found Gwen after the first day of rehearsal, because while we were looking at the churches, we were also looking up "who played this in such and such." Gwen's name came across our desks from whatever musical she was in. We called and she was in town. So for her it was the timing.

Gwen Stewart: The day I went in to audition, there was a miserable storm. More than once I thought I'd turn back and go home. I finally got to NYTW, and eight or nine other really talented black women were waiting their turns. One after the other, they went in and sang, and each one peeled a little more paint off the walls. Then it was my turn. Tim Weil made me feel very comfortable—he bopped and swayed as I sang. After that, Michael Greif asked me if I would mind playing a bag lady—tastefully done, of course. I said no. Then I looked around the room, said my goodbyes and thank-yous and left. I headed home, a bit ticked off at wasting my time—there was just so much talent in that room—but happy to have seen Michael. When I got to my house, there was a message on my machine from Bernie Telsey saying, "They absolutely loved you. Can you come in for rehearsal tomorrow?"

After four months of auditions, with almost a thousand people seen, the fifteen members of the *Rent* cast were finally chosen.

Anthony Rapp: The Larsons said that Jonathan told them we were the sexiest, most talented, most exciting group of people he had ever seen assembled.

from top:

Adam Pascal rehearsing at NYTW; Bernard Telsey's *Rent* casting notes; an unpublished *Daily News* photo of Jonathan Larson (last row, third from right) with NYTW *Rent* cast and crew.

Measure in Love

One of the reasons Jonathan invited the cast to his Peasant Feast was that he hoped to foster among them the same kind of community feeling he had with his friends...the kind that's depicted in the *Rent* script. From the first rehearsal on, everyone worked hard to cultivate a family atmosphere. As at the workshop, they began by singing "Seasons of Love."

Anthony Rapp: The first day of rehearsal, I could feel it happening again, people coming alive.

Adam Pascal: Once I heard everyone sing together, it was like magic. That's part of the success of the show: the fifteen of us together.

Timothy Britten Parker: The word that came to mind was *glorious;* it had a gospel feeling to it. I hadn't heard this kind of music from Jonathan before, and I was so moved and excited by it that I called up three or four people who knew Jonathan and said, "It's incredible. These voices, I've never heard voices like this. And everyone together!" It was really a special day.

Fredi Walker: "Seasons of Love" is the perfect example of what we are. My friend said when he first saw the show, "You're such a beautiful rainbow of humanity." I love these people. I still don't know many of their résumés. The first several weeks of rehearsals, those conversations never came up. We talked about real things, we talked about life, but we never talked about all that junk.

Wilson Jermaine Heredia: We walked in there, and it wasn't like walking into a room full of actors but a room full of people with amazing abilities, the ability to communicate. For a month, I had an overwhelming feeling of déjà vu.

Rodney Hicks, cast member: The first week of rehearsal, I said, "This is going on Broadway." Michael laughed at me.

Michael Greif was central to creating a supportive environment for people to get to know each other and the work. His manner was informal: he let the cast bring out their characters themselves, then orchestrated their portrayals into scenes and tableaux. He spent a lot of rehearsal time watching the show and dancing in place.

Jim Nicola: It starts with Michael Greif and then Tim Weil: wonderful, warm, nonneurotic people. They created an atmosphere where people felt comfortable and at peace and not afraid to step off a cliff. In my experience, there is no stronger sense of community than those people in rehearsal.

Michael Greif: I wanted to create a strong feeling of community among the cast. That's true in all shows I do, but this show lends itself really beautifully to it. I thought the energy of the play would be affected by that feeling of community. And it has been, very positively. The rehearsal process was when I fell as deeply in love with *Rent* as Jonathan was.

Taye Diggs: Michael's approach was unlike any other approach I've experienced. At the time, it was a little annoying. He said, "I don't know what I'm doing either; we're just going to take time to grow." He was always dancing around. I remember not being all buddy-buddy with people, because when I came in, it was just another music theater show, and I can't stand stereotypical music theatery people: everybody kissing each other on the cheeks before they know each other's last names, hugging, talking French to each other. If I had known *Rent* wasn't going to be like *Victor/Victoria* or *Carousel,* I probably would have been a bit more chill from the get-go.

Anthony Rapp: Michael's a great mixture of taskmaster and older brother. He can be your friend and your leader. He's cerebral, but also very sweet and an open book. We would walk home from rehearsals sometimes and talk. Friend/collaborator/director—the lines were a little blurred, but it never felt dangerous.

Wilson Jermaine Heredia: He's the daddy that cracks the whip. He's the one that gives you the hard love. He allows you to see his human side, but when it's time to work and he knows things have to be done, he does it. Jonathan had the vision, and Michael had the organization skills and talents.

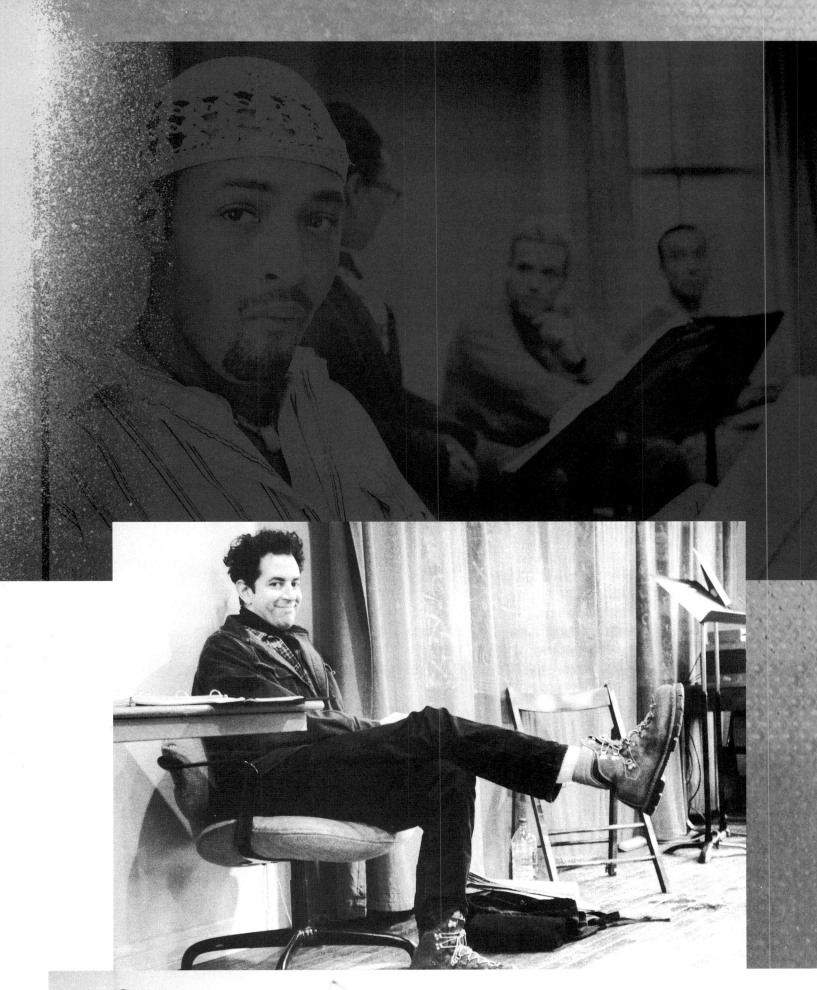

from top:

Jesse L. Martin, Fredi Walker, Adam Pascal and Timothy Britten Parker, in rehearsals at NYTW, 1995; Jonathan at rehearsal, 1995; Rodney Hicks and Taye Diggs, 1995.

One key to creating a collaborative environment was pulling together a strong creative team. Greif, Nicola and Larson sought out people who had downtown credentials and were not typical musical theater players. In addition to Weil, they hired choreographer Marlies Yearby, who had her own dance company, Movin' Spirits; set designer Paul Clay, an installation artist; lighting designer Blake Burba, whose credits included lighting the glam Manhattan nightclub Squeezebox; and costume designer Angela Wendt, who had worked with Greif in the past.

Michael Greif: Marlies really seemed to be a wonderful person for the material. It was very clear we didn't want an uptown dancer type. I was hung up on creating a language that was not Broadway, that was not choreography. And she seemed to really click with that and be happy that we were talking about that as opposed to "kick-ball change." Jonathan really liked her, too.

Marlies Yearby: I got the script and read it. I could tell it was more commercial than anything I had ever done. Then I met Michael and Jonathan. Jonathan was particularly excited, saying that there was such an honesty in the emotional life of my dancers. I found that Michael knows the downtown contemporary dance and performance scene and was able to talk about it in a very intelligent way. So I had to put all my biases aside and listen to how they saw themselves working with me.

At that time, they had varied ideas about dance. Jonathan saw dance happening in many different places; Michael was concerned about how the homeless people were to be depicted. He told me they were trying to find an honest and not demeaning way to depict the lives of the people they were representing. That was simple to me, as so much of my dance

work is about gesture. So I walked away thinking this could be incredible, and wondering how we were going to do it in the short amount of time I had.

Michael Greif: What was nice about doing the workshop on my own was that I got to do everything, and I'm a big selfish hog that way. I really enjoyed that I got to conceptualize all the musical numbers. And so when Marlies came in, I was able to speak to her about what those conceptualizations were. What Marlies is great at doing is watching things, taking things from people and cleaning them up. She more specifically worked on "Contact," "Santa Fe," Wilson's dance, and the top of "La Vie Bohème." We have very different rhythms. When the company had had it up to here with me, it was a wonderful break to go with her, and then when they'd Zenned out enough with her, they'd come back to me.

Marlies Yearby: It took time for us to build our relationship. It was hard initially, because we had to find the language. What Michael called dance, ultimately to me was gesture. I realized that sitting there with him—and this goes for most directors—was the best way to build a relationship. Michael loves to play. I honored that; that was the most familiar thing to me. As high-pressured as it was, I was always having fun. Sitting next to him was a hoot.

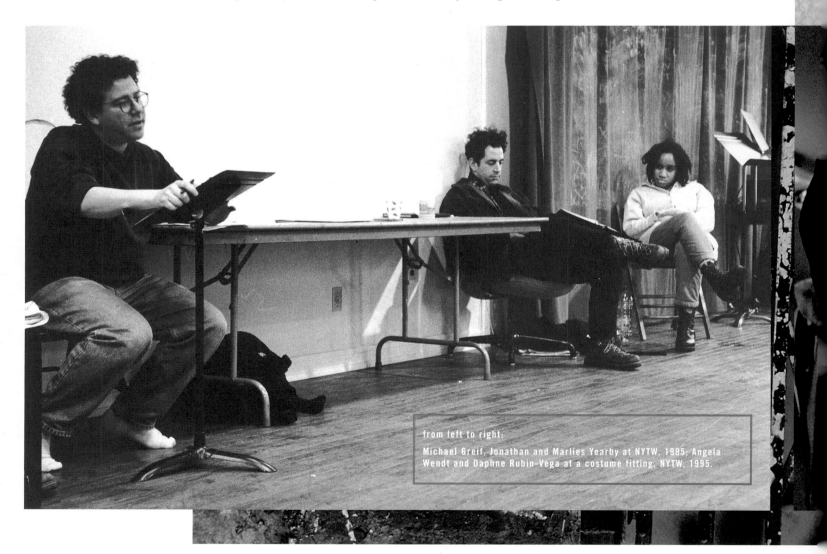

from left to right:
Michael Greif, Jonathan and Marlies Yearby at NYTW, 1995; Angela Wendt and Daphne Rubin-Vega at a costume fitting, NYTW, 1995.

NEW YORK THEATRE WORKSHOP

Since its inception, in 1979, NYTW has provided a laboratory for playwrights and directors, cultivating artists at all stages of their careers. The nonprofit theater company offers such development programs as a reading series, productions of works-in-progress, a new-directors series and a summer residency program. NYTW has been a venue for well-known writers and directors to present more experimental work. In 1993, the theater mounted a double bill of Caryl Churchill's early plays *Owners* (1972) and *Traps* (1977). Even after Tony Kushner had won two Tony Awards and a Pulitzer Prize for *Angels in America*, he took his *Slavs!* (1994), about the death of Russia's Leninist-Stalinist revolution, to NYTW. It's also a place where lesser-known voices have produced acclaimed work, such as Claudia Shear's *Blown Sideways Through Life* (1993) and Douglas Wright's *Quills* (1995), a comedy about the final years of the Marquis de Sade's life.

NYTW has also showcased socially incisive work such as *View of the Dome*, in September 1996, about a Washington, D.C. sex scandal. With an unofficial policy of developing theatrical pieces with consciousness and conscience, NYTW has never made mainstream appeal a criterion for its projects.

Rent's critical and popular success has left an indelible mark on the Workshop. In 1995 the theater had 2,600 members; by 1996 their numbers had jumped to 4,300. But for artistic director Jim Nicola and the staff of NYTW, every award *Rent* has received is a reminder of Jonathan's absence.

clockwise from top: NYTW production of "Quills;" Marisa Tomei in the NYTW production "Slavs!"; Jim Nicola and Nancy Diekmann, cutting the ribbon for opening of the New York Theatre Workshop's new location, 1993.

Greif's idea was not to have people dressed in costumes, following choreography and reciting lines, but to treat the show more as a concert, a presentation of styles and personalities. His collaborators proceeded accordingly. Many of the clothes that people wore came from the actors' own closets. Wendt lived in the East Village, so outfitting people seemed like an extension of her everyday life.

Angela Wendt: *Rent* was the ideal musical for me, because I can do this neighborhood with my eyes closed. I thought it was important to be true to the East Village, not to do caricatures but to reflect the mix that really exists here. I think that's a big part of why people identify with the characters—they never look too extreme.

A lot of the clothing was secondhand, and there's a lot of mixing of decades: the '60s, '70s and '80s. Some of the design was based on monetary considerations—my budget downtown was only five hundred dollars—but they're looks that worked for the East Village.

We worked with clothing that people already had. Daphne really created Mimi with me. She has a wonderful style, so we had a great time working together. Wilson had never done drag before in his life. Doing his costume was all about finding out what he felt comfortable with.

Yearby similarly worked the show around individual styles.

Marlies Yearby: Dancers who work in the Broadway scene tend to be slicker and more presentational. I ask people to be more internal, to be inside breath, to have an easiness and naturalness in their body. Mimi needs a celebration in her sensuality rather than raunchiness. There were some beautiful movers in the company: Taye, Aiko, Fredi, Rodney. I love the way Anthony moves. Daphne is fire, she's a woman who is extremely comfortable in her body. In "Out Tonight," Daphne jumped up on that rail. I looked at her and said, "Okay!"

Even though they were getting to bring themselves to their parts, actors were still playing roles, and rehearsals could be difficult. Although Wilson Jermaine Heredia had a couple of plays under his belt, as a club kid from Williamsburg he was in some ways the most "street" of all the cast members. During rehearsals, he felt both exhilarated and intimidated.

Marlies Yearby: Wilson was a big part of my journey. I walked him hand in hand through being a woman. First it was difficult finding how the femininity went in his body, because he was a little funky. A lot of it was him understanding his hips, how he needed to let go of his hips so that they moved when he walked. Then he had to connect his hips to telling his story. Then it was about understanding that he needed to tell a story with his body. Out of that came things like him running up the stairs or jumping off the stairs. I told him to jump on the table, because Wilson is always jumping on stuff. I've never seen anyone jump from standing position without any effort and land on their feet on the table like he does.

"First it was difficult finding how the femininity went in his body, because he was a little funky."

Wilson Jermaine Heredia: One day we were improvising, and I did a spin and jumped up on the table. They liked that, so the next thing was to get me off the table, and so I jumped. Marlies said, "Are you sure you can do that in heels?" I said, "Oh, please." I picked out the heels because they were the easiest to dance in. Walking was the least of my problems; I've always had good balance. I also took four years of martial arts, which taught me to always walk on the balls of my feet. Walking on heels just shifts your weight, your center of gravity, forward. You throw your hips forward and arch your back.

After a year of doing nothing, I wanted to prove to myself that I could do stuff, so I was almost my own barrier. I was really nervous that Jonathan was around, because it was his baby and I wanted to prove to him that I could do it. My biggest problem was "Take Me," because it's like public masturbation. I'm singing and touching myself, and I had a problem with expressing myself in that way. It's really the culmination of everything up to that point: pain, love, death, life, struggle—all of that is expressed through Angel's death dance. He's dying and having an orgasm at the same time. He's breakin' on through. When you know that there's so much behind it, you're afraid to release it. Jonathan saw my reluctance. I saw his face, his disappointment. Tim said, "Don't worry, we're going to work with it." The first few times I did it, I felt like a wreck.

Adam Pascal had no theatrical training at all. That enabled him to convey the raw power of Roger's character; but still, he had to learn not only to sing with his eyes open but also the meaning of terms like "downstage," and how to memorize a script and perform it night after night.

Fredi Walker: That's what convinced me that Michael's a brilliant director: I watched him turn Adam into a wonderful actor. He gave him instant craft.

Taye Diggs: I heard Adam sing that first day. I said, "Holy cow, who's this smiley blond kid?" I had never heard anybody sing like that before. I said, "Well, if he's singing like that, then this must be pretty cool."

Anthony Rapp: Adam sang like that from day one, minute one, at the top of his lungs, at the top of his range. Some people in that situation get cocky or try to prove themselves. He was totally aware of the fact that he didn't know what he was doing, in terms of blocking, et cetera, and that he should just listen to Michael and let us help him. He was completely available to that. It was such a pleasure. One time he was singing "Glory," and Michael and I were watching, and we had this moment where we were amazed by how he was able to sing from his soul.

Adam Pascal: I always credit Michael Greif along with the rest of the cast. He was wonderful with me and really allowed me to find myself as an actor. He never tried to push me in a direction he didn't think I could go. I wanted to listen to him. I wanted to do what he wanted. I didn't come into this experience as if I knew what I was doing. I wanted to learn. I had the greatest time in rehearsals. They were probably the best time in this whole thing. The whole process was brand-new, so every day was fun and interesting. I was falling in love with all my friends, I was involved in this process of making this incredible music. If it had never gone further than rehearsal, it would still have been the greatest experience.

Sometimes, however, the looseness of Greif's approach and the collective rehearsal process could be frustrating for the actors.

Jesse L. Martin: I remember a discussion about how "I'll Cover You: Reprise" was going to be sung, whether it was going to be a big gospel number or a sweet, beautiful homage to Angel or somewhere in between. Jonathan was extremely specific about how he wanted it to turn out, which made it impossible for me to sing it. I remember having to leave the room, because I got totally confused and frustrated that the song was being played with so much and I wasn't a part of the decision. Eventually it became my decision. I was told to sing it how I wanted to sing it. We were allowed to go as far as we wanted to go. Once Michael figures out that you're talented, which is usually when he casts you, he says, "I can just tell him to do this, and he'll go to town." Jonathan, too, said, "I totally trust that you can do this better than anybody." The only time it got hard was when you held back. Then all hell broke loose.

from far left:
Fredi Walker and Wilson Jermaine Heredia;
Jesse L. Martin, Fredi Walker, Idina Menzel,
Daphne Rubin-Vega and Adam Pascal
rehearsing at NYTW, 1995.

Jonathan was still rewriting, letting the actors shape the script in some parts. Maureen's performance piece was a bone of contention between him and Greif. The director wanted to hire an actual performance artist like Holly Hughes to write it; Jonathan refused. At the workshop, in 1994, the actress played a cello, and "Over the Moon" had an Oedipus/Tiresias theme. For Idina Menzel, Larson made the piece less artsy and more naive, cribbing from the old nursery rhyme about the cow and the fiddle, and from the children's book *Harold and the Purple Crayon*. He rewrote the piece late in rehearsal, with Menzel's and Weil's help.

Idina Menzel: The rehearsal process was scary, because I identified more as a singer than an actress, but Jonathan made me feel comfortable. He pulled me aside one day and said, "Just so you know, I'm going to wait until I hear your voice better, but I'm going to write something much more fitting for you. This part is going to be much bigger, because I love what you do." That was an honor. Jonathan spoke to Michael and said, "I'd like to scrap everything and have her sing more of it." He said, "Make up your melody, Tim will sit here on the piano." Tim was really inspiring with the chords he was playing, and we made music up. I took key lines whose melodies I liked, and we kept them.

Michael Greif: We really worked hard to find checks and balances in Maureen's performance. It was very important to Jonathan that she had something to say. It was very important to me that it seemed like bad performance, but with all the best intentions. She hasn't found out who she is as a performer yet, in the same way that I tried to emulate many directors for a long time. I'm very proud that Maureen chooses to emulate Laurie Anderson and Diamanda Galas. I think she has good taste.

The last hole in the script up until late in rehearsals was the long-problematic love song between Joanne and Maureen. Finally Jonathan brought in "Take Me or Leave Me"—probably the last song he ever wrote.

Bernard Telsey: "Take Me or Leave Me" totally came out of Idina and Fredi. They didn't create the song, but they created an improvisational situation which fed him.

Lisa Hubbard: It shows that he really got it, because it stops being a song just about lesbians and becomes a song about a relationship that happens to be lesbian.

Eddie Rosenstein: I remember the day he wrote "Take Me or Leave Me." He called me at ten in the morning and said, "What are you doing tonight?" He had been hunkered down since September, and we'd only seen each other a few times. "What's going on?" I said. He said, "I've got one song to write." He had such a command of his characters, he wrote the song that day—lyrics and music. And we went out that night.

Anthony Rapp: He'd gotten so much better at distilling conflict and character through a song that really rocked. "Take Me or Leave Me" was so concise and specific. He was bouncing off the walls when he came into rehearsal with it.

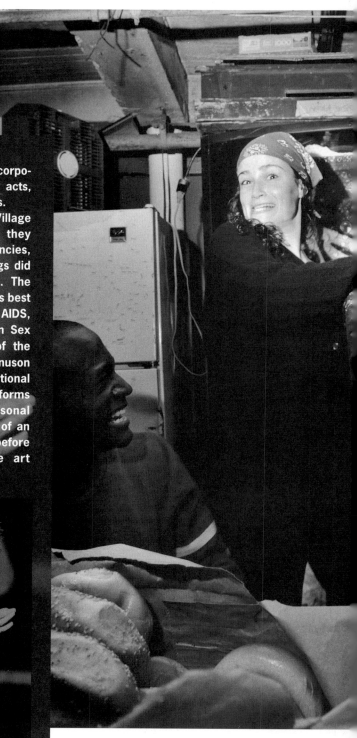

right: Performance artist Laurie Anderson

Rent's showstopping number is "La Vie Bohème," in whose lyrics Jonathan Larson paid tribute to all the things he loved. Greif similarly let the cast make the song a celebration of their own lives.

Michael Greif: The first thing I said was, "You're here because I believe you can be a part of this world, so find the part of you that's in this world and bring that out in 'La Vie Bohème.' That's where you get to be you."

Jesse L. Martin: When we started working on it, we all just got onto the table and started singing. Whatever came about just came about. Then Michael would say, "I think if you did something up, it would be beautiful," and, "I think if you did something down, it would be beautiful." Then Marlies set it. That was one of the great things about that number: we totally created it. It becomes a lot of fun, because you say, "I made up this move myself, so I can do it any way I want to."

The staging of "La Vie Bohème" actually determined the look of Rent.

Michael Greif: I think the design of the whole show was dictated by our desire to dance on tables in "La Vie Bohème." It just seemed like a wonderful way in such a small space to show that kind of exuberance—just a bursting through the seams. Also, the song begins in a religious frame: there's all this talk of Bethlehem. We staged a Last Supper, and it became this big feast, this big ceremony. And then I think we decided we needed the tables for everything else, that they could be everywhere.

Timothy Britten Parker: One of the last things I had an opportunity to tell Jonathan was how lucky I felt he was that Michael was directing, because he's an exceptional stager. He has an innate understanding of staging, this spatial understanding. Michael took what could have been unstageable—a bowl of oatmeal—and he made it into this very fine entrée. It's neat and colorful and precise.

Gilles Chiasson: There are all these moments in the play where we were directed to blur the line between character and actor, the notion being that we're fifteen people in front of however many other people together in a room, sharing common dilemmas and common fears. In "Seasons of Love," we come to the end of the stage, ask a very simple question and then make a suggestion as to what the answer could be. It harkens back to a storytelling tradition and moves away from where musicals have been going, which is cinematic, towards a TV-like, passive experience for the audience. Instead we reinforce the fact that we're all in the theater together. It requires an act of participation.

Michael Greif: I'm always interested in opportunities to break the fourth wall and treat the piece as a concert as much as a piece of musical theater. Just knowing how immediate the concert form is, and how as an audience member you are swept up in it in a very specific way—I think that I was very interested in finding those elements in a musical. So we found places where the singer sang to the audience. It's really pragmatic. It just comes from, "How do you give the audience the most jolt?" And then, conversely, "How do you get the audience involved in the story?" And those things have to do with how the characters relate to each other.

from left:
Taye Diggs and Idina Menzel; Jonathan's notes for "La Vie Bohème," 1995.

45

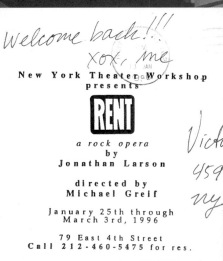

Welcome back!!!
xox, me

New York Theater Workshop
presents

RENT

a rock opera
by
Jonathan Larson

directed by
Michael Greif

January 25th through
March 3rd, 1996

79 East 4th Street
Call 212-460-5475 for res.

Victo
459
ny

from left:

Aiko Nakasone; a postcard from Jonathan to
Victoria Leacock, 1995; Jonathan and
Marlies Yearby at NYTW, 1995; early NYTW
Rent posters, East Village.

During rehearsals, Jonathan was generally quiet, letting Michael run the show. Conflicts happened offstage or behind the scenes. Many cast members didn't know Larson well, but he was a formidable presence at the back of the theater.

Kristen Lee Kelly: I was kind of intimidated by Jonathan, because I'd auditioned for him twice and hadn't been cast. He was very much a perfectionist, but he was really a very good man. I was just starting to feel comfortable sitting next to him in the theater on some downtime when he left us.

Gwen Stewart: Jonathan wanted to put together a trip for the cast to go see *La Bohème* at the Met. He wanted to share with us something that he was excited about, something that inspired him on his journey to *Rent*. I was really looking forward to it, but the rehearsal process got heavier and heavier, so we never got it together.

Aiko Nakasone, cast member: I think that, during the whole time, I spoke to him at the most maybe four times. I was intimidated, because his stuff was brilliant to me. I felt tongue-tied. I remember that the first thing I said to him in rehearsal was, "I just wanted to say that I think your stuff is brilliant." He said, thank you. Then he kind of just walked away, and I said, "Oh, my God, that was so stupid."

Daphne Rubin-Vega: Jonathan wanted something that was bigger than him. He was on a mission, because this was so much his baby. I could perceive that sometimes he wouldn't let go. Michael was very principled in his weighing of what Jonathan needs to have and when he needs Jonathan to defer to him as director. It was the first time I saw a composer defer to a director. Sometimes it was hard. Sometimes he would go farther and farther back into the theater or not show up at rehearsal. At the end of it all, he allowed other people to collaborate with him without having less of *Rent*.

Jim Nicola: The rehearsal periods for both the workshop and the production were the happiest I ever saw Jonathan—before you have to face the terror of a public response to your work.

Marlies Yearby: One of the last things I remember of Jonathan was him sitting in the theater, watching rehearsal. I turned to him and said, "How does it feel? Your baby is about to be born." He said, "I just feel great. I just feel thankful. I'm so happy." Jonathan, in his heart of hearts, felt that there was something about this alternative theater scene and something about commercial musical Broadway that could come together. He really felt that this piece was it, that it could bridge those worlds. I heard that. I don't think he'd realize how much of an effect he has had in his passing. In his living.

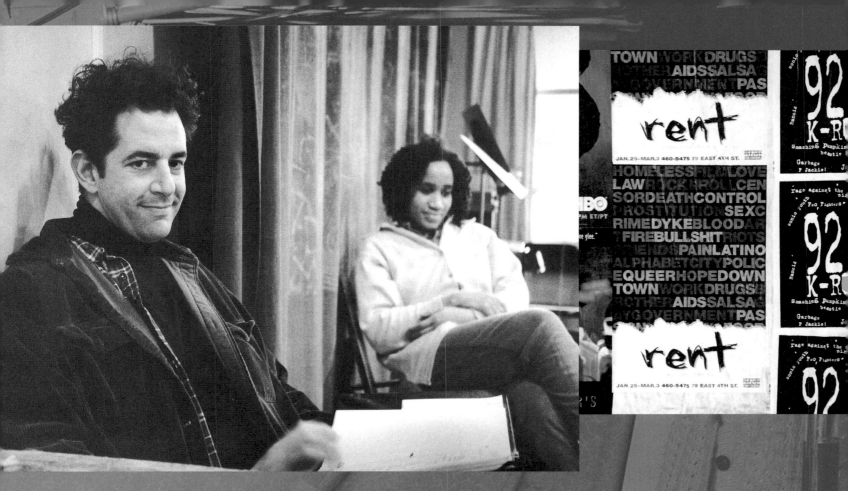

Although he was elated that his show was finally taking shape, Jonathan was also tired and worn out from all the rewrites—and broke.

Eddie Rosenstein: He was pressed on the deadline by Jim and Michael. By November, when they told him it still needed work, he hadn't got a dime yet. A big check arrived the day he died. I bought him his groceries the week he died—the boy didn't have shit. He was so bad about business—it made him insane. So he had to block it out. But he was really upset about it. Nicola says he became Jonathan's father figure, and so Jonathan put the brunt on him.

Jim Nicola: Jonathan had one foot downtown and one foot uptown. That latter part of him was in the old Broadway world, where a producer would come along, put a lyricist, composer and book-writer together, hire them, produce the play and take it to Boston, bring it to New York. The world we're a part of here, there isn't money for that. What we can provide is a building with a rehearsal hall; they can have our attention, caring, opinion. We only exist because people are not paid the value of their labor. That's not just artists, that's everybody. From my point of view, I could only take on so much of the guilt of his not being paid. Everybody's not being paid. If I take on too much of that I have to quit.

Lisa Hubbard: Jonathan had no money. Two weeks before he died, we went to the movies. Usually we'd go to dinner and go to the movies, but he couldn't afford to do both. And even for the movies, he had to go sell books. And even then he didn't have enough; he had to borrow five bucks.

Tim Weil: Jonathan, he was a rare one. In terms of all the stress, he internalized so much—*uuooghhh!* You could just feel it coming out of him! The other thing is, he would be very upset if his vision got postponed, because he wanted to see it up there. On the other hand, what if you had just written this great show, and it was something you had been working on for, like, seven, eight, nine

years. But all of a sudden, it's getting done. And it's really getting done, like, pretty well. You start going, "Cool, cool, cool." But then at the same time, "Oh, it's so cool, but wait! It could be cooler!"

Eddie Rosenstein: Around Christmastime, he called at seven, desperate to go out. I was going to a party, and he got there, and there were a lot of very beautiful women around, people working on commercials. He came in even grungier than he usually went out. My friend who threw the party asked, "What do you like to do?" He said, "I like to be sitting in a room with people listening to my music." And she said okay, and walked away. Ten minutes later, he said, "I gotta go." Then, a week later, he started to emerge from this intense period with an incredible lightness. He was so pleased with himself, said the play is so smart. He prided himself on smart—that was his favorite word. He said, about a week and a half before he died, "I wouldn't change one word." No, he said he wanted to change one sentence. I don't know what it was.

On January 21, *Rent* went into technical rehearsals, the period when all the elements—costumes, lights, sound, props—are brought into the show.

Jim Nicola: Because the design was relatively simple, we were able to focus in tech on the big new element for us, which was the sound. We know sets, lights and costumes, but we were not adept at body mikes and balancing an orchestra. So the tech mainly dealt with sound issues, and we dealt with sound right up until it closed to go uptown. Artistically it was a learning process for me, because I had never understood how vulnerable we could be to that technology. You try not to think what would happen if it fucks up the night the *Times* is there.

That evening, Jonathan ate dinner at a local diner. Then he returned to rehearsals.

Jonathan Burkhart: Jonathan sat next to Michael as they started singing some songs from the second act. He stood up to go to the back of the house, and on his way, he was struck with a very sharp pain in his chest, and his breathing became difficult. So he staggered the last couple of steps up to the lobby. He said, "You better call 911; I think I'm having a heart attack." He went back inside and laid himself on the ground. He told me this in the emergency room: while he was waiting for the ambulance, they were doing "What You Own," and there's a key change from "living in America" to "dying in America." And at that very point, he said, "It sounded good, like the show's coming together, the sound's finally mixed properly. But I can't believe I'm lying on the floor, feeling like I'm dying, and I'm hearing, 'dying in America.'"

Larson was taken to Cabrini Medical Center.

Jonathan Burkhart: When they brought him to the ER, I went back there. They had him on an IV and a breathing machine. His shirt was off and they had these things on his torso, EKGs. He was white and sweating, and every breath was a massive task. Aside from not keeping the air in his lungs, he was squirming and weeping and very uncomfortable. I held his hand and got right into his face and said, "What is it?" He said, "I don't know."

After running some tests, Cabrini diagnosed food poisoning, pumped Larson's stomach and sent him home. Monday, January 22, was a day off for the cast; on the twenty-third, feeling exhausted, weak and feverish, Jonathan called in sick to rehearsals, saying he thought he had the flu. They rehearsed without him, focusing on ironing out the many technical problems of the show. Rosenstein, Burkhart and Jonathan's roommate, Brian Carmody, took care of him. On the night of January 23, Jonathan felt chest pain again and went to St. Vincent's Hospital. He was again evaluated and this time sent home with the diagnosis of a bad flu.

Jonathan Burkhart: Obviously, since this was the second trip to the emergency room, Eddie and Brian and I were pretty freaked out. We had come to some kind of a conclusion that *Rent* was getting to him, that this was nerves, stress. He probably wasn't eating properly, and he wasn't swimming. So when we went in, I went up to him and said, "Jonathan, what is this? Are you nervous?" And he said, "Yeah, I'm worried about tomorrow. But, something doesn't feel right in my chest."

The next day was the final dress rehearsal. Despite continuing chest pain, Jonathan got a haircut and made it to the theater. Everyone was nervous; during tech, the cast had not yet made it through the entire show without stopping. But the dress rehearsal before a packed house went smoothly. At the end, *Rent* got a standing ovation.

Eddie Rosenstein: I'd been taking care of him for a whole week and fighting with him for a month, telling him he shouldn't take another job. I was trying to make him chill out and let things happen, because maybe he'd make some money out of this. Then I saw the final dress rehearsal. I couldn't stand up at the standing ovation, I was so choked up.

Timothy Britten Parker: I had never experienced anything like that before at that stage of a show. Of course, Jonathan would have gone on to reach higher, but that moment was the zenith, the crowning moment of his creative life. At least he got to see that; that was his last moment with us and with *Rent*.

Jim Nicola: All the Usual Suspects are invited to dress rehearsals here, as a sort of support in a time of stress. It's a wonderful night when everybody remembers that all of us are in this horrible place often and we all need to be supported. We try to be together and be a community. They tend to be very generous, so it's hard to judge exactly what the impact of the piece will be. I was only looking at the work list. You can't think about the outcome, because you've got to get the tasks done. Jonathan was there, and he was looking pretty ragged. The good thing was that there were people from the *Times*: Tony Tommasini and Andrea Stevens, the cultural editor. Tommasini had a conversation after the show with Jonathan in the box office. He said all these very wonderful things. So Jonathan did hear some good things before he died.

Unbeknownst to *Rent*'s creative staff, their opening coincided with the 100th anniversary of *La Bohème*—a serendipitous news hook. Anthony Tommasini was already planning a story for *The New York Times*.

Anthony Tommasini: I was interested in doing a piece about how young people continually see themselves in this opera of struggling bohemian artists in Paris in the 1800s. So the theater editor points out this show, which is doing exactly that. I went to see it, with the idea being that I do a piece and use this show to make my point about *La Bohème*. I went there not knowing what I'd find, and there was a possibility that if I thought it was terrible we wouldn't have done anything. It was terribly rough. The sound mix was quite poor, the words were not clear, and I sat there thinking, "I don't know how they're going to get this together." But I thought the material was terrific. I was very taken and impressed by Jonathan's work, and the cast; I thought they looked a little "what do I do next," but they were all full of energy.

The only place where we could talk was the box office. He sat on this crate and I sat in the chair, and we talked. He looked a little wistful, a little distracted and quite tired, but as anyone would in the middle of a crazy production. He was very articulate and very committed to his show, and I told him how strong I thought the material was, and I think I paid him the compliment of taking the show very, very seriously.

We talked a lot about his life and his background, and he said many of the things that I mentioned in the article that were so incredibly ironic: that he had just been able to quit his job as a waiter, he had some more work coming in, and he said, "It looks like I may just have a life as a composer." Virtually the last thing he said to me was about how the show was inspired by friends of his who died of AIDS and that the message really is that it's not how long you're here but what you do while you're here. I had by this point decided that I was going to base the article on the show, and I would use the show to make my points about *La Bohème*.

I found out after the fact that Jon was very worried about this interview, he was very nervous about it. He used to say all the time, "The day I get my *New York Times* interview, you watch, it's gonna happen, the day I win my Tony." I'd never felt so much that something was meant to happen, that I was brought together with him so that he could have the chance to tell the world about his life and his work and what it meant to him and what he was trying to say.

"...it's not how long you're here but what you do while you're here."

Nicola, Greif, Larson and others were supposed to meet and go over problems after the show, but the interview lasted an hour. So they agreed to get together the next morning at Time Cafe for breakfast, as had been their habit for the last few months. Jim and Michael sent Jonathan home in a cab.

Jim Nicola: That was the last we saw of him. But I think we all felt we were going to get through it. It wouldn't come crashing down.

Jonathan came home to an empty apartment and a note from Brian Carmody congratulating him on the show and inviting him to the bar downstairs for a beer.

Jonathan Burkhart: What we guess happened is this: Jonathan must have gotten home by about midnight, twelve-thirty, and put on a pot of water to boil for tea. There in the kitchen his aorta opened up. It had been weakening for days. The last breakage happened, and it ripped open. He probably felt another sharp pain much like he felt before. This time, as the blood was pouring into his chest, he probably fell unconscious within ten or fifteen seconds. He died within about five minutes.

Carmody came home at 3:30 in the morning, January 25, the day scheduled for *Rent*'s first preview, and found Larson's body on the floor. He called 911; when the police came, they pronounced Jonathan dead. Carmody then began phoning Jonathan's family, friends and colleagues.

Chuck McCollum: Brian used to work with Julie, so he had her number. At that time, we only had one phone line, and I would get a lot of faxes at night, so I usually kept the fax machine on, but I forgot to that night. So after the third or fourth time the phone rang, I picked it up, expecting to get a fax tone, and it was Brian.

I could tell by his voice that something absolutely horrible had happened. He asked for Julie, and I told him she was in Albuquerque. He said yeah, and then he kept repeating my name a couple of times. He said, "I don't know how to say it," and I said, "Just say it." And he said, "Jonathan died last night." It hit me like a brick—even though I knew something horrible had happened, to have it said so finalized like that . . . I wanted to hear, "Jonathan's in the hospital—it looks bad," or, "Jonathan is very, very ill."

I started almost getting hysterical at first, saying "Oh, my God" and shaking all over. I hung up the phone and just immediately dialed. Al answered the phone, and I told him. It felt like a nightmare. I hope I never have to make another phone call like that again in my life. Beyond being saddened and horrified, it was like a cosmic joke. The show's about to open, this whole thing's about to blow wide open, we know it's going to be a big thing—you've got to be kidding me. It felt like a mistake, like *Heaven Can Wait*: put him back in his body, and let's keep going.

Jonathan Burkhart: I got the call at 6:35. It was freezing, but I lived just up the street, so I went there. There were two policemen standing over his body, and Brian was in the kitchen. I went up to Jonathan and shook him a little to try to wake him up. His skin was kind of white. At that point, I learned what the word *absolute* meant.

Jim Nicola: The phone rang at 7:30 at home. It was the production manager, Sue White, saying she had got a call from the police that Jonathan was dead. I got up, took a shower, got in a cab, came in, and I couldn't reach Michael by phone. So I met him at 9:30 at Time Cafe and told him the news. We came back and called the company, so they would hear from me and not on the street. They were supposed to come at noon, and this was 10:00 so we just said to come on down whenever they felt like it.

Allan Gordon: Kevin called in the morning. Jonathan was dead. I was shattered. It wasn't possible. The night before I had spoken to Jonathan after the dress rehearsal. Three hours later he was gone.

Jeffrey Seller: I was in shock. I remember falling against the wall with fear and surprise and not understanding how this could be. I'm not good with death, and I don't know many people who've died. So when someone you knew well and saw last night is dead, it's scary. Because it could be anybody. Someone you know and had affection and love for has gone somewhere, and you don't know where it is. I cried all day. Then Kevin finally arrived, and we went out for a walk. It's weird when something drastic has changed in your life and the rest of the world is going on as if nothing happened.

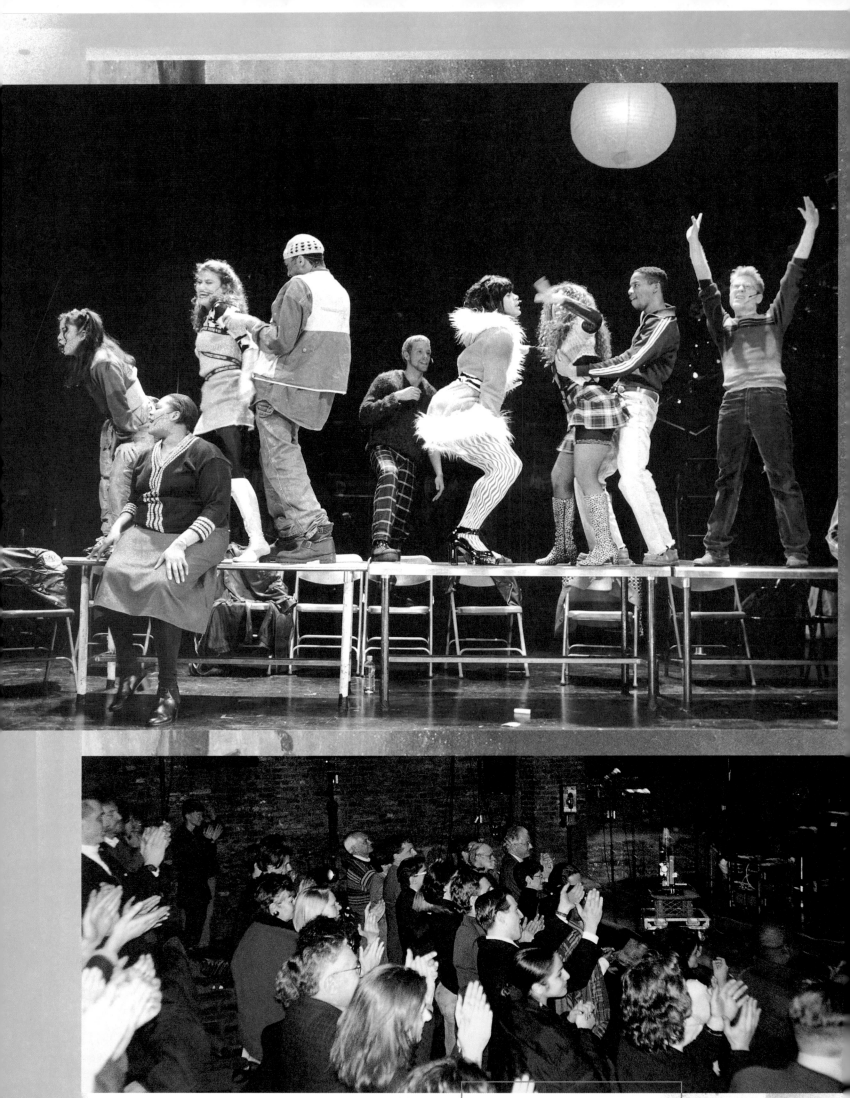

clockwise from top left:
Scene from "La Vie Bohème" at NYTW, 1996;
curtain call at NYTW; standing ovation at
NYTW, 1996.

Glory

During previews, a play is performed before audiences for the first time to gauge reaction. The show may go through many changes during this period; some shows never even make it to opening night, when the press is officially invited. In *Rent*'s case, only limited adjustments could be made; its keepers had to figure out how to fine-tune the show without the creator around to write new material, offer input and argue. Michael Greif, Jim Nicola, Tim Weil and Lynn Thomson worked together to make *Rent* the best show possible, while still preserving the integrity of Jonathan's work.

Anthony Rapp: Michael and Tim and Jim and Lynn had to do a lot of soul-searching about how to progress. They knew that Jonathan knew it wasn't finished when he died. He was looking forward to working on the play during previews. It's a terrible game of second-guessing.

Michael Greif: From the time of Jonathan's death to the opening, I was operating with a more focused sense of urgency than perhaps I have in other situations, because I really wanted to succeed for him. We proceeded with a lot of knowledge of Jonathan's intentions and a lot of experience discussing and collaborating and arguing with him about various things, with a lot of consideration and care. Because Jonathan is not here to argue with, I need to include his argument in my argument.

Essentially what we did in those two and a half weeks was cut from the first act. We did internal trims within songs and lost maybe ten minutes, maybe more. We lost a verse and a chorus of "What You Own" in the second act. And we futzed a lot with the ending. One change was that stage directions and character descriptions Jonathan had written—for example, when he describes Mark and Roger's apartment—were given to Mark as dialogue. Before he died, those narrative moments were not in the script. They were in the workshop we did a year ago. We determined they helped in storytelling, and so they were reintroduced. I believe that after seeing a couple of previews Jonathan would have consented and agreed that they were helpful.

Gwen Stewart: The preview process was when we needed him the most. So it was really hard for Michael and Lynn and Jim. I remember Michael saying that he had to say to himself, "Okay, I know this is something I would push Jonathan for, but he wouldn't

go for it, so I'm not going to do that." They looked through his notes, what he might have said at any given moment. But whatever this unfinished state is, it's what has made *Rent* as special as it is.

Daphne Rubin-Vega: It's really textured and overflowing with information, for better and for worse. Part of what makes *Rent* beautiful is its roughness. It's just like living on the Lower East Side: there's a lot of shit going on. It's messy. Good.

Audiences were enthusiastic, and tickets were selling well. Still, *Rent*'s future was unclear.

Jim Nicola: The audience response was strong, but I thought that that's how it is when you do a musical. I couldn't really tell what it meant. I was walking my line of not getting overheated. We were having moments of elation and then the opposite, trying to find an equilibrium.

Anthony Tommasini's *New York Times* article ran in the Arts & Leisure section on February 11, two days before opening night. The story was now about Jonathan's death as well as *La Bohème*'s enduring generational appeal. It started the rumblings of what was to become a media avalanche.

Anthony Tommasini: People got very curious. Jonathan's death did bring—obviously, understandably—much more attention to his life. But I personally believe that the show is strong enough that it would have absolutely had the kind of success that it's having had this horrible thing not happened—and Jonathan would have just been dancing in the streets.

clockwise from top left:
Cast members backstage before their final performance at NYTW;
Jonathan's Pulitzer Prize; cast members onstage at the Nederlander;
Isabella Rossellini and Christie Brinkley, opening night on Broadway;
Sigourney Weaver, opening night on Broadway; Nederlander *Rent* poster.

Unknowns yesterday, budding Broadway stars tomorrow, the cast suddenly found themselves part of a media phenomenon, being photographed for *The New York Times, Rolling Stone, Vanity Fair* and *Harper's Bazaar*. The experience was heady and exhilarating, but always balanced by the intensity of the tragedy they had just gone through together.

Jesse L. Martin: The last night at NYTW, there was this wave of, *whatever,* that came from the audience when we finished— I've never experienced anything like that before in my life. I know what people talk about now when they say they get high from doing things like this.

Taye Diggs: You get all that thunderous applause for doing a show, for doing a piece of theater. Then, at the same time, it was like we were rock stars.

Timothy Britten Parker: All the theater experience over the years—it meant nothing. This whole experience has been totally different. It's been like being strapped to a rocket, willingly, and just going for a ride.

Adam Pascal: I'd been onstage hundreds of times with my band, but it's a different vibe, a different animal. Everything from the first day has just been a fantasy—barring Jonathan's death, mind you.

The actors were no longer performing an off-Broadway show for $300 a week. The stakes changed dramatically.

Fredi Walker: It's a job now. It's a profession. It's politics. It's a lot of things that it wasn't before. And those things make it different, because people are trying to make money off it now. Somewhere deep down in my heart, part of me believes that's why Jonathan is no longer with us. I don't know if he could have reconciled himself to the negotiations, the agents, the lawyers. The things you have to do to make a career and make money off something.

Gilles Chiasson: An amazing thing happened, which is that—and it is my understanding that this had only happened once before, and never at this stage—when the producers took the reins and decided to move the show to Broadway, they made a "favored nations" offer to all the actors, which meant that Daphne and Adam, even though they were playing the parts they were, and they were in *Vanity Fair,* got the exact same offer as the rest of the cast. I, the squeegee man, was on the same par. So what we did, which was unique, is we got together and met about the terms and decided to negotiate as an ensemble.

What was amazing this whole time was that the producers were buying us Sunday dinner. They're young, and they were as excited as we were. I said at a talk-back at the workshop that they were trying to be as innovative in the producing as Jonathan was in the writing. As we talked about negotiating, making a counteroffer, we really did it with a feeling that we were collaborating with them. "We want to ask for more because we should, but we shouldn't ask for too much." The goodwill could barely fit in the room. The fact that we were banding together, we knew full well that the people who were principals were bringing their salary down. It was quite amazing. And wonderfully naive. I wouldn't trade that time for anything.

On April 9, while the cast was in the middle of rehearsing for Broadway, it was announced that Jonathan Larson had won the Pulitzer Prize for drama for *Rent*.

Anthony Rapp: I'd heard a rumor on-line that *Rent* was being considered for a Pulitzer. We were onstage in technical rehearsal, and I knew, because I follow these things, that it was going to be announced that afternoon. So then I see, in the back of the house, the producers, TV crews. At our next break, Kevin McCollum told us. It was snowing.

Victoria Leacock: Even Jonathan, with all his confidence, never thought he'd win a Pulitzer. I don't think that ever entered his mind.

Nan Larson: Someone from the AP called, and then we got a telegram from Columbia University. We were just overwhelmed.

By this time, the excitement in and around *Rent* was tremendous. The show had accelerated from tragedy to triumph in three months. People were operating with a collective sense of focus, mission and momentum.

Marlies Yearby: The journey to Broadway was such an intense road. It was a different world. The tech time was monstrous; sometimes it took twenty minutes to move a chair. And there was the pressure of the money that was being put into the project. I saw everyone fighting to be happy about this. Everybody was still grieving, but you also wanted to jump for joy, because it was an opening for people. We had such a rough ride; by opening night, we were *Rent*ed.

On April 29, *Rent* opened at the Nederlander Theater.

Don Summa, press agent: The opening was spectacular. It was, I think, the most exciting night I've ever seen in the theater. There was absolute electricity, and if you were there, you were just swept away by it. The amount of interest was phenomenal; we were getting calls from all over the world. At the opening, we had Michelle Pfeiffer, Sigourney Weaver, George Clooney, Isabella Rossellini, David Geffen and Barbara Walters, plus a ton more—the street was just mobbed with people. At various times during the evening, there were at least fifty photographers and twenty-five or thirty TV crews.

Jeffrey Seller: It was almost like an out-of-body experience, because you pull up in a cab and you can't turn right because they've blocked off the street. Suddenly you're actually in one of the Hollywood events you used to watch at the gym on VH1, and here it is taking place for the show I produced! It was a very heavy experience. I had twenty-two family members come from Michigan. It was like: family member, movie star, family member, movie star.

Don Summa: It was also very sad and very moving. There were TV crews, and they talked to the Larsons. They were as happy as they could be; it was Jonathan's dream, and it came true, but he wasn't there to see it.

Nan Larson: It's a wonderful thing that has happened, and it's horrible that he's not around to enjoy the fruits of his labor. We always got a big kick out of whatever he did that we went to see. And from that point, *Rent* has been quite exceptional. But there's a very, very mixed bag of feelings here.

Marlies Yearby: I think opening night was the first time I openly cried. It was such a relief that it was up, the realization of the whole journey.

Don Summa: When the show started, Adam walked on, the cast walked on and everybody in the audience just stood up. Then everybody sat down, and Anthony said, "We dedicate this and every performance to the memory of Jonathan Larson," and then everybody just stood up again, cheering and applauding and screaming and whooping.

Daphne Rubin-Vega: We were operating on pure adrenaline. When we hit the wood and people began applauding, that was the moment when Jonathan's absence was so loud and pathetically ironic.

Timothy Britten Parker: As we got to our places, the applause started out slowly and built to a crescendo for what was probably two or three minutes. There was such a feeling of love, a feeling of being embraced, a feeling that already Jonathan's work had touched these people.

"We dedicate this and every performance to the memory of Jonathan Larson."

"Broadway bound!"—*Rent* cast onstage at NYTW, 1996

The Libretto |

RENT

Book, Music & Lyrics
Directed by Michael Greif

Produced by Jeffrey Seller, Kevin McCollum, Allan S. Gordon and New York Theatre Workshop

Original Broadway | *Performance*

Cast in order of appearance

ROGER DAVIS
Adam Pascal

MARK COHEN
Anthony Rapp

TOM COLLINS
Jesse L. Martin

BENJAMIN COFFIN III
Taye Diggs

JOANNE JEFFERSON
Fredi Walker

ANGEL DUMOTT SCHUNARD
Wilson Jermaine Heredia

MIMI MARQUEZ
Daphne Rubin-Vega

MAUREEN JOHNSON
Idina Menzel

MARK'S MOM & OTHERS
Kristen Lee Kelly

MR. JEFFERSON, SOLOIST #2, CAROLER, A PASTOR & OTHERS
Byron Utley

MRS. JEFFERSON, SOLOIST #1, WOMAN WITH BAGS & OTHERS
Gwen Stewart

GORDON, THE MAN, MR. GREY & OTHERS
Timothy Britten Parker

STEVE, MAN WITH SQUEEGEE, A WAITER & OTHERS
Gilles Chiasson

PAUL, POLICE OFFICER & OTHERS
Rodney Hicks

ALEXI DARLING, ROGER'S MOM & OTHERS
Aiko Nakasone

UNDERSTUDIES
Yassmin Alers, Darius de Haas, Shelly Dickinson, Norbert Leo Butz, Mark Setlock, Shayna Steele

Set Design
Paul Clay

Costume Design
Angela Wendt

Lighting Design
Blake Burba

Sound Design
Kurt Fischer

Original Concept and Additional Lyrics
Billy Aronson

Musical Arrangements
Steve Skinner

Publicity
Richard Kornberg and Don Summa

Casting
Bernard Telsey Casting

Technical Supervision
Unitech Productions, Inc.

General Management
Emanuel Azenberg and John Corker

Production Stage Manager
John Vivian

Music Supervision and Additional Arrangements
Tim Weil

Choreography
Marlies Yearby

Dramaturg
Lynn M. Thomson

The Band
Conductor, Piano, Synthesizers
Tim Weil
Bass
Steve Mack
Guitars
Kenny Brescia
Drums and percussion
Jeff Potter
Keyboards, Guitars
Daniel A. Weiss

by Jonathan Larson

Act I

1.	Tune Up #1	Mark
2.	Voice Mail #1	Mrs. Cohen
3.	Tune Up #2	Mark, Roger, Collins & Benny
4.	Rent	The Company
5.	You Okay Honey?	Angel & Collins
6.	Tune Up #3	Mark & Roger
7.	One Song Glory	Roger
8.	Light My Candle	Roger & Mimi
9.	Voice Mail #2	Mr. & Mrs. Jefferson
10.	Today 4 U	Mark, Collins, Roger & Angel
11.	You'll See	Benny, Mark, Collins, Roger & Angel
12.	Tango: Maureen	Mark & Joanne
13.	Life Support	Paul, Gordon & the Company
14.	Out Tonight	Mimi
15.	Another Day	Roger, Mimi & the Company
16.	Will I?	Steve & the Company
17.	X-Mo Bells #2/Bummer	The Company
18.	Santa Fe	Collins & the Company
19.	I'll Cover You	Angel & Collins
20.	We're Okay	Joanne
21.	Christmas Bells	The Company
22.	Over the Moon	Maureen
23.	La Vie Bohème	The Company
24.	I Should Tell You	Roger & Mimi
25.	La Vie Bohème B	The Company

Act II

26.	Seasons of Love	The Company
27.	Happy New Year	Mark, Mimi, Roger, Maureen, Joanne, Collins & Angel
28.	Voice Mail #3	Mrs. Cohen & Alexi Darling
29.	Happy New Year B	Maureen, Mark, Joanne, Benny, Roger, Mimi, Angel, Collins & the Man
30.	Take Me or Leave Me	Maureen & Joanne
31.	Seasons of Love B	The Company
32.	Without You	Roger & Mimi
33.	Voice Mail #4	Alexi Darling
34.	Contact	The Company
35.	I'll Cover You: Reprise	Collins & the Company
36.	Halloween	Mark
37.	Goodbye, Love	Mark, Mimi, Roger, Maureen, Joanne, Collins & Benny
38.	What You Own	Pastor, Mark, Collins, Benny & Roger
39.	Voice Mail #5	Roger's Mom, Mimi's Mom, Mr. Jefferson & Mrs. Cohen
40.	Finale A	The Company
41.	Your Eyes	Roger
42.	Finale B	The Company

Italic type indicates spoken lines.
The Libretto is published as performed on
Broadway at the Nederlander Theatre, April 29, 1996.
Variations may occur during a performance.

Act I | (The audience enters the theater to discover a stage bare of curtains. At stage left looms a metal sculpture intended to represent: (a) a totem pole/Christmas tree that stands in an abandoned lot, (b) a wood stove with a snaky chimney that is at the center of MARK & ROGER's loft apartment, and (c) in Act II, a church steeple. On stage the five-musician band performs under a wooden platform surrounded by railing. The wooden platform has a staircase on the upstage side. Downstage left is a black, waist-high rail fence. Once the audience is in the theater, CREW and BAND MEMBERS move about informally onstage in preparation for Act I.

ROGER DAVIS, carrying an electric guitar, enters upstage left and crosses to a guitar amp sitting on a chair at center stage. He casually plugs his guitar into the amp and adjusts levels, then crosses downstage and sits on the table.

After a few chords, the COMPANY, led by MARK COHEN, enters from all directions and fills the stage. MARK sets up a small tripod and a 16mm movie camera downstage center, aimed upstage. He addresses the audience.)

We begin

MARK *We begin on Christmas Eve, with me, Mark, and my roommate, Roger. We live in an industrial loft on the corner of 11th Street and Avenue B, the top floor of what was once a music-publishing factory. Old rock-'n'-roll posters hang on the walls. They have Roger's picture advertising gigs at CBGB's and the Pyramid Club. We have an illegal wood-burning stove; its exhaust pipe crawls up to a skylight. All of our electrical appliances are plugged into one thick extension cord which snakes its way out a window. Outside, a small tent-city has sprung up in the lot next to our building. Inside, we are freezing because we have no heat.*

(MARK turns the camera to ROGER.)

Smile!

4. Rent

(The COMPANY bursts into a flurry of movement, then everyone except MARK and ROGER freezes in a group upstage.)

MARK How do you document real life / When real life's getting more / Like fiction each day / Headlines – breadlines / Blow my mind / And now this deadline / "Eviction – or pay" / Rent

ROGER How do you write a song / When the chords sound wrong / Though they once sounded right and rare / When the notes are sour / Where is the power / You once had to ignite the air

MARK And we're hungry and frozen

ROGER Some life that we've chosen

MARK & ROGER How we gonna pay / How we gonna pay / How we gonna pay / Last year's rent

MARK (to audience) We light candles

ROGER How do you start a fire / When there's nothing to burn / And it feels like something's stuck in your flue

MARK How can you generate heat / When you can't feel your feet

MARK & ROGER And they're turning blue!

MARK You light up a mean blaze

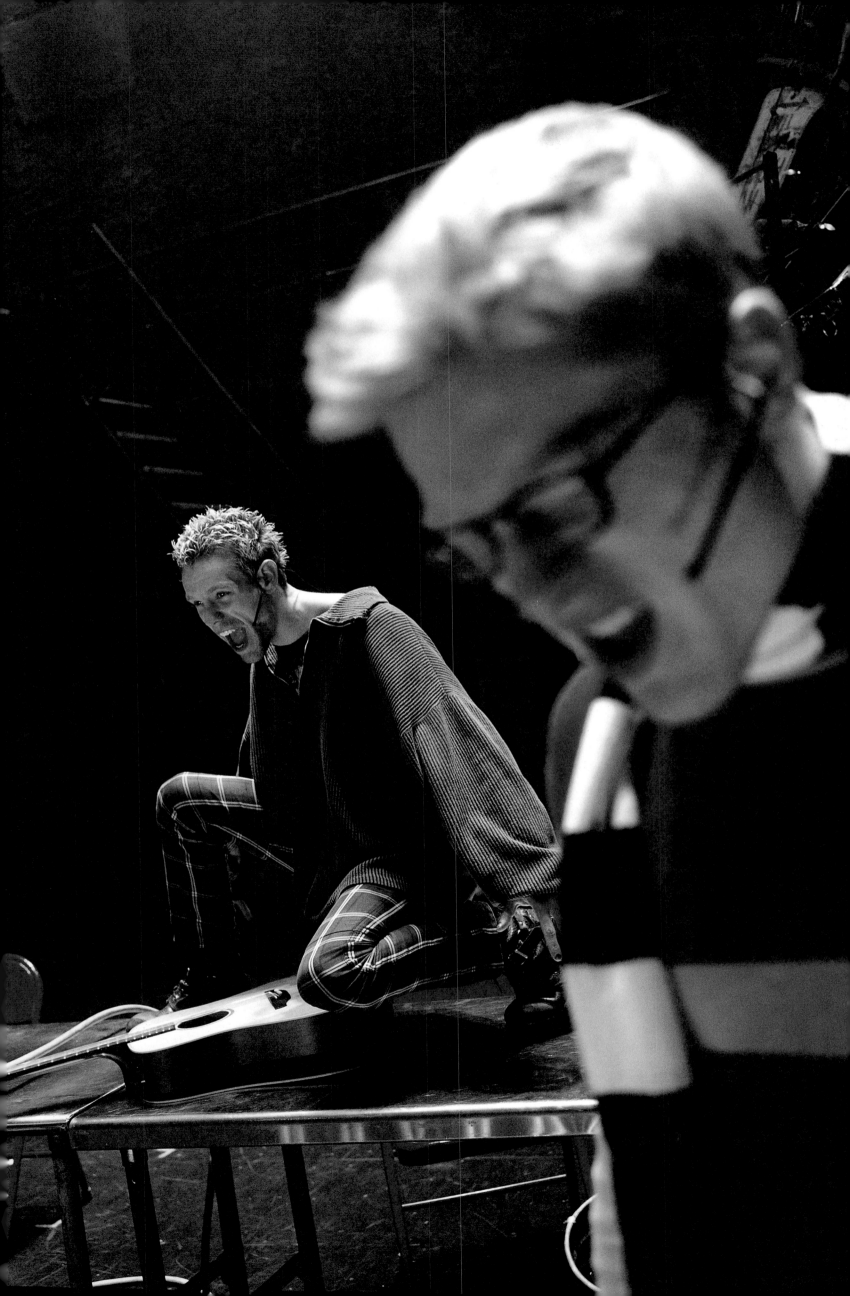

(ROGER grabs one of his own posters.)

ROGER With posters–

(MARK grabs old manuscripts)

MARK And screenplays
MARK & ROGER How we gonna pay /
How we gonna pay / How we gonna pay /
Last year's rent

(Lights go down on the loft and go up on
JOANNE JEFFERSON, who's at the pay phone.)

JOANNE Don't screen, Maureen /It's me,
Joanne /Your substitute production manager /
Hey hey hey! (Did you eat?) /Don't change
the subject Maureen /But Darling – you

haven't eaten all day /You won't throw up /
You won't throw up /The digital delay – /
didn't blow up (exactly) /There may have been
one teeny-tiny spark /You're not calling Mark

(Lights go up on COLLINS who struggles
and stands.)

COLLINS How do you stay on your feet /
When on every street /It's "trick or treat" /
(And tonight it's "trick") /"Welcome back to
town" /I should lie down /Everything's
brown /And uh – oh /I feel sick
MARK (at the window) Where is he?
COLLINS Getting dizzy (HE collapses)
MARK & ROGER How we gonna pay /
How we gonna pay / How we gonna pay /
Last year's rent

(MARK & ROGER stoke the fire. Crosscut to
BENNY's Range Rover.)

BENNY (on cellular phone) Alison baby –
you sound sad /I don't believe those two /
After everything I've done /Ever since our
wedding /I'm dirt – they'll see /I can help
them all out in the long run

(Three locales: JOANNE at the pay
phone, MARK & ROGER in their loft, and
COLLINS on the ground. The following is
sung simultaneously.)

BENNY Forces are gathering /Forces

are gathering / Can't turn away / Forces are gathering

COLLINS Ughhhh – / Ughhhh – / Ughhhh – I can't think / Ughhhh – / Ughhhh – / Ughhhh – I need a drink

MARK (*reading from a script page*) "The music ignites the night with passionate fire"

JOANNE Maureen – I'm not a theater person

ROGER "The narration crackles and pops with incendiary wit"

JOANNE Could never be a theater person

MARK (*to audience*) Zoom in as they burn the past to the ground

JOANNE (*realizing she's been cut off*) Hello?

MARK & ROGER And feel the heat of the future's glow

JOANNE Hello?

(*The phone rings in the loft. MARK picks it up.*)

MARK Hello? Maureen? / Your equipment won't work? / Okay, all right, I'll go!

MARK & HALF THE COMPANY How do you leave the past behind / When it keeps finding ways to get to your heart / It reaches way down deep and tears you inside out / 'Til you're torn apart / Rent

rn the past to the ground

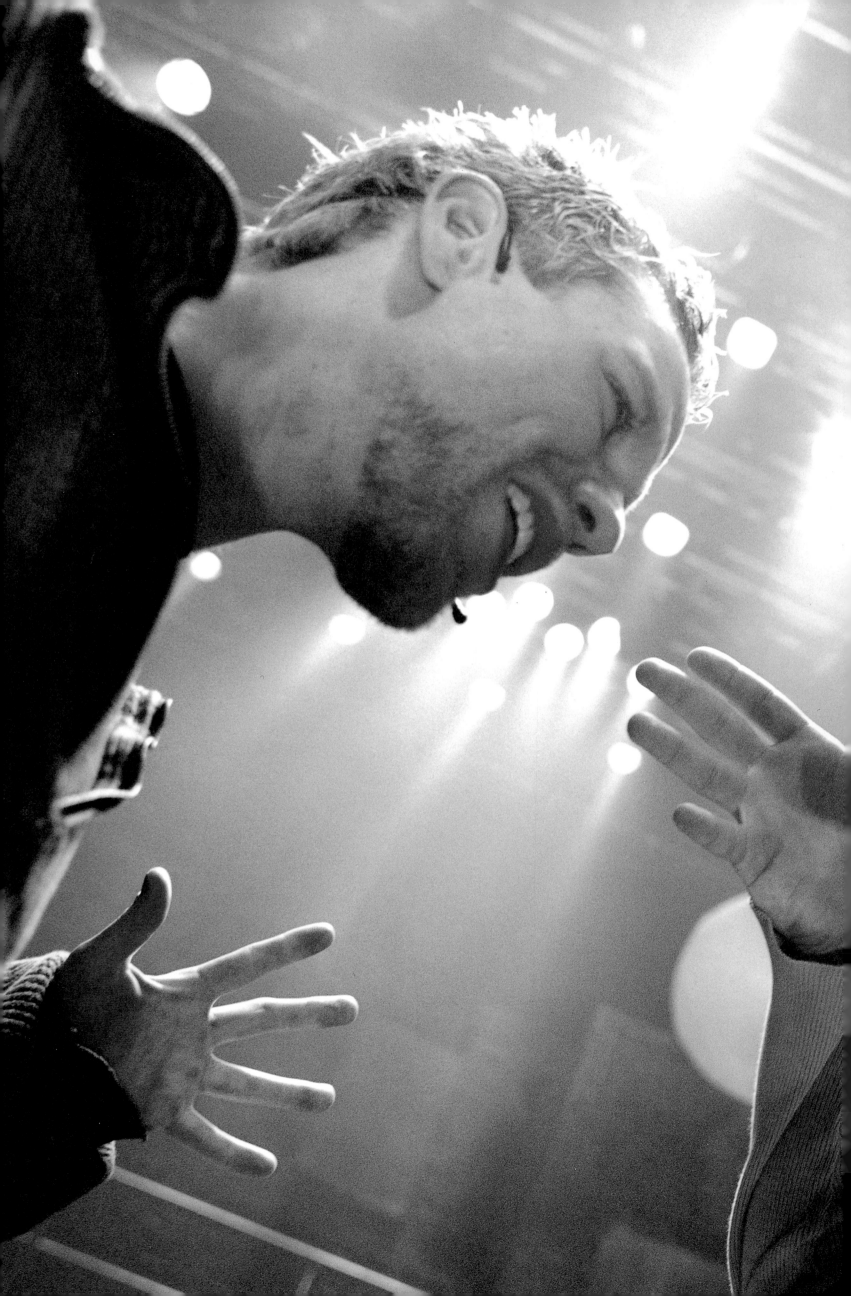

YOUR OWN BLOOD CELLS BETRAY

**ROGER & OTHER HALF OF
COMPANY** How can you connect in an
age / Where strangers, landlords, lovers /
Your own blood cells betray

COMPANY What binds the fabric together /
When the raging, shifting winds of change /
Keep ripping away

BENNY Draw a line in the sand / And then
make a stand

ROGER Use your camera to spar

MARK Use your guitar

COMPANY When they act tough – you call
their bluff

MARK & ROGER We're not gonna pay

**MARK, ROGER & HALF THE
COMPANY** We're not gonna pay

**MARK, ROGER & OTHER HALF OF
COMPANY** We're not gonna pay

COMPANY Last year's rent / This year's
rent / Next year's rent / Rent, rent, rent,
rent, rent / We're not gonna pay rent

MARK & ROGER 'Cause everything is rent

5. *You Okay Honey?*

(The street in front of the pay phone. A HOMELESS MAN appears above on the right. Across the stage, ANGEL DUMOTT SCHUNARD is seated on the Christmas tree sculpture, with a plastic pickle tub balanced like a drum between his knees.)

HOMELESS MAN Christmas bells are ringing / Christmas bells are ringing / Christmas bells are ringing / Somewhere else / Not here

(The HOMELESS MAN exits. ANGEL gets a good beat going on the tub, but is interrupted by a moan. HE starts to drum again and sees COLLINS limp to downstage-left proscenium.)

I'm Angel

ANGEL You okay honey?
COLLINS I'm afraid so
ANGEL They get any money?
COLLINS No, had none to get / But they purloined my coat / Well you missed a sleeve! – thanks
ANGEL Hell, it's Christmas Eve / I'm Angel
COLLINS Angel? Indeed / An angel of the first degree / Friends call me Collins – Tom Collins / Nice tree...

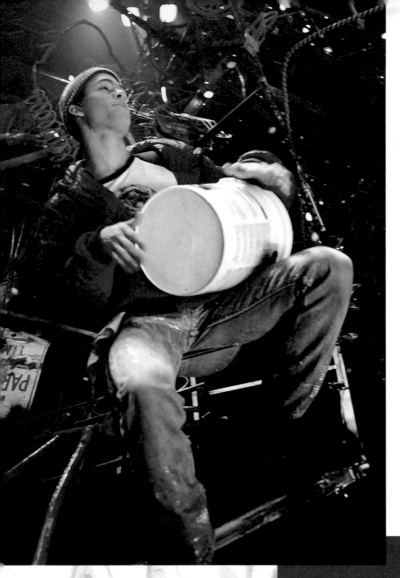

| (Lights come up on loft.)

ROGER *Where are you going?*
MARK *Maureen calls.*
ROGER *You're such a sucker.*
MARK *I don't suppose you'd like to see her show in the lot tonight?* (ROGER shrugs) *Or come to dinner?*
ROGER *Zoom in on my empty wallet.*
MARK *Touché. Take your AZT.* / (To audience) Close on Roger / His girlfriend April / Left a note saying, "We've got AIDS" / Before slitting her wrists in the bathroom / *I'll check on you later. Change your mind. You have to get out of the house.*

an ANGEL of the first degree

NGEL Let's get a Band-Aid for your knee /
I change, there's a "life support" meeting /
nine-thirty / Yes, this body provides a
mfortable home / For the acquired
mune deficiency syndrome
OLLINS As does mine
NGEL We'll get along fine / Get you a
at, have a bite / Make a night – I'm flush
OLLINS My friends are waiting –
NGEL You're cute when you blush
e more the merrier – Ho ho ho / And I do
t take no

NGEL and COLLINS walk off stage
ght.)

7. *One Song Glory*

ROGER I'm writing one great song before I... / One song / Glory / One song / Before I go / Glory / One song to leave behind / Find one song / One last refrain / Glory / From the pretty-boy front man / Who wasted opportunity / One song / He had the world at his feet / Glory / In the eyes of a young girl / A young girl / Find glory / Beyond the cheap colored lights / One song / Before the sun sets / Glory – on another empty life / Time flies – time dies / Glory – one blaze of glory / One blaze of glory – glory / Find /

A song about love

Glory

From the soul of a young man

Glory / In a song that rings true / Truth liké a blazing fire / An eternal flame / Find / One song / A song about love / Glory / From the soul of a young man
A young man / Find / The one song / Before the virus takes hold / Glory / Like a sunset / One song / To redeem this empty life / Time flies / And then – no need to endure anymore / Time dies

(ROGER is interrupted by a sharp knock on the door. It is MIMI MARQUEZ, a beautiful stranger from downstairs.)

ROGER *The door.*

(ROGER crosses to the door.)

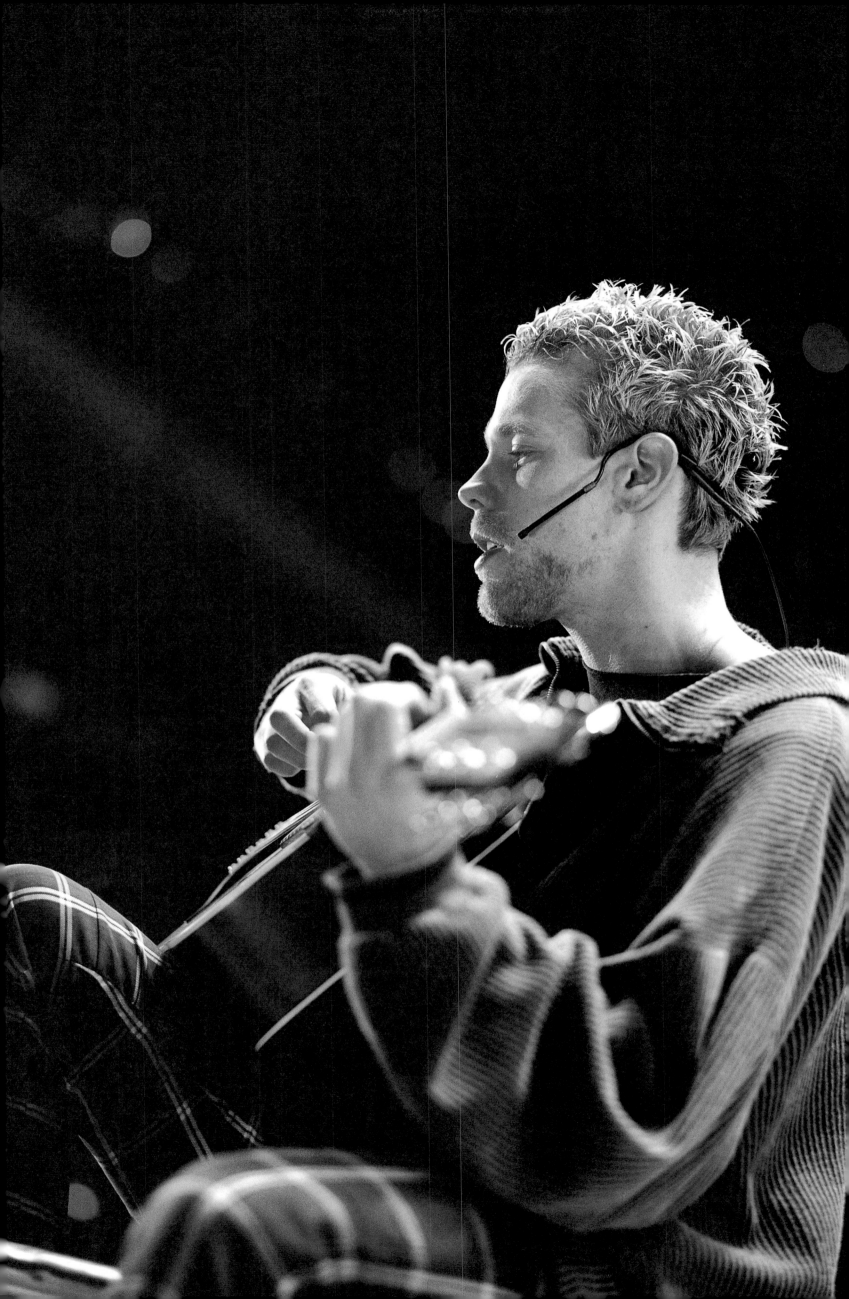

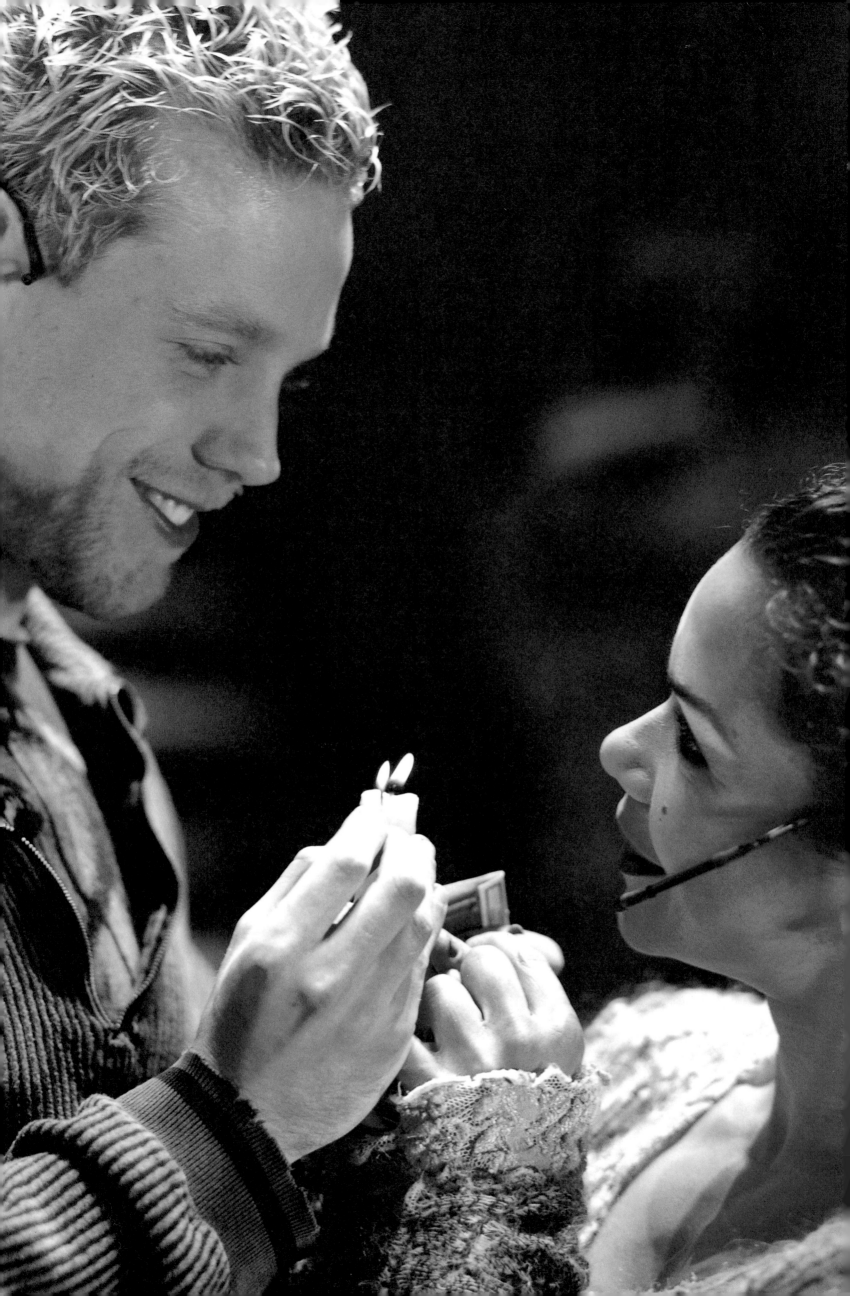

8. Light My Candle

ROGER What'd you forget?

(MIMI enters, holding a candle and looking for a match; her electricity is down, too.)

MIMI Got a light?
ROGER I know you – you're – / You're shivering
MIMI It's nothing / They turned off my heat / And I'm just a little / Weak on my feet / Would you light my candle? / What are you staring at?
ROGER Nothing / Your hair in the moonlight / You look familiar

(ROGER lights her candle. MIMI starts to leave, but stumbles.)

ROGER Can you make it?
MIMI Just haven't eaten much today / At least the room stopped spinning. Anyway. What?
ROGER Nothing / Your smile reminded me of –
MIMI I always remind people of – who is she?
ROGER She died. Her name was April

(MIMI discreetly blows out the candle.)

MIMI It's out again / Sorry about your friend / Would you light my candle?

(ROGER lights the candle. They linger, awkwardly.)

ROGER Well –
MIMI Yeah. Ow!
ROGER Oh. The wax – it's –
MIMI Dripping! I like it – between my –
ROGER Fingers. I figured... / Oh, well. Goodnight

(MIMI exits. ROGER heads back toward his guitar on the table. There is another knock, which he answers.)

ROGER It blew out again?
MIMI No – I think that I dropped my stash
ROGER I know I've seen you out and about / When I used to go out / Your candle's out
MIMI I'm illin' – I had it when I walked in the door / It was pure – is it on the floor?
ROGER The floor?

(MIMI gets down on all fours and starts searching on the floor for her stash. SHE looks back at ROGER, who is staring at her again.)

MIMI They say I have the best ass below 14th Street / Is it true?
ROGER What?
MIMI You're staring again
ROGER Oh no / I mean you do – have a nice – / I mean – you look familiar
MIMI Like your dead girlfriend?
ROGER Only when you smile / But I'm sure I've seen you somewhere else –

MIMI Do you go to the Cat Scratch Club / That's where I work – I dance – help me look
ROGER Yes! / They used to tie you up –
MIMI It's a living

(MIMI douses the flame again.)

ROGER I didn't recognize you / Without the handcuffs
MIMI We could light the candle / Oh won't you light the candle?

(ROGER lights it again.)

ROGER Why don't you forget that stuff / You look like you're sixteen
MIMI I'm nineteen – but I'm old for my age / I'm just born to be bad
ROGER I once was born to be bad / I used to shiver like that
MIMI I have no heat – I told you
ROGER I used to sweat
MIMI I got a cold
ROGER Uh-huh / I used to be a junkie
MIMI But now and then I like to –
ROGER Uh-huh
MIMI Feel good
ROGER Here it – um –

(ROGER stoops and picks up a small object: MIMI's stash.)

MIMI What's that?
ROGER Candy-bar wrapper

(ROGER puts it behind his back and into his pocket.)

MIMI We could light the candle

(ROGER discreetly blows out the candle.)

MIMI What'd you do with my candle?
ROGER That was my last match
MIMI Our eyes'll adjust. Thank God for the moon
ROGER Maybe it's not the moon at all / I hear Spike Lee's shooting down the street
MIMI Bah humbug... bah humbug

(MIMI places her hand under his, pretending to do it by mistake.)

ROGER Cold hands
MIMI Yours too / Big. Like my father's / You wanna dance?
ROGER With you?
MIMI No – with my father
ROGER I'm Roger
MIMI They call me / They call me Mimi

(They come extremely close to a kiss. MIMI reaches into his pocket, nabs the stash and makes a sexy exit.)

9. *Voice Mail #2*

(JOANNE's loft. In blackout another phone rings. We see MAUREEN in silhouette.)

MAUREEN *Hi. You've reached Maureen and Joanne. Leave a message and don't forget* Over the Moon *– my performance, protesting the eviction of the homeless (and artists) from the 11th Street lot. Tonight at midnight in the lot between A and B. Party at Life Cafe to follow.* / (Beeep!)

MR. JEFFERSON Well, Joanne – we're off / I tried you at the office / And they said you're stage-managing or something

MRS. JEFFERSON Remind her that those unwed mothers in Harlem / Need her legal help, too

MR. JEFFERSON Call Daisy for our itinerary or Alfred at Pound Ridge / Or Eileen at the State Department in a pinch / We'll be at the spa for New Year's / Unless the Senator changes his mind

MRS. JEFFERSON The hearings

MR. JEFFERSON Oh yes – kitten / Mummy's confirmation hearing begins on the tenth / We'll need you – alone – by the sixth

MRS. JEFFERSON Harold!

MR. JEFFERSON You hear that? / It's three weeks away / And she's already nervous

MRS. JEFFERSON I am not!

MR. JEFFERSON For Mummy's sake, kitten / No Doc Martens this time, and wear a dress... / Oh, and kitten – have a merry

MRS. JEFFERSON And a bra!

10. *Today 4 U*

(MARK & ROGER's loft.)

MARK *Enter Tom Collins, computer genius, teacher, vagabond anarchist who ran naked through the Parthenon.*

(COLLINS carries ANGEL's pickle tub, now filled with provisions.)

MARK & COLLINS Bustelo – Marlboro / Banana by the bunch / A box of Captain Crunch will taste so good

COLLINS And firewood

MARK Look – it's Santa Claus

COLLINS Hold your applause

ROGER Oh hi

COLLINS "Oh hi" after seven months?

ROGER Sorry

COLLINS This boy could use some Stoli

COLLINS, MARK & ROGER Oh holy night

ROGER You struck gold at MIT?

COLLINS They expelled me for my theory of actual reality / Which I'll soon impart / To the couch potatoes at New York University / Still haven't left the house?

ROGER I was waiting for you don't you know?

COLLINS Well, tonight's the night / Come to the Life Cafe after Maureen's show

MARK & ROGER No flow

COLLINS Gentlemen, our benefactor on this Christmas Eve / Whose charity is only matched by talent, I believe / A new member of the Alphabet City avant-garde / Angel Dumott Schunard!

(ANGEL sashays in. HE's gorgeously done up in Santa drag, with a fan of twenty-dollar bills in each hand.)

ANGEL Today for you – tomorrow for me / Today for you – tomorrow for me

COLLINS And you should hear her beat!

MARK You earned this on the street?

ANGEL It was my lucky day today on Avenue A / When a lady in a limousine drove my way / She said, "Dahling'– be a dear – haven't slept in a year / I need your help to make my neighbor's yappy dog disappear / This Akita – Evita – just won't shut up / I believe if you play nonstop that pup / Will breathe its very last high-strung breath / I'm certain that cur will bark itself to death" / Today for you – tomorrow for me / Today for you – tomorrow for me / We agreed on a fee – a thousand-dollar guarantee / Tax-free – and a bonus if I trim her tree / Now who could foretell that it would go so well / But sure as I am here that dog is now in doggy hell / After an hour – Evita – in all her glory / On the window ledge of that 23rd story / Like Thelma & Louise did when they got the blues / Swan-dove into the courtyard of the Gracie Mews / Today for you – tomorrow for me / Today for you – tomorrow for me

(ANGEL does a fabulous drum and dance solo.)

Then back to the street where I met my sweet / Where he was moaning and groaning on the cold concrete / The nurse took him home for some Mercurochrome / And I dressed his wounds and got him back on his feet / Sing it / Today for you – tomorrow for me / Today for you – tomorrow for me / Today for you – tomorrow for me / Today for you – tomorrow for me

11. *You'll See*

(BENNY enters.)

BENNY Joy to the world – hey, you bum – yeah, you, move over / Get your ass off that Range Rover

MARK *That attitude toward the homeless is exactly what Maureen is protesting tonight* (to audience, holding camera up to BENNY) *Close-up: Benjamin Coffin the third, our ex-roommate, who married Alison Grey, of the Westport Greys, then bought the building and the lot next door from his father-in-law in hopes of starting a cyberstudio.*

BENNY Maureen is protesting / Losing her performance space / Not my attitude

ROGER What happened to Benny / What happened to his heart / And the ideals he once pursued

BENNY The owner of that lot next door / Has the right to do with it as he pleases

COLLINS Happy birthday, Jesus!

BENNY The rent

MARK You're wasting your time

ROGER We're broke

MARK And you broke your word – this is absurd

BENNY There is one way you won't have to pay

ROGER I knew it!

BENNY Next door, the home of Cyberarts, you see / And now that the block is re-zoned / Our dream can become a reality / You'll see boys / You'll see boys / A state-of-the-art, digital, virtual interactive studio / I'll forego your rent and on paper guarantee / That you can stay here for free / If you do me one small favor

MARK What?

BENNY Convince Maureen to cancel her protest

MARK Why not just get an injunction and call the cops?

BENNY I did, and they're on standby / But my investors would rather / I handle this quietly

ROGER You can't quietly wipe out an entire tent city / Then watch "It's a Wonderful Life" on TV!

BENNY You want to produce films and write songs? / You need somewhere to do it / It's what we used to dream about / Think twice before you pooh-pooh it / You'll see boys / You'll see boys / You'll see – the beauty of a studio / That lets us do our work and get paid / With condos on the top / Whose rent keeps open our shop / Just stop her protest / And you'll have it made / You'll see – or you'll pack

(BENNY exits.)

ANGEL That boy could use some Prozac

ROGER Or heavy drugs

MARK Or group hugs

COLLINS Which reminds me – / We have a detour to make tonight / Anyone who wants to can come along

ANGEL Life Support's a group for people coping with life / We don't have to stay too long

MARK First I've got a protest to save

ANGEL Roger?

ROGER I'm not much company, you'll find

MARK Behave!

ANGEL He'll catch up later – He's got other things on his mind / You'll see boys

MARK & COLLINS We'll see boys

ROGER Let it be boys

COLLINS I like boys

ANGEL Boys like me

ALL We'll see

(The lot. JOANNE is reexamining the cable connections for the umpteenth time.)

MARK And so – into the abyss / The lot. Where a small stage is partially set up
JOANNE "Line in"... / I went to Harvard for this...
MARK Close on Mark's nosedive
JOANNE "Line out..."
MARK Will he get out of here alive...?

(JOANNE notices MARK approaching.)

JOANNE Mark?
MARK Hi
JOANNE I told her not to call you
MARK That's Maureen / But can I help since I'm here
JOANNE I hired an engineer...
MARK Great! / So, nice to have met you
JOANNE Wait! / She's three hours late / The samples won't delay / But the cable –
MARK There's another way / Say something – anything
JOANNE (into the mike) Test – one, two, three...
MARK Anything but that
JOANNE This is weird
MARK It's weird
JOANNE Very weird
MARK Fuckin' weird
JOANNE I'm so mad / That I don't know what to do / Fighting with microphones / Freezing down to my bones / And to top it all off / I'm with you
MARK Feel like going insane? / Got a fire in your brain? / And you're thinking of drinking gasoline?
JOANNE As a matter of fact –
MARK Honey, I know this act / It's called the Tango Maureen / The Tango Maureen / It's a dark, dizzy / Merry-go-round / As she keeps you dangling
JOANNE You're wrong
MARK Your heart she is mangling
JOANNE It's different with me
MARK And you toss and you turn / 'Cause her cold eyes can burn / Yet you yearn and you churn and rebound
JOANNE I think I know what you mean
BOTH The Tango Maureen
MARK Has she ever / Pouted her lips / And called you "Pookie"?
JOANNE Never
MARK Have you ever doubted a kiss or two?
JOANNE This is spooky / Did you swoon / When she walked through the door?
MARK Every time – so be cautious
JOANNE Did she moon over other boys – ?
MARK More than moon –
JOANNE I'm getting nauseous

(They begin to dance, with MARK leading.)

MARK *Where'd you learn to tango?*
JOANNE *With the French Ambassador's daughter in her dorm room at Miss Porter's. And you?*
MARK *With Nanette Himmelfarb, the rabbi's daughter, at the Scarsdale Jewish Community Center.*

(They switch, and JOANNE leads.)

MARK *It's hard to do this backward.*
JOANNE *You should try it in heels!* / She cheated!
MARK She cheated
JOANNE Maureen cheated
MARK Fuckin' cheated
JOANNE I'm defeated / I should give up right now
MARK Gotta look on the bright side / With all your might
JOANNE I'd fall for her still anyhow
BOTH When you're dancing her dance / You don't stand a chance / Her grip of romance / Makes you fall
MARK So you think, "Might as well"
JOANNE "Dance a tango to hell"
BOTH "At least I'll have tangoed at all" / The Tango Maureen / Gotta dance 'til your diva is through / You pretend to believe her / 'Cause in the end – you can't leave her / But the end it will come / Still you have to play dumb / 'Til you're glum and you bum / And turn blue
MARK Why do we love when she's mean?
JOANNE And she can be so obscene
MARK Try the mike
JOANNE (the word echoes in digital-delay land) My Maureen (reverb: Een, Een, Een...)
MARK Patched
JOANNE Thanks
MARK You know – I feel great now!
JOANNE I feel lousy

(The pay phone rings. MARK hands it to JOANNE.)

JOANNE Hi, honey, we're... / Pookie? / You never called me Pookie / Forget it / We're patched

(SHE hangs up, looks at MARK.)

BOTH
The Tango Maureen!

a tango to hell

13. *Life Support*

(ANGEL & COLLINS attend an AIDS Life Support group. PAUL, the support leader, sits on the downstage railing above. GORDON, one of the members of the group, is standing downstage left, facing the audience. As the members enter, they introduce themselves and form a semicircle. Note: The names of the support group members should change every night and should honor actual friends of the company who have died of AIDS.)

STEVE *Steve.*
GORDON *Gordon.*
ALI *Ali.*
PAM *Pam.*
SUE *Sue.*
ANGEL *Hi, I'm Angel.*
COLLINS *Tom. Collins.*
PAUL *I'm Paul. Let's begin.*
ALL There's only us / There's only this...

(MARK blusters in noisily.)

MARK Sorry...excuse me...oops
PAUL And you are?
MARK Oh – I'm not – / I'm just here to – / I don't have – / I'm here with – / Um – Mark / Mark – *I'm Mark* /Well – this is quite an operation
PAUL Sit down Mark / We'll continue the affirmation
ALL Forget regret, or life is yours to miss
GORDON Excuse me Paul – I'm having a problem with this / This credo – / My T-cells are low – / I regret that news, okay?
PAUL All right / But Gordon – how do you feel today?
GORDON What do you mean?
PAUL How do you feel today?
GORDON Okay
PAUL Is that all?
GORDON Best I've felt all year
PAUL Then why choose fear?
GORDON I'm a New Yorker! / Fear's my life! / Look – I find some of what you teach suspect / Because I'm used to relying on intellect / But I try to open up to what I don't know
GORDON & ROGER (who sings from his loft) Because reason says I should have died three years ago
ALL No other road / No other way / No day but today

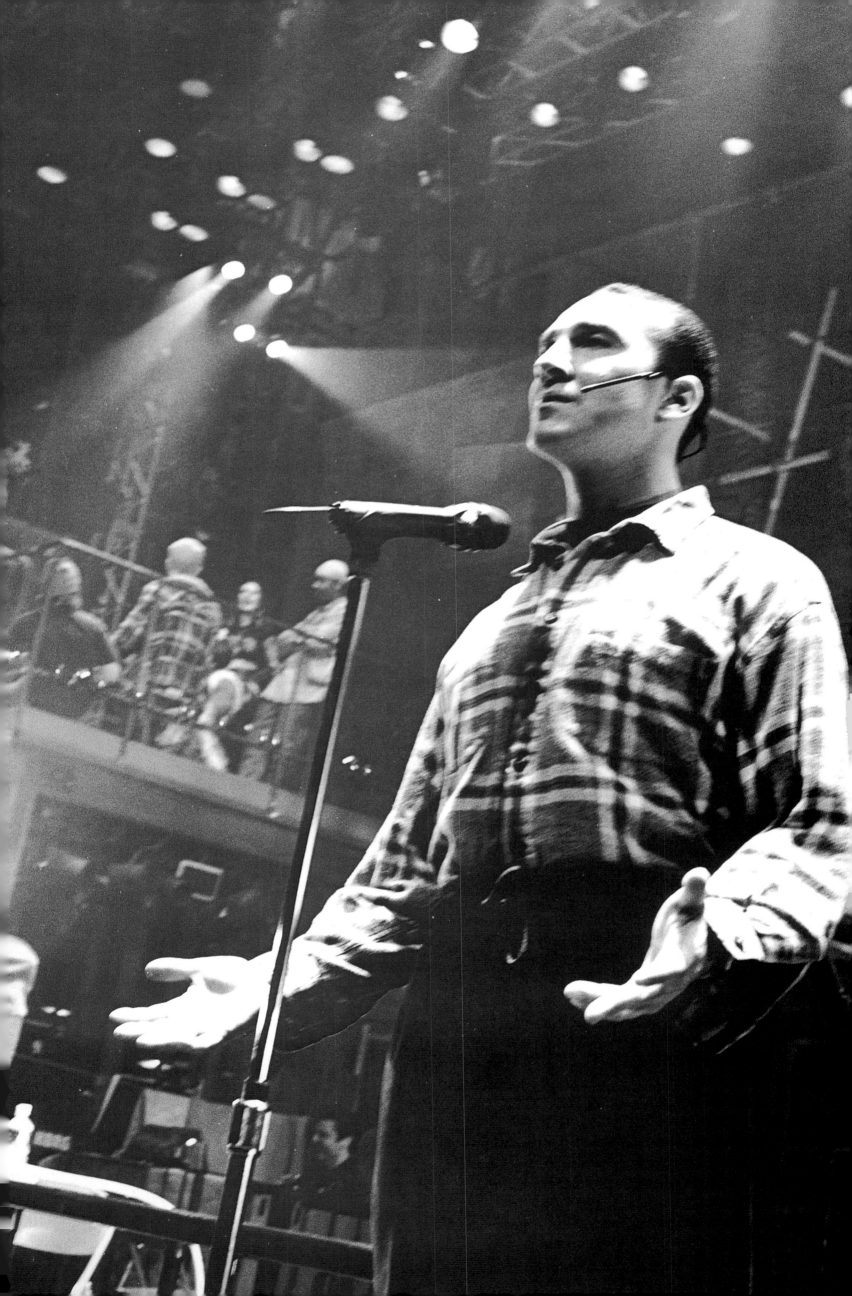

14. *Out Tonight* | (MIMI's apartment.)

MIMI What's the time? / Well it's gotta be close to midnight / My body's talking to me / It says, "Time for danger" / It says, "I wanna commit a crime / Wanna be the cause of a fight / Wanna put on a tight skirt and flirt with a stranger" / I've had a knack from way back / At breaking the rules once I learn the games / Get up – life's too quick / I know someplace sick / Where this chick'll dance in the flames / We don't need any money / I always get in for free / You can get in too / If you get in with me / Let's go out tonight / I have to go out tonight / You wanna play? / Let's run away / We won't be back / Before it's Christmas Day / Take me out tonight (Meow) / When I get a wink from the doorman / Do you know how lucky you'll be? / That you're on line with the feline of Avenue B / Let's go out tonight / I have to go out tonight / You wanna prowl / Be my night owl? / Well take my hand we're gonna howl / Out tonight / In the evening I've got to roam / Can't sleep in the city of neon and chrome / Feels too damn much like home / When the Spanish babies cry / So let's find a bar / So dark we forget who we are / And all the scars from the / Nevers and maybes die / Let's go out tonight / Have to go out tonight / You're sweet / Wanna hit the street? / Wanna wail at the moon like a cat in heat? / Just take me out tonight

(MIMI makes her way to ROGER's door and ends the song in front of him.)

Please take me out tonight / Don't forsake me – out tonight / I'll let you make me – out tonight / Tonight – tonight – tonight

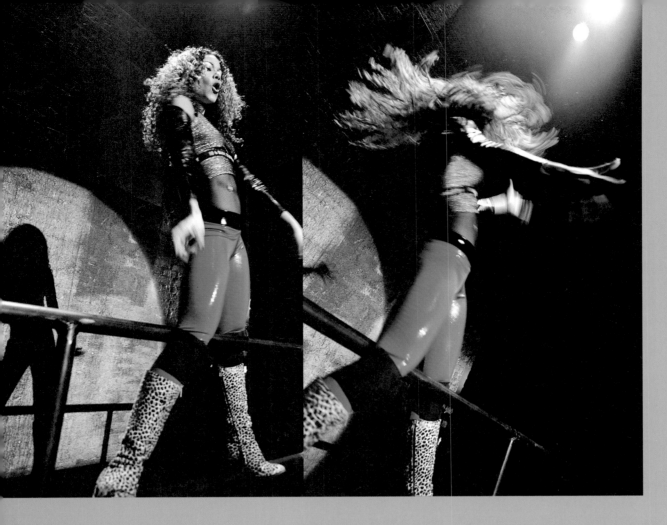

15. Another Day

(The loft. MIMI plants a huge kiss on ROGER, who recoils.)

(Lights slowly fade up on the Life Support group.)

ROGER Who do you think you are? / Barging in on me and my guitar / Little girl – hey / The door is that way / You better go, you know / The fire's out anyway / Take your powder – take your candle / Your sweet whisper / I just can't handle / Well take your hair in the moonlight / Your brown eyes – goodbye, goodnight / I should tell you, I should tell you / I should tell you, I should – No! / Another time – another place / Our temperature would climb / There'd be a long embrace / We'd do another dance / It'd be another play / Looking for romance? / Come back another day / Another day

MIMI The heart may freeze or it can burn / The pain will ease if I can learn / There is no future / There is no past / I live this moment / As my last / There's only us / There's only this / Forget regret / Or life is yours to miss / No other road / No other way / No day but today

ROGER Excuse me if I'm off track / But if you're so wise / Then tell me – why do you need smack? / Take your needle / Take your fancy prayer / And don't forget / Get the moonlight out of your hair / Long ago – you might've lit up my heart / But the fire's dead – ain't never gonna start / Another time – another place / The words would only rhyme / We'd be in outer space / It'd be another song / We'd sing another way / You wanna prove me wrong? / Come back another day / Another day

MIMI There's only yes / Only tonight / We must let go / To know what's right / No other course / No other way / No day but today

MIMI & OTHERS
I can't control
My destiny
I trust my soul
My only goal
Is just – to be

ALL
There's only now
There's only here
Give in to love
Or live in fear
No other path
No other way
No day but today

No day but today

No day but today

No day but today

No day but today

No day but today

ROGER
Control your temper
She doesn't see
Who says that
there's a soul?

Just let me be

Who do you think
you are?

Barging in on me
and my guitar
Little girl, hey
The door is that way
The fire's out anyway

Take the powder
Take the candle
Take your brown eyes
Your pretty smile
Your silhouette

Another time,
another place
Another rhyme,
a warm embrace
Another dance,
another way
Another chance,
another day

(MIMI and the Life Support group members exit. One person, STEVE, remains at stage right, above.)

16. *Will I* | (Various locations.)

ROGER I'm writing one great song before I...
STEVE Will I lose my dignity / Will someone care / Will I wake tomorrow / From this nightmare?
GROUP #1 Will I lose my dignity / Will someone care / Will I wake tomorrow / From this nightmare?
GROUP #2 Will I lose my dignity / Will someone care / Will I wake tomorrow / From this nightmare?
GROUP #3 Will I lose my dignity / Will someone care / Will I wake tomorrow / From this nightmare?
GROUP #4 Will I lose my dignity / Will someone care / Will I wake tomorrow / From this nightmare?

(ROGER puts on his jacket and exits the loft.)

17. X-Mo Bells #2/Bummer

(On the Street.)

THREE HOMELESS PEOPLE Christmas bells are ringing / Christmas bells are ringing / Christmas bells are ringing – / Out of town / Santa Fe

SQUEEGEEMAN Honest living, man!

(SQUEEGEEMAN recoils as though he's almost been run over by a car.)

Feliz Navidad!

(Three POLICE OFFICERS, in full riot gear, enter and approach sleeping BLANKET PERSON. The FIRST OFFICER pokes her with a nightstick.)

HOMELESS PERSON Evening, officers

(Without answering, the FIRST OFFICER raises his nightstick again.)

MARK (pointing his camera) Smile for Ted Koppel, Officer Martin!

(The FIRST OFFICER lowers his stick.)

HOMELESS PERSON And a Merry Christmas to your family
POLICE OFFICERS Right!

(The POLICE OFFICERS stride offstage. MARK continues to film BLANKET PERSON.)

BLANKET PERSON (to MARK) Who the fuck do you think you are? / I don't need no goddamn help / From some bleeding heart cameraman / My life's not for you to / Make a name for yourself on!
ANGEL Easy sugar, easy / He was just trying to –
BLANKET PERSON Just trying to use me to kill his guilt / It's not that kind of movie, honey / Let's go – this lot is full of / Motherfucking artists / Hey artist / Gotta dollar? / I thought not

(BLANKET PERSON crosses to downstage left with another HOMELESS PERSON.)

18. Santa Fe

(The Street.)

ANGEL New York City –
MARK Uh-huh
ANGEL Center of the universe
COLLINS Sing it girl –
ANGEL Times are shitty / But I'm pretty sure they can't get worse
MARK I hear you
ANGEL It's a comfort to know / When you're singing the hit-the-road blues / That anywhere else you could possibly go / After New York would be a pleasure cruise
COLLINS Now you're talking / Well, I'm thwarted by a metaphysic puzzle / And I'm sick of grading papers – that I know / And I'm shouting in my sleep, I need a muzzle / All this misery pays no salary, so / Let's open up a restaurant / In Santa Fe / Oh sunny Santa Fe would be nice / We'll open up a restaurant in Santa Fe / And leave this to the roaches and mice / Oh – oh
ALL Oh –
ANGEL You teach?
COLLINS I teach – computer-age philosophy / But my students would rather watch TV
ANGEL America
ALL America!
COLLINS You're a sensitive aesthete / Brush the sauce onto the meat / You could make the menu sparkle with rhyme / You could drum a gentle drum / I could seat guests as they come / Chatting not about Heidegger, but wine!
COLLINS (with HOMELESS PEOPLE in the shadows) Let's open up a restaurant in Santa Fe
ALL Santa Fe
COLLINS Our labors would reap financial gains
ALL Gains, gains, gains
COLLINS We'll open up a restaurant in Santa Fe
ALL Santa Fe
COLLINS And save from devastation our brains
HOMELESS PEOPLE Save our brains
COLLINS We'll pack up all our junk and fly so far away / Devote ourselves to projects that sell / We'll open up a restaurant in Santa Fe
ALL Santa Fe
COLLINS Forget this cold Bohemian hell / Oh –
ALL Oh –
COLLINS Do you know the way to Santa Fe? / You know, tumbleweeds...prairie dogs... / Yeah

sunny Santa Fe would be NICE

19. *I'll Cover You*

(The street.)

MARK *I'll meet you at the show. I'll try and convince Roger to go.*

(MARK exits)

ANGEL *Alone at last.*
COLLINS *He'll be back – I guarantee.*
ANGEL *I've been hearing violins all night.*
COLLINS *Anything to do with me? Are we a thing?*
ANGEL *Darling – we're everything.*
Live in my house / I'll be your shelter / Just pay me back / With one thousand kisses / Be my lover – I'll cover you
COLLINS Open your door / I'll be your tenant / Don't got much baggage / To lay at your feet / But sweet kisses I've got to spare / I'll be there – I'll cover you
BOTH I think they meant it / When they said you can't buy love / Now I know you can rent it / A new lease you are, my love / On life – be my life

(THEY do a short dance)

BOTH Just slip me on / I'll be your blanket / Wherever – whatever – I'll be your coat
ANGEL You'll be my king / And I'll be your your castle

COLLINS No, you'll be my queen / And I'll be your moat
BOTH I think they meant it / When they said you can't buy love / Now I know you can rent it / A new lease you are, my love / On life / All my life / I've longed to discover / Something as true as this is

COLLINS	ANGEL
So with a thousand sweet kisses I'll cover you	If you're cold and you're lonely
With a thousand sweet kisses I'll cover you	You've got one nickel only
When you're worn out and tired	With a thousand sweet kisses I'll cover you
When your heart has expired	With a thousand sweet kisses I'll cover you

BOTH Oh lover I'll cover you / Oh lover I'll cover you

20. We're Okay

(At the pay phone.)

JOANNE (on her cellular phone) Steve - Joanne / The Murget case? / A dismissal! / Good work, counselor

(The pay phone rings. JOANNE answers it and begins a conversation with MAUREEN simultaneously juggling two other calls on her cellular phone.)

We're okay / Honeybear – wait! / I'm on the other phone / Yes, I have the cowbell / We're okay / (into the cellular phone) So tell them we'll sue / But a settlement will do / Sexual harassment – and civil rights, too / Steve, you're great / (into the pay phone) No you cut the paper plate / Didja cheat on Mark a lot would you say? / We're okay / *Honey, hold on...* / (into the cellular phone) *Steve...hold on...*

(JOANNE presses the call-waiting button on the cellular phone.)

Hello? / Dad – yes / I beeped you / Maureen is coming to Mother's hearing / We're okay / (into the pay phone) Honeybear – what? / Newt's lesbian sister / I'll tell them / (into the cellular phone) You heard? / (into the pay phone) They heard / We're okay / (into the cellular phone) And to you, Dad

(JOANNE presses call-waiting as SHE speaks into the pay phone.)

Oh – Jill is there? / (into the cellular phone) Steve, gotta go – / into the pay phone) Jill with the short black hair? / The Calvin Klein model? / (into the cellular phone) Steve, gotta go! / (into the pay phone) The model who lives in penthouse A? / We're / We're okay / I'm on my way

21. *Christmas Bells*

(Various locations, St. Marks Place.)

FIVE HOMELESS PEOPLE Christmas bells are ringing / Christmas bells are ringing / Christmas bells are ringing / On TV – at Saks
SQUEEGEEMAN Honest living, honest living / Honest living, honest living / Honest living, honest living
FIVE HOMELESS PEOPLE Can't you spare a dime or two / Here but for the grace of God go you / You'll be merry / I'll be merry / Tho' merry ain't in my vocabulary / No sleighbells / No Santa Claus / No yule log / No tinsel / No holly / No hearth / No
SOLOIST Rudolph the red-nosed reindeer
ALL FIVE Rudolph the red-nosed reindeer / No room at the Holiday Inn – oh no

(A few flakes of snow descend.)

And it's beginning to snow

(The stage suddenly explodes with life! The scene is St. Marks Place on Christmas Eve – an open-air bazaar of color, noise, movement.)

VENDORS Hats, bats, shoes, booze / Mountain bikes, potpourri / Leather bags, girlie mags / Forty-fives, AZT
VENDOR #1 No one's buying / Feel like crying
ALL No room at the Holiday Inn, oh no / And it's beginning to snow

(Lights up on one woman, who is showing off a collection of stolen coats to COLLINS and ANGEL.)

VENDOR #2 How about a fur – / In perfect shape / Owned by an MBA from uptown / I got a tweed / Broken in by a greedy / Broker who went broke / And then broke down

COLLINS You don't have to do this
ANGEL Hush your mouth, it's Christmas
COLLINS I do not deserve you, Angel

COLLINS	**ANGEL**
Give – give	Wait – what's on
All you do	the floor?
Is give	Let's see some more
Give me some	
way to show	No – No – No...
How you've touched	
me so	

ANGEL
Kiss me – it's beginning to snow

(Lights focus on MARK & ROGER on right above.)

MARK ...She said, "Would you light my candle" / And she put on a pout / And she wanted you / To take her out tonight?
ROGER Right
MARK She got you out!
ROGER She was more than okay / But I pushed her away / It was bad – I got mad / And I had to get her out of my sight
MARK Wait, wait, wait – you said she was sweet
ROGER Let's go eat – I'll just get fat / It's the one vice left – when you're dead meat

(MIMI has entered looking furtively for THE MAN.)

ROGER There – that's her
MARK Maureen?
ROGER Mimi!
MARK Whoa!
ROGER I should go.
BOTH Hey – it's beginning to snow

(The POLICE OFFICERS, in riot gear, enter above.)

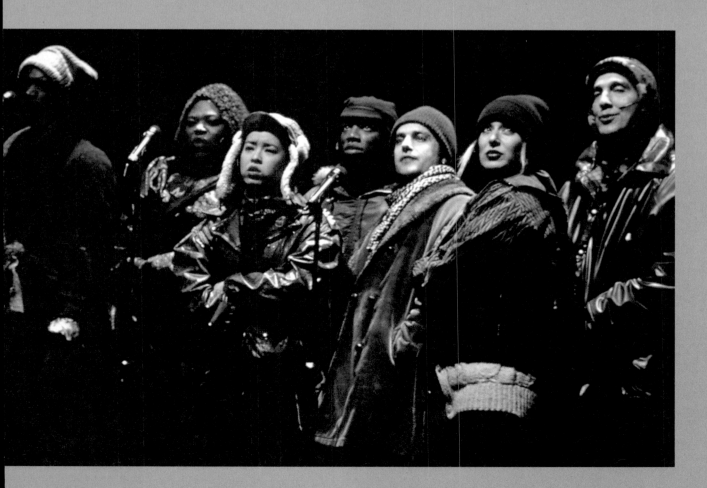

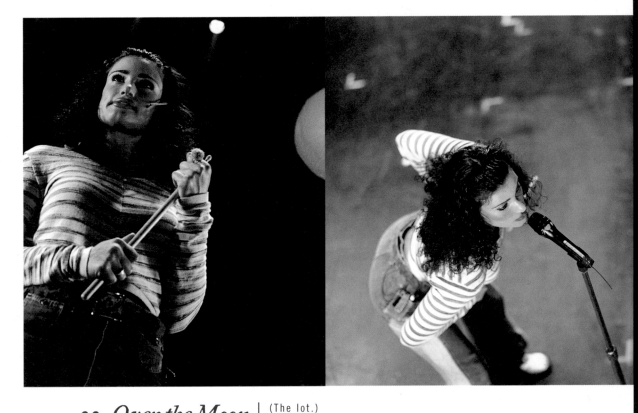

22. Over the Moon | (The lot.)

MARK *Maureen's performance.*

(MAUREEN stands in front of a micro-phone.)

MAUREEN Last night I had this dream. I found myself in a desert called Cyberland. It was hot. My canteen had sprung a leak and I was thirsty. Out of the abyss walked a cow – Elsie. I asked if she had anything to drink. She said, "I'm forbidden to produce milk. In Cyberland, we only drink Diet Coke." (reverb: Coke, Coke, Coke)
She said, "Only thing to do is jump over the moon. They've closed everything real down...like barns, troughs, performance spaces...and replaced it all with lies and rules and virtual life. (reverb: Life, Life, Life) But there is a way out..."
BACKUPS Leap of faith leap of faith / Leap of faith leap of faith
MAUREEN Only thing to do is jump over the moon / I gotta get out here! It's like I'm being tied to the hood of a yellow rental truck, packed in with fertilizer and fuel oil, pushed over a cliff by a suicidal Mickey Mouse! – I've gotta find a way

MAUREEN	**BACKUPS**
To jump over	
the moon	Leap of faith, etc.
Only thing to do is	
Jump over the moon	

MAUREEN Then a little bulldog entered. His name (we have learned) was Benny. And although he once had principles, he abandoned them to live as a lapdog to a wealthy daughter of the revolution. "That's bull," he said. "Ever since the cat took up the fiddle, that cow's been jumpy. And the dish and spoon were evicted from the table – and eloped... She's had trouble with that milk and the moon ever since. Maybe it's a female thing, 'cause who'd want to leave Cyberland anyway? ...Walls ain't so bad. The dish and spoon for instance. They were down on their luck – knocked on my

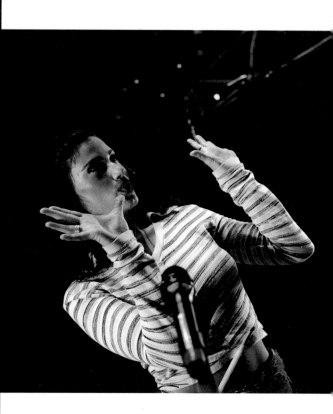

doghouse door. I said, 'Not in my backyard, utensils! Go back to China! The only way out – is up.'" Elsie whispered to me, "A leap of faith. Still thirsty?" she asked. Parched. . "Have some milk." I lowered myself beneath her swollen udder and sucked the sweetest milk I'd ever tasted.

(MAUREEN makes a slurping, sucking sound.)

"Climb on board," she said. And as a harvest moon rose over Cyberland, we reared back and sprang into a gallop. Leaping out of orbit!

MAUREEN	BACKUPS
I awoke singing	Leap of faith, etc.
Only thing to do	
Only thing to do is	
jump	
Only thing to do is	
jump over the moon	
Only thing to do is	
jump over the moon	
Over the moon – over the	
Moooooooo	
Moooooooo	
Moooooooo	
Moo with me	

(MAUREEN encourages the audience to moo with her. SHE says "C'mon, sir, moo with me," etc. The audience responds. When the "moos" reach a crescendo, she cuts them off with a big sweep of her arms.)

Thank you.

(Blackout)

mooooo

23. La Vie Bohème

(Life Cafe. Downstage right, the PRINCIPALS have lined up and are waiting to be seated. A large table is situated down center. Down and to the right, BENNY & MR. GREY are seated at a smaller table. The RESTAURANT MAN tries to shoo our friends out.)

RESTAURANT MAN No, please, no / Not tonight, please, no / Mister – can't you go – / Not tonight – can't have a scene
ROGER What?
RESTAURANT MAN Go, please go – / You – hello, sir – / I said no / Important customer
MARK What am I – just a blur?
RESTAURANT MAN You sit all night – you never buy!
MARK That's a lie – that's a lie / I had a tea the other day
RESTAURANT MAN You couldn't pay
MARK Oh yeah
COLLINS Benjamin Coffin the third – here?
RESTAURANT MAN Oh no!
ALL Wine and beer!
MAUREEN The enemy of Avenue A / We'll stay

(THEY sit.)

RESTAURANT MAN Oy vey!
COLLINS What brings the mogul in his own mind to the Life Cafe?
BENNY I would like to propose a toast / To Maureen's noble try / It went well
MAUREEN Go to Hell
BENNY Was the yuppie scum stomped / Not counting the homeless / How many tickets weren't comped
ROGER Why did Muffy –
BENNY Alison
ROGER Miss the show?
BENNY There was a death in the family / If you must know
ANGEL Who died?
BENNY Our Akita

BENNY, MARK, ANGEL & COLLINS
Evita
BENNY Mimi – I'm surprised / A bright and charming girl like you / Hangs out with these slackers / (Who don't adhere to deals) / They make fun – Yet I'm the one / Attempting to do some good / Or do you really want a neighborhood / Where people piss on your stoop every night? / Bohemia, Bohemia's / A fallacy in your head / This is Calcutta / Bohemia's dead

(The BOHEMIANS immediately begin to enact a mock funeral, with MARK delivering "the eulogy.")

MARK Dearly beloved, we gather here to say our goodbyes
COLLINS & ROGER Dies irae – Dies illa / Kyrie eleison / Yitgadal V'Yitkadash, etc.
MARK Here she lies / No one knew her worth / The late great daughter of Mother Earth / On this night when we celebrate the birth / In that little town of Bethlehem / We raise our glass – you bet your ass to – (MAUREEN flashes hers) / La Vie Bohème
ALL La Vie Bohème / La Vie Bohème / La Vie Bohème / La Vie Bohème
MARK To days of inspiration, / Playing hooky, making something / Out of nothing, the need / To express – / To communicate, / To going against the grain, / Going insane, / Going mad / To loving tension, no pension, / To more than one dimension, / To starving for attention, / Hating convention, hating pretension, / Not to mention of course, / Hating dear old Mom and Dad / To riding your bike, / Midday past the three-piece suits – / To fruits – to no absolutes – / To Absolut – to choice – / To the *Village Voice* – / To any passing fad / To being an us – for once – / Instead of a them –
ALL La Vie Bohème / La Vie Bohème

(JOANNE enters.)

HATING CONVENTION, HATING PRETENSION

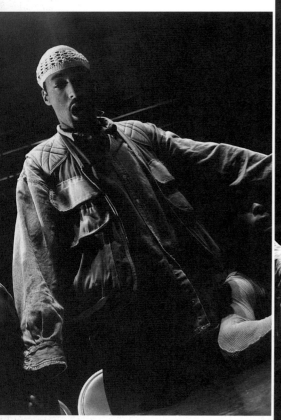

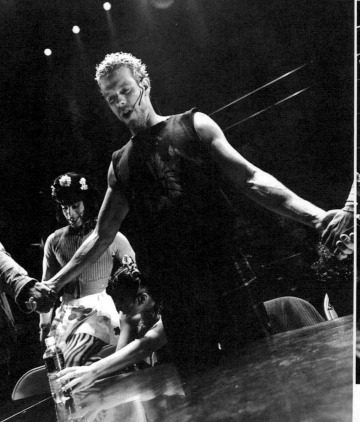

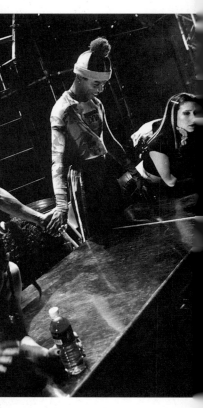

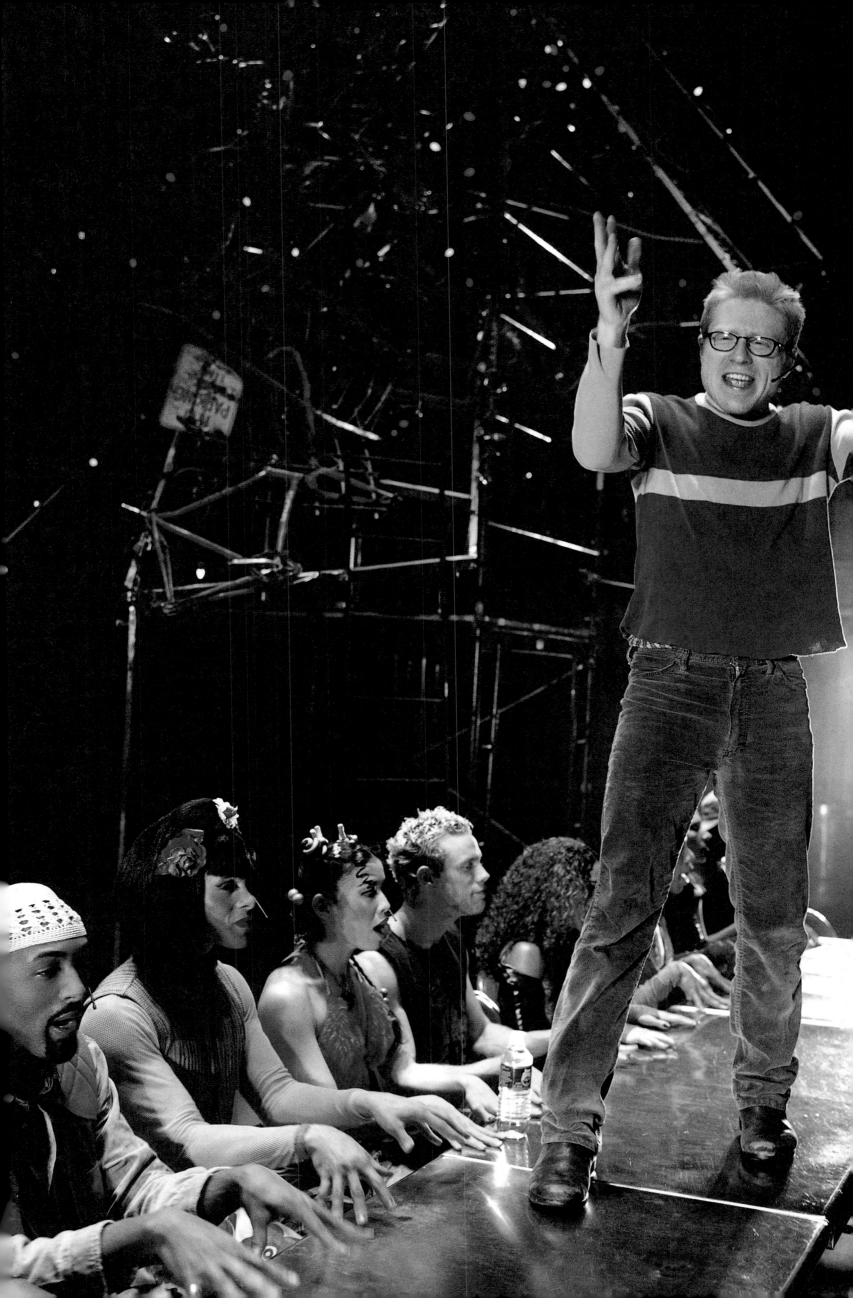

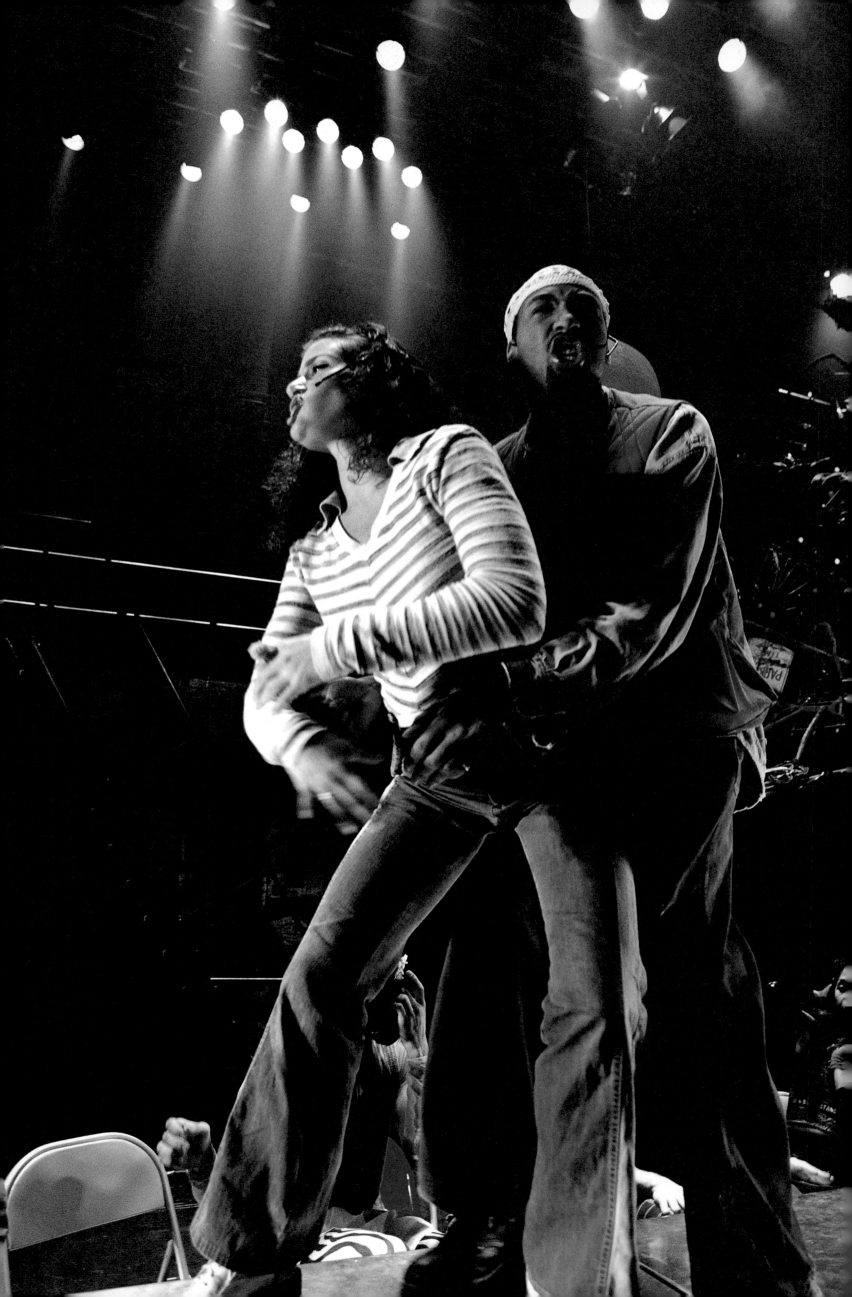

MAUREEN Is the equipment in a pyramid?
JOANNE It is, Maureen
MAUREEN The mixer doesn't have a case /
Don't give me that face

(MAUREEN smacks JOANNE's ass as she exits. MR. GREY reacts.)

MR. GREY Ahhemm!
MAUREEN Hey mister – she's my sister
RESTAURANT MAN So that's five miso soup, four seaweed salad / Three soy burger dinner, two tofu dog platter / And one pasta with meatless balls
A BOY Ugh
COLLINS It tastes the same
MIMI If you close your eyes
RESTAURANT MAN And thirteen orders of fries / Is that it here?
ALL Wine and beer!
MIMI & ANGEL To handcrafted beers made in local breweries / To yoga, to yogurt, to rice and beans and cheese / To leather, to dildos, to curry vindaloo / To huevos rancheros and Maya Angelou
MAUREEN & COLLINS Emotion, devotion, to causing a commotion / Creation, vacation
MARK Mucho masturbation
MAUREEN & COLLINS Compassion, to fashion, to passion when it's new
COLLINS To Sontag
ANGEL To Sondheim
FOUR PEOPLE To anything taboo
COLLINS & ROGER Ginsberg, Dylan, Cunningham and Cage
COLLINS Lenny Bruce
ROGER Langston Hughes
MAUREEN To the stage
PERSON #1 To Uta
PERSON #2 To Buddha
PERSON #3 Pablo Neruda, too
MARK & MIMI Why Dorothy and Toto went over the rainbow / To blow off Auntie Em
ALL La Vie Bohème

(JOANNE returns.)

MAUREEN And wipe the speakers off before you pack
JOANNE Yes, Maureen
MAUREEN Well – hurry back

(MAUREEN & JOANNE kiss.)

MR. GREY Sisters?
MAUREEN We're close

(ANGEL jumps on top of COLLINS, who's on the table. They kiss.)

ANGEL, COLLINS, MAUREEN, MARK & MR. GREY Brothers!
MARK, ANGEL, MIMI & THREE OTHERS Bisexuals, trisexuals, homo sapiens / Carcinogens, hallucinogens, men, Pee-wee Herman / German wine, turpentine, Gertrude Stein / Antonioni, Bertolucci, Kurosawa / "Carmina Burana"
ALL To apathy, to entropy, to empathy, ecstasy / Vaclav Havel – The Sex Pistols, 8BC, / To no shame – never playing the fame game
COLLINS To marijuana
ALL To sodomy / It's between God and me / To S & M

(Mr. GREY walks out.)

BENNY Waiter...waiter...waiter
ALL La Vie Bohème
COLLINS In honor of the death of Bohemia, an impromptu salon will commence immediately following dinner... Mimi Marquez, clad only in bubble wrap, will perform her famous lawn-chair-handcuff dance to the sounds of iced tea being stirred
ROGER Mark Cohen will preview his new documentary about his inability to hold an erection on the high holy days

(ROGER picks up an electric guitar and starts to tune it.)

MARK And Maureen Johnson, back from her spectacular one-night engagement at the 11th Street lot, will sing Native American tribal chants backward through her vocoder, while accompanying herself on the electric cello – which she has never studied.

(At this point, JOANNE has entered and seen MAUREEN playfully kiss MARK. JOANNE exits. BENNY pulls MIMI aside.)

BENNY Your new boyfriend doesn't know about us?
MIMI There's nothing to know
BENNY Don't you think that we could discuss –
MIMI It was three months ago
BENNY He doesn't act like he's with you
MIMI We're taking it slow
BENNY Where is he now?
MIMI He's right – Hmm
BENNY Uh-huh
MIMI Where'd he go?
MARK Roger will attempt to write a bittersweet, evocative song

(Roger picks up a guitar and plays Musetta's theme.)

MARK That doesn't remind us of "Musetta's Waltz"
COLLINS Angel Dumott Schunard will model the latest fall fashions from Paris while accompanying herself on the ten gallon plastic pickle-tub
ANGEL And Collins will recount his exploits as an anarchist – including the tale of his successful programming of the MIT virtual-reality equipment to self-destruct as it broadcast the words
ALL "Actual reality – act up – fight AIDS"
BENNY Check!

(BENNY exits. Lights on MIMI and ROGER.)

MIMI Excuse me – did I do something wrong? / I get invited – then ignored – all night long
ROGER I've been trying – I'm not lying / No one's perfect – I've got baggage
MIMI Life's too short – babe – time is flying / I'm looking for baggage that goes with mine
ROGER I should tell you –
MIMI I've got baggage too
ROGER I should tell you
BOTH Baggage – wine –

OTHERS And beer!

(Several beepers sound. Each turns off his or her beeper.)

MIMI AZT break

(MIMI, ROGER, ANGEL & COLLINS take pills.)

ROGER You?
MIMI Me. You?
ROGER Mimi

(They hold hands and stare into each other's eyes lovingly. The rest of the COMPANY freezes.)

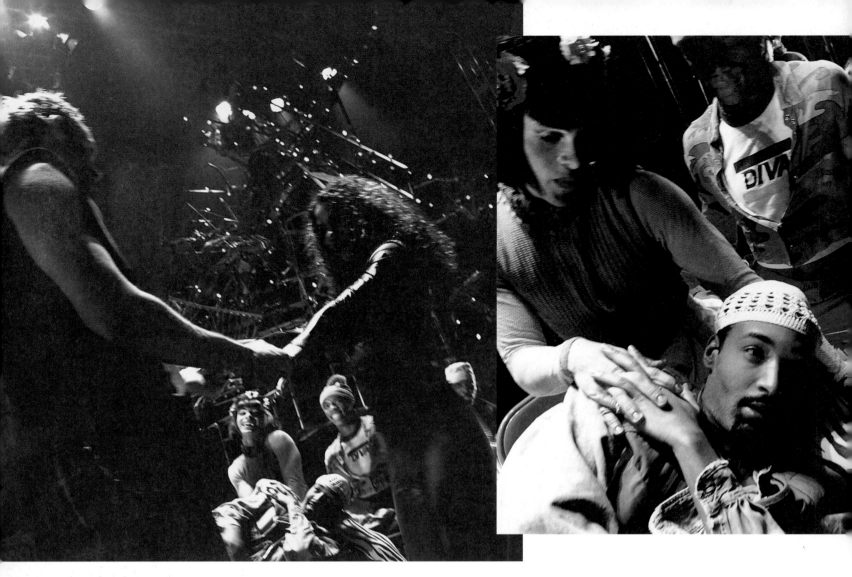

24. *I Should Tell You*

ROGER I should tell you I'm disaster / I forget how to begin it

MIMI Let's just make this part go faster / I have yet – to be in it / I should tell you

ROGER I should tell you

MIMI I should tell you

ROGER I should tell you

MIMI I should tell you I blew the candle out / Just to get back in

ROGER I'd forgotten how to smile / Until your candle burned my skin

MIMI I should tell you

ROGER I should tell you

MIMI I should tell you

BOTH I should tell / Well, here we go / Now we –

MIMI Oh no

ROGER I know – this something is / Here goes –

MIMI Here goes

ROGER Guess so / It's starting to / Who knows –

MIMI Who knows

BOTH Who knows where / Who goes there / Who knows / Here goes / Trusting desire – starting to learn / Walking through fire without a burn / Clinging – a shoulder, a leap begins / Stinging and older, asleep on pins / So here we go / Now we –

ROGER Oh no

MIMI I know

ROGER Oh no

BOTH Who knows where – who goes there / Here goes – here goes / Here goes here goes / Here goes – here goes

VIVA LA VI

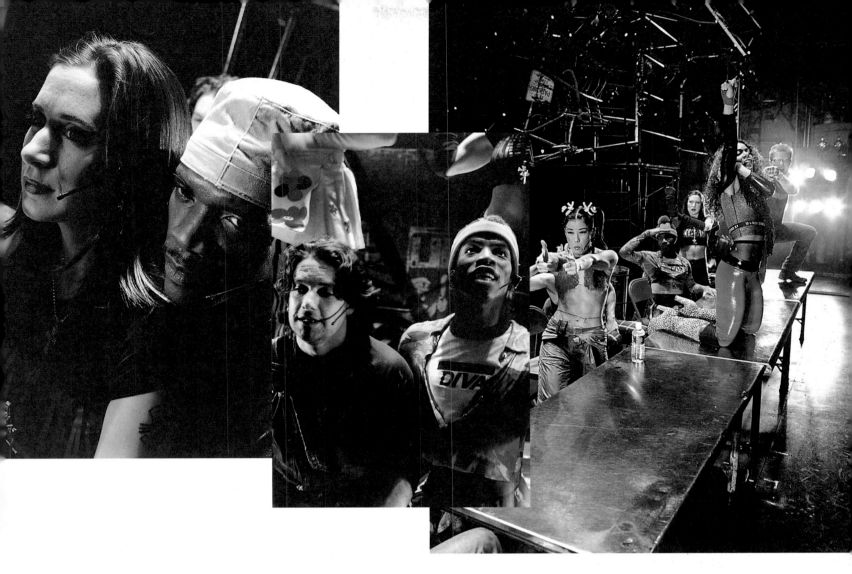

25. La Vie Bohème B

(ROGER and MIMI exit. JOANNE reenters, obviously steamed.)

MAUREEN Are we packed?
JOANNE Yes and by next week / I want you to be
MAUREEN Pookie?
JOANNE And you should see / They've padlocked your building / And they're rioting on Avenue B / Benny called the cops
MAUREEN That fuck
JOANNE They don't know what they're doing / The cops are sweeping the lot / But no one's leaving / They're sitting there, mooing!
ALL Yea!!!

(Pandemonium erupts in the restaurant.)

ALL To dance!
A GIRL No way to make a living, masochism, pain, perfection, / Muscle spasms, chiropractors, short careers, eating disorders
ALL Film
MARK Adventure, tedium, no family, boring locations, / Darkrooms, perfect faces, egos, money, Hollywood and sleaze
ALL Music
ANGEL Food of love, emotion, mathematics, isolation, rhythm, / Power, feeling, harmony, and heavy competition
ALL Anarchy
COLLINS & MAUREEN Revolution, justice, screaming for solutions, / Forcing changes, risk and danger, making noise and making pleas
ALL To faggots, lezzies, dykes, cross-dressers too

MAUREEN To me
MARK To me
COLLINS & ANGEL To me
ALL To you, and you and you, you and you / To people living with, living with, living with / Not dying from disease / Let he among us without sin / Be the first to condemn / La Vie Bohème / La Vie Bohème / La Vie Bohème

MARK	**ALL**
Anyone out of the mainstream	La Vie Bohème
Is anyone in the mainstream?	La Vie Bohème
Anyone alive – with a sex drive	La Vie Bohème
Tear down the wall	
Aren't we all	
The opposite of war	
isn't peace...	
It's creation	

ALL
La Vie Bohème
MARK *The riot continues. The Christmas tree goes up in flames. The snow dances. Oblivious, Mimi and Roger. Share a small, lovely kiss.*
ALL Viva la Vie Bohème

End of Act One

LA VIE BOHÈME

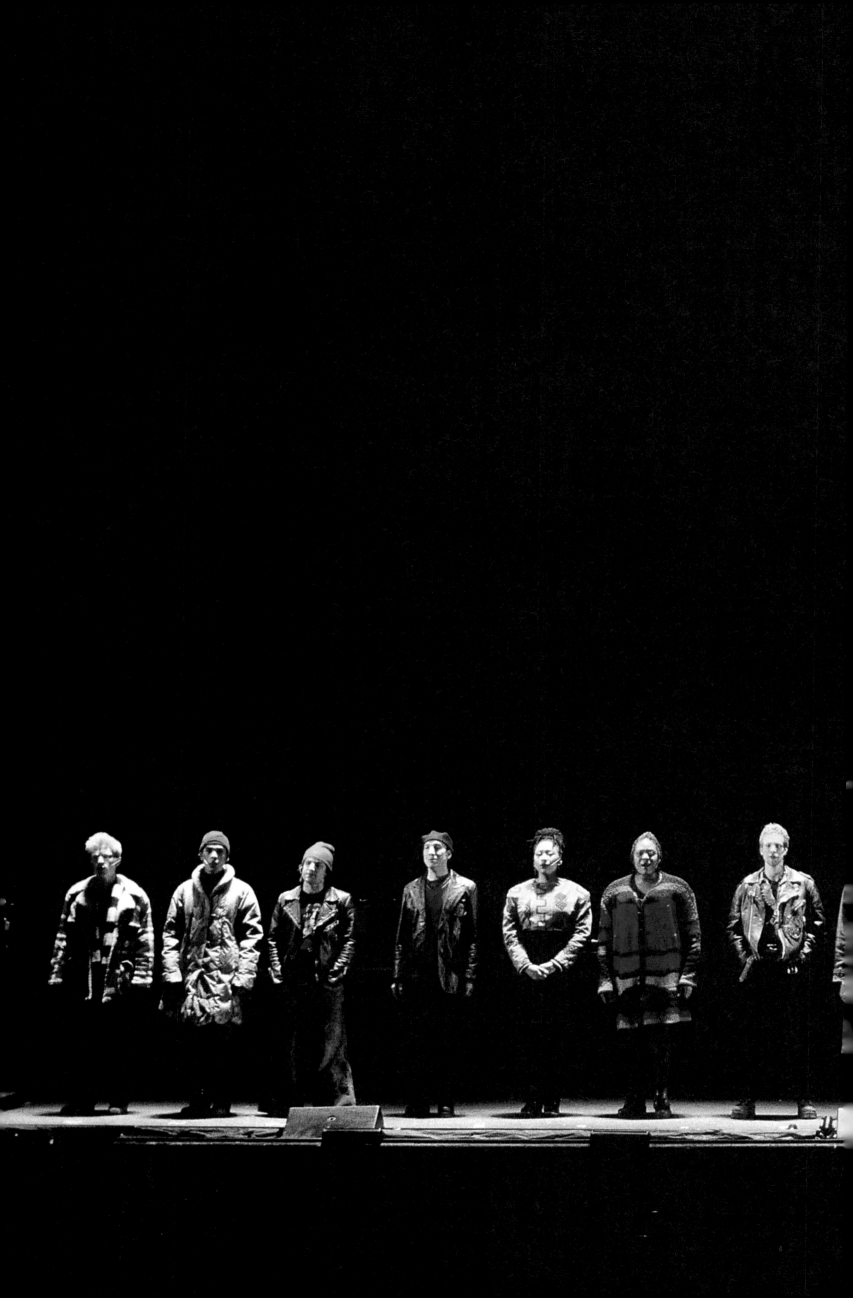

(The COMPANY enters from all directions and forms a line across the apron of the stage.)

26. Seasons of Love

COMPANY Five hundred twenty-five thousand / Six hundred minutes / Five hundred twenty-five thousand / Moments so dear / Five hundred twenty-five thousand / Six hundred minutes / How do you measure – measure a year? / In daylights – in sunsets / In midnights – in cups of coffee / In inches – in miles / In laughter – in strife / In – five hundred twenty-five thousand / Six hundred minutes / How do you measure / A year in the life? / How about love? / How about love? / How about love? / How about love? / Seasons of love / Seasons of love

SOLOIST #1 Five hundred twenty-five thousand / Six hundred minutes / Five hundred twenty-five thousand / Journeys to plan / Five hundred twenty-five thousand / Six hundred minutes / How do you measure the life / Of a woman or a man?

SOLOIST #2 In truths that she learned / Or in times that he cried / In bridges he burned / Or the way that she died

ALL It's time now – to sing out / Tho' the story never ends / Let's celebrate / Remember a year in the life of friends / Remember the love / Remember the love / Remember the love / Measure in love

SOLOIST #1 Measure, measure your life in love / Seasons of love / Seasons of love

27. Happy New Year

(New Year's Eve. The scene opens on the street outside the apartment. One table, lying on its end, serves as the door.)

MARK (carrying mock door) *Pan to the padlocked door. New Year's-Rocking Eve. The breaking-back-into-the-building party...*

(ROGER & MIMI try in vain to pry a padlock from the door. They appear to be happy.)

MIMI How long 'til next year?
ROGER Three-and-a-half minutes...
MIMI I'm giving up my vices / I'm going back – back to school / Eviction or not / This week's been so hot / That long as I've got you / I know I'll be cool / I couldn't crack the love code, dear / 'Til you made the lock on my heart explode / It's gonna be a happy new year / A happy new year

(MARK enters the scene.)

MARK Coast is clear / You're supposed to be working / That's for midnight / Where are they? / There isn't much time
MIMI Maybe they're dressing / I mean what does one wear that's apropos / For a party – that's also a crime

(MAUREEN enters wearing a skintight "cat burglar" suit and carrying a bag of potato chips.)

MAUREEN Chips, anyone?
MARK You can take the girl out of Hicksville / But you can't take the Hicksville out of the girl
MAUREEN My riot got you on TV / I deserve a royalty
MIMI Be nice, you two / Or no God-awful champagne

(MAUREEN takes out a cellular phone and dials.)

MAUREEN Don't mind if I do / No luck?
ROGER Bolted plywood, padlocked with a chain / A total dead end
MAUREEN Just like my ex-girlfriend / (on the cellular phone) Honey...? / I know you're there... / Please pick up the phone / Are you okay? / It's not funny / It's not fair / How can I atone? / Are you okay? / I lose control / But I can learn to behave / Give me one more chance / Let me be your slave / I'll kiss your Doc Martens / Let me kiss your Doc Martens / Your every wish I will obey

(JOANNE enters.)

JOANNE That might be okay / Down girl / Heel... stay / I did a bit of research / With my friends at legal aid / Technically, you're squatters / There's hope / But just in case

(JOANNE whips out...)

MARK & JOANNE Rope!
MARK (pointing off) We can hoist a line –
JOANNE To the fire escape –
MARK And tie off at
MARK & JOANNE That bench!
MAUREEN I can't take them as chums
JOANNE Start hoisting...wench

(All three cross upstage and attempt to throw up the length of rope over a plank. ROGER & MIMI are laughing and holding each other.)

ROGER I think I should be laughing / Yet I forget / Forget how to begin / I'm feeling something inside / And yet I still can't decide / If I should hide / Or make a wide-open grin / Last week I wanted just to disappear / My life was dust / But now it just may be a happy new year / A happy new year

(COLLINS & ANGEL enter. COLLINS, dressed in black and wearing sunglasses, carries a bottle of champagne. ANGEL wears a plastic dress and blonde wig: a small blowtorch is slung around his shoulder.)

COLLINS Bond – James Bond
ANGEL And Pussy Galore – in person
MIMI Pussy – you came prepared
ANGEL I was a Boy Scout once / And a Brownie / 'Til some brat got scared
COLLINS (to MIMI) Aha! Moneypenny – my martini!
MIMI Will bad champagne do?
ROGER That's shaken – not stirred
COLLINS Pussy – the bolts

(COLLINS takes a swig of champagne as ANGEL graps the blowtorch.)

ANGEL Just say the word!

(ANGEL turns on the torch.)

MIMI Two minutes left to execute our plan
COLLINS Where's everyone else?
ROGER Playing Spiderman
MARK Ironic close-up: tight / On the phone machine's red light / Once the Boho boys are gone / The power mysteriously comes on

28. Voice Mail #3

(Lights up on MRS. COHEN, who's standing on a chair and holding up a phone.)

MRS. COHEN Mark, it's the wicked witch of the West / Your mother / Happy New Year from Scarsdale / We're all impressed that the riot footage / Made the nightly news / Even your father says mazel tov / Honey – call him / Love, Mom

(MRS. COHEN, stepping off the chair, passes the phone to ALEXI DARLING.)

ALEXI DARLING (on the chair) Mark Cohen / Alexi Darling from *Buzzline*
MARK *Oh, that show's so sleazy.*
ALEXI DARLING Your footage of the riots: A-one / Feature-segment-network-deal time / I'm sending you a contract / Ker-ching, ker-ching / Marky, give us a call / 970-4301 / Or at home try 863-6754 / Or – my cellphone, at · 919-763-0090 / Or – you can E-mail me / At Darling Alexi Newscom dot net / Or – you can page me at— / (Beeep!)

29. Happy New Year B

MAUREEN I think we need an agent!
MARK We?
JOANNE That's selling out
MARK But it's nice to dream
MAUREEN Yeah – it's network TV / And it's all thanks to me
MARK Somehow I think I smell / The whiff of a scheme
JOANNE Me too
MAUREEN We can plan another protest
JOANNE We?!
MAUREEN This time you can shoot from the start... / (to MARK) You'll direct / (to JOANNE) Starring me!

(Lights shift back to downstairs.)

ALL 5, 4, 3...Open sesame!!

(The door falls away, revealing MARK, JOANNE & MAUREEN)

Happy New Year / Happy New Year / Happy New...

(BENNY enters.)

BENNY I see that you've beaten me to the punch
ROGER How did you know we'd be here?
BENNY I had a hunch
MARK You're not mad?
BENNY I'm here to end this war / It's a shame you went and destroyed the door
MIMI Why all the sudden the big about-face
BENNY The credit is yours / You made a good case
ROGER What case?
BENNY Mimi came to see me / And she had much to say
MIMI That's not how you put it at all yesterday
BENNY I couldn't stop thinking about the whole mess / Mark – you might want this on film

(MARK picks up his camera.)

MARK I guess
BENNY (formally) I regret the / Unlucky circumstances / Of the past seven days
ROGER Circumstance? / You padlocked our door
BENNY And it's with great pleasure / On behalf of Cyberarts / That I hand you this key

(BENNY hands him the key.)

ANGEL Golf claps

(THEY oblige.)

MARK I had no juice in my battery
BENNY Reshoot
ROGER I see – this is a photo opportunity
MAUREEN The benevolent God / Ushers the poor artists back to their flat / Were you planning to take down the barbed wire / From the lot, too?
ROGER Anything but that!
BENNY Clearing the lot was a safety concern / We break ground this month / But you can return
MAUREEN That's why you're here with people you hate / Instead of with Muffy at Muffy's estate

BENNY I'd honestly rather be with you tonight / Than in Westport –
ROGER Spare us, old sport, the soundbite
BENNY Mimi – since your ways are so seductive
MIMI You came on to me!
BENNY Persuade him not to be so counterproductive
ROGER Liar!
BENNY Why not tell them what you wore to my place?
MIMI I was on my way to work
BENNY Black leather and lace! / My desk was a mess / I think I'm still sore
MIMI 'Cause I kicked him and told him I wasn't his whore!
BENNY Does your boyfriend know / Who your last boyfriend was?
ROGER I'm not her boyfriend / I don't care what she does
ANGEL People! Is this any way to start a new year? / Have compassion / Benny just lost his cat
BENNY My dog – but I appreciate that
ANGEL My cat had a fall / And I went through hell
BENNY It's like losing a – / How did you know that she fell?
COLLINS (hands BENNY a glass of champagne) Champagne?
BENNY Don't mind if I do / To dogs
ALL BUT BENNY No Benny – to you!
ANGEL Let's make a resolution
MIMI I'll drink to that
COLLINS Let's always stay friends
JOANNE Tho' we may have our disputes
MAUREEN This family tree's got deep roots
MARK Friendship is thicker than blood
ROGER That depends
MIMI Depends on trust
ROGER Depends on true devotion
JOANNE Depends on love
MARK (to ROGER) Depends on not denying emotion
ROGER Perhaps
ALL It's gonna be a happy new year
ROGER I guess
ALL It's gonna be a happy new year
ROGER You're right

(ANGEL brings ROGER & MIMI together. ANGEL & others move away from MIMI & ROGER.)

ANGEL It's gonna be a happy new year
ROGER & MIMI I'm sorry
ROGER Coming?
MIMI In a minute – I'm fine – go

(ROGER kisses MIMI and exits. THE MAN appears.)

THE MAN Well, well, well. What have we here?

(HE walks over to MIMI and holds out a small plastic bag of white powder.)

It's gonna be a happy new year / There, there...etc.

(Fade out.)

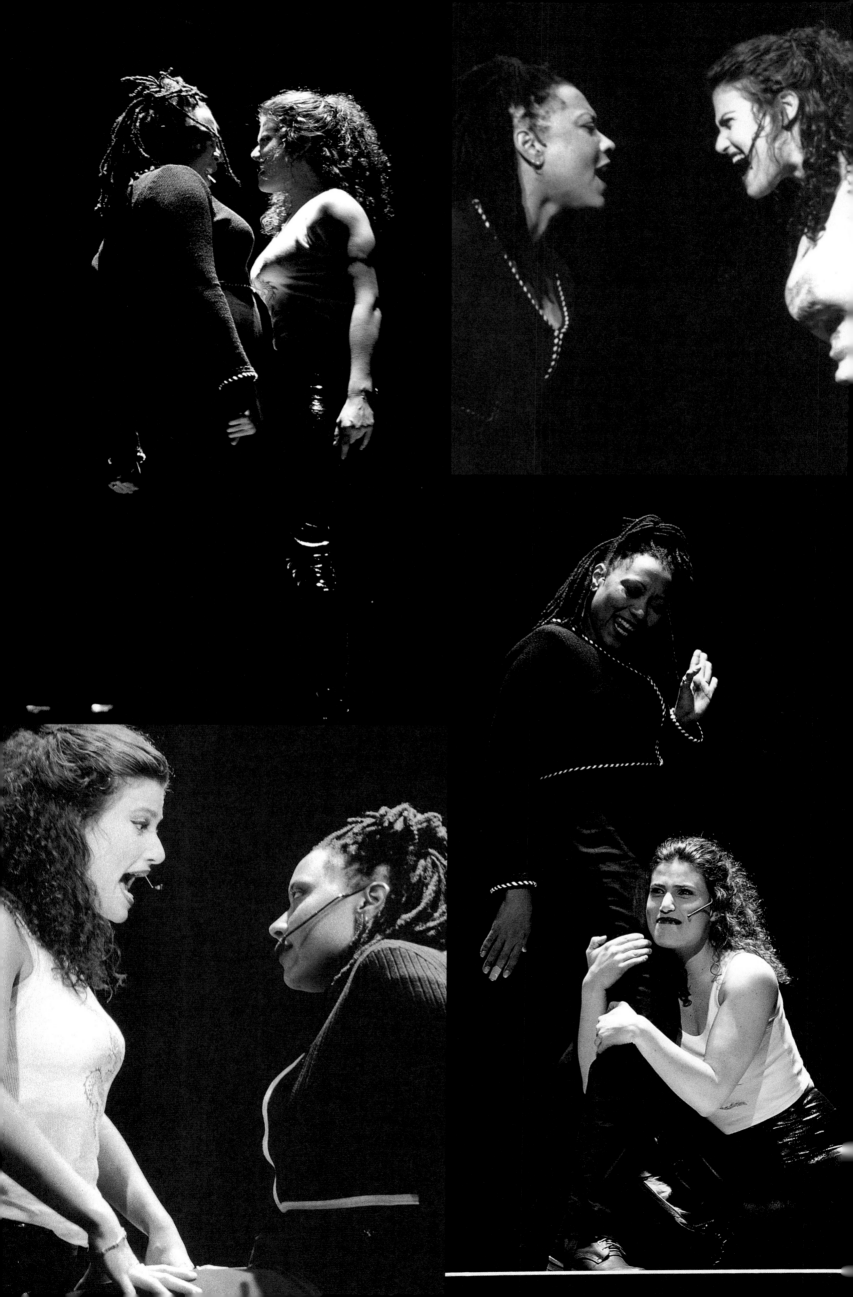

30. *Take Me or Leave Me*

(Any location and JOANNE's loft.)

MARK *Valentine's Day...pan across the empty lot. Roger's down at Mimi's, where he's been for almost two months now, although he keeps talking about selling his guitar and heading out of town. (Still jealous of Benny)... God knows where Collins and Angel are.... Could be that new shantytown near the river or a suite at the Plaza.... Maureen and Joanne are rehearsing.*

JOANNE *I said – once more from the top!*
MAUREEN *I said no!!*
MARK *That is if they're speaking this week.... Me? I'm here. Nowhere.*

(Lights up on the scene.)

JOANNE *And the line is, "Cyberarts and its corporate sponsor, Grey Communications, would like to mitigate the Christmas Eve riots...." What is so difficult...?*
MAUREEN *It just doesn't roll off my tongue. I like my version.*
JOANNE *You – dressed as a groundhog – to protest the groundbreaking....*
MAUREEN *It's a metaphor!*
JOANNE *It's...less than brilliant.*
MAUREEN *That's it, Miss Ivy League!*
JOANNE *What?*
MAUREEN *Ever since New Year's, I haven't said boo. I let you direct. I didn't pierce my nipples because it grossed you out. I didn't stay and dance at the Clit Club that night 'cause you wanted to go home....*
JOANNE *You were flirting with the woman in rubber.*
MAUREEN *That's what this is about? There will always be women in rubber – flirting with me! Give me a break. /* Every single day / I walk down the street / I hear people say / "Baby's so sweet" / Ever since puberty / Everybody stares at me / Boys – girls / I can't help it baby / So be kind / Don't lose your mind / Just remember that I'm your baby / Take me for what I am / Who I was meant to be / And if you give a damn / Take me baby or leave me / Take me baby or leave me / A tiger in a cage / Can never see the sun / This diva needs her stage / Baby – let's have fun! / You are the one I choose / Folks'd kill to fill your shoes / You love the limelight too, baby / So be mine or don't waste my time / Cryin' – "Honeybear – are you still my baby?" / Take me for what I am / Who I was meant to be / And if you give a damn / Take me baby or leave me / No way can I be what I'm not / But hey – don't you want your girl hot! / Don't fight – don't lose your head / 'Cause every night – who's in your bed? / Who's in your bed, baby? *(pouts in JOANNE's direction)/ Kiss, Pookie.*

JOANNE *It won't work /* I look before I leap / I love margins and discipline / I make lists in my sleep / Baby what's my sin? / Never quit – I follow through / I hate mess – but I love you / What to do / With my impromptu baby / So be wise / This girl satisfies / You've got a prize – don't compromise / You're one lucky baby / Take me for what I am
MAUREEN A control freak
JOANNE Who I was meant to be
MAUREEN A snob – yet overattentive
JOANNE And if you give a damn
MAUREEN A lovable, droll geek
JOANNE Take me baby or leave me
MAUREEN And anal retentive!
BOTH That's it!
JOANNE The straw that breaks my back
BOTH I quit
JOANNE Unless you take it back
BOTH Women
MAUREEN What is it about them?
BOTH Can't live – / With them – Or without them! / Take me for what I am / Who I was meant to be / And if you give a damn / Take me baby or leave me / Take me baby / Or leave me / Guess I'm leavin' / I'm gone!

(They both sit.)

A tiger in a cage
Can never see the sun
This diva needs her stage

I look before I leap
I love margins and discipline
I make lists in my sleep
Baby what's my sin?

COMPANY In diapers – report cards / In spoked wheels – in speeding tickets / In contracts – dollars / In funerals – in births / In – five hundred twenty-five thousand / Six hundred minutes / How do you figure / A last year on earth? / Figure in love / Figure in love / Figure in love / Measure in love / Seasons of love / Seasons of love

32. *Without You*

(MIMI's apartment. Three beds appear downstage. One, a hospital bed, is occupied by ANGEL. ROGER sits on another, JOANNE on the third. MIMI approaches ROGER, and appears to be in a hurry.)

ROGER *Where were you?*
MIMI *I'm sorry, I'm late....*
ROGER (interrupting) *I know. You lost your keys. No, you went for a walk; you had to help your mother.* (As he picks up the guitar) *And how's Benny? I'm gonna work upstairs tonight.*
MIMI Wait.... / I should tell you / I should... / Never mind....
ROGER Happy spring

(ROGER exits. MIMI pulls out a just-purchased stash and angrily flings it across the room. As she sings the following, a stylized "musical beds" is choreographed around her; during the bridge of the song, COLLINS carries ANGEL from the hospital bed and ROGER takes his place. By the end of the song, JOANNE & MAUREEN are reunited, as are ROGER and MIMI. COLLINS & ANGEL have lain down together, where ANGEL dies.)

MIMI Without you / The ground thaws / The rain falls / The grass grows / Without you / The seeds root / The flowers bloom / The children play / The stars gleam / The poets dream / The eagles fly / Without you / The earth turns / The sun burns / But I die / Without you / Without you / The breeze warms / The girl smiles / The cloud moves / Without you / The tides change / The boys run / The oceans crash / The crowds roar / The days soar / The babies cry / Without you / The moon glows / The river flows / But I die / Without you
ROGER The world revives
MIMI Colors renew
BOTH But I know blue / Only blue / Lonely blue / Within me, blue / Without you
MIMI Without you / The hand gropes / The ear hears / The pulse beats
ROGER Without you / The eyes gaze / The legs walk / The lungs breathe
BOTH The mind churns / The heart yearns / The tears dry / Without you / Life goes on / But I'm gone / 'Cause I die
ROGER Without you
MIMI Without you
ROGER Without you
BOTH Without you

The flowers bloom
the children play the stars
gleam the poets dream

(The loft. The phone rings....)

ROGER & MARK'S ANSWERING MACHINE Speak... / *(Beeep!)*
ALEXI DARLING Mark Cohen / Alexi Darling / Labor Day weekend / In East Hampton / On the beach / Just saw Alec Baldwin / Told him you say hi / Just kidding / We still need directors / You still need money / You know you need money / Pick up the phone / Don't be afraid of ker-ching, ker-ching / Marky – sell us your soul / Just kidding / We're waiting...

Touch
Deep Dark
Kiss

34. Contact

(THE COMPANY forms two main groups. As the music begins, a group of dancers start a sensual life and death dance, while a group of actors gather around a table centerstage to speak words of passion which punctuates the dancing. Eventually, the actors converge on the table and cover themselves with a white sheet, while moving to the music.)

GROUP A (ROGER, MARK, JOANNE & BENNY) Hot-hot-hot-sweat-sweet / Wet-wet-wet-red-heat / Hot-hot-hot-sweat-sweet / Wet-wet-wet-red-heat / Please don't stop please / Please don't stop stop / Stop stop stop don't / Please please please please / Hot-hot-hot-sweat-sweet / Wet-wet-wet-red-heat / Sticky-licky-trickle-tickle / Steamy-creamy-stroking-soaking

GROUP B (MIMI, COLLINS, MAUREEN & ANGEL) Hot-hot-hot-sweat-sweet-wet-wet-wet-red-heat
COLLINS Touch!
MAUREEN Taste!
MIMI Deep!
COLLINS Dark!
MAUREEN Kiss!
COLLINS Beg!
MIMI Slap!
MIMI, MAUREEN & COLLINS Fear!
COLLINS Thick!
COLLINS, MIMI & MAUREEN Red, red / Red, red / Red, red – please
MAUREEN Harder
ANGEL Faster
MAUREEN Wetter
MIMI Bastard

COLLINS You whore
MAUREEN You cannibal
MIMI & ANGEL More
MAUREEN You animal
MAUREEN, COLLINS & MIMI Fluid no fluid no contact yes no contact
ALL Fire fire burn – burn yes! / No latex rubber rubber / Fire latex rubber latex bummer lover bummer

(The music explodes into a fevered rhythmic heat as ANGEL is revealed in a lone spotlight, dancing wildly.)

ANGEL Take me / Take me / Today for you / Tomorrow for me / Today me / Tomorrow you / Tomorrow you / Love / You / Love you / I love you / I love / You I love / You! / Take me / Take me / I love you

(The music dies as ANGEL vanishes.)

ROGER'S VOICE Um
JOANNE'S VOICE Wait
MIMI'S VOICE Slipped
COLLINS' VOICE Shit
JOANNE'S VOICE Ow!
ROGER'S VOICE Where'd it go?
MIMI'S VOICE Safe
COLLINS' VOICE Damn
MAUREEN'S VOICE I think I missed – don't get pissed
ALL It was bad for me – was it bad for you?
JOANNE It's over
MAUREEN It's over
ROGER It's over
MIMI It's over
COLLINS It's over

35. I'll Cover You: Reprise

(In a church. ANGEL's memorial.)

MIMI *Angel was one of my closest friends. It's right that it's Halloween, because it was her favorite holiday. I knew we'd hit it off the moment we met – that skinhead was bothering her and she said she was more of a man than he'd ever be and more of a woman than he'd ever get...*

MARK *...and then there was the time he walked up to this group of tourists – and they were petrified because, A – they were obviously lost, and B – had probably never spoken to a drag queen before in their lives...and he...she just offered to escort them out of Alphabet City.... And then she let them take a picture with her – and then she said she'd help 'em find the Circle Line...*

MAUREEN *...so much more original than any of us – you'd find an old tablecloth on the street and make a dress – and next year, sure enough – they'd be mass-producing them at the Gap! You always said how lucky you were that we were all friends – but it was us, baby, who were the lucky ones.*

COLLINS Live in my house / I'll be your shelter / Just pay me back with one thousand kisses / Be my lover / And I'll cover you / Open your door – I'll be your tenant / Don't got much baggage / To lay at your feet / But sweet kisses I've got to spare / I'll be there – I'll cover you / I think they meant it / When they said you can't buy love / Now I know you can rent it / A new lease you were, my love, on life / All my life / I've longed to discover / Something as true / As this is

(The following is sung simultaneously.)

JOANNE & SOLOIST	COLLINS
So with a thousand sweet kisses I'll cover you	If you're cold and you're lonely
With a thousand sweet kisses I'll cover you	You've got one nickel only
With a thousand sweet kisses I'll cover you	When you're worn out and tired
With a thousand sweet kisses I'll cover you	When your heart has expired

COMPANY Five hundred twenty-five thousand six hundred minutes / Five hundred twenty-five thousand moments so dear / Five hundred twenty-five thousand six hundred minutes / Five hundred twenty-five thousand six hundred – / Measure a year / Oh lover I'll cover you / Oh lover I'll cover you
COLLINS & COMPANY Oh lover / I'll cover you / Oh lover
COLLINS I'll cover you
COMPANY Five hundred twenty-five thousand six hundred minutes / Five hundred twenty-five thousand / Seasons of love
COLLINS I'll cover you

36. *Halloween* |

MARK *Hi. It's Mark Cohen. Is Alexi there?... No, don't bother her. Just tell her I'm running a little late for our appointment.... Yes, I'm still coming.... Yes, I signed the contract.... Thanks....*

How did we get here? / How the hell... / Pan left – close on the steeple of the church / How did I get here? / How the hell... / Christmas / Christmas Eve – last year / How could a night so frozen / Be so scalding hot? / How can a morning this mild / Be so raw? / Why are entire years strewn / On the cutting-room floor of memory / When single frames from one magic night / Forever flicker in close-up / On the 3-D Imax of my mind / That's poetic / That's pathetic / Why did Mimi knock on Roger's door / And Collins choose that phone booth / Back where Angel set up his drums? / Why did Maureen's equipment break down? / Why am I the witness? / And when I capture it on film / Will it mean that it's the end / And I'm alone?

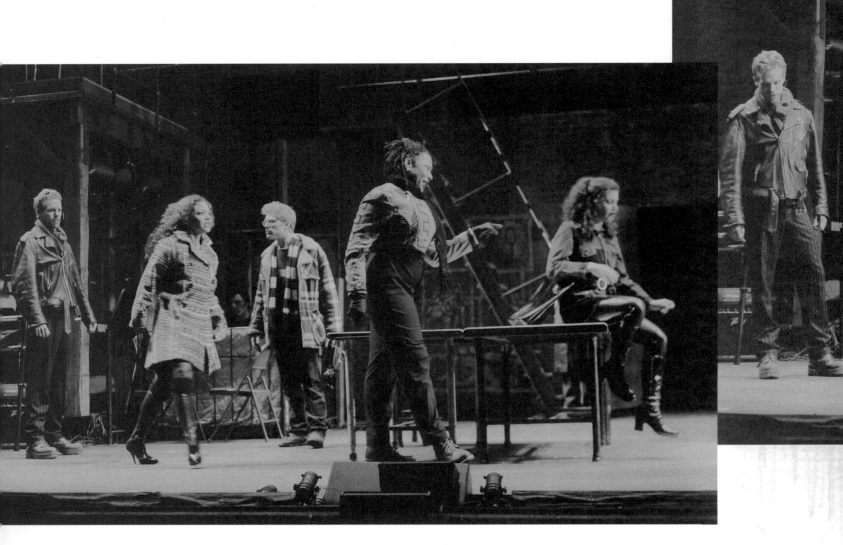

37. Goodbye Love

(The principals emerge from the church.)

MIMI (to ROGER) It's true you sold your guitar and bought a car?
ROGER It's true – I'm leaving now for Santa Fe / It's true you're with this yuppie scum?
BENNY You said – you'd never speak to him again
MIMI Not now
MAUREEN Who said that you have any say / In who she says things to at all?
ROGER Yeah!
JOANNE Who said that you should stick your nose in other people's...
MAUREEN Who said I was talking to you?

JOANNE	MARK
We used to have this	
fight each night	Calm down
She'd never admit	Everyone please
I existed	

MIMI	BENNY
He was the	Mimi
same way – He was	
always / "Run away –	
hit the road / Don't	
commit" – you're full	
of shit	

JOANNE She's in denial
MIMI He's in denial

JOANNE	MARK
Didn't give	Come on
an inch / When I	
gave a mile	

MIMI I gave a mile
ROGER Gave a mile to who?
MARK & BENNY Come on guys, chill!
MIMI & JOANNE I'd be happy to die for a taste / Of what Angel had / Someone to live for – unafraid / To say I love you
ROGER All your words are nice Mimi / But love's not a three-way street / You'll never

share real love / Until you love yourself – I should know
COLLINS You all said you'd be cool today / So please – for my sake... / I can't believe he's gone (to ROGER) I can't believe you're going / I can't believe this family must die / Angel helped us believe in love / I can't believe you disagree
ALL I can't believe this is goodbye

(MAUREEN & JOANNE reconcile. COLLINS returns to the church. MIMI & BENNY leave together. ROGER & MARK are left alone.)

MAUREEN Pookie
JOANNE Honeybear
MAUREEN I missed you so much
JOANNE I missed you
MAUREEN I missed your smell
JOANNE Your mouth / Your –

(JOANNE gives MAUREEN a firm kiss on the lips.)

MAUREEN Ow
JOANNE What?
MAUREEN Nothing, Pookie
JOANNE No, baby – you said "Ow" – What?
MAUREEN You bit my tongue
JOANNE No, I didn't
MAUREEN You did – I'm bleeding
JOANNE No, it isn't
MAUREEN I think I should know...
JOANNE Let me see –
MAUREEN She doesn't believe me
JOANNE I was only trying to...

(They hug & exit. The PASTOR from the church emerges on the above.)

PASTOR Thomas B. Collins?
COLLINS Coming

goodbye love
Hello - disease

(The PASTOR exits above and COLLINS exits into the church. BENNY stands off to the side as MIMI approaches ROGER, who turns away. She hesitates before leaving with BENNY.)

MARK I hear there are great restaurants out west

ROGER Some of the best. How could she?

MARK How could you let her go?

ROGER You just don't know... How could we lose Angel?

MARK Maybe you'll see why when you stop escaping your pain / At least now if you try – Angel's death won't be in vain

ROGER His death is in vain

(MIMI reappears up left, in the shadows. She overhears ROGER & MARK's conversation.)

MARK Are you insane? / There's so much to care about / There's me – there's Mimi –

ROGER Mimi's got her baggage too

MARK So do you

ROGER Who are you to tell me what I know, what to do

MARK A friend

ROGER But who, Mark, are you? / "Mark has got his work" / They say, "Mark lives for his work" / And, "Mark's in love with his work" / Mark hides in his work

MARK From what?

ROGER Facing your failure, facing your loneliness / Facing the fact you live a lie / Yes, you live a lie – tell you why / You're always preaching not to be numb / When that's how you thrive / You pretend to create and observe / When you really detach from feeling alive

MARK Perhaps it's because I'm the one of us to survive

ROGER Poor baby

MARK Mimi still loves Roger / Is Roger really jealous / Or afraid that Mimi's weak

ROGER Mimi did look pale

MARK Mimi's gotten thin / Mimi's running out of time / Roger's running out the door –

ROGER No more! Oh no! / I've gotta go

MARK Hey, for somebody who's always been let down, / Who's heading out of town?

ROGER For someone who longs for a community of his own, / Who's with his camera, alone?

(ROGER takes a step to go, then stops, turns.)

I'll call / I hate the fall

(ROGER turns to go and sees MIMI.)

ROGER You heard?

MIMI Every word / You don't want baggage without lifetime guarantees / You don't want to watch me die? / I just came to say / Goodbye, love / Goodbye, love / Came to say goodbye, love, goodbye

MIMI	ROGER
Just came to say	Glory
Goodbye love	One blaze of
Goodbye love	Glory
Goodbye love	I have to find
goodbye	

(ROGER exits. BENNY returns. MIMI steps away.)

MIMI Please don't touch me / Understand / I'm scared / I need to go away

MARK I know a place – a clinic

BENNY A rehab?

MIMI Maybe – could you?

BENNY I'll pay

MIMI Goodbye love / Goodbye love / Came to say goodbye, love, goodbye / Just came to say / Goodbye love / Goodbye love / Goodbye love / Hello – disease

(MIMI runs off. After a moment, COLLINS quickly enters, with the PASTOR trailing behind him.)

WE'RE DYING IN AMERCIA

TO COME INTO OUR OWN

38. *What You Own*

PASTOR Off the premises now / We don't give handouts here!
MARK What happened to "Rest in peace"?
PASTOR Off the premises, queer!

(The PASTOR starts to exit.)

COLLINS That's no way to send a boy / To meet his maker / They had to know / We couldn't pay the undertaker
BENNY Don't you worry 'bout him. Hey, I'll take care of it

(The PASTOR acknowledges BENNY and exits.)

MARK Must be nice to have money
ALL THREE No shit
COLLINS I think it only fair to tell you / You just paid for the funeral / Of the person who killed your dog
BENNY I know / I always hated that dog / Let's pay him off / And then get drunk
MARK I can't, I have a meeting
COLLINS & BENNY Punk! Let's go

(COLLINS & BENNY exit.)

MARK (imagining) *"Hi. Mark Cohen here for Buzzline.... Back to you, Alexi. Coming up next – vampire welfare queens who are compulsive bowlers."* Oh, my God, what am I doing? / Don't breathe too deep / Don't think all day / Dive into work / Drive the other way / That drip of hurt / That pint of shame / Goes away / Just play the game / You're living in America / At the end of the millennium / You're living in America / Leave your conscience at the tone / And when you're living in America / At the end of the millennium / You're what you own

(Lights up on ROGER.)

ROGER The filmmaker cannot see
MARK And the songwriter cannot hear
ROGER Yet I see Mimi everywhere
MARK Angel's voice is in my ear
ROGER Just tighten those shoulders

MARK Just clench your jaw 'til you frown
ROGER Just don't let go
BOTH Or you may drown / You're living in America / At the end of the millennium / You're living in America / Where it's like the Twilight Zone / And when you're living in America / At the end of the millennium / You're what you own / So I own not a notion / I escape and ape content / I don't own emotion – I rent

MARK **ROGER**
What was it about
that night What was it about
 that night

BOTH Connection – in an isolating age

MARK **ROGER**
For once the shadows
gave way to light For once the shadows
 gave way to light

BOTH For once I didn't disengage

(MARK goes to the pay phone and dials.)

MARK Angel – I hear you – I hear it / I see it – I see it / My film!
ROGER Mimi I see you – I see it / I hear it – I hear it / My song!

MARK **ROGER**
Alexi – Mark One song – Glory
Call me a Mimi
hypocrite Your eyes
I need to finish
my film
I quit!

BOTH Dying in America / At the end of the millennium / We're dying in America / To come into our own / But when you're dying in America / At the end of the millennium / You're not alone / I'm not alone / I'm not alone

(Blackout.)

39. *Voice Mail #5*

(Various locations. In blackout, once again the phone rings.)

ROGER & MARK'S ANSWERING MACHINE Speak... / (Beeep!)
ROGER'S MOTHER Roger / This is your mother / Roger, honey, I don't get these postcards / "Moving to Santa Fe" / "Back in New York" / "Starting a rock band" / Roger, where are you?? Please call

(The following is sung simultaneously)

MIMI'S MOTHER Mimi, chica, dondé estas? / Tu mama esta llamando / Dondé estas, Mimi, call?
MR. JEFFERSON Kitten — wherever are you — call
MRS. COHEN Mark — are you there — are you there? / I don't know if he's there / We're all here wishing you were, too — / Where are you, Mark, are you there, are you, where are you? / Mark — are you there — are you there? / I don't know if — please call your mother

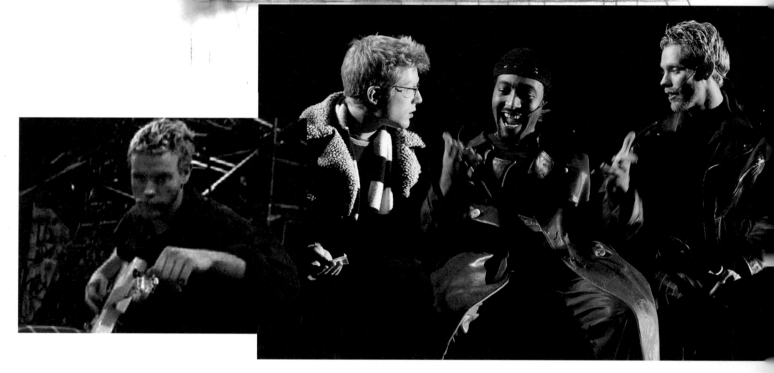

40. *Finale A*

(The lot & the loft.)

ALL SEVEN HOMELESS PEOPLE
Christmas bells are ringing / Christmas bells are ringing / Christmas bells are ringing / How time flies / When compassion dies / No stockings / No candy canes / No gingerbread / No safety net / No loose change / No change no
ONE HOMELESS MAN Santy Claus is coming
ALL 'Cause Santy Claus ain't coming / No room at the Holiday Inn — again / Well, maybe next year / Or — when

(Lights shift back to the loft. A small projector rests on a milk crate, which is on a dolly.)

MARK December 24, ten p.m. Eastern standard time / I can't believe a year went by so fast / Time to see — what we have — time to see / Turn the projector on

(A rough title credit, "TODAY 4 U: Proof Positive," appears, followed by a shot from last Christmas of ROGER tuning his guitar.)

MARK First shot Roger / With the Fender guitar he just got out of hock / When he sold the car / That took him away and back
ROGER I found my song
MARK He found his song / If he could just find Mimi

ROGER I tried — You know I tried

(MARK's image appears on-screen.)

MARK Fade in on Mark / Who's still in the dark
ROGER But he's got great footage
MARK Which he's cut together
ROGER To screen tonight

(BENNY's image appears on-screen.)

MARK In honor of Benny's wife
ROGER Muffy
MARK Alison / Pulling Benny out of the East Village location

(The projector blows a fuse. Blackout.)

ROGER *Then again. Maybe we won't screen it tonight.*
MARK *I wonder how Alison found out about Mimi?*
ROGER *Maybe a little bird told her.*

(COLLINS enters in the dark, with several twenty-dollar bills in each hand.)

COLLINS *Or an angel.* (lights fade up) / I had a hunch that you could use a little flow
ROGER Tutoring again?
COLLINS Negative
MARK Back at NYU?

COLLINS No, no, no / I rewired the ATM at the Food Emporium / To provide an honorarium to anyone with the code
ROGER & MARK The code – / Well...?
COLLINS A-N-G-E-L / Yet Robin Hooding isn't the solution / The powers that be must be undermined where they dwell / In a small, exclusive gourmet institution / Where we overcharge the wealthy clientele
ALL THREE Let's open up a restaurant in Santa Fe / With a private corner banquette, in the back / We'll make it yet, we'll somehow get to Santa Fe
ROGER But you'd miss New York before you could unpack
ALL THREE Ohh –

(MAUREEN & JOANNE enter, carrying MIMI.)

MAUREEN Mark! Roger! Anyone – help!
MARK Maureen?
MAUREEN It's Mimi – I can't get her up the stairs
ROGER No!

(They enter the loft.)

MAUREEN She was huddled in the park in the dark / And she was freezing / And begged to come here
ROGER Over here / Oh, God

(They lay her down carefully on the table.)

MIMI Got a light – I know you – you're shivering...
JOANNE She's been living on the street
ROGER We need some heat
MIMI I'm shivering
MARK We can buy some wood and something to eat
COLLINS I'm afraid she needs more than heat
MIMI I heard that
MAUREEN Collins will call for a doctor, honey
MIMI Don't waste your money on Mimi, me, me
COLLINS Hello – 911? / I'm on hold
MIMI Cold...cold...would you light my candle?
ROGER Yes, we'll, oh God – find a candle
MIMI I should tell you / I should tell you
ROGER I should tell you / I should tell you
MIMI I should tell you / Benny wasn't any –
ROGER Shhh – I know / I should tell you why I left / It wasn't 'cause I didn't –
MIMI I know / I should tell you
ROGER I should tell you
MIMI (whispering) I should tell you / I love you –

(MIMI fades.)

ROGER Who do you think you are? / Leaving me alone with my guitar / Hold on there's something you should hear / It isn't much but it took all year

(MIMI stirs and ROGER begins playing acoustic guitar at her bedside.)

41. *Your Eyes*

ROGER Your eyes / As we said our goodbyes / Can't get them out of my mind / And I find I can't hide (from) / Your eyes / The ones that took me by surprise / The night you came into my life / Where there's moonlight / I see your eyes

(Band takes over.)

How'd I let you slip away / When I'm longing so to hold you / Now I'd die for one more day / 'Cause there's something I should have told you / Yes there's something I should have told you / When I looked into your eyes / Why does distance make us wise? / You were the song all along / And before the song dies / I should tell you I should tell you / I have always loved you / You can see it in my eyes

(We hear Musetta's theme, played correctly and passionately. Mimi's head falls to the side and her arm drops limply off the edge of the table.)

Mimi!

(Suddenly, MIMI's hand twitches. Incredibly, she is still alive.)

MIMI *I jumped over the moon!*
ROGER *What?*
MIMI *A leap of mooooooooooooo –*
JOANNE *She's back!*
MIMI *I was in a tunnel. Heading for this warm, white light....*
MAUREEN *Oh, my God!*
MIMI *And I swear Angel was there – and she looked* good. *And she said, "Turn around, girlfriend – and listen to that boy's song...."*
COLLINS She's drenched
MAUREEN Her fever's breaking
MARK There is no future – there is no past
ROGER Thank God this moment's not the last

MIMI & ROGER There's only us / There's only this / Forget regret or life is yours to miss
ALL No other road no other way / No day but today

(As the finale grows, the entire COMPANY makes its way on stage)

WOMEN	MEN
I can't control	Will I lose my dignity
My destiny	Will someone care
I trust my soul	Will I wake tomorrow
My only goal	From this nightmare
Is just to be	

(MARK's film resumes, along with two more films projecting on the back wall, "Scenes from *Rent*...")

no da

Without you There's only now
The hand gropes There's only here
The ear hears Give in to love
The pulse beats Or live in fear
Life goes on No other path
But I'm gone No other way
'Cause I die
Without you No day but today
I die without you No day but today
I die without you No day but today
I die without you No day but today
I die without you No day but today
I die without you
No day but today

y but today

Over the Moon

Rent was now a showbiz sensation: a Broadway smash in neon lights, which needed to open by the end of April in order to qualify for that year's Tonys. The timing paid off: Rent swept all the spring awards, winning six Drama Desks, three Obies, the New York Drama Critics Circle Award for best musical, an Outer Critics Circle Award and a Drama League Award. Rent was nominated for ten Tonys, and won four, including Best Musical, Best Score, Best Book and Best Featured Actor in a Musical, Wilson Jermaine Heredia.

Wilson Jermaine Heredia: Think of it this way: you're a Brooklyn boy. Tony's big time. Now, I may have gotten some awards in high school for art, I may have gotten a trophy for track, I got one for martial arts. That is nothing compared to When they called out my name, I could only react physically. I jumped up the stairs, flew on the stage and stomped on the stage, in order to feel real. I couldn't walk up to the mike. Tears were welling up. Then I collected myself and spoke. I'm glad that the right things came out.

To me, winning the Tony means that Wilson the straight boy worked hard to play a drag queen and was acknowledged for it. A month after that, I almost had a nervous breakdown, because everything was going too fast. There was no moment to react. I was going nuts, because no one could understand. It felt like a dream.

Jeffrey Seller: I've been watching the Tonys since 1978 on TV. We had Tony parties in high school! So it's always been a meaningful night for me. But I never went, because I didn't have a reason to. In 1996 I had a compelling reason. It was dream-come-true time. I jumped out of my seat!

Julie Larson McCollum, in her acceptance speech: My brother Jonathan loved musical theater. He dreamed of creating a youthful, passionate, pertinent piece that would bring a new generation to the theater, so they would find as much joy in it as he did. That dream became Rent. Thank you all for embracing Rent, and with it, my brother, Jonathan.

Nan Larson: We were thrilled and just wanted Jonathan to be there. He should have been there accepting the award, not his sister, who I think did a marvelous job, but she didn't want to be there, either. He would have been great, because he would have just loved all of it and reveled in it, and he would have deserved to revel in it.

Martha Banta: It's always been a stifled joy, because you're happy, but you're immediately sad. Oh, it's great; what a shame—in one sentence.

THE NEW YORK TIMES **OP-ED** *SATURDAY, MARCH 2, 1996*

Journal

FRANK RICH

East Village Story

lets them revel in their joy, their capacity for love and, most important, their tenacity, all in a ceaseless outpouring of melody.

At so divisive a time in our country's culture, "Rent" shows signs of revealing a large, untapped appetite for something better. It's too early to tell. What is certain is that Jonathan Larson's brief life belies the size of his spirit. In the staying power of his songs, he lingers, refusing to let anyone who hears his voice abandon hope. □

By this point, *Rent* was becoming not just a success but a phenomenon. Tickets were selling out months in advance; lines formed early in the morning for the $20 first-row tickets that went on sale at 6:00 P.M. each day. Article after article and news show after news show heralded *Rent* for accomplishing Larson's dream: reinventing musical theater and bringing new life to Broadway.

The *Times* had set the pace for the media accolades: After Tommasini's article and Brantley's review, Frank Rich—the legendary critic who could once make or break a show, and whom Larson had often talked of getting reviewed by—wrote a glowing op-ed piece on March 2, saying *Rent* countered the conservative Buchananism of the day. The Arts & Leisure section featured a several-page *Rent* spread on March 17. Publicists Richard Kornberg and Don Summa had never seen anything like it.

Don Summa: You always want the first article to be in the Arts & Leisure section, because that's what everyone reads. I think Jonathan's death did two things: it made the Tommasini story in the *Times* about him, not *La Bohème,* and gave the *Times* the only interview with Jonathan Larson, which they then could run with. Once that second Arts & Leisure piece happened, that big spread, then everything just blew up.

Julie Larson McCollum: We got the sense Jonathan was haunting the *New York Times* pressroom! When Frank Rich did the commentary, well, I nearly lost it.

Don Summa: When we opened on Broadway, for two and a half months I worked every day. I was putting in eighty-hour weeks, just because we couldn't keep up with the phone calls. I would keep these huge lists, and every day we would decide what to do and what not to do. Our idea was to make it a show you had to see—not a show that you wanted to see but that you had to see.

Prime Time Live and *Hard Copy* did segments on *Rent*. The cast performed on *The Late Show with David Letterman* and *The Tonight Show*. And on May 13, *Rent* made the cover of *Newsweek*, with a photo of Adam Pascal and Daphne Rubin-Vega.

Adam Pascal: It's exciting playing a celebrity once in a while. It's so fake, so phony, so fantasy, but I've never done it. At the Tonys, I felt like I was playing a character, and that's how I feel when I see the *Newsweek* cover. I feel like I'm looking at somebody else. I still feel the same, and I look at this picture and say, "Why don't I feel different?" Maybe because of the pace of this whole thing, maybe in five years I'll look back and then feel it.

Don Summa: Jonathan was very eager. He called me up once early in the process; there was some little radio show that he had heard about that he thought he would be really good on. He clearly knew this was his shot, and he was willing to do anything. It was so ironic: he called about these teeny things, and if he had lived, he would have seen what he would have gotten, which would have been everything.

Rent did become the show you had to see, and celebrity after celebrity made the trek. To get backstage at the Nederlander, you have to walk down an alley. One backstage guard began asking famous people to sign the wall there in Magic Marker, calling it the Wall of Fame. But in *Rent* spirit, Michael Greif felt that anyone should be able to sign. Now the alley is covered with notes from friends, family and fans. Among the signatures, you can recognize some names: Larson's childhood hero Billy Joel, Spike Lee, RuPaul, Nicole Kidman, Jodie Foster, Janet Jackson and many more.

Gilles Chiasson: I don't care about celebrities, but when Mike Richter, the goalie for the New York Rangers, came, I totally lost my mind! He's been a hero of mine for years. He and I talked for ten minutes and then shared a cab uptown. He gave me his number and said I should call him for tickets, but I felt too shy to do that. Everyone got excited when Cher came, and Jodie Foster. I was

thrilled when Tori Amos came, because I think she's a goddess. I went over to her, and she just opened her arms and held me.
Byron Utley: Shirley MacLaine, Quincy Jones, Demi Moore, Michael J. Fox, Robert de Niro—all these famous people you've always dreamed about, ushering in a whole new group of people who will carry on.

Like the cast, the producers were new to this level of success, and they approached it with fresh ideas and a sense of deep respect for Jonathan's work. Instead of the usual excesses, they ran *Rent* practically, as a business. They made the first two rows of every show available to people who couldn't afford the usual Broadway prices. And they created a distinctive ad campaign that loomed over Times Square on a billboard and filled subway cars.

Julie Larson McCollum: I think that the producers and Michael have been very good in staying true to Jonathan's vision and enhancing things and making things better while staying within what he wanted. Every day, we agonize over every decision. Some things we're clear on, other things And Jonathan would have been very conflicted, he wouldn't have known, either. He had really big goals and dreams, but this has exceeded anything he could have imagined for this specific project. Over the course of his career, over twenty or thirty years, he could have imagined getting all these different awards. So he would have been calling us saying, "Jul, what do I do?"
Jonathan Burkhart: At every single level, it turned into unprecedented moves. And it hurts, it really hurts, because it's confusing. This wasn't his next step, to be an icon, to wash over the planet. His next step was to get a show onstage and change the way people thought. Okay, so you've got to be responsible for your actions, and if he were here today, he'd be very fine with the success of *Rent*. He'd be probably just as whacked out as we are at how big it's gotten. He would have gotten a new pair of sneakers. He bought maybe one pair of sneakers a year, and he wore them till they were disgusting.

clockwise from top left:

Cast being photographed, opening night on Broadway; the Larson family at opening night on Broadway; *Newsweek* cover story on *Rent*; cast of *Rent* performing at the Democratic National Convention, 1996; Jesse L. Martin and Rodney Hicks with Cher; detail of backstage "Wall of Fame;" Adam Pascal with his mother, Barbara Walters and David Geffen, opening night.

RENT HEADS

In front of the Nederlander Theatre, Times Square regulars have become accustomed to an unusual sight—a line of people camped outside the box office waiting for their twenty-dollar front-row tickets, which go on sale two hours before each show begins. In the wintertime they bundle up in sleeping bags and even huddle in pitched tents. Weekdays the line forms around noon. Weekends it forms a full twenty-four hours before each show begins.

Some fans—sometimes called Squatters or Rent Heads—return repeatedly for cheap tickets. As of December 1996, Anish Khanna, a twenty-two-year-old medical student at the University of Medicine and Dentistry in New Jersey, had seen *Rent* more than a dozen times. One night he camped out with three friends in a pup tent. "The show is a deeply cathartic experience, but so is waiting outside in the cold," Khanna says.

Thirty-one-year-old Joel Torrence had waited on line more than three dozen times. The *Rent* line is his social break. Torrence devised a Rent Head survival kit: a huge duffel bag filled with two comforters, a pillow, plastic bags in case it rains, books and a towel. The duffel doubles as a couch.

Producers Jeffrey Seller, Allan Gordon, and Kevin McCullom decided to price the first two rows at twenty dollars a ticket as soon as the show moved uptown. "Kevin's thought was, wouldn't it be great to have people standing in line like for David Letterman?" recalls Jeffrey Seller. "My memory was that I couldn't afford to go see *Smile* in 1986 for $47.50. This policy met both of these needs. It meant kids who couldn't afford Broadway could afford *Rent*, and it meant lines outside the theater, which would have a positive effect on marketing."

To keep the line organized, the Nederlander management created the job of "lobby control," for which they hired Justin Plowman. "I started I.D.ing people to get rid of the scalpers," says the lanky nineteen-year-old. "I tell most of the people who come looking for tickets to forget about it—the wait is simply too long. The other day these people brought a car battery, tent and VCR. They were watching Jerry Seinfeld on Forty-first Street all night long."

Plowman says most of the people in line are young theater-world fans or drama students, plus the odd foreign tourist or family from Beverly Hills. "I've had to turn away people from countries like Brazil and Guatemala," Plowman says. "I've heard so many sob stories from people who came and didn't realize you had to get here so early. Or people come and try to hold a spot for ten of their friends. There are only thirty-four seats, two seats per person. But before I kick anybody off line, I get the whole line to agree."

above: "*Rent* Heads" waiting on the $20-ticket line

Allan Gordon: The revolution is also a business revolution. The show cost three and a half million instead of ten million. That itself will increase the odds for a success; it means you can do shows for a reasonable price. You can make money with them, so you're not as scared. Broadway had become very hackneyed, completely fungible; it didn't matter which theater you wandered into. The old Broadway is dead, because it is choking itself off.

Jeffrey Seller: My biggest contribution to *Rent* was its marketing: how we market the show on Broadway and how we create the look. All the answers as to how to proceed lay within the show itself. An innovative show demands an innovative campaign. We took pains not to label the show. Nowhere in any advertising does it say *Rent,* the Broadway musical. It's *Rent.* We were selling this concept called *Rent,* hoping those people would go because they want to see *Rent.*

Kevin McCollum: That's why we don't call it a musical or an opera, because it is what you bring to it. It's written in a very traditional musical theater style, in terms of its structure, like *Gypsy* or *Fiddler on the Roof,* Jonathan's favorite musicals. At the same time, he knew there was a young, hip, urban, bohemian sensibility that his friends weren't experiencing on Broadway. They were getting it at concerts, but they weren't exposed to musical storytelling. *Rent* is musical storytelling, which is why we did not market it as a '90s rock opera.

Everything continued to happen at an intense pace. In June 1996 veteran R&B producer Arif Mardin and *Rent* musical arranger Steve Skinner were given the biggest budget in Broadway history to produce the original-cast recording of *Rent,* which was released by DreamWorks in late August.

Steve Skinner: It was a big job, with a lot more logistics than doing a regular pop album. You've got that theater/record interface, contracts for both of them. The cast makes a lot of money when they're there, the clock is ticking at a phenomenal rate, so you really have to go boom, boom, boom. It's not like doing a pop album, where you can say, "Let's see if we can get this; let's spend some time on doing this." You had to be very concerned with the budget at all times, or else you couldn't get it done. I didn't try to second-guess what Jonathan would have liked—that's never productive—I just made sure it was something I liked, knowing that in most cases that if I really liked it, he also liked it. He trusted my judgment on recording matters.

Anthony Tommasini: I adore the record, because there every word comes through, the balances are perfect, you hear all the inner voices of his harmonies, you hear the beautiful choral writing. I think that the score is actually stronger on the record. People who go see the show and then buy the record will get into it more and more every time.

In November the national tour of *Rent* opened in Boston; additional productions in Los Angeles, Toronto and London are currently scheduled.

Jeffrey Seller: When you have a show that has this kind of effect, you need to create a supply to meet the demand. It was clear to us from the amount of press and publicity the show received that people all over the country want this. Let's get it to them as soon as possible.

Kevin McCollum: People say, "It's a New York story; it's the Village." I say, "It doesn't matter whether it's New York or Seattle; it's arts supporters." You know, people who are deciding whether to get an MBA or teach ballet.

Allan Gordon: We're franchising it to the extent that we're reproducing almost the same thing in different areas of the country and internationally. So we hire local musicians, local talent. In Toronto we're trying to do an all-Canadian cast. Some of the words and costumes are not the same. The theaters are different, so the design changes. It evolves naturally. And it'll outlive everybody. We could all die tomorrow and there'd still be *Rent.* The beauty of theater, unlike film, is that it is always evolving and changing.

Timothy Britten Parker: People have asked, "How will it play in Peoria?" If it does play, if people do get over their bigotry and their racism and their misunderstanding of people like the people in this play, it will be because of the music. Although the play deals with relevant social issues, the disenfranchised and the homeless and the sick and the pained, the story is beautiful. It's a love story; it's the music that's really connecting people.

Gwen Stewart: This show is very basic. You've got a pulse, you ought to be able to relate. Somebody's lost someone to AIDS, somebody's had a bad relationship, somebody's made bad decisions in their lives, somebody's struggling with what they should do with their life. That's what people from all walks of life are dealing with.

Daphne Rubin-Vega: This bad boy can fly on its own. You can phone it in and people are still getting it. It's a masterpiece whether the fifth-grade class does it or whether major people are doing it.

THE CAST RECORDING

When *Rent: Original Broadway Cast Recording* was released in August 1996, the two-CD set of the complete score entered the Billboard Top 200 album chart at number 19, the highest Broadway cast album debut in more than a decade. By the end of the year, the record went gold. It was one of the first major releases by David Geffen's music wing of DreamWorks, the entertainment conglomerate he formed with Steven Spielberg and Jeffrey Katzenberg.

The album was co-produced by Arif Mardin, whose career includes disco-era hits such as the *Saturday Night Fever* soundtrack as well as recordings by Aretha Franklin, Chaka Khan and Phil Collins, and the Grammy Award–winning cast album for the Leiber and Stoller revue *Smokey Joe's Cafe.* Mardin invited Steve Skinner, who had worked with Mardin on other projects, to coproduce.

Coordinating fifteen cast members and a five-piece band for thirty-five songs presented an enormous logistical challenge. This is perhaps one of the reasons why the project had the largest budget for a cast album in recording history. Typically with cast albums, the music and the vocals are all recorded together. But for *Rent,* the producers decided to record the band and vocalists separately.

Cast members recorded their parts in sound-isolation areas, so the producers could fully capture the qualities of each voice. Similarly, each band member was recorded in a separate booth, so that the sounds of their instruments wouldn't bleed into other band members' microphones. Because of the massive amount of material, the producers spent only one to five hours mixing each song, whereas for a typical pop album they might have spent a day and a half.

The album includes a bonus track, a collaboration between superstar Stevie Wonder and the cast on a version of "Seasons of Love."

from left: Anthony Rapp, Wilson Jermaine Heredia and Idina Menzel recording the *Rent* album

Along with everything else, *Rent* is an extraordinary financial success story: Jonathan Larson would have more than a new pair of sneakers. But the effects of its success are philanthropic as well as materialistic. Early in 1997, the Larsons announced the first grant by the Jonathan Larson Performing Arts Foundation, an organization formed with the proceeds of *Rent* to benefit people working in the theater.

Al Larson: It will go towards performers, composers, et cetera. It could take any form: If they need a computer, time in a studio. My hope is to keep the application process simple. I know what goes on in the world of grant-seeking, and it's ridiculous. We have set up a committee of theater people to make the judgments, but to the extent that I have my way, I would hope to award grants to people who have proven their dedication in the way Jonathan did, by working. And, somewhat tongue-in-cheek, I say they have to have been waiting tables for ten years.

Marlies Yearby: *Rent* can help me make things happen for people I know. I was able to pay for rehearsal space for a friend doing her first choreographic work. I put my dancers in to rehearse with Laurie Carlos and Robbie McCauley for two weeks. That was unheard of in my world. Everybody has their different worlds they exist in, and I've chosen to stay in the world we existed in pre-*Rent*.

Matthew O'Grady: I'm going tomorrow to speak at Princeton and Thursday at New York University for the Ali Gertz Foundation, Love Heals. I was sitting there staring at the laptop for weeks, saying, "I've got to collect my thoughts." I realized that I don't want to go back to that scary time when I was first diagnosed. It was really horrific to be young and afraid and have shame and think you're going to die. But I never would have done this had Jon not died, had *Rent* not gone on. Even from the grave, he's pushing me to get out there and say what it's like.

from left:
Gwen Stewart, Wilson Jermaine-Heredia and Timothy Britten Parker backstage at the Nederlander; Aiko Nakasone and guitarist Kenny Brescia.

Rent continues to be a uniquely communitarian experience—sometimes impossibly, idealistically so.

Timothy Britten Parker: It has really helped this cast that there are a lot of people who haven't been in the theater that long. There's a lack of cynicism or jadedness. There are times that the cast have expectations which are not realistic. There are certain traditions in the theater and a certain etiquette, and—not to sound stuffy or conservative—I've seen things happen that I've never seen happen in the theater before. I'm not used to seeing actors have a fit, because we're usually so beholden and submissive. But with *Rent*, there is a feeling that we are all on a very level playing field and that we all have our jobs to do and that anyone can speak up at any time. If somebody has a problem, people take it right to the producers, in front of the whole cast. I've never seen that, ever; I was literally speechless when it happened. Certainly it could be done with a bit more tact, but the message was what was important, and it was an important message to get out there. There's this feeling that, "You're the producer. Fine. But we're doing our jobs, too."

This is a whole different animal, I think, because when Jonathan died, all of us, even those of us in the very fringes of the production, however much we grow apart or together, we will always be cemented in that time and place, our lives permanently in the fabric of that moment. Because of that, there is a feeling of commonality. So there's no point in "you're up there and we're down here." Let's cut through the shit, because we have already been through the shit.

The producers have been more generous than any I've ever heard of. People don't know what the standards are.

Fredi Walker: There is never going to be a cast of *Rent* like this one. Instead of drifting apart because of the success, we've come closer together.

Jesse L. Martin: It feels even more like a family now, like a real family. People are fighting, getting on each other's nerves, making up the next day. It's totally annoying to know that these fifteen people have every right to be in your face. But it's true, because when the show starts, we all remember we're the ones who are supposed to do this.

Marlies Yearby: About a month after it opened on Broadway, I walked in there and I could see *Rent* for the first time. And I liked what I saw. Maybe a veil had been lifted from my eyes, or maybe it was coming from the cast members—we were all released. They could take over the work, live inside it and make it their own. Doing it for themselves is different from doing it to please and to honor. They realize that they do give honor in doing it for who they are as artists. I think when they realized that, the work deepened somehow.

Once the initial intensity of the show's success on Broadway was over, the cast settled in for the long haul. *Rent*'s not just an adventure, it's a job—albeit one with a guiding spirit.

Daphne Rubin-Vega: I have this fantasy that we're the mighty powers. It's like *A Hard Day's Night*, and we're just going to go on and on.

Taye Diggs: Jonathan's death brought it all closer to me. The message was more urgent, more meaningful. I felt that I had more of an assignment. I come in days when I just don't want to be here. And I say, "Okay, you knew this guy personally and he completely made himself an example of what this whole thing was about. So you better go out there and do your thing."

Jeff Potter, *Rent* band drummer: Even when these kids are tired and cracked and ragged, it comes off as very real. I've never seen a cast that puts themselves into it every night like this one does. Nobody phones in their performance. They really identify and feel part of the creation.

John Vivian: They understand the enormity of what's happening here, they know that this is a very unusual animal, and all of them are treating it basically very tenderly and lovingly. There's never been any neglect of the piece.

Michael Greif still gives the cast notes and tweaks their performances.

Michael Greif: Because of the way we built it, with great freedom, I have to remind people every once in a while that they have to remember the parameters. The thing that I'm incredibly proud of is that they are still playing the piece with the same urgency, they still talk to each other. They're not just moving to the same spot every night. I'd much rather have to remind them every once in a while about staging than have to tell them, "I don't believe you care anymore."

Idina Menzel: I know every night that the performers work off each other. They're not so set in what they do that they won't notice different things. If something funny happens, I lose it in the middle, which I can get away with because of my character. I think a lot of it is maintained because everyone keeps it fresh. I change every day as a person, so every day I walk in there, my character changes. Every day something else went on with me that I can contribute to the play.

Byron Utley: In this piece, there are things I'm still finding. That's the beauty of being in the theater: not having to go though the motions every night. Other actors find little things each night, too, and you react to that.

The show is demanding. With only one day off a week, the cast doesn't get to live *la vie bohème* much themselves. Most of them have battled to keep their voices—and occasionally lost.

Tim Weil: You've got to live like a monk. Ideally, you don't smoke. Ideally, you don't drink. Ideally, voice lessons and going to the health club are good. Can we expect people to do all that? I'm not sure. But certainly quite a bit of that you can do to make yourself

"I have this fantasy we're the mighty powers. It's like *A Hard Day's Night* and we're just going to go on and on."

Clockwise from top right:
Cast members backstage at the Nederlander: Byron
Utley; Jesse L. Wilson; Adam Pascal; Rodney Hicks;
Fredi Walker; Anthony Rapp and Daphne Rubin-Vega.

more successful. Because there's a responsibility to yourself, there's a responsibility to the twelve hundred people paying seventy-five bucks a pop, there's a responsibility to your other cast members. What we're asking is not unreasonable, but it is considerable. It's a Broadway show; part of what gives it its thing, its soul, its spark, is that you have these people really singing with a lot of commitment.

Jesse L. Martin: You literally have to tune your life to the show. I have to eat before four, because if I eat after, I'll be sick onstage. I can't eat cheese after two; otherwise I'll be dealing with phlegm. I used to use the excuse "I'm really busy" with my friends all the time, and now I really am busy. I don't go out much anymore. Every minute I get by myself, I take to myself.

Anthony Rapp: I've gone days without talking. I drink a lot of water. I think I've finally figured out a way to sing the show eight times a week, to reel it in without losing intensity. It's a drag sometimes, because you want to be able to let it rip.

Being an artist of any kind is like playing the lottery: very few hit the jackpot. Success of the magnitude people who work on *Rent* have achieved can take getting used to, especially for artists accustomed to working in the margins of the performing arts.

Marlies Yearby: When Jonathan wrote *Rent,* he was in his apartment doing the same thing we do: how are we going to

pay the rent and do the work? In America, as an artist, no matter what the genre, you're going to struggle. *Rent* is a machine, but on this machine are artists who have struggled and have gotten here, for whatever reason. Wilson was trying to decide if he wanted to be in the business at all; Adam just wanted to do his music. We don't want to struggle until we die. That was the hard thing for me once *Rent* happened, feeling okay about not struggling for a moment. That is scary: if I'm not struggling to do it, then how do I do it? The commercial world has always borrowed from the alternative. Usually what happens is that one person from the other world will cut through the door, and then the rest are co-opted. *Rent* has afforded an opportunity to have a dialogue.

Daphne Rubin-Vega: With going ahead come new rites of passage. We aren't these little minstrels, we are actors. We're required to be disciplined; it's a lot of work. It's emotionally, spiritually, physically demanding, and we have earned our right to be recognized for it, to have a living where we are self-supporting and have a chance to take care of our bodies.

The best way for me to keep it real and basic is to remember that I have an incredible core of human beings who have shared this experience with me and whom I love dearly. What keeps me rooted is the feeling that my job is an exceptional job for today. If I keep it really focused on what I'm doing in the show right now, it's like a prayer. It's work, but it's about something. There's a spirit behind the drama, and that's what our lives are about.

Connection

Rent

Love = Art = Disease = Pain = Life

Humanness.

"Otherness"

In our desentised society, the artists, the bohemians poor, discared, "others", recoverin addicts — all are more in touch with their human-ness than the so called mainstream.

despite everything — Humaness, Love, Life, Art Survives.

"What was it about that night?" Mark sings in "What You Own." Everyone has a theory as to why sold-out audiences give *Rent* standing ovations performance after performance. Cynics say Jonathan's death made it a human-interest story, that it's much easier to appreciate a dead artist than a living one. It's certainly impossible to separate that loss from *Rent*'s success: it had an undeniable effect on the media coverage and on the cast's relationship to each other and to the work. But *Rent* has had a great emotional impact on many people who never knew Jonathan Larson: just ask those who camp out overnight for $20 tickets.

top left:

An exuberant cast at curtain call as *Rent* opens on Broadway, 1996; Jonathan's notes, 1993.

Melissa Boberick, *Rent* line regular: How can you see *Rent* and not be profoundly affected by it on some level? So many things affect me: the tremendous talent and energy and love of the cast; the music—the haunting melodies like "Will I?" and "Without You." Numbers that have me on the edge of my seat, like "La Vie Bohème" and "Rent" and "What You Own." It is a truly cathartic experience, taking me from joy to excitement to sorrow and back again in just over two hours.

Nan Larson: One of the things that helps us in our mourning is the effect that the show is having on other people's lives. We get letters from people saying how much the show has meant to them, how it has affected them. And being with people who knew Jonnie real well. Also, remembering things, little incidents that flash through your mind. You try to work your way through it, and I think each one of us does it in a different way.

Jesse L. Martin: Only one of my friends who's HIV-positive has actually seen it. I was nervous, because he's having a hard time dealing with the issues himself. He had been away from New York for some time and had left because all his friends were HIV-positive and everybody had a drug problem or some kind of trauma. When he came back to New York, "everything," he said, "felt so strange to me here, because I used to be king of the streets, and now I'm this guy who feels sort of alien." After he saw the show, he said, "It feels like I'm back home again. You know the best part about the show, and you should tell the director this, is

that it's not about death, it's about hope, and that's the greatest thing I could have ever seen."

My friend Frank said, "You know how everyone goes around with their inner monologues: 'I'm going through this kind of hell and that kind of hell'?" This play allowed him to let it all out. He was allowed to feel weak, and feel afraid, and be sad, and be joyous and celebratory, and not feel bad about it.

Kevin McCollum: *Rent* has a tremendous amount of sentimentality and romanticism to it. People say, "Why doesn't Mimi die?" Because it's about living another day with your diseases, or your emotional roadblocks, or your medical roadblocks, or economic roadblocks, and realizing they're only roadblocks. The fact that in the theater we're not alone in this experience makes it feel safer to connect. We're in an age where all the profit is made by not showing up: movies, America Online. Beam it! Project it!

Jonathan Burkhart: Here's what I think *Rent* does: it puts on the table a lot of things we think about but are afraid to vocalize. Like saying, "I love you." And saying, "I'm afraid." And saying, "This is what I believe and this is what I will do." People come away and think that things do matter.

Jonathan himself called *Rent* the *Hair* of the '90s. Certainly the show presents the styles, interests, beats and beliefs of a generation that had not been depicted on a Broadway stage before—it's powered by youthful energy. And yet, *Rent* is not just reaching fifteen to thirty-five-year-olds.

Wilson Jermaine Heredia: This play is the anthem of all artists.

Daphne Rubin-Vega: There are particulars that color this that are very identifiable to our generation. But they're not as fantastic as one might think. In the book and the opera of *La Bohème,* they burn their manuscripts and they suffer for their art and they're very sort of elitist and apart from the rest of society because of it. I don't think that's a very common experience in our generation. It's no longer a big elitist thing. Everybody's struggling in some way or another.

Adam Pascal: It doesn't speak for a generation, it speaks to a generation. And to everybody else, because it's such a moving and genuine story. It's not a Pepsi commercial. I think if you at all are a music fan, you should come to the show. I spent my life playing hard rock in heavy-metal bands. That doesn't stop me from seeing the beauty of this and loving the music. If *Les Mis* is the kind of thing that makes you nauseous, this might be a good antidote. I've never been involved in something that won so many people over.

Idina Menzel: It's just people trying to live their lives with passion and creativity and love. It's the struggle to get it all in time, and to see through your dreams. That's anybody and anytime. I think that what's going to save it from anybody who has close-minded ideas is that once they sit in the seat and the music comes at them, they can't resist, because music's music, and it will seep through the pores, and they're going to have to feel something.

Al Larson: *Rent* hits home with people of all ages. I see people with gray hair in the audience and I think, "What are they doing?" That's one of my regrets, that I can't tell Jon how good a job he did, how enduring his message is.

Allan Gordon: People say it's not a family show. Take a look at the audience and you'll see grandparents, parents, kids, whole extended family groups. It's not a mindless spectacle. It has a message, but it's not judgmental. You see things from other people's perspective—it softens you to some degree. These characters are the real thing. You see how people are living with insurmountable odds. It shows how they cope with them, how they respond to them, the emotions involved, the unfairness of it all, and yet the life support and community they give each other. It is life-affirming. I have seen the show countless times and its ability to affect me remains diminished. Talk about impact.

Rent is a beautiful love story (or three), a joyous musical, a tear-jerking tragedy. But it's also a play with a serious message.

Shelley Dickinson: This piece represents those of us who are looking forward—both performers and the audience. A large part of our population lives many years ago, they have a difficult time accepting "otherness." All you hope is that somebody can be touched or get a little bit more understanding.

Eddie Rosenstein: The art of *Rent* is that people who have no connection to this population could see these people as human beings and may walk out with an empathy they didn't have.

Timothy Britten Parker: Jonathan rarely got on his soapbox. The political messages are apparent in the piece, they're vital and undeniable, but it's not preachy. It's a love story in its most simple form. Jonathan was filled with compassion for Matt, for Pam, for Gordon, for all people, because of who he was and the way he lived. It's hard for many people to remember and identify with how hard life is, how lonely life can be when you seem to live on the fringes of society, when you're sick or poor or gay or live what some might call an alternative lifestyle. One thing about *Rent* is that it reminds people or informs people for the first time that these are lives of quality, that they have as much value as any other life. It's such a powerful message, and that was part of Jonathan's life.

"Connection in an isolating age," Mark answers his own query in "What You Own." In his final statement of concept to Jim Nicola, Jonathan said *Rent* was about a community. In the story about *Rent*, community is a continuing thread: the Larson family, Jonathan's friends and their Peasant Feasts, the cast and crew, the people who come to the theater each night and share an experience. Connecting is the opposite of being rent, as in torn apart. Jonathan wrote *Rent* because of friends who had a disease to which society had responded with prejudice and hatred—because he was horrified by the way fear was replacing compassion. The love he poured into *Rent* is what *Rent* now receives.

Fredi Walker: I think Jonathan's spirit is part of what made this piece what it is. You get what you put out, and he put out so very much. *Rent* works because it hits things that everybody understands. Your mother is there, and everybody understands that moment. You have a wedding with Roger and Mimi, and everybody understands that moment. A funeral when Angel dies, and there's great grief—everybody understands that. *Rent* is about love.

Adam Pascal: The energy we bring to it, the connection we have offstage, transfers. People ask us if we love each other as much as it looks like we do, and we do.

Jonathan Larson, in a statement written shortly before his death and found on his computer: In these dangerous times, where it seems that the world is ripping apart at the seams, we all can learn how to survive from those who stare death squarely in the face every day and [we] should reach out to each other and bond as a community, rather than hide from the terrors of life at the end of the millennium.

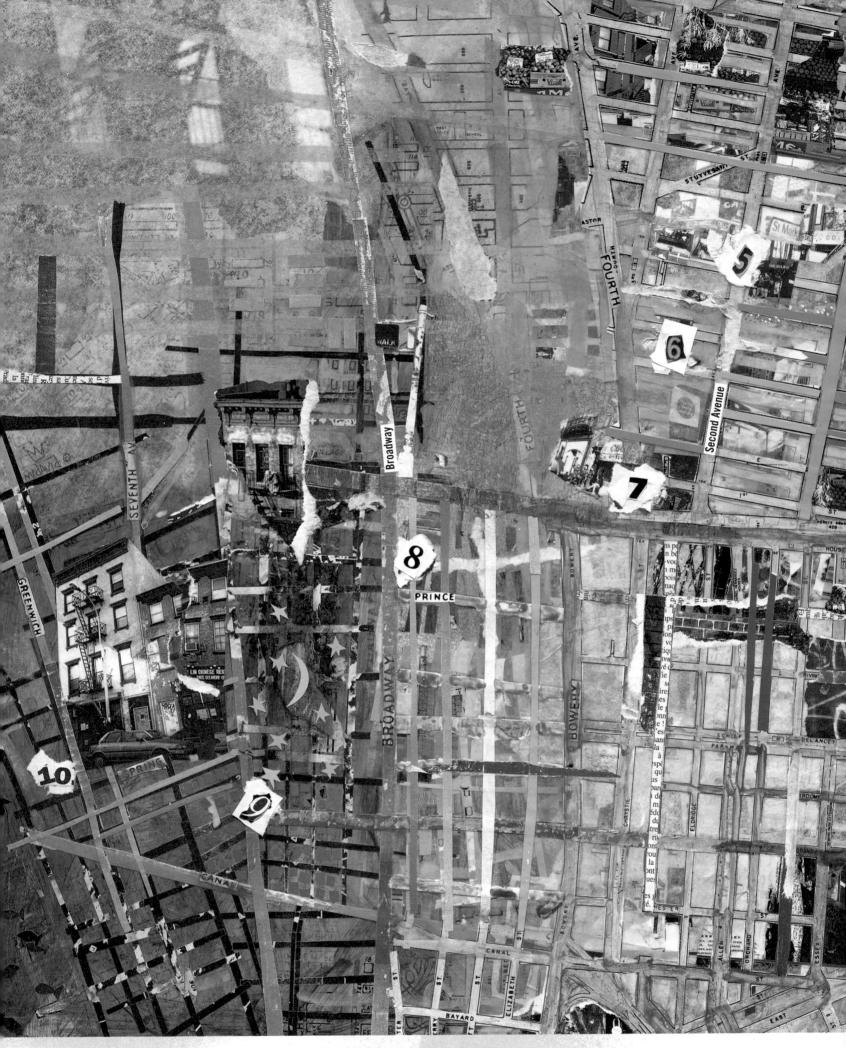

THE GEOGRAPHY OF *RENT*

1. 11th Street vacant lot, the stage for Maureen's performance piece, "Over the Moon"
2. The Life Cafe, 343 East 10th Street (at Avenue B)
3. Tompkins Square Park
4. Community Garden with Christmas tree sculpture (at Avenue B and 6th Street)
5. St. Mark's Place
6. New York Theatre Workshop, 79 East 4th Street (between Bowery and 2nd Avenue)
7. CBGB & OMFUG, 315 Bowery
8. Friends in Deed, 594 Broadway
9. Moondance Diner, 80 6th Avenue (at Grand Street)
10. Jonathan's apartment, on Greenwich Street

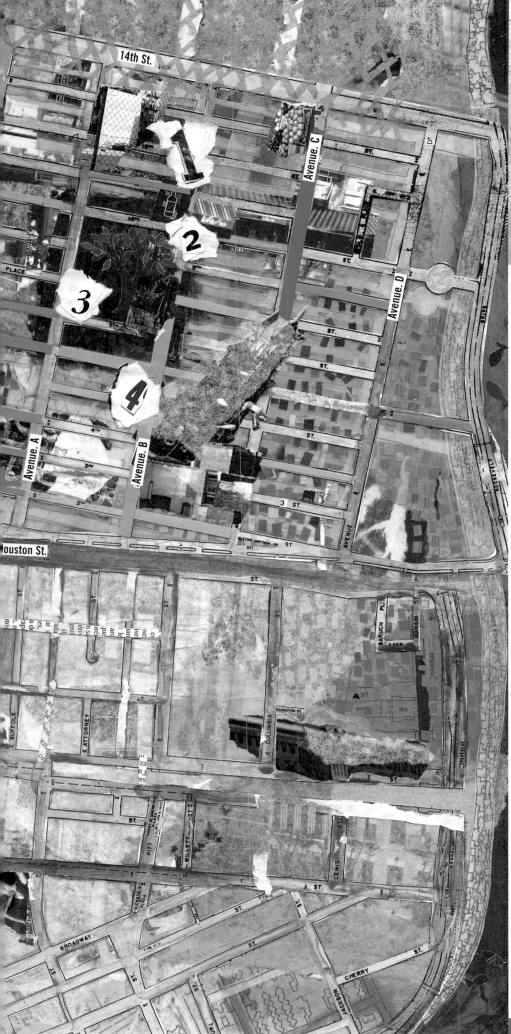

14th St.

Avenue. C

Avenue. D

1

2

3

4

Avenue. A

Avenue. B

ouston St.

THE LIFE CAFE, where Maureen hosts the party after her performance: you can get good, cheap huevos rancheros and margaritas at this restaurant and bar on the corner of Avenue B and Tenth Street, on Tompkins Square Park. Its reading series was a literary and performance hotbed during the downtown arts revival in the 1980s.

TOMPKINS SQUARE PARK. The riot on Avenue B that occurs at the end of *Rent*'s first act is based on the violent and bitter East Village turf battles that erupted in the late '80s, prompted by the city-imposed curfew in Tompkins Square Park.

Since the draft riots of the Civil War, Tompkins Square Park has been a stage for political action, the site of free concerts by the Grateful Dead and Jimi Hendrix in the 1960s, the downtown arts revival in the early 1980s and the original Wigstock celebration, perhaps the largest drag festival in America. Tompkins Square park is still a gathering point for the neighborhood, with drumming circles, tables for chess games, and a dog run.

ST. MARK'S PLACE. As depicted in the "Christmas Bells" scene in *Rent*, St. Mark's Place has been a counterculture bazaar and hangout since the 1960s. It has also become the commercial heart of the East Village. On this strip of Eighth Street between Third Avenue and Avenue A, you can buy cheap sunglasses, vintage clothes, underground comics and used Cds; have a nipple pierced; and at one shop, sip a cappucino while getting a tattoo.

CBGB & OMFUG. The name stands for Country, Bluegrass, Blues, and Other Music for Uplifting Gourmandizers, but since the 1970s, when acts like Patti Smith, Television, Blondie, and the Talking Heads played there, this club on the Bowery has been punk rock's main home. In *Rent*, posters on the wall of Mark and Roger's loft advertise gigs by Roger's band at CBGB's.

MOONDANCE DINER. For nine and a half years, Jonathan Larson waited tables at this renovated railway dining car, which has been parked on Sixth Avenue since the 1940s. When he quit, shortly before *Rent* went into rehearsals, he wrote his colleagues a farewell letter: "What I've loved has been the lack of pretension, the human scale of this place, the supportive management ... and, of course, the regulars."

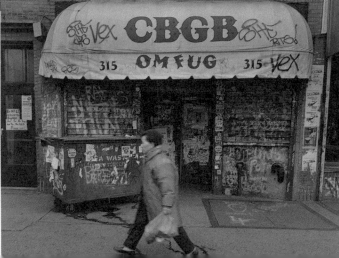

MICHAEL GREIF
Director

*Michael Greif received nominations for the 1996 Tony and Drama Desk awards, for Best Direction of a Musical, and won the Obie Award for **Rent**. He is the artistic director of La Jolla Playhouse, where he directed **Randy Newman's Faust**, **Slavs!**, **Thérèse Raquin** and **What the Butler Saw** and codirected, with Bill Irwin, **The Three Cuckolds**. As an artistic associate at the New York Shakespeare Festival, Greif directed **Machinal**, for which he received the Obie Award, **A Bright Room Called Day**, **Casanova**, **Marisol** and **Pericles**. Regionally, he has directed at Baltimore's Center Stage, Providence's Trinity Repertory Company, the Williamstown Theater Festival and Los Angeles' Mark Taper Forum, among others. Greif has had a long association with New York Theatre Workshop, where he directed **Seven Scenes of Halloween** and the studio and off-Broadway productions of **Rent**.*

Jonathan's tenacity is an incredible lesson in perseverance and belief in yourself. I think it's important for people to hear that. I remember what Julie Larson said at the Tonys: "My brother was an overnight sensation after fifteen years of hard work." It's incredibly ironic and sad to me that Jonathan worked for so long with little professional encouragement, and yet he still worked. And now look what they're saying about him! Too often we need to find that encouragement from other sources, and he found it within himself.

I liked that *Rent* was a musical about people I knew. I liked that it celebrated the kinds of people who aren't often celebrated in musicals, and I worked hard with Jonathan to make sure we presented those people in rounded, developed and, I hope, truthful ways. In some way, I was attracted to a romantic notion of my own past life as a struggling creative person in New York City. When my friend Gordon Edelstein saw the play downtown, he said, "Even if you are no longer young, you remember when you were. And even if you never lived on the edge, you fantasized about living that way." I think that's a really accurate and enlightened opinion about why people respond to *Rent* the way they do.

I had always hoped I would only do the work that I most wanted to do. Now, with the success of *Rent,* I have the financial security to be more loyal to that hope. I can attach myself to projects that matter most to me, even if they require long-term commitments. I'm most excited by the kind of theater produced in nonprofit regional theaters like La Jolla Playhouse and New York Theatre Workshop, which take great chances in developing new material.

*Gilles Chiasson made his Broadway debut in **Rent**. He has acted in national tours of **Les Misérables**, **Forever Plaid** and **Gift of the Magi**. Off-Broadway he has had roles in **Groundhog** and **Rent**. His regional credits include parts in **Heartbeats**, **A Little Night Music**, **The Good Person of Szechuan**, **Pippin**, **A House Divided** and **Broadway Bound**. Chiasson is a founding member of the Adirondack Theatre Festival.*

GILLES CHIASSON
Ensemble

I'm one of the few members of the cast who loves musical theater. But musicals suck most of the time, especially when viewed through a contemporary lens. Most are antiquated in terms of their politics; they're apolitical. A musical carries a funny burden, because it is an emotionally driven medium. The thing that drives a musical is not necessarily plot, and certainly not its intellectual content; it's really an emotional ride. *Rent* has a point of view that takes the risk of stating what it believes. It risks failure in many ways, which is one of the things that makes it exciting.

One of my hopes for the play is that it will inspire a generation of writers. Whenever I talk to a group of high school kids, I tell them, "If you want to write a musical, go listen to them. You have to challenge yourself to explore the medium you're going to write in." I encourage them to listen to *Carousel* and the Police. That's why *Rent* is successful; even though there are all these bass lines that sound like Sting or U2, Jonathan knew how to write a lyric for the stage. That's how he was able to successfully bring pop music back into the theater.

TAYE DIGGS
Benny

*Taye Diggs previously acted on Broadway in **Carousel**. Off-Broadway he performed in **Rent**. He has appeared on television in **New York Undercover**, and also acted in the film **Blind Date**. Diggs' other credits include **The Greeks**, **Black Love Song #1** and **Dutchman**.*

Before I started acting, I wanted to be a psychologist. Cheesy as it sounds, I wanted to help people. I was always the one people went to for advice. I guess being onstage and doing my thing is one way of helping people, by taking them away from whatever they want to be taken away from.

At the time I got involved in *Rent*, I had just gotten back from a seven-month stint working at Tokyo Disneyland. I don't care what anyone says: it was a life-changing experience. It was a chance to see Japan. They pay you amazingly well and treat you like a king. I'd been in New York for a year doing *Carousel*, and I was bored. I was fed up with the city and had never been outside of America, so I auditioned, got in and got over there. It turned out that I was doing a Caribbean cabaret thing. I wore bananas on my arms, a straw hat. Kind of minstrelsy, but it wasn't anything Harry Belafonte didn't do.

One of the cool things about Mike as a director is that he didn't do much explaining. That's one of the reasons we in the cast are so attached to our roles: we literally created them. The process of getting to know the cast paralleled the process of the play growing. Since we were always rehearsing, I was always the bad guy. So I was never interacting with the other characters as much. I was busy being bad. There were times when I just wanted to hang out with everybody else and dance on the table. Instead I had to bury myself deep in the character so I wouldn't be personally affected by being the one that everyone thinks is the asshole. Now my character has a lot more complexity. But to hear what people thought of me back then is really interesting, because they thought I seemed really closed off and not very approachable. I don't consider myself like that at all.

WILSON JERMAINE HEREDIA
Angel

Wilson Jermaine Heredia made his Broadway debut in **Rent**, for which he received the 1996 Tony and Drama Desk awards for Best Featured Actor in a Musical. Raised in Brooklyn, Heredia previously starred in **The New Americans**, for which he composed the song "No Es Asi." He has also appeared in **Popol Vuh** and **The Tower**. Wilson has danced in and choreographed several music videos, including "Joli" and "Josue de Jesus."

My mother is a seamstress and my father was a super. But they were both very musical. My mother sang a lot and my father played the guitar. I connected music with happiness, a way that we enjoyed ourselves. I was very withdrawn in elementary school—I didn't know how to relate to people. I was always daydreaming. I was accustomed to affection from my parents, and the kids in school were neither affectionate nor kind. When I broke out of my shell in high school, people were shocked.

I studied medicine and thought about advertising, but I realized I had to express myself, so I got into acting. I still have the manager I had in the very beginning; he's a good friend of mine. He took me on because he liked me. I lied and said I had taken a course in acting. But he saw that I had balls, that I had hunger. He's one of the people I'm doing this for.

Angel is a fun character, and I'm not afraid to dress up, to wear heels and look pretty. I'm not afraid to change my image to play a role. I become very expressive. Dressing up as Angel makes me feel fabulous.

Originally from Philadelphia, Rodney Hicks made his Broadway debut in **Rent**. He appeared in the world premiere production of **I Was Looking at the Ceiling, Then I Saw the Sky**. He performed in the national tour of **Jesus Christ Superstar**. Off-Broadway he has performed in **Rent**, **Lotto**, **Chaos** and **Bring in the Morning**. He has appeared on television in **One Life to Live** and as cohost of **Dance Party USA**.

RODNEY HICKS
Ensemble

Rent seemed really "street," and that wasn't anything new for me. Except that I come from the suburbs! As a young black male, I used to get cast only in street roles. But I'm straight out of suburban Pennsylvania! My father, who raised me and my brother by himself, was a lieutenant in the police department. I rarely went out, never partied. My dad expected a lot of me. When I was a teenager, I resented it, but I realize now that it was out of love.

At twenty-two, I'm the youngest person in the cast. I came to New York in February 1995 from two years of college in upstate Pennsylvania. One of the first jobs I got was at the Theatre for Young Audiences in a play called *Blocks*, and Jonathan wrote the music. It had issues similar to *Rent*'s. I was one of five adolescent characters. Anthony Rapp was in it, too, and Yassmin Alers, who's an understudy in *Rent*, played the lead.

During *Blocks*, I saw how intense Jonathan was about his work. His dedication impressed me deeply, and it's something I can learn from. The experience of doing *Rent* has made me very open-minded. I'm so grateful that Jonathan believed in me.

KRISTEN LEE KELLY
Ensemble

*Kristen Lee Kelly made her Broadway debut in **Rent**. Off-Broadway she has performed in **Rent**, **Loved Less**, **Blaming Mom** and **The Apollo of Bellac**. Her regional credits include **The Diary of Anne Frank**, **The Heidi Chronicles**, **Oleanna** and **Dream of the Red Spider**. She appeared on television in **The Kennedys of Massachusetts**.*

Before *Rent*, I sang with this blues band called the Reputations. But I just sang *ooohhhs* and *aaahhhs* in the background and wore really tight black dresses. We played at little clubs like Kenny's Castaways and the Rock 'n' Roll Cafe. In high school I wanted to be Stevie Nicks more than anything in the world, so I would perm and frost my hair. I used to write her lyrics down on rainbow stationery and put them on my wall. I thought I was being really deep!

At the time *Rent* happened, I was still waiting tables, and a couple days after I'd gotten the part, the restaurant manager came up to me and said, "You're not folding the napkins right." I remember looking at him, and the concept of "No Day But Today" really hit home. I quit a couple days later, not knowing we were on our way to Broadway. Any doubts I had about *Rent*, the money and so on, went completely out the window.

*Jesse Martin has appeared on Broadway in **Timon of Athens** and **The Government Inspector**. Off-Broadway he has performed in **Rent**, **The Arabian Nights** and **Ring of Men**. Regional credits include **I Ain't Yo Uncle**, **Shakespeare's Rock-n-Roles**, **The Butcher's Daughter**, **Two Gentlemen of Verona** and **Romeo and Juliet**. He has appeared on television in **New York Undercover**, **One Life to Live** and **Guiding Light**. Martin is currently preparing two one-man shows, **Fiend** and an untitled piece based on the life of Marvin Gaye.*

The first time I knew what a play was, I was in the fourth grade. We had just moved to Buffalo from a part of Virginia that was the deep Deep South, way in the hills. I was part of the first year of forced busing at my school. On the first day of school there was a huge riot; they turned the bus over with the kids still in it.

JESSE L. MARTIN
Tom Collins

One day this really sweet teacher, Miss Barney, asked me if I wanted to do a play called *The Golden Goose*. I played a priest and had only one scene, marrying the prince and princess. I was scared, because I had a thick southern accent, and I was reluctant to say anything. My teacher told me, "Just say it, say it, it doesn't matter." The only preacher I'd ever known was the preacher back in Virginia. So I go, "We ahh gathahed heah t'day...." The whole school thought it was hysterical. They loved it! I thought, "Wow, this is a great way to get attention!"

Everyone in *Rent* is sort of raw. We don't have that shiny, happy mentality that is typical of the music-theater crowd. There's a lot of me in Tom Collins. I remember Jonathan had this specific idea that Tom Collins reminded him of Tom Waits—a grizzled character, just a big mess with a heart of gold.

Being in *Rent* has changed how I feel about singing. I used to think that in musicals you had to be a completely different kind of actor. You don't. Musicals can actually be even more expressive than straight drama. That's opened me up in a way, but in another way it's put a lot of pressure on me, because people see the show and say that you're amazing, but whatever they see you do next has to be equally amazing. Although I'd rather be in that position than not. I'm lucky; working with such a talented group of people has brought out the best in me.

*Idina Menzel made her Broadway debut in **Rent**, for which she received a 1996 Tony Award nomination for Best Featured Actress in a Musical. Menzel is a singer/songwriter who performs with her own band on the New York club circuit. She recently signed a deal with Hollywood Records.*

When I was fifteen, I got a gig with a wedding band. I lied and said I was eighteen. I was making money and had my own savings account. In my neighborhood, other kids had crazy allowances and took everything for granted, got into drugs and sex early. I never quite felt I belonged. So this job was a good excuse to not have to go to their parties on Fridays and Saturdays. I was proud to be working.

IDINA MENZEL
Maureen

When I started doing *Rent,* I was so scared I was going to let Jonathan down. To research the role before my first rehearsal, I got videotapes of *Dyke TV* and some stuff on Reno and Laurie Anderson. I read a lot on Karen Finley. The East Village performance scene had a lot of very powerful and expressive women. I'm not especially political, and artistically I have chosen to be more optimistic in how I express myself. Perhaps this is conveyed through Maureen, negating that stereotype of the angry woman performer.

At first, when the show was getting so overwhelming vocally, physically and time-wise, I didn't think there'd be a way for me to keep my music as a part of my life. Every time I got to the piano, I'd think, "I'll have less of a voice." Slowly but surely I've developed endurance for the demands of the show, so that I can wake up and do what I need to do for myself—work with songwriters and producers, sing—and have enough left over to do this show. But my truest dream is to be a singer and perform my own music.

*Before appearing in **Rent**, Aiko Nakasone performed in the Broadway revival of **How to Succeed in Business Without Really Trying**. National tours have included **The Who's Tommy** and **Starlight Express**. She also performed in **Rent** off-Broadway.*

My mom came from Japan and lived her life as a dancer. That's where her beauty comes from. I grew up dancing, but still my family emphasized that I should do something practical. So I graduated from New York University with a degree in finance. But I needed to take a risk and do what I love. Even though my mom preached practicality, I chose to follow in her footsteps.

AIKO NAKASONE
Ensemble

The first couple of weeks in *Rent,* I thought the music was great—groovy and appealing. But I kept wondering whether it would be too out-there for the general public. I had some concerns that the production would exploit the communities depicted in the play for shock value rather than presenting them as a way of confronting real-life issues. With "La Vie Bohème," I thought about some of the words: "To faggots, lezzies, dykes, cross-dressers," and I considered some of the topics: S & M, drugs, AIDS. For a long time I thought the work was great for off-Broadway, but that it wouldn't cross over too well. But after *Rent* started getting performed, I realized that audiences really connected to its messages about love and integrity.

If *Rent* makes people more open to Broadway, then I'm glad. People say it's an unusual work for Broadway, but truthfully, I think people have been looking for work with messages like these. *Rent* very much speaks to the issues we live with.

*Timothy Britten Parker has previously appeared on Broadway in **The Visit**, **Runaways** and **The Innocents**. His forty-nine off- and off-off-Broadway credits include **Night and Her Stars**, **Machinal**, **The Cherry Orchard**, **Rent** and Jonathan Larson's **Superbia**. He is a founding member of Naked Angels Theater Company. Favorite roles there have included parts in **Summer Winds**, **Suffering Colonel**, **Heartsick Pioneer**, **Perfectly Happy**, **Claus** and **Chelsea Walls**. He was seen in the films **Quiz Show** and **Joey Breaker**. On television he has appeared in **Law & Order** and **New York Undercover**.*

TIMOTHY BRITTEN PARKER
Ensemble

I feel very comfortable and safe doing plays where I don't have to reveal myself. But I find it terrifying to do a musical. To sing in front of people is the ultimate show of vulnerability. When I sing, I'm immediately saying, "This is who I am."

I knew the real Gordon, a friend of Jonathan's who died of AIDS. When we did *Superbia* at the Village Gate, he worked with the costumes and did various other things backstage. That's also how I met Pam, who I later went out with, and who also died of AIDS. It's less that I feel I have a responsibility to portray Gordon and more to show the pain and hurt of his being gone. His point of view in the support group is an important one, because everyone else is so accepting, one day at a time, no regrets, and Gordon says, "Fuck that, I have lots of regrets." Because of the emotional vulnerability and intensity of the role and because that vulnerability is projected straight out to the audience, it was terrifying. It took me six months to relax.

When I think about *Rent*, I think about the beginnings and endings of important relationships like the ones I had with Jonathan and Pam, as well as my relationship to my work in theater. There's some aspect of all of us that needs closure. These have become meaningful, powerful moments, landmarks of my life.

*Adam Pascal made his debut theatrical performance in **Rent**, for which he received the 1996 Theatre World Award for Best Actor in a Musical, as well as nominations for the 1996 Tony and Drama Desk awards. Prior to joining the cast of **Rent**, he played guitar with the group Mute.*

I was born in the Bronx and raised on Long Island, in the same town as Idina Menzel. I realized at ten or eleven that music was what I wanted to do with my life. The singers I loved while I was growing up were from these amazing heavy metal bands. They were expressive and they had the most beautiful, incredible voices. The singer from Queensryche;

ADAM PASCAL
Roger

Bruce Dickinson from Iron Maiden—the guy's brilliant! They had real quality in their voices, and I would try to sing along. Half the time it was way out of my range.

Look at the character I'm playing. Jonathan had told me that he was kind of Kurt Cobain, kind of Eddie Vedder. And I thought, "Well, those are the two guys everyone's going to pick." But in Jonathan's defense, he was a theater guy. When he said those names, I knew that the way I sing would work. He was looking for the passion.

At this point in my life, everything's going so well that I should be smacked if I complain. A little notoriety, opportunities to do some films here and there. How could you argue with that? I've just got a new band together and I'm writing music. I've had auditions that have gone very well, and a couple that didn't. At one audition, they said, "He's real green." I am real green, and in the process of becoming a lighter shade of green.

ANTHONY RAPP
Mark

*Anthony Rapp has been associated with **Rent** since its studio production. On Broadway he has appeared in **Six Degrees of Separation** and **Precious Sons**, for which he won an Outer Critics Circle Award and was nominated for a Drama Desk Award. Off-Broadway he has appeared in **Rent**, **Raised in Captivity**, **Trafficking in Broken Hearts**, **Youth Is Wasted**, **Sophistry** and **The Destiny of Me**. He has acted in the films **Adventures in Babysitting**, **School Ties**, **Dazed and Confused**, **Six Degrees of Separation**, **Twister**, **The Mantis Murder**, and **David Searching**, and on television in **The Lazarus Man**.*

I came out in the fall of 1992, when I was in *The Destiny of Me*. I thanked my then-partner-for-life (that's what I naively called him) in my bio. It was an important moment for me; at that time, I decided that part of my life's work was going to be helping to break down this particular barrier. I love the response I've gotten from kids, especially those of high school and college age who are at various stages of coming out and who really thank me for being out. I also like the fact that all the queer principal characters in the show are played by straight people.

Since I've been doing *Rent*, I have felt that I have been able to grieve Jonathan's death with every performance. Preserving Jonathan's show is a way of mourning him. We are living with him every day. We get to go to the theater and still be with him. After Jonathan died, Michael Greif said to me, "You get to be him for us for a while now." That was intense. He didn't mean it literally, but I was a link to Jonathan because Mark is a link to Jonathan. Jonathan's friends said similar things. There were gestures I was making unconsciously that they said were things that Jonathan did. At the end of every show, after the curtain call, I send four claps up to Jonathan.

DAPHNE RUBIN-VEGA
Mimi

*Daphne Rubin-Vega performed in the studio production of **Rent**. She received the Theatre World Award for Best Actress in a Musical, and was nominated for the Tony and Drama Desk awards for her performance. Currently, Rubin-Vega is working on her debut album for Mercury Records.*

I was born in Panama and eventually ended up in Greenwich Village. When I think about Village bohemia, one of the things I think of is my dad, who is a writer. My stepfather is Jewish and my mom, who died when I was a kid, was a dark-skinned Latina. They moved into this Italian neighborhood just as it was getting gentrified, so it was a real big thing at the time. My stepfather is named Rubin and my real father is Vega. So my name is my homage to my dads.

Panama doesn't have much by way of living treasures, so to speak, so when I was presented with a plaque of honor from the president and the Panamanian consul, it was pretty major. They have lots of jockeys and boxers, but no females that I can think of. They were totally thrilled with the fact that there was a Panamanian cultural ambassador on Broadway.

I feel like this is being a part of history, like I'm a part of something greater. But there's nothing like doing your own stuff. I always call those dreams my babies, and you have to attend to them.

In many ways, *Rent* has changed my life: I have a fax machine. I treasure my sleep. I respect the parameters of my body. I still live in the same crib, and I pretty much have the same friends. But I've made other friends, who've shared the same experience and know what time it is here. And there's glitter everywhere now! It's in my bed, in the dog, embedded in my scalp. It's getting on my nerves!

GWEN STEWART
Ensemble

*Gwen Stewart has performed on Broadway in **Starmites** and **Truly Blessed**. She has appeared off-Broadway in **Rent** and **Suds**. Her regional credits include **Avenue X**, **Ain't Misbehavin'**, **Dreamgirls**, **The Wiz**, **Abyssinia** and **Big River**. Stewart is also a two-time winner on **Showtime at the Apollo**.*

Unlike a lot of other people, I did not think *Rent* was going to make it to Broadway. I didn't think the Great White Way was going to accept something like *Rent*, with the kind of issues it dealt with. I knew it was a special piece, the music was phenomenal and Jonathan dared to talk about things no one else wanted to address.

I'm very happy and honored to be one of the few people who were handpicked by Jonathan for *Rent*. I'm sad, though, because the song "Seasons of Love," with my gospel solo, as he called it, blossomed after Jonathan passed away. He never had a chance to hear me sing it the way I sing it now. I regret that. Every night I say, "Well, if you can hear me, honey, this is for you."

*Byron Utley has previously performed on Broadway in **Death and the King's Horseman** and **Big Deal**. Regional theatrical credits include **I Ain't Yo Uncle**, **A Midsummer Night's Dream**, **Joe Turner's Come and Gone** and **Othello**. Off-Broadway he appeared in **Rent**. Utley has acted in the film **Night and the City** and the television shows **Law & Order**, **Ghostwriter** and **The Dudley Moore Show**. He was the featured vocalist with Hannibal Peterson at the 1995 Theatre Festival in Venice and Milan. Utley also participates in the Colgate Palmolive Partnership Mentor Program.*

BYRON UTLEY
Ensemble

Before I did *Rent*, I wasn't too interested in doing another musical. I was sick and tired of the British imports and was bored with the musical theater being produced on Broadway. It seemed very white-bread, Middle America. It wasn't about our time or what was really going on, especially in New York.

Rent is uniquely on target with all that. In this show, you're dealing with homelessness, gay rights, human rights, housing. We are all affected by these issues. To me, the piece is political as well as spiritual. Theater gives you a podium, a platform to say certain things you might not otherwise have the opportunity to say.

Even though I'm a performer, I have a lot of interests that are not connected with the entertainment business at all. Offstage I try to weave creativity throughout my life and my relationships. I mentor kids, I do a lot of photography, I love cooking, I paint. I want to do creative work that helps people discover their true self, which is spiritual. When you discover your own divinity, you can generate all kinds of wonderful possibilities.

Fredi Walker made her Broadway debut in **Rent**. Prior to **Rent**, Walker directed the Audelco Award–winning play **When the Chickens Came Home to Roost**. Her acting credits include **Once on This Island**, **Cinderella**, **Little Shop of Horrors**, **Ain't Misbehavin'**, **They're Playing Our Song**, **Nunsense II**, **God Is a Guess What**, **Esther**, **A Vaudeville Meghillah** and **The Buddy Holly Story**. On television, she has appeared in **New York Undercover**, **The Upper Room** and **Night of Swords**.

FREDI WALKER
Joanne

Joanne and I are not one and the same. Her outward identity is that of a lawyer and a lesbian, and this is not my identity: I'm a heterosexual actress. But in terms of her internal needs and wants, I can relate completely. Her work, her social life, her friends: she's good with that. She's cool with her blackness. She's worked out a lot of her baggage. But the one thing she longs for is love, and I can relate to that, too. She goes out and gets her law degree and defies her parents. I understand that. My family are all teachers and professionals. They thought I was stupid to go into acting. But my mom finally said, "It's her life, she's gotta do what she's gotta do."

Jonathan reminds me that in spite of the hardships of the business, underneath was a man who gave his life for what is one of the best spiritual messages available in the form of entertainment. The spiritual message of *Rent* is all about love, accepting the imperfections of others, being human. That's what *Rent* is about, and it's what we in the cast have allowed ourselves to do with each other.

THE UNDERSTUDIES

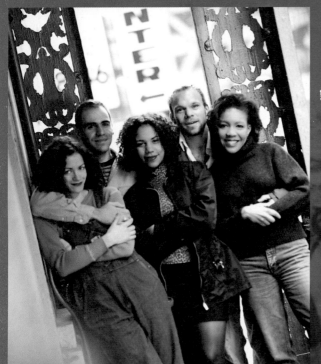

From left: Yassmin Alers, Mark Setlock, Shayna Steele, Norbert Leo Butz, Shelley Dickinson

YASSMIN ALERS made her Broadway debut in **Rent**. Off-Broadway she has appeared in **Bring in the Morning** and **Blocks**. She understudied in the European premiere of **The Who's Tommy**.

As an understudy, you can't get totally focused on one character. You have to be wide open. Although sometimes it feels like you have multiple personalities, it's a wonderful thing to experience the show from so many different views.

MARK SETLOCK was featured in the studio production of **Rent**. He has appeared in productions at HERE, Primary Stages, Ontological/Hysterical, NADA, the Beckett, ONE DREAM, and the Adirondack Theatre Festival, among others.

I enjoy going on as Angel, but there's a higher stress level since Wilson won the Tony—I have a lot to live up to. If I can get through Wilson's dance, the rest of the show is cake—that dance is hard!

SHAYNA STEELE made her Broadway debut in **Rent**. Regional credits include **The Wiz**, **Little Shop of Horrors**, **Big River**, **Chicago** and **Annie**.

At first I was somewhat intimidated at the prospect of working with such a tight-knit and talented cast. But I put my heart and soul into the show, because the show's all heart and soul.

DARIUS DE HAAS performed in the world premiere production of **I Was Looking at the Ceiling**, **Then I Saw the Sky**. He has appeared on Broadway in **Carousel** and **Kiss of the Spider Woman**. He was in the national tours of **Once on This Island** and **Heart Strings**. His regional credits include **Cry the Beloved Country**, **Five Guys Named Moe**, **Jacques Brel Is Alive and Well and Living in Paris**, **Hair**, **A Christmas Carol** and **Dreamgirls**.

I've played two parts of a couple—Angel and Collins—within days of each other. That's really challenging, especially since you have to know both parts of their harmonies. But you bring a freshness to the roles when you swing—you go onstage with your own point of view.

SHELLEY DICKINSON appeared in the national tour of **And the World Goes 'Round**. She has appeared off-Broadway in **Merrily We Roll Along** and in the studio production of **Rent**, as well as in numerous regional productions. Dickinson has also performed in concerts and benefits at the Russian Tea Room and Carnegie Hall.

Understudying Gwen's part scared me more than understudying Joanne, because I played Joanne in the workshop, so I already knew who she was. The first night I went on for Gwen, I was a mess. It was intriguing to people that I was having angst, but I think the bag-lady role is so important, because sometimes we're not conscious of whose space we're invading.

NORBERT LEO BUTZ spent four seasons at the Alabama Shakespeare Festival. He has played the title role in **Lizard** and appeared in **Hamlet**, **Saint Joan** and **Balm in Gilead**. Other credits include productions for the Repertory Theatre of St. Louis, Hope Rep and New Stage Theatre.

I went on as Roger ten days after signing my contract, and the audience clapped for me. I thought, "Okay, they're not going to throw tomatoes."

THE BAND

DANIEL A. WEISS (Keyboards/guitar and associate conductor)

*Daniel Weiss has worked as a freelance musician and composer in New York since age seventeen. He assisted Tim Rice in recording early versions of some songs from the film **The Lion King**. Weiss played and arranged on **Big Skies**, the debut album by the band Miles High, as well as on the soundtrack for **Mr. White**, a romantic comedy featuring Paul Reiser and Martin Mull. He is collaborating with singer/songwriter Ina May Wool for their upcoming debut on Megadisc Records.*

In these songs, we changed a lot of grooves and parts, which gives an organic quality to the arrangements. If I realize the bass is doing a certain funkiness, I'll adjust my part accordingly. Like with the organ stuff, there was a grittiness missing. I've been playing organ for years and years—in fact it's one of my specialties—so I just brought my organ in, and it really helped those parts a lot. I remember Jonathan was really thrilled about that.

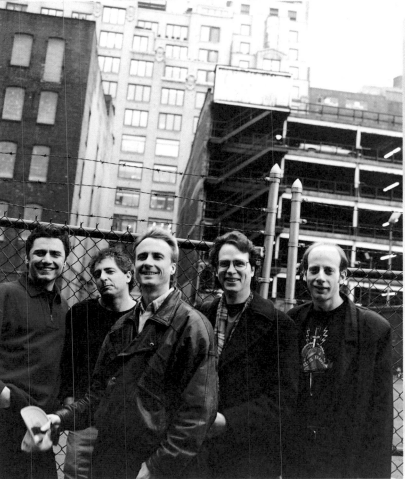

From left: Kenny Brescia, Tim Weil (see next p.), Jeff Potter, Steve Mack, Daniel A. Weiss

KENNY BRESCIA (Guitar)

*Kenny Brescia has recorded, performed live, toured worldwide and appeared in videos and on radio and television with a long list of performers, including the Mamas and the Papas, Chaka Kahn, Ben E. King, Wilson Pickett, Rupert Holmes, Lou Christie, The Big Apple Circus and the Apollo Theater House Band. He performed on WCBS Radio's twenty-fifth anniversary live broadcast and played in the orchestra of **The Who's Tommy** on Broadway. He has also performed a number of national television and radio jingles, performed and written music for **Sesame Street** and arranged a variety of guitar music folios for Warner Brothers Music Publications.*

A lot of musical challenges came from the fact that much of the music in *Rent* was not written in traditional rock and roll guitar keys; they were in B flat and G flat and things like that. Since day one, it was, "We've got all this brilliant stuff, now let's figure out how to play those parts and make it ours. Let's make it a real band."

STEVE MACK (Bass)

*Steve Mack has recorded numerous radio and television jingles, including work for the arranger Don Sebesky, and played on various albums for composers such as Andrew Lloyd Webber, Alan Menken, Yoko Ono and R&B composer Otis Blackwell. He has also played as a sideman for a wide variety of artists, and his Broadway credits include work in the pits of the original **Grease**, **Evita** and **Dreamgirls**.*

I had an opportunity, because of Tim's tremendous confidence in us as a band, to come up with parts that worked. We were also given the satisfaction of putting ourselves into our parts. For example, in the tune "What You Own," I started with a skeletal arrangement and from that was given the freedom to come up with a part that helps the song be what it is, because the bass is so important to that song. The bass is one of the things that helps that song move in an authentic way.

JEFF POTTER (Drums)

*Jeff Potter has performed with rock, jazz and blues acts in New York and Boston, and with modern dance and performance art groups. He studied with the late jazz drummer Alan Dawson. He has toured internationally with shows and musicals, and has performed Broadway and off-Broadway gigs. He has appeared regularly with the orchestra at Radio City Music Hall. Potter also drummed for **Rent** in the studio production and the off-Broadway run.*

This band's contribution was much greater than with a typical show. Steve Skinner gave us demos of arrangements on MIDI synthesizer, but doing it live was up to us. We didn't just come in and read the ink. Tim Weil knew how to make the music serve the drama but maintain the energy of pop. The piece isn't so subservient to the drama that it loses the passion.

TIM WEIL
Music Supervision and Additional Arrangements

*Before he became the musical director on **Rent**, Tim Weil worked on the Broadway production **Sally Marr and Her Escorts**. Off-Broadway he has worked on **Rent**, **The Baker's Wife** and **Romance in Hard Times**. Other shows include **Blues in the Night**, **Conrack**, **The Rothschilds**, and **A Christmas Carol**.*

Jonathan became very trusting of me. He would bring something in and say, "Tim, I know you'll make this sound good." And I would kind of arrange it, or help arrange it, continue along the path that he had begun. Another composer might not have let me have that kind of leeway, but Jonathan and I were a great mix. Before he died, we were already talking about the next show we were going to do.

Rent is really good theater, and we're playing in a real band. One of the guys who came in to sub for one of the musicians said to me, "This isn't like doing a show at all, it's like a gig." I think that's the best thing I could ever hear.

The band is a great group of guys with enormously great taste. They all know the history of rock and roll and they enjoy the theatrical environment. Over the course of time, you continue to grow and play together, listen and anticipate each other. There's so much joy in making music together in the theatrical context. When the whole singing, acting, dancing thing comes together, I don't think there's anything better.

*Marlies Yearby received a 1996 Tony Award nomination for Best Choreography for **Rent**. Her theatrical commissions include American Music Theatre Festival, Penumbra Theater, National Black Arts Festival and En Garde Arts, American Center, in France. She has collaborated with writers, playwrights and performance artists such as Shay Youngblood, Laurie Carlos, Sekou Sundiata, Carl Hancock Rux and Robbie McCauley. As founder and artistic director of Movin' Spirits Dance Theater, her commissions have included works for Lincoln Center, American Dance Festival, Jacob's Pillow, Tribeca Performing Arts Center and Performance Space 122. Yearby received a Bessie for choreography for Lisa Jones and Alva Rogers's **Stained**.*

MARLIES YEARBY
Choreography

The way I listen to music is to look at the rhythm between the downbeats, to hear the dialogue between the instruments. I always had a sense of music as language, which has influenced my sense of dance as language.

My work is interdisciplinary; I call it dance-based performance. When we talk about music, we don't talk numbers; everything is done through breath or sound or thought, the history of our bones. That's how the name of my company, Movin' Spirits Dance Theater, evolved.

When I work with dancers and performers, the words and the music become a landscape in which they can define their onstage personas or characters. The work is always telling someone's story. I try to attach them to what it is about the text or music that speaks to them personally, very much the way an actor will walk toward the language on a page.

I remember that when I first came to New York I auditioned at Dance Theater Workshop, for their *Fresh Tracks*. They asked me, "What do you want for yourself as a choreographer?" I said, in a moment of total openness, "I plan on being world-renowned." All the established artists, like Bebe Miller, just smiled and thought, "How cute." You never know when you put something out in the universe how it will fall back on you.

Paul Clay is a visual artist who has designed for Mabou Mines, Eduardo Machado, Susan Marshal, Tom Noonan and many others in the New York downtown community, and for Steve Shill and Philip McKenzie in London. He received a Bessie in 1991 and was an NEA/TCG Designer Fellow in 1993–94. He served as visual adviser on Tom Noonan's feature film **What Happened Was...**, which received the 1994 Grand Jury Prize at the Sundance Film Festival.

PAUL CLAY
Set Design

I'd characterize my work as environmental, taking in the architecture of the space and working from there. My design approach is that of an artist who works experimentally and organically. I take stock of available materials and the structure of the space, and synthesize the design from that. I try to make work that's strong and spare, with all the elements integrated into a coherent whole. At the same time, I think each individual set element ought to be able to stand alone as a jewel or work of art.

I think I take a sort of anthropological approach to my projects, trying to understand the politics and cultural meanings within a work and then exploring how those can be explicated through the design. When I start a project, part of the process involves seeing everything that's happening within the visual field of contemporary culture, from architecture and interior design to fashion and especially contemporary art. I'm also inspired by materials, from the latest high-tech glass or plastics to what's in stock at the local hardware store.

Angela Wendt received a 1996 Drama Desk Award nomination for **Rent**. She comes from Germany, where she studied set and costume design at Hochschule der Kunste, in Berlin. Her theatrical credits include the studio and off-Broadway productions of **Rent**; the American premiere of **Play with Repeats**; **Lysistrata**; **The Autobiography of Aihen Fiction**; **Twelfth Night**; **The Great Pretenders**; and **Marisol**. Her feature film and dance credits include **Childhood's End**, **Tilliboyo**, **Regions** and **Savanna**. She has also designed for numerous music videos in the U.S. and Europe.

ANGELA WENDT
Costume Design

In general, I love the research part of my job the most. I research the era, the social milieu, the references of the set. I ask myself, "Who are these people and what do the clothes mean to them? How do they decide to put on a particular piece of clothing? What does it say about their attitude toward other people and the world?" Even though I do research beforehand, I always leave myself the freedom to wait until I've

BLAKE BURBA
Lighting Design

Blake Burba received a 1996 Tony Award nomination for Best Lighting Design for **Rent**. At New York Theatre Workshop he was the lighting designer for **Rent**, **Quills**, and the studio production of **Rent**; he was assistant lighting designer for **Slavs!**, **Blown Sideways Through Life**, **Owners** and **Traps**. Burba was the resident assistant lighting director at Opera Theatre of St. Louis for four seasons and at Glimmerglass Opera for one season. Other recent New York designs include **Too Many Clothes**, at the Kitchen, and **Triptych**, for choreographers Tymberly Canale and Paul Mosley, at the Merce Cunningham Studio. Burba directs the lighting every Friday night for Squeeze Box! at Don Hill's, a rock and roll club in New York.

I learned most of what I know from Chris Akerlind, who was the lighting director at NYTW for a while. He's my biggest influence in terms of developing an aesthetic. What I try to do is tell a story through lighting in ways that punctuate and reinforce the music and action. I'm a musical person, so I try to be very sensitive to the musical changes. Points that Jonathan wanted to punctuate with music I tried to reinforce with lighting.

I'm a big believer in the idea that you never really know what's going on until you bring all the elements together in the theater. A lot of designers want to plan everything in advance, which is understandable considering the economic pressures of Broadway: the more time you spend messing around with stuff, the more people are going to ask, "Why didn't he get it right the first time?" which is a stifling way to work. When you're actually in the theater, with all the elements at your disposal, that's where the real work happens.

KURT FISCHER
Sound Design

A fifth-generation Iowan, Kurt Fischer made his Broadway sound-design debut with **Rent**. His other credits include assistant sound designer to Otts Munderloh; production sound engineer for **Nick & Nora**, **Jelly's Last Jam** and **Sunset Boulevard**; and associate sound designer to Martin Levan.

I came on board the project a week or so after *Rent* opened downtown. I spent four weeks with it there, and then helped move it to the Nederlander. When I saw the show, I was completely stunned and overwhelmed. What affected me was the story. In 1979 I moved from Iowa to the Lower East Side. Although I work on Broadway shows now, I still feel like I was one of those kids up there.

I came to New York as a modern dancer. I started to go to Broadway musicals and was enchanted by the combination of theater, music and dance. In *Rent*, what struck me was the integration of music with theater in a way that captured my imagination. With dance, you have the ability to tell a story in a minimal setting. Your theatrical imagination kicks into gear. *Rent* was a show about a locale that spoke to my experience, with music that touched me emotionally. It is about something important: a group of people seeking the truth about the human spirit under adverse circumstances.

*Billy Aronson's plays have been featured in **Best American Short Plays 1992-93** and performed at Ensemble Studio Theatre. His writing for television has been featured on Comedy Central, MTV and Nickelodeon. His lyric writing includes the libretto for **Flurry Tale** (a holiday opera with music by Rusty Magee, performed annually by American Opera Projects) as well as first-draft lyrics (many of which remain) for two songs in **Rent**: "Santa Fe" and "I Should Tell You."*

BILLY ARONSON
Original Concept / Additional Lyrics

At each step of working with Jonathan, I was very impressed with the huge strides he made as a composer. The early workshop production was all over the place. There were parts that were hard to sit through, but what was good was so good. I still don't understand why something works on Broadway, why your grandparents are going to like one thing and not another, but right from the beginning, I really thought Jonathan was on to something—which was strange, because I felt like a sperm donor whose kid becomes president!

The fact that I get credited with original concept and additional lyrics makes me very proud. Those were Jonathan's terms, and I'm still not sure what they mean, but they're fair. When I heard my lyrics on Broadway, there was kind of a tingle. It wasn't a place I'd thought of working.

STEVE SKINNER
Musical Arrangements

*Steve Skinner worked with Jonathan Larson as arranger and recording producer for twelve years. He received the Drama Desk Award for Best Arrangements for **Rent**. He has also worked on the Broadway production of **Doonesbury** as assistant conductor and keyboardist. Skinner has done recording and arranging for artists such as Bette Midler, Taylor Dayne, Billy Mann, Chaka Khan, Bebe and Cece Winans and Michael Crawford.*

When I do arranging and producing work with someone, I try to bring out the artist's vision. I help the artist realize what he or she wants to hear. In essence, my job is to make the artist happy. But as it happens, I was also very happy with the final result. Jonathan and I seemed to share a vision; if I liked something, he liked it, too. On a personal level, what I learned from Jonathan is the importance of being nonjudgmental, of having an almost childlike appreciation of the world, of not excluding ideas because they may not be the idea of the moment, of staying open to experience. And that shows in the play. A lot of things I learned from Jonathan I learned only after he had died, when I saw the work in its entirety.

James C. Nicola has been artistic director of New York Theatre Workshop since 1988. Under his direction, NYTW has sponsored works that have won many awards, including Obies, Tonys and the Pulitzer Prize. Nicola was also the producing associate at the Arena Stage, in Washington, D.C., and casting coordinator at the Public Theater. He was a National Endowment for the Arts Director Fellow.

JAMES NICOLA
Artistic Director, NYTW

One of my earliest memories is of wanting to be a minister. I grew up in the Baptist church. I was intrigued by the idea of playing a positive role in the community and thought at the time that the church was the place to find that sustenance. Somewhere along the way, as I got older and learned more about who I was, I realized that was never going to happen—and shouldn't. But in a way, theater is like a secular church, a place where the community can go and can take something away. I never think of myself as the preacher; I think of the artists as doing the real communicating.

*Bernard Telsey, along with Will D. Cantler, Lori Saposnick, David Vaccari and Heidi Marshall, cast the original production of **Rent** and continues to cast current productions. His other theater credits include **Present Laughter**, **Cape Man**, **Young Man from Atlanta**, **The Food Chain**, **The Grey Zone**, and **Nixon's Nixon**. Bernard Telsey is also coexecutive director of MCC Theater.*

BERNARD TELSEY
Casting

Casting *Rent* was, on difficulty scale, beyond ten. And it still is. Casting for the Boston production alone required 212 days of auditions. But what makes it worthwhile is that it really is giving people a break. It's great to come up with a match, really thrilling. It's the core definition of casting. You cast each TV show hoping it'll become the next *ER*, but you can't do that with theater, because it just doesn't happen. But even if the show isn't a success, it's a thrill to cast. For the show to explode, the thrill is even greater.

In a lot of ways, *Rent* was an ensemble production. That's what was such an honor; it's why I'll do anything for this piece. The performance's beauty and success came from the collaboration. Casting is getting so much recognition for this show, because we were really a part of it.

THE PRODUCERS

theatrical journey that has included acting, directing, writing, selling ads, publicizing, booking shows and, finally, producing. In 1990, Seller met *Rent* producer Kevin McCollum, with whom he cofounded what is now known as The Booking Group. That year, he also met Jonathan Larson, whose rock monologue **tick, tick...BOOM!** inspired Seller to produce his work. Seller grew up in Oak Park, Michigan, and is a 1986 graduate of the University of Michigan.

I always loved musical theater. When I was growing up, while my peers were listening to Led Zeppelin and Rod Stewart, I was listening to *Pippin*, *Annie* and *Evita*. In the last decade, there hasn't been a show like *A Chorus Line* for kids to relate to, where they can look up on the stage and see people who are like them. There hasn't been anything that speaks to young gay kids and teens, who might be thinking that if they reveal that they're gay they'll be outcasts, not cool, that their friends and family will disapprove. *Rent* shows them that it's okay. It gives them a musical to love. I've had shows to love, and now I can enjoy producing one for others to love.

One day during the summer after *Rent* had opened, I was walking home up Eighth Avenue wearing my college backpack again, and gym shoes instead of a tie. I was struck by the thought that at thirty-one years of age I am doing exactly what I want in life. I am doing my hobby.

From left: Allan S. Gordon, Jeffrey Seller, Kevin McCollum (recipients of the 1996 Tony Award for Best Musical for **Rent)**

KEVIN MCCOLLUM

*Kevin McCollum developed a passion and talent for the theater from the age of six, when he performed in many children's choirs and plays. The love of theater endured, and McCollum ultimately earned his masters of fine arts from the University of Southern California. In 1991 McCollum cofounded and became a principal of The Booking Office, a New York theatrical booking and producing agency that is now known as The Booking Group. McCollum and his business partner, Jeffrey Seller, have produced shows for Broadway, off-Broadway and the road. In addition, McCollum was executive producer of the feature film **Jeffrey**, based on Paul Rudnick's off-Broadway hit. At this time, he is the President and CEO of the Ordway Music Theatre, a world class performing arts center in St. Paul, Minnesota.*

The theater, in my opinion, is a research and development business that is currently structured like manufacturing, and we should turn it back into research and development. People ask, "Where are all the young writers?" There are plenty of young writers. They're writing for animation, getting $150,000 a year. Let's do the same thing in theater and support young writers with salaries they can live on—and I'm not talking about work-for-hire. We need to recognize the needs of our times, to restructure the economic equations so that young writers who want to write for the theater can remain committed to their craft.

I'm in a position now to make some of these changes. I try not to let the roadblocks affect my thinking, such as "experts" who say, "That's not how it's done." The let's-put-on-a-show mentality is how *Rent* was made—Jonathan had an ability to recognize that when people said no to him, it was irrelevant. We should remember that *Rent* was created because of Jonathan's commitment to his vision, against great odds. It's a lesson for all of us. He should have been able to make a decent living writing for the theater while perfecting his craft.

ALLAN S. GORDON

*Allan Gordon has been involved in law, investment banking and venture capital, but his first love has always been the theater. He made his debut as a Broadway producer with **Rent**. Gordon frequently participates in film and theater ventures, and in the financing of productions, both personally and through his investment banking firm, Gordon, Haskett & Co. Gordon has coproduced numerous theatrical events, including **Sammy Cahn in Person: Words & Music**, **Chicago** and **The Real Live Brady Bunch**, in cities across the country. Gordon is a graduate of Harvard Law School and a trustee of New York Theatre Workshop.*

With *Rent* we've been very hands-on, right down to the type of sinks in the bathroom! The production of *Rent* has become a significant business. We are trying to create the very best product, but we're also looking to present it in such a way that it's profitable, without sacrificing artistic merit. We have an opportunity that most people don't, which is to bring a message of lasting value to theater audiences.

Our disciplined approach brings a sense of reality to the business. The *Rent* experience shows that you can do meaningful productions for a reasonable price and be profitable; with shows like these, you're not as scared to be innovative and are more willing to take risks. The content and life and very presentation of it is a hundred years ahead of what's out there. It's like using a telephone when other people are using telegrams. It's a throwback, yet it's forward-looking. You put it all together, and

Acknowledgments

Our gratitude to Jonathan Larson's family and friends, and to the *Rent* cast and creative team, all of whom shared their experiences and personal insights to tell the collective *Rent* story. We would like to thank the following persons and organizations for their encouragement and assistance in the making of this book:

For the new photography at The Nederlander Theater: John Vivian, production stage manager; Crystal Huntington, stage manager; Catherine J. Haley, assistant stage manager; Karen Lloyd, wardrobe supervisor; David Santana, wig, hair and makeup designer; Mary T. Clark, Kathe Mull and Mary Beth Regan, dressers; Jack Culver, electrician; Tom O'Neill and Morgan Shevett, follow spot operators; Brian Ronan and Tucker Howard, sound board operators; John Cooper, assistant sound operator; Joe Ferreri, house carpenter; Victor Marmo, assistant house carpenter; Billy Wright, house prop master; Jan Marasek, production prop master; Bill Terrill, assistant prop master; Bob Garner, stage doorman; Jorge Abreu, associate hair and make-up consultant; Gilbert Cortez, porter.

Eric M. Schnall, assistant to Jeffrey Seller and Kevin McCollum, The Booking Group; Brig Berney, company manager, and John Corker, general manager, Iron Mountain Management; Don Summa, publicist, Richard Kornberg & Associates; Robert Levine and Conrad Rippy, Levine Thall Plotkin & Menin, LLP.

Special thanks to Jonathan Burkhart and Amy Asch, Finster & Lucy Music Ltd. Co. and the staff at New York Theatre Workshop.

For the preparation of this book: David Pryor, Toppan Printing Company; Pat Goley and Jennifer McKinney, Professional Graphics.

For Stewart Ferebee's performance photography: Jessie Friend of the Set Shop; Scott Hagendorf of 68 Degrees; T. R. E. C.; Shazi of Print Zone.

And a personal acknowledgment from the Larson-McCollum family

It is impossible to list, and thank, all of the people who helped Jonathan become the person he was. While there were many others, each of the following played a significant role in shaping his outlook on life, music and the theater. Beginning in his earliest years and continuing throughout his life, the extended family: "Aunt" Marcie and "Uncle" Chickie Dean; Barbara Taback; Laurie Kraman; "Uncle" Dave and "Aunt" Barbara Maness; Martha Maness; Laura Studer; Susan Maness; Sawyer and Ethel Larson; Violet Conell; Gene and Leah Larson; Ann Ortelee; Fred and Rita Petta; Emily and Barney Krucoff; Ann McCollum; Anne Taback; Daniel Taback; Adam Kraman; Jennifer Kraman; and especially his beloved nephews Matthew and Dylan McCollum.

In addition to those mentioned or quoted in this book: the Kudans, Falcones, Rabinoves and O'Gradys; Wilma Machover, and the many teachers who influenced him in the White Plains school system and at Adelphi University, including: Sharon Greene, Nicholas Galloti, Alfred A. Renino, Jacques Burdick and Nick Petron. Stephen Sondheim, who gave the term "mentor" real meaning. Lou Levithan, who gave Jon a brief but thorough education in the art of being a waiter—and a human being. Larry Panish, who regularly let Jon take time off from waitering at Moondance to "do his theater thing." Jay Harris, Bill Craver, Jim Nicola, Nancy Diekmann, Sue White and everyone at the New York Theatre Workshop. The organizations that gave him grants and commissions; everyone responsible for the ASCAP and Dramatists Guild Workshops; the lyricists who collaborated on various songs; and everyone of those actors whose participation in innumerable readings and performances of Jon's different works helped him develop into the playwright/composer he wanted to be.

And, most important, Jon's amazing universe of wonderful friends. While some names will be omitted inadvertently—for which we beg forgiveness in advance—we must mention (alphabetically): Ed Aronoff, Billy Aronson, Roger Bart, Randi Blanco, Lynn Blumenfeld, Tom and Debbie Buderwitz, Scott Burkel, Jonathan Burkhart, Brian Carmody, Janet Charleston, Ann Egan, Diane Fratantoni, Bob Golden, Christina Haag, Anne Hamburger, Tony Hoylen, Lisa Hubbard, Dan Kagen, Violette Klimczewska, Victoria Leacock, Michael Lindsey, Barb Marineau, Craig Martone, Marin Mazzie, Nancy O'Conner, Matt O'Grady, Molly Ringwald, Todd and Liz Robinson, Traci Robinson, Eddie Rosenstein, Alison Roth, David Saint, Michelle Weinberg and Ira Weitzman.

Producers Jeffrey Seller, Kevin McCollum and Allan Gordon, who told Jon they believed in him... then put their money where their mouths were, and shepherded *Rent* to the heights. And, finally, Steve Skinner, Michael Greif, Tim Weil, and the fantastic cast and crew who lovingly brought *Rent* to brilliant life.

We love and thank you, one and all.

From Julie Larson-McCollum:
A very special thank you to Nan and Al Larson for giving Jon a lifetime of unconditional support.

About the writers:
Evelyn McDonnell's writing has appeared in numerous books and magazines, including *Rolling Stone, Interview, Ms.* and *The New York Times.* She coedited the anthology *Rock She Wrote: Women Write About Rock, Pop and Rap,* and is a former music editor of *The Village Voice.*

Katherine Silberger is a New York–based writer who has contributed to publications including *Mirabella, Rolling Stone, The Village Voice* and *Ms.* She was the founding editor of *Radio Aahs,* a children's magazine.

This book was produced by Melcher Media, Inc.
Charles Melcher, editorial director
Kate Giel, editor
Robert Hudson, editorial and production assistant
Erin Bohensky, editorial assistant
Susan Chun, production director
Pam Smith, associate production director
Leslie Fratkin, photo coordinator
Arlene Lee, production design
David Terrien, Greg Villepique, Ellen Mendlow and Lee Buttala, copyeditors and proofreaders
Jean Wagner, fact checker

The book was designed and typeset by Spot Design
Drew Hodges, art director
Naomi Mizusaki and Rymn Massand, designers

Richard Nash-Siedlecki and Tina Johnson, transcribers

Stewart Ferebee, photographer for new performance photographs and biography portraits
Bobby Fisher, Paulo Netto and Erskin Childers, photographer's assistants

Larry Fink, photographer for backstage and East Village photographs

The separations were made by Professional Graphics, in Rockford, Illinois.

The book was printed and bound in Japan by Toppan Printing, on Oji OK Bright Rough text.

from left: Adam Pascal and Daphne Rubin-Vega; Wilson Jermaine Heredia and Evelyn McDonnell; Darius De Haas, Shelly Dickinson and Jesse L. Martin; Yassmin Alers and John Vivian; Wilson Jermaine Heredia and Katherine Silberger; Tim Weil.

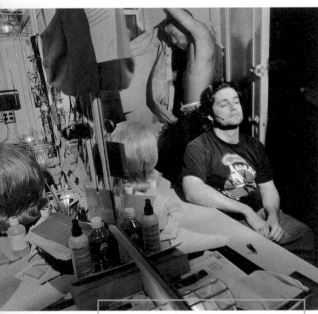

lynn haller

creative edge

LETTERHEAD + BUSINESS CARD DESIGN

NORTH LIGHT BOOKS
CINCINNATI, OHIO
www.howdesign.com

FOR ROGER + VIRGINIA HALLER

Other fine North Light Books are available from your local bookstore, art supply store or direct from the publisher. Visit our Web site at www.howdesign.com for information on more resources for graphic designers.

05 04 03 02 01 5 4 3 2 1

Library of Congress Cataloging-in-Publication Data
Haller, Lynn.
 Creative edge : letterhead + business card design / Lynn Haller.
 p. cm.
 Includes indexes.
 ISBN 1-58180-152-1 (alk. paper)
 1. Letterheads—Design. 2. Business cards—Design. I. Title:
Letterhead + business card
design. II. Title: Letterhead and business card design. III. Title.
NC1002.L47 H34 2001
741.6'85—dc21 00-068712

Editor: Clare Warmke
Production Coordinator: Sara Dumford
Designer: Lisa Buchanan
Layout Artist: Kathy Gardner
Interior illustrations: Brenda Grannan
Section opener photography: Al Parrish
Other photography: Guildhaus Photography

ABOUT THE AUTHOR

Lynn Haller is a freelance writer and editor specializing in design and travel.

As former acquisitions editor for the North Light Books design line, Lynn acquired and edited a wide variety of graphic design books. In doing so, she has talked to or collaborated with hundreds of designers around the world and evaluated thousands of design submissions. Lynn is the author of two other books in the Creative Edge series, *Creative Edge: Type* and *Creative Edge: Page Design*, and she has authored or co-authored six other books on design.

ACKNOWLEDGMENTS

Thanks to Clare Warmke, who squired this book through production and who attended to the important details that make all the difference in a project like this one. Thanks also to Linda Hwang, who got the ball rolling. I'd also like to thank Lisa Buchanan, the book's designer, who made it all look good. But most of all, thanks to all the designers who provided work for the book.

Contents

IMAGERY

01.16

These thirty-eight systems let the pictures do the talking.

LOW BUDGET

03.78

These twenty-one pieces use every trick in the trade to create systems that are low budget but high impact.

TYPOGRAPHY

02.58

While type is the building block behind most letterhead and business card designs, these nineteen systems go beyond the ABCs.

SPECIAL TECHNIQUES

04.98

From hand-fed letter-press to futuristic metal business cards, from twine to rubber bands, these forty-three systems break the mold to get your attention.

FROM THE AUTHOR

Once, nothing set a tone for a business quite like its letterhead. A company letterhead was expected, and not having one would make a business seem less established, fly-by-night—suspicious.

In this new millennium, the same might be said of a Web site: Just try telling a prospective client that your business doesn't have one—especially if you're a designer—and prepare to be accused of being behind the curve. And a large percentage of business-to-customer communication is now done through e-mail. So do these developments spell the end of letterhead as a force in corporate identity?

In an age where so much communication is conducted across cyberspace, there's still something special about the written, snail-mail word. In fact, many annoying aspects of e-mail serve to highlight the appealing aspects of communicating by post. For instance, when you go to the mailbox, you don't have to worry about opening a letter that will wipe out your library or send itself to everyone in your address book; and you are not likely to get such letters from five different friends, all spreading the same hoax. Not to mention that e-mail is still, for the most part, undesigned—fine for communicating efficiency on behalf of a business, but not so fine for communicating style.

In fact, if you want to communicate that you (or your client) has staying power, a well-designed letterhead works much better than a Web site. It means you've committed to your business (as well as your location) enough to bet that it will be around awhile and put some money behind that belief. And of course, business cards won't be going away anytime soon—even if they serve only to spread the news about the cardholder's URL or e-mail address.

In short, don't think that having a Shockwave-laden Web site relieves you (or your client) from having an appropriate letterhead and business card system. In an age where Web sites come and go every day, you now must have both printed and Internet identity to show that you truly mean business.

The majority of systems included in this book are part of a larger identity campaign for the client. But they must stand on their own, and in this book they do—some playfully, some enigmatically, and some daringly. And though this is the fifth book about letterhead and business cards I've worked on, I can say that design surprises still await for me—and I hope you find that as well.

{ In an age where so much communication is conducted across cyberspace, there's still something special about the written, snail-mail word. }

THE BASICS OF LETTERHEAD DESIGN

Designing letterhead may be among a designer's favorite projects: Where else can a design idea be conveyed so economically, allowing the brilliance of the concept to be uncluttered by coupons, price lists, graphs or bad photographs supplied by the client? But for that same reason, letterhead is also among the most challenging pieces to design: When working within the strict parameters—and often tight budgets—that come with a typical letterhead project, the lack of a good concept is hard to hide. It's one of the truest tests of your skills as a designer.

This introductory course in letterhead design may not give you the one magic way to come up with a perfect concept. But it will point out the questions you should ask yourself to get that concept and show you what to do with it once you've got it.

GET TO KNOW YOUR CLIENT

Your first step in designing a letterhead project, as in any other design project, is to get as much information as possible from your client. It's important to emphasize this because the simplicity of letterhead design can lead you to assume that all you need to know is the company name and address. Not true. Because of letterhead's importance in conveying an impression (often the first one) of your client, you must take nothing for granted.

Here are some questions you need to consider before you start designing a letterhead system. Your client should be able to answer many of these questions for you, while others might require further thought or research on your part.

■ What pieces does your client need to have designed? Beyond the obvious, list other components related to letterhead that they may not have thought of, such as presentation folders, stickers, invoices, fax cover sheets, etc. Make sure they're aware that the best letterhead design can be undercut when used in conjunction with ill-designed (or undesigned) collateral.

■ Do they already have a letterhead? If so, why do they want a new letterhead? Is there anything they still like about it (the ink colors, the paper) that you should consider retaining?

■ What other corporate identity elements, if any, already exist and does your client intend to keep any of them? If no other components exist, you need to consider whether the elements from your letterhead design might eventually be used on other pieces. For instance, a client that is a delivery service may eventually want to use design elements from your letterhead on their trucks, so you should design something flexible enough to be adapted to this or other uses.

■ What is your client's self-image, and what is their image within their industry and

with their customers? Do they like their image and want their stationery to further communicate it, or do they think they need a change? If they want to retool their image, their letterhead is a good place to start.

■ What is their competition doing, and how can they stand out from the crowd? Research their primary competitors, and get letterhead from them when possible to get an idea of the industry standard. Whether you decide to buck the industry trends or follow them, you need to know what they are.

■ How will they use the system? For instance, if the letterhead is likely to be photocopied or faxed, darker paper would be a poor choice. If they often mail large items, you may need to design a shipping label in addition to, or maybe instead of, an envelope. Additionally, products of some heat-set processes— such as thermography or foil-stamping— could melt if fed through a laser printer, ruining your client's office equipment; die cuts could cause the printer to jam. Try to get input from the people who will use the stationery on a daily basis, not just from the CEO.

■ Who are their clients? Are their clients' tastes likely to be similar to or different from their own? If the latter is true, then you're actually designing for two different kinds of end user, the client and the recipient. You need to have background information about both of them and keep them both in mind when designing.

■ Do recipients of your client's business correspondence (1) want to receive it, (2) have a neutral attitude toward it, or (3) have no idea who your client is? The importance of using an eye-catching envelope to grab recipients' attention, for instance, is

more important to a publicity department issuing press releases than it is for a college admissions office notifying students whether or not they've been admitted.

■ Will the system's components often be seen together, or will each part need to stand alone most of the time? Is any component more important than the others? If you can only splurge for four-color printing on one element of a system and your client uses his business cards far more often than his letterhead, then splurging on the business card would be the sensible choice.

DEVELOP A CONCEPT

Now translate what you've learned into a concept that satisfies your client's objectives. Turning all this raw data into a visual concept that communicates your client's business and personality is one of the most mysterious parts of the design process, and the hardest to teach, but here are a few questions that you can use to generate ideas if you get stuck:

- Can the client's name be translated into a visual? Is there any way the client's name and business can be graphically linked?

- Can you find a way to graphically link your client's initials with what your client does?

- Can you use a visual pun—illustrating your client's product or service literally—to convey your client's business?

- Can you use the letterhead itself to demonstrate your client's skills (as on pages 90 and 100)?

- If your budget allows, can you use a die cut or embossing to convey what your client does?

- Is a more abstract or decorative solution appropriate for your client? If so, can you pick up colors or patterns from the client's office in the letterhead? Or might a classic, elegant solution, utilizing foil-stamping, engraving or a watermark, be more appropriate?

- Are there concepts related to your client's business that might be better communicated with words than pictures? If so, how will you convey these ideas typographically?

- Can you find a way to link your type conceptually to what your client does (e.g., use icing to spell out a pastry chef's name, use script for a wedding planner or use typewriter font for a copywriter)?

- Are there any photographs or patterns linked to what your client does that can be ghosted on the letterhead or printed on the back of the sheet to show through?

- Would a retro look suit your client (as on page 67)?

- Can the business card be designed in a shape that is appropriate for your client's name or business (as on page 133)?

This is obviously just a start. For more ways to generate design ideas, see *Creativity for Graphic Designers* by Mark Oldach (North Light Books, 1995).

6¾ (3⅝" x 6½")

Monarch (3⅞" x 7½")

No. 10 (4⅛" x 9½")

A2 (4⅜" x 5¾")

A6 (4¼" x 6½")

A7 (5¼" x 7¼")

Envelopes are either stock or converted. Stock envelopes are made and then printed; converted ones are printed and then cut and folded. Stock envelopes are less expensive in small quantities and available with little lead time; however, they don't come in all paper grades.

You can have converted envelopes made from any paper, but it generally takes about four weeks. You'll also need to order about 25,000 to make envelope conversion a cost-effective option. The main reason for choosing an envelope conversion, however, is the printing technique to be used. Embossing, thermography and bleeds often do not work as well on stock envelopes.

THE ELEMENTS OF LETTERHEAD DESIGN

Now that you have that great idea, you need to translate it into a design that works on many levels—graphically, conceptually and practically. And while your options are more limited than if you were designing, say, a booklet, you still have more choices than you might realize. Following are the major elements you have to work with, as well as brief comments about how each element differs in letterhead design.

Color

You have many of the same color options that you have with any other project, with just a few important exceptions. Since letterhead has to be reprinted so often, you're more likely to be restricted to a cheaper one- or two-color print job than on other design projects. If you do have four-color printing to work with, you will probably have to use uncoated paper stock—meaning your colors won't pop the way they would on coated stock, unless you can afford spot varnish too. And allover dark colors are, of course, usually not desirable—the correspondence will be too hard to read, and faxing and photocopying it will just exacerbate the problem.

Despite these limitations, you can still use color inventively to communicate your client's business, spirit and image. If you're limited in the number of colors you can use and want a classic look, think beyond black ink to other neutrals—dark gray, brown, even dark green or red—that will give your system a classic feel equal to that of black ink, but without that desktop-published look. Consider using different paper stock colors for each component of the system to add color to your design at no extra cost. Some paper even includes patterns or four-color accents, extending your options; but if you're considering going this route, you should pick the paper before you start designing.

Graphics

Most letterhead includes at least one graphic—the logo of the company. Books have been written about designing logos, but the same basic rules apply as in letterhead design: Try to convey your client's business, as well as their image or personality, as succinctly as possible.

Traditionally, letterhead design has had only a few additional graphic possibilities beyond the logo—either the logo (or some detail of it) was enlarged and ghosted on the front of the first sheet, or the first sheet contained a watermark (one that came with the paper or one designed especially for the client). With the advent of stock photography, photo manipulation and clip art, it's now more common to see visuals used on letterhead strictly for decorative purposes. If you plan additional visuals, however, keep your client's image in mind, and make sure to leave room enough to keep the piece functional—after all, letterhead is used to communicate a message.

Also, be especially careful when designing visuals for an envelope. If you're not tripped up by the limitations of various printing processes, you may be tripped up by the requirements of the post office. When in doubt, check with your printer and the U.S. Postal Service's Domestic Mail Manual (also known as Publication 25).

Type

Type is a crucial part of virtually any design, but it's especially important in letterhead and business card design. If you give your business card to someone or write to them, you want them to know how to contact you, so readability is key. Even if your client is on the leading edge of their industry, you should seek out a typeface that's both trendy and readable. Since you are likely to have little type on any of the pieces, you'll probably be able to use only a few typefaces; choosing typefaces that immediately communicate your client's personality is crucial.

Paper

We've already discussed the color possibilities of paper; just as important in letterhead design is the texture of the paper you choose. Unlike some other design pieces, your audience is guaranteed at some point to hold the letterhead or business card, so its tactility is an important component of the overall design. Thus, you should try to become sensitive to the differences in paper weaves and weights, as well as differences that come from the content of the paper. In general, wove paper is smoother than laid paper, and paper with some cotton content is stiffer than paper without it. To learn more about the qualities of different papers, get on the mailing lists of as many paper companies as you can to receive their swatchbooks and promotions.

Another important consideration is whether to use recycled paper. First ask your client whether they have a preference. If using recycled paper is important to them, keep that in mind as you choose a stock for your job. Even if they don't have a preference, you might still want to use recycled paper-it's environmentally sound, and a wide variety of fine recycled stocks is now available.

A final consideration is the opacity of the paper. If you want a design on the back of the letterhead to show through to the front, check with your printer to make sure you choose the proper paper weight to achieve this effect. And while transparent vellum has become popular in letterhead design in recent years, as always, make sure this will work with your client's office equipment.

Size and format

You'll normally work with an 8½" x 11" (21.6cm x 27.9cm) letterhead sheet, a no. 10 (4⅛" x 9" [10.5cm x 22.9cm]) envelope and a 2" x 3" (5.1cm x 7.6cm) business card, but even within these limitations plenty of variety is possible. You have a lot of options for placing the logo and text on letterhead (see the illustration on page 12). Also keep in mind that letterhead will almost always first be seen folded in thirds, so consider designing a two-sided layout that will look equally good whether the letterhead is folded or not.

The traditional placement of the logo, company name and address is in the upper-left corner of the sheet, but you can, in fact, put them just about anywhere. Let your design suggest the placement. If you are doing a strongly symmetrical design, placing the information anywhere but the top center of the sheet may throw the design off entirely. However, a design that suggests motion might call for placement in the upper left or even in the upper right. Remember that the paper is to be typed and written on. Don't let your design get in the way of communication unless there is a compelling reason to do so.

If your client (and their budget) will allow it, and if your client's office equipment can handle it, use a slightly larger or smaller size for any one of the letterhead components to guarantee that it will stand out. Using a 6" x 9" (15.2cm x 22.9cm) envelope, so the letterhead can be folded into halves instead of thirds, is one possibility. Another is the use of a monarch-size letterhead and envelope (which measure $7\frac{1}{4}$" x 10" [18.4cm x 25.4cm] and $3\frac{7}{8}$" x $8\frac{7}{8}$" [9.8cm x 22.5cm], respectively); this stationery size is traditionally associated with executive stationery, so it can be a good choice for a client who wants a prestigious effect.

Printing

Because of the subtlety and small scale of letterhead and business cards, special printing processes such as letterpress, engraving, thermography and the like are more important in this kind of design than any other—they're among the best ways to set your client apart from the competition. You need to decide early on which process or processes you want to use and discuss it with your printer in conjunction with the design you're planning to make sure that what you envision is actually possible. If you plan to use more than one printing process, communication with your vendors will be especially important. If you try to emboss before you offset print your piece, for instance, your embossing will be flattened by the offset process.

Business cards can be folded or unfolded. They can have a design or information printed on one side or both sides; the choices are virtually limitless. A business card, however, should be durable and easy to carry. Because cards are handled frequently, they should be printed on a heavy weight of paper, for example, 65-lb. or 80-lb. cover stock. Most business cards measure 3 $\frac{1}{2}$ x 2", but through folds and die cuts, many kinds of cards may be produced. If the business cards will be folded, have it scored on the press to ensure accuracy.

WORKING WITH A LIMITED BUDGET

You've now examined all the ingredients that go into a letterhead system except for one—budget. Letterhead projects are often low-budget projects, but the ability to make the most of a limited budget in your design work, even if you have more money to spend, will always impress clients. With that in mind, here are questions to ask yourself to make sure you make the most of your budget, regardless of its magnitude.

- Have you considered creative ways to combine offset and laser printing to add an extra color for no extra cost?

- Can you use a different second color on each piece, to add a multicolored look to your system for less?

vertical short fold vertical

horizontal

- Have you considered using a variety of paper colors to add color to a one- or two-color system?

- Have you examined creative type and graphic layouts that will distract viewers from the lack of color variety?

- Can you tag some component of a one- or two-color system (for instance, the business card) onto a four-color print job, to allow you the luxury of four-color printing on at least one component of the piece? Or can you go in on a four-color press-run with another firm?

- Have you eliminated traps, bleeds and other elements that will make your system more expensive to print (as on page 80)?

- Have you thought of using unusual sizes that could make your system attention-getting without spending more money?

- Have you simplified graphics so that they don't require high-quality printing (as on page 82)?

- Can you or your client do any kind of handwork on the system (such as folding, scoring, hole punching or tying) that would add an element to the system for a little more work, but little more cost?

- Do you have any preexisting dies that might work on this job? If you want to splurge on a custom die for this job, is it something you might be able to use on a future job?

- Can you add graphics or colors with custom-designed rubber stamps?

- Can you strike a deal with the printer to have your job printed for a reduced cost or free? If you're designing for a nonprofit organization, you may be able to find a printer who believes in your client as much as you do. For your own letterhead, you may get a reduced cost if you do a lot of business with that printer or if you offer to do some design work for the printer.

gate fold

book fold

tent fold

"z" fold

short fold horizontal

imagery

We all know the adage about the power of the image vs. the power of the word. So why, in general, do so few stationery systems sport imagery beyond a logo? Sure, there are practical considerations: This type of system tends to cost more, and the images could interfere with what's written on the letter-head or business card.

But the real reason is that the power of the image is a double-edged sword: While communicative and memorable, imagery has the power to offend—precisely because it's communicative and memorable. In other words, it can make clients skittish. That's why so many systems in this section are systems for design studios and designers, who make a living pushing the envelope. So congratulations are in order to the clients in this section who aren't designers and were still brave enough to hang their trust on an image—thereby gaining a stronger impression for their company.

CHAPTER

STUDIO: Epoxy, Montreal, Canada **ART DIRECTORS:** Michel Valois, Daniel Fortin, George Fok **DESIGNER:** Michel Valois **CLIENT/SERVICE:** La Fabrique d'Images/film production **SOFTWARE:** Adobe Illustrator, Adobe Photoshop **PAPER:** Mohawk Neenah **COLORS:** Two, match **PRINT RUN:** 10,000 **COST PER UNIT:** CAN $0.66 **TYPEFACES:** hand-lettering **CONCEPT:** "A series of techniques that could be described as freehand photographic expression were used in combination with a warm palette of colors to portray these live-image makers," says Daniel Fortin of this system for a film production company. "This almost abstract texture, made of overlapping film, in a dreamlike way represents filmmaking in its most simple form."

STUDIO: Thumbnail Creative Group, Vancouver, Canada **ART DIRECTOR:** Rik Klingle **DESIGNERS:** Valerie Turnbull, Judy Austin **PHOTOGRAPHER:** John Sinal Photography **CLIENT/SERVICE:** Thumbnail Creative Group/design **SOFTWARE:** Adobe Illustrator, Adobe Photoshop, QuarkXPress **PAPER:** Mohawk Vellum (letterhead); Mohawk Vellum, CTI Glama Natural (business cards); CTI Glama Natural (envelope) **COLORS:** Two, match **PRINT RUN:** 1,000 **COST PER UNIT:** CAN $1 **TYPEFACES:** Agfa Rotis Semisans, Meta **CONCEPT:** Rik Klingle says, "We wanted to use the program to showcase our conceptual skills, our strategic approach and our ability to organize complex projects. The words *Inspire, Truth, Strive, Clarity* and *Intrigue* are boldly embossed throughout the design and reflect the philosophy of our firm." **SPECIAL PRODUCTION TECHNIQUES:** "We printed both sides of the letterhead and business cards in specially matched, solid colors," says Klingle. "In essence, we visually created our own custom-colored paper stock." **SPECIAL FOLDS OR FEATURES:** "We created a custom-matched color palette, an imagery palette, a materials palette, a numerical palette and a vocabulary palette, all of which could be combined in various sequences. Special features included translucent envelopes and business cards that utilized the same embossed translucent paper secured with a metal grommet. These materials were chosen in part for the effect they convey. The grommet, for instance, not only makes the business cards swivel but gives them a hard metal contrast against the softness of the vellum." **SPECIAL COST-CUTTING TECHNIQUES:** "We wanted to demonstrate how effective limited color can be. Each component could only be printed black plus-one color. We alternated the colors on press using the same film and plates, which resulted in a system that looks more complex than it really is."

STUDIO: Scott Wallin Design, Pasadena, California **ART DIRECTOR/DESIGNER:** Scott Wallin **CLIENT/SERVICE:** Champagne/supper club-style band **SOFTWARE:** Macromedia FreeHand **PAPER:** Neenah Classic Crest Soft White Text and Cover **COLORS:** Three, match **PRINT RUN:** 1,000 (letterhead); 500 (each of four business cards) **TYPEFACE:** Geometric **CONCEPT:** "When I was first approached to do this job, the band manager told me they wanted the logo to be a cork popping out of a champagne bottle," says Scott Wallin. "That seemed too cliché and expected. I suggested that we try to create a mood and attitude that would reflect the band's supper club style. I first developed the logo, using research to inspire my color palette, forms and type choices. From there, the letterhead and business cards just naturally took form: simple, straightforward, stylish and appropriate." **SPECIAL TYPE TECHNIQUES:** "The only type trick I used on this piece was to extend the height of the *h* in the logotype, a simple trick to customize an existing font and make it feel more tasteful," says Wallin. **SPECIAL PRODUCTION TECHNIQUES:** "I used a feature in Macromedia FreeHand that I often use in my work, which is the 'paste inside' feature. This enabled me to tint the music clef and paste it into the shape that it is a tint of. Also, I overprinted the gold and teal colors to create a new green and get a fourth color out of a three-color job." **SPECIAL FOLDS OR FEATURES:** "We printed extra copies of the letterhead on cover stock and had them scored as a trifold. The client laser-prints them and uses them as self-mailers to update fans and to promote upcoming events." **SPECIAL COST-CUTTING TECHNIQUES:** "We used color overlap to create a new color, making our three-color job look like a four-color job."

STUDIO: EAI, Atlanta, Georgia CREATIVE DIRECTORS: Matt Rollins, Phil Hamlett DESIGNERS: Matt Rollins, Todd Simmons PHOTOGRAPHERS: various CLIENT/SERVICE: EAI/design SOFTWARE: QuarkXPress PAPER: Gilbert Voice White COLORS: Four, process, plus black letterpress TYPEFACE: Trade Gothic CONCEPT: "The EAI identity system is an exploration of the function of design," says Matt Rollins. "When stripped to its basic elements, our job as communicators revolves around the skillful, strategic combination of words and pictures. We communicate by creating new context or new combinations. Any given word or picture conjures its own set of meanings (which differ for everyone), but when combined, the two take on new meaning. We communicate by creating these new contexts. Hence, 'Context alters meaning'. Thirty-two different word-picture combinations appear on the business cards, as well as stickers that apply to an embossed square on the letterhead and as a seal on the envelope." SPECIAL PRODUCTION TECHNIQUES: letterpress, perfed envelopes, debossing, the use of stickers SPECIAL COST-CUTTING TECHNIQUES: "We rounded the corners of our business cards using our own corner rounder."

STUDIO: W2 Multidisciplines Design Inc., Ottawa, Canada **ART DIRECTOR:** Don Wong **DESIGNER:** René Dick **PHOTOGRAPHER:** Jim Cochrane **CLIENT/SERVICE:** W2 Multidisciplines Design Inc./marketing, print design and Web design **SOFTWARE:** QuarkXPress, Adobe Photoshop **PAPER:** Beckett Expression Iceberg White **COLORS:** Three, black and match **PRINT RUN:** 1,000 per item **COST PER UNIT:** CAN $2.20 **TYPEFACES:** Platelet (slogan), Dead History (logo), Trade Gothic (body copy) **CONCEPT:** "The photographic images of a microscope and a steaming brain represent a playful send-up of the Frankenstein theme," says Don Wong of W2 Multidisciplines Design Inc. "The slogan further enhances this theme."

STUDIO: Johnson & Wolverton, Portland, Oregon **CREATIVE DIRECTORS:** Alicia Johnson, Hal Wolverton **DESIGNERS:** Hal Wolverton, Alicia Johnson, Jeff Dooley **CLIENT/SERVICE:** Johnson & Wolverton/design **PAPER:** Consolidated Fortune Gloss **COLORS:** Two, match **TYPEFACE:** Interstate **CONCEPT:** "There is a system to the way the Johnson & Wolverton identity is broken into two distinct parts, front and back," says Amie Champagne of Johnson & Wolverton. "The front is the business side of Johnson & Wolverton. It is a pure expression of the buttoned-up business capabilities of Johnson & Wolverton. Art on the back represents free reign and surprises. The use of alternative four-color on the back is about exploration. It is a nod to the work from SAY, a project that was a cornerstone of creative success for us. Imagery was influenced by our Portland space, a 1950s building. We value and respect modern ideology and are fascinated by the patina appearing on this modern world as it decays. Inspiration also came from drawings for the building and the space's grid proportion systems."

STUDIO: Lodge Design Co., Indianapolis, Indiana **DESIGNERS:** Eric Kass, Jarrett Hagy, Jason Roemer **CLIENT/PRODUCT:** UrbanSpace/commercial properties specializing in retail space and upscale office space in downtown Indianapolis **SOFTWARE:** Adobe Illustrator **PAPER:** Strathmore Pure Cotton **COLORS:** Four, match **PRINT RUN:** 1,000 **TYPEFACES:** Trade Gothic Oblique (address); Future Book, Clarendon (logotype) **CONCEPT:** "UrbanSpace specializes in selling and leasing mainly retail space (bars, clothing stores, restaurants) and upscale offices in downtown Indianapolis," says Jarrett Hagy. "To relate to these brand- and fashion-conscious businesses, UrbanSpace needed a strong, upscale, fashion-oriented brand of its own. To achieve a strong first impression for this commercial properties start-up, we created a distinctive name and colorful stationery system which sets this company apart from others in this profession." **SPECIAL PRODUCTION TECHNIQUES:** Custom-converted no. 10 business envelope **SPECIAL COST-CUTTING TECHNIQUES:** "The printer was a friend of the client, which always helps."

STUDIO: Hollis Design, San Diego, California **ART DIRECTOR:** Don Hollis **DESIGNER:** Darin Clark **PHOTOGRAPHER:** Craig Tomkinson **CLIENT/SERVICE:** Fuel Power/distribution of premium fuel products **SOFTWARE:** Macromedia FreeHand **PAPER:** Strathmore **COLORS:** Four, process, plus varnish on business cards **COST PER UNIT:** $1.78 per set **TYPEFACES:** Agfa Rotis Semiserif, Letter Gothic **CONCEPT:** The goal of this letterhead for a distributor of fuel products was "surpassing the limits, to go beyond typical industry solutions for fuel products and packaging," according to Don Hollis. **SPECIAL PRODUCTION TECHNIQUES:** Spot varnish on business card.

STUDIO: Acrobat, Gdańsk, Poland **ART DIRECTOR/DESIGNER:** Robert Bak **ILLUSTRATOR:** Robert Bak **CLIENT/SERVICE:** Acrobat/design **SOFTWARE:** Macromedia FreeHand **PAPER:** Nitech Nordset (letterhead), Bereg Magnomatt (business cards), Nitech Raflagloss (stickers) **COLORS:** Two, match **COST PER UNIT:** $0.22 **TYPEFACE:** Amplifier Light **CONCEPT:** "The inspiration for the design of this piece was the color green, which was a very good contrast to the black color of the logo," says Robert Bak. The letterhead also features a tiny figure which acts out the name of the studio. **SPECIAL COST-CUTTING TECHNIQUES:** The punching press was used for ring-shaped stickers.

acrobat
WISEFULL

ACROBAT, 80 170 GDAŃSK, Ulica LISZTA 2A/8, NIP 839-106-36-28

propaganda
acrobat
☎/☏ 300 41 57

advertising
acrobat
☎/☏ 300 41 57

robert bak
DESIGNER

ACROBAT /studio/
80 809 GDAŃSK
Ulica DRAGANA 15D
TEL./FAX +58 300 41 57
MOB. 0 602 73 86 72

gdańsk, ul. dragana 15D, tel./fax 300 41 57
acrobat

acrobat

biuro/studio:
80 809 GDAŃSK
Ulica DRAGANA 15D
TEL./FAX +58 300 41 57

STUDIO: Designaholix, Oconomowoc, Wisconsin ART DIRECTOR: John Jenson DESIGNERS: Designaholix ILLUSTRATORS: John Jenson; David Jenson; Holly Messer, Messer Illustration PHOTOGRAPHERS: John Jenson, David Jenson CLIENT/SERVICE: Designaholix/art creative, digital and multimixed media illustration SOFTWARE: Adobe Photoshop, Adobe Illustrator, QuarkXPress PAPER: nongloss medium, 100-pound card stock COLORS: Four, match PRINT RUN: 500 COST PER UNIT: $0.60 TYPEFACES: Hand-rendered fonts, digitally manipulated CONCEPT: David and John Jenson, brothers and the owners of Designaholix, wanted to boldly support their studio's identity with "mind-blowing creative." So far, according to them, with the help of this system, business couldn't be better. SPECIAL PRODUCTION TECHNIQUES: The business cards are laminated in durable driver's license-like laminate pockets that are easily sealed with a household iron. According to the Jenson brothers, "These cards could make it to Atlantis and back!" SPECIAL COST-CUTTING TECHNIQUES: "Doing the design, printing and every other production duty ourselves left us with cost cuts that we consider the best payment there is: Skills to pay the bills!"

STUDIO: Cahan & Associates, San Francisco, California **ART DIRECTOR:** Bill Cahan **DESIGNER:** Benjamin Pham **ILLUSTRATOR:** Benjamin Pham **CLIENT/SERVICE:** Zeum/art center where young people can create and explore art using technology **SOFTWARE:** QuarkXPress **PAPER:** Beckett Expression Text **COLORS:** Seven, match **TYPEFACES:** various **CONCEPT:** Says Ben Pham of Cahan & Associates, "Zeum is a new hands-on multimedia arts studio for children and teens. To capture the essence of the museum, a logo of dotted lines was designed and die cut around the museum's name, representing the space that Zeum occupies. The idea was to use the artwork from kids and teens to fill in the area that is intentionally left blank. In essence, Zeum would always be representative of the evolving creativity and work of local youth and budding artists."

ZEUM

CAHAN & ASSOCIATES
CREATIVE DESIGN TEAM
221 FOURTH STREET, SAN FRANCISCO, CA 94103
T.415.284.7129 F.415.777.2851
WWW.ZEUM.ORG CAHAN@ZEUM.ORG

imagine

ZEUM

ZEUM

ZEUM

ZEUM 221 FOURTH STREET, SAN FRANCISCO, CA 94103

STUDIO: Stoltze Design, Boston, Massachusetts **ART DIRECTOR:** Clifford Stoltze **DESIGNERS:** Cynthia Patten, Lee Schulz **CLIENT/SERVICE:** Planet Interactive/ multimedia development **SOFTWARE:** Adobe Illustrator, QuarkXPress **PAPER:** Mohawk Superfine **COLORS:** Three, match **TYPEFACES:** Interstate, The Sans **CONCEPT:** "The challenge for this system was to suggest the concept of interactivity within a contemporary minimal identity that reflected an established and formidable organization," says Clifford Stoltze. **SPECIAL TYPE TECHNIQUES:** The designers worked with the transparent effect of overprinting offset colors. **SPECIAL COST-CUTTING TECHNIQUES:** Many pieces were ganged up (such as CD covers with business cards, envelopes with letterheads) to cut down on printing costs.

Bløk Design

STUDIO: Bløk Design, Toronto, Canada **ART DIRECTOR/DESIGNER:** Vanessa Eckstein **CLIENT/SERVICE:** Industry Films/film production **SOFTWARE:** Adobe Illustrator **PAPER:** Strathmore Writing Ultimate White **COLORS:** Three, match **TYPEFACE:** Trade Gothic **CONCEPT:** "Industry Films positioned itself as a high-quality production company with a growing roster of leading directors," says Vanessa Eckstein. "In an ever-growing market of production companies, Industry Films had to distinguish itself by the clarity of its identity and voice. It is confident, reliable, playful, hip but undeniably classic. Both in form and content, Industry has maintained consistency and cohesiveness. Color and simplicity in its letterhead system ensure a unified, consistent voice for the company, yet playfulness in its stickers and collateral allow for diversity and surprise in its communication."

STUDIO: Firehouse 101 Art + Design, Columbus, Ohio **ART DIRECTOR/DESIGNER:** Kirk Richard Smith **ILLUSTRATOR:** Kirk Richard Smith **PHOTOGRAPHERS:** Kirk Richard Smith, Chas Krider **CLIENT/SERVICE:** Firehouse 101 Art + Design/design and illustration **SOFTWARE:** Macromedia FreeHand **PAPER:** Mead Moistrite, Fox River Starwhite Vicksburg Cover **COLORS:** Two, match, plus varnish; four, match, plus varnish; four, process **TYPEFACES:** Bell Gothic , Rotis **CONCEPT:** Firehouse 101 Art + Design has three different sets of business cards, each of which use a different tactic to catch the recipient's attention. One is inspired by Robert Rauschenberg's silk screens, one incorporates song lyrics into the visuals on the back of each card, and one incorporates Kirk Richard Smith's paintings as a sort of mini portfolio of his work.

Cahan & Associates

STUDIO: Cahan & Associates, San Francisco, California **ART DIRECTOR:** Bill Cahan **DESIGNER:** Michael Braley **PHOTOGRAPHER:** Jock McDonald **CLIENT/SERVICE:** Fine Arts Museums/museum **SOFTWARE:** QuarkXPress **PAPER:** Fox River Starwhite Vicksburg Tiara Smooth **COLORS:** Four, process, plus two, match **TYPEFACE:** Baskerville GH **CONCEPT:** Michael Braley of Cahan & Associates says, "This stationery system is a component of the de Young Museum's capital campaign to build a new de Young in Golden Gate Park. Since the de Young's art collection is a public collection, every resident of San Francisco is an owner. Our concept for the campaign, 'My de Young,' illustrates that sense of ownership by depicting individuals holding pieces of artwork and sharing their personal stories about experiences they've had in the museum. Through this campaign, the de Young Museum hopes to elicit contributions from a wide range of donors. It's a grassroots fund-raising campaign that's supported by this feeling of ownership.

My de Young

The Public Campaign for a new de Young in Golden Gate Park
M.H. de Young Memorial Museum Golden Gate Park San Francisco California 94118

My de Young

The Public Campaign for a new de Young in Golden Gate Park
M.H. de Young Memorial Museum Golden Gate Park San Francisco California 94118

STUDIO: Iridium Marketing + Design, Ottawa, Canada **ART DIRECTORS:** Etienne Bessette, Jean-Luc Denat **DESIGNER:** Etienne Bessette **PHOTOGRAPHER:** Headlight Innovative Imagery **CLIENT/SERVICE:** Headlight Innovative Imagery/traditional and digital photography **SOFTWARE:** QuarkXPress, Adobe Illustrator, Adobe Photoshop **PAPER:** Horizon Dull (business cards, postcards), Domtar Plainfield Plus (letterhead, envelope) **COLORS:** Four, process, plus two, match **PRINT RUN:** 3,000 **TYPEFACES:** Bell Gothic, Minion, OCR-B **CONCEPT:** Inspired by a fortune cookie, according to Etienne Bessette, this letterhead for a photography studio puts their work front and center graphically. **SPECIAL TYPE TECHNIQUES:** Digital manipulation and custom editing **SPECIAL PRODUCTION TECHNIQUES:** Special color mixing, special die cutting, custom-made envelope.

STUDIO: Iridium Marketing + Design, Ottawa, Canada **ART DIRECTORS:** Mario L'Écuyer, Jean-Luc Denat **DESIGNER:** Mario L'Écuyer **ILLUSTRATOR:** David Plunkert **CLIENT/SERVICE:** Iridium Marketing + Design/full marketing and visual communication services **SOFTWARE:** QuarkXPress, Adobe Illustrator, Adobe Photoshop **PAPER:** Strathmore Elements **COLORS:** Four, process, plus one, match **PRINT RUN:** 3,000 **TYPEFACES:** Clarendon, Folio, Monaco **CONCEPT:** "With a memorable name like Iridium, it was easy to come up with the postmodern 'Iridiumette' cyberbabe logo," says Mario L'Écuyer. "A quick phone call to Spur's Dave Plunkert, a kind of neoindustrial packing slip treatment applied throughout the stationery applications and voilà—an image with personality that carries dynamism, intelligence and catalytic properties. To the large-as-life face on the back of letterhead and cards, purposely pixelated to reflect our high-tech environment, we added "the 'Ir192' designation. It's the atomic mass of iridium in the periodic table of elements and relates to our Web URL. Our bold new ID also acts as our differentiator in the marketplace and reflects the company's expanded multidimensional capabilities." **SPECIAL TYPE TECHNIQUES:** "Monaco being a Macintosh system font, we had to digitally manipulate the outlines of the typeface to obtain the proper weights suitable for printing." **SPECIAL PRODUCTION TECHNIQUES:** Creation of custom match color, special die cuts, custom-made envelope and stickers.

STUDIO: Disturbance Design, Durban, South Africa **ART DIRECTOR/DESIGNER:** Richard Hart **ILLUSTRATOR:** Richard Hart **TYPEFACE DESIGNER:** Brode Vosloo (Shoe Repairs) **CLIENT/SERVICE:** Up Marketing/marketing consultation **SOFTWARE:** Adobe Photoshop, Macromedia FreeHand **PAPER:** Reviva Blush **COLORS:** Three, black and match **PRINT RUN:** 500 **TYPEFACES:** Shoe Repairs, hand-lettering **CONCEPT:** "The inspiration came from the name Up Marketing, which suggested something flying, and I liked the implication the illustration makes that good marketing can make even pigs fly," says Richard Hart. "The client loved the fact that her identity flew in the face of the very slick image of most marketing specialists. She also loved the fact (God knows why) that the pig's eyes bore a striking resemblance to her own." **SPECIAL TYPE TECHNIQUES:** "Hand-lettering was used extensively, using cutting-edge technology which included marker pens and a layout pad!" says Hart. **SPECIAL PRODUCTION TECHNIQUES:** "The special orange and blue were overprinted in areas to produce the illusion of a fourth color: muddy brown." **SPECIAL COST-CUTTING TECHNIQUES:** "Doing all the work for next to nothing....The client is a close friend, and since we'd portrayed her as a pig, cutting her costs seemed appropriate," Hart says.

METROPOLITAN DRIVE

ITAS, CA 95035

408.934.5800

408.934.1850

metro@aol.com

STUDIO: Visual Asylum, San Diego, California **ART DIRECTORS:** MaeLin Levine, Amy Levine **DESIGNER:** Joel Sotelo **CLIENT/SERVICE:** RGC/new housing development **SOFTWARE:** Adobe Illustrator **COLORS:** Four, process **TYPEFACES:** Cirrus Plain, Futura **CONCEPT:** Since the letterhead is used in a selective direct mail campaign, the goal when designing it was to create a unique package, according to MaeLin Levine. "We designed the envelope mechanism to actually be a box, piquing interest. So the letterhead was rolled and put into the box, which has an Asian influence appropriate to the target audience." **SPECIAL FOLDS OR FEATURES:** The business card is a two-part piece, die cut and scored so it will stand up on its own.

JENIFER DUGAT
SALES ASSOCIATE

133 METROPOLITAN DRIVE
MILPITAS, CA 95035
TEL 408.934.5800
FAX 408.934.1850
parcmetro@aol.com

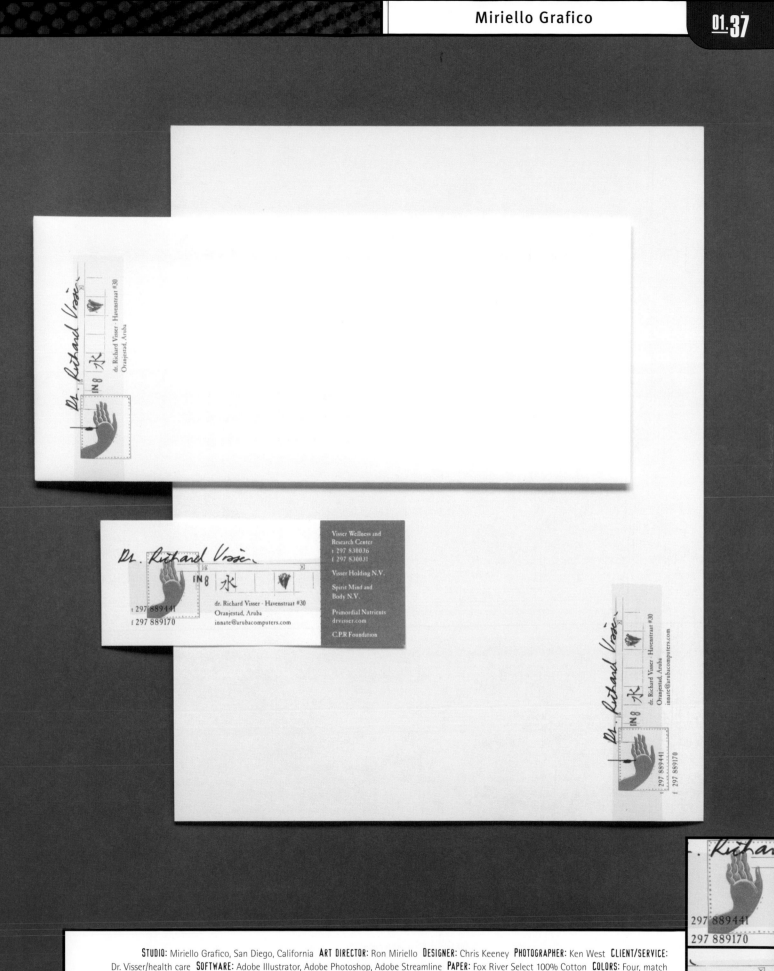

STUDIO: Miriello Grafico, San Diego, California ART DIRECTOR: Ron Miriello DESIGNER: Chris Keeney PHOTOGRAPHER: Ken West CLIENT/SERVICE: Dr. Visser/health care SOFTWARE: Adobe Illustrator, Adobe Photoshop, Adobe Streamline PAPER: Fox River Select 100% Cotton COLORS: Four, match PRINT RUN: 5,000 TYPEFACE: Caslon Antique CONCEPT: Using ancient Chinese art as inspiration, this system for a doctor located in Aruba is an elegant solution that conveys quality medical care in an exotic location. SPECIAL FOLDS OR FEATURES: "The client wanted to list all of his company information on the card but didn't want to have a two-sided card," says Chris Keeney. "So we made the card a larger size that can be folded back to standard business card size."

Epoxy

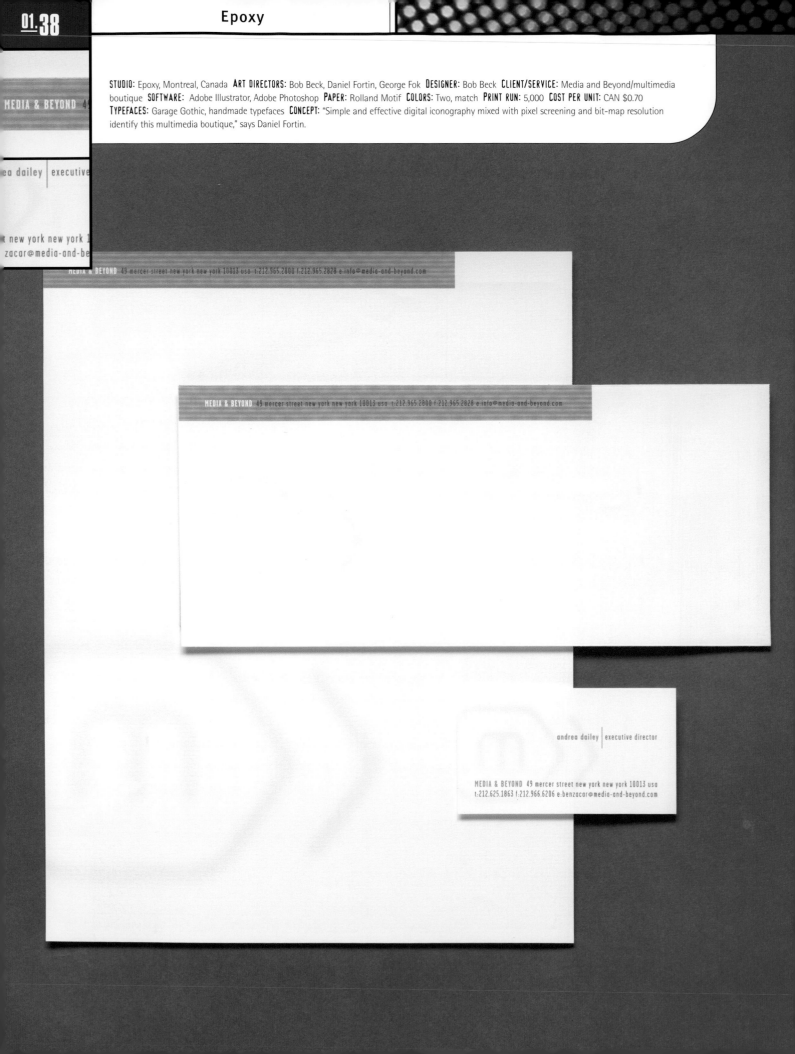

STUDIO: Epoxy, Montreal, Canada ART DIRECTORS: Bob Beck, Daniel Fortin, George Fok DESIGNER: Bob Beck CLIENT/SERVICE: Media and Beyond/multimedia boutique SOFTWARE: Adobe Illustrator, Adobe Photoshop PAPER: Rolland Motif COLORS: Two, match PRINT RUN: 5,000 COST PER UNIT: CAN $0.70 TYPEFACES: Garage Gothic, handmade typefaces CONCEPT: "Simple and effective digital iconography mixed with pixel screening and bit-map resolution identify this multimedia boutique," says Daniel Fortin.

MEDIA & BEYOND 49 mercer street new york new york 10013 usa t:212.965.2800 f:212.965.2828 e:info@media-and-beyond.com

andrea dailey | executive director

MEDIA & BEYOND 49 mercer street new york new york 10013 usa
t:212.625.1863 f:212.966.6206 e:benzacar@media-and-beyond.com

STUDIO: Segura Inc., Chicago, Illinois ART DIRECTOR: Carlos Segura DESIGNER: Teeranop Wangsillapakun PHOTOGRAPHER: Photonica CLIENT/SERVICE: Yosho/programming and back-end engineering SOFTWARE: Adobe Illustrator, Adobe Photoshop COLORS: Four, process PRINT RUN: 10,000 CONCEPT: Carlos Segura says of this system for a computer engineering firm, "The task was to brand the company in a way that visualizes what they do. So we designed a logo made of numbers to represent the letters, just as code represents programming language." SPECIAL TYPE TECHNIQUES: "We created a font made out of numbers." SPECIAL FOLDS OR FEATURES: Custom die cut envelopes.

MIKE MCGRATH
PRESIDENT/CEO

y05

STUDIO: HEBE Werbung & Design, Leonberg, Germany ART DIRECTOR/DESIGNER: Reiner Hebe PHOTOGRAPHERS: Dominik Hatt, Francis Koenig CLIENT/PRODUCT: Maas Goldsmith/jewelry SOFTWARE: QuarkXPress PAPER: Croxley Supreme Weiss Glatt COLORS: One, match TYPEFACES: Equipe, Equipe Medium, Fut Boo Reg, Cog Ext Hea CONCEPT: "Jewels from Maas are very extraordinary," says Reiner Hebe. "This corporate identity gives his products the right frame." Juxtaposing the jewels with ordinary household objects gives these images a quirky, cutting-edge feel.

MT +44 0378 813 399
THE WORKSTATION 15 PATERNOSTER ROW T +44 0114 221 0369
SHEFFIELD S1 2BX UK F +44 0114 221 2589
E charlotte@vincentdt.demon.co.uk

vincent dance theatre

CHARLOTTE VINCENT vincent dance theatre

THE WORKSTATION 15 PATERNOSTER ROW SHEFFIELD S1 2BX UK

MT +44 0378 813 399 T +44 0114 221 0369 F +44 0114 221 2589

E charlotte@vincentdt.demon.co.uk

THE WORKSTATION 15 PAT
SHEFFIELD S1 2BX UK

vincent dance theatre

STUDIO: Eg.G, Sheffield, United Kingdom **DESIGNER:** Pat Walker **CLIENT/SERVICE:** Vincent Dance Theatre/dance company **SOFTWARE:** Adobe Illustrator, Adobe Photoshop **PAPER:** Tullis Russell Mellotex **COLORS:** Two, match **PRINT RUN:** 1,000 **COST PER UNIT:** £0.05 **TYPEFACES:** DIN Engschrift, Rockwell, Trade Gothic **CONCEPT:** This system was meant to be "reflective of the company's dance style—energetic and vigorous within confined spaces," according to designer Pat Walker. **SPECIAL FOLDS OR FEATURES:** Metallic ink.

STUDIO: Ricardo Mealha/Ana Margarida Cunha/Criação Digital, Lisbon, Portugal **ART DIRECTORS/DESIGNERS:** Ricardo Mealha, Ana Margarida Cunha
CLIENT/SERVICE: Luis de Barros/photography **SOFTWARE:** Adobe Photoshop, Macromedia FreeHand **PAPER:** Couchet Mate **COLORS:** Two, match **TYPEFACE:**
Helvetica Neue **CONCEPT:** This system was designed for a young freelance photographer who specializes in fashion design. Says Cunha, "We opted on using a
refreshing and young-looking design based on two colors, green and white. The black-and-white illustration refers to his daily contact with slides and arrows."

STUDIO: 5D Studio, Malibu, California **ART DIRECTOR:** Jane Kobayashi **DESIGNER:** Victor Corpuz **ILLUSTRATOR:** Karen Graham **CLIENT/SERVICE:** 16x16/user interface design **SOFTWARE:** Adobe Illustrator, QuarkXPress **PAPER:** Neenah Classic Crest **COLORS:** Three over one, match **PRINT RUN:** 2,500 **TYPEFACE:** Microscan **CONCEPT:** For this system for an interface designer, Jane Kobayashi says, "We wanted to design something that obviously reflects what she does and would appeal to her clientele in the computer software industry." This was accomplished by using one of the client's icons, the truck from one of her software projects, as a 'mark.'

Gee + Chung Design

STUDIO: Gee + Chung Design, San Francisco, California **ART DIRECTOR:** Earl Gee **DESIGNERS:** Earl Gee, Kay Wu **CLIENT/SERVICE:** iAsiaWorks, Inc./Asian-focused Internet service provider offering infrastructure, bandwidth and data centers for companies doing business in Asia **SOFTWARE:** Adobe Illustrator, QuarkXPress **PAPER:** Strathmore Writing Natural White Vellum (letterhead and envelope), Strathmore Writing Natural White Vellum Pasted Cover (business card) **COLORS:** Three, match **PRINT RUN:** 10,000 **TYPEFACE:** Mrs Eaves **CONCEPT:** For this stationery system for an Asian-focused ISP, Earl Gee says, "The logo combines a classic Asian motif with an integrated circuit, symbolizing connection, integration and the linking of cultures through technology. The letterhead features a subtle watermark of the logo emanating from the center. The back of the letterhead utilizes an outline form of the logo in various scales to create depth. The flap of the envelope utilizes a pattern of circles from the logo as a metaphor for a massive Asian doorway or gateway for businesses in Asia." Gee points out that "the business card backs form a complete logo when put together, functioning as a metaphor for the linking of Asian Internet service providers." **SPECIAL TYPE TECHNIQUES:** A color break in the logotype differentiates the two words.

iAsiaWorks, Inc.
U.S. HEADQUARTERS
2000 Alameda de las Pulgas
Suite 125
San Mateo, CA 94403
United States of America
Tel 650.524.1790
Fax 650.524.1799
www.iasiaworks.com

iAsiaWorks

Jon Beizer
CFO and President U.S.
jbeizer@iasiaworks.com

iAsiaWorks, Inc.
U.S. HEADQUARTERS
2000 Alameda de las Pulgas
Suite 125
San Mateo, CA 94403
United States of America
Tel 650.524.1790 x107
Fax 650.524.1799
www.iasiaworks.com

iAsiaWorks

Global Technology.

Asian Focus.

www.iasiaworks.com

iAsiaWorks, Inc.
U.S. HEADQUARTERS
2000 Alameda de las Pulgas
Suite 125
San Mateo, CA 94403
United States of America

iAsiaWorks

Global Technology. Asian Focus.

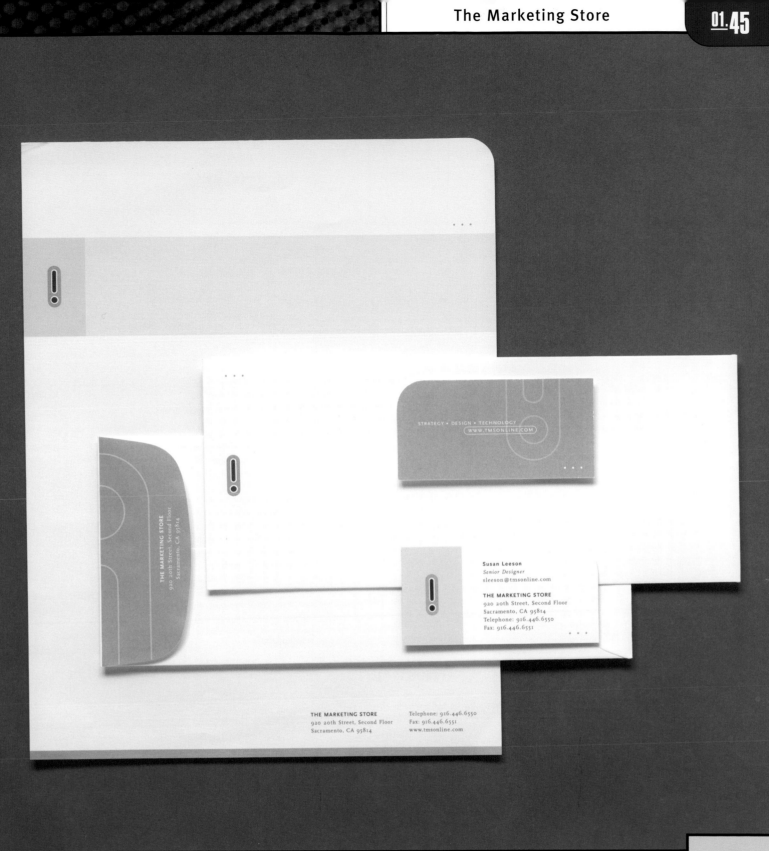

STUDIO: The Marketing Store, Sacramento, California **ART DIRECTOR:** Tracy Roberts **DESIGNER:** Susan Leeson **PRINT CONSULTANT:** Joe Zaniker, Graphic Focus **CLIENT/SERVICE:** The Marketing Store/interactive agency **SOFTWARE:** Adobe Illustrator **PAPER:** Neenah Classic Crest Solar White **COLORS:** Three, match **PRINT RUN:** varied (2,000 letterhead; 18 lots of business cards at 250 each; 5,000 no. 10 envelopes; 200 sheets of kiss-cut mailing labels) **COST PER UNIT:** varied **TYPEFACE:** Scala **CONCEPT:** "The logo, an exclamation point, depicts the defining moment of creating the 'big idea,'" says Susan Leeson. "The logo's solid nature reflects the company's strong capabilities, while its rounded shape conveys the company's softer, human side—a concept echoed with the rounded corners found on every component of the system. On the business card, the company's strength is reinforced by the heavy 130-pound stock, while its creativity is celebrated on the back with its refreshing typography and orange color. And as a final touch, three dots were added, representing the core strengths of The Marketing Store: strategy, design and technology. In addition, the three dots resemble an ellipse, indicating that there is more to come!" **SPECIAL PRODUCTION TECHNIQUES:** "In order to ensure consistency from component to component as well as reduce die and setup costs," says Leeson, "we used the same die to cut the rounded corner on the letterhead and business card. The corners were rounded first with the die, then the pieces were trimmed to size." **SPECIAL COST-CUTTING TECHNIQUES:** A special ink mix was created in a large volume for future print jobs, minimizing additional costs and color guesswork.

STUDIO: Visual Asylum, San Diego, California **ART DIRECTOR:** MaeLin Levine **DESIGNER:** Amy Jo Levine **CLIENT/SERVICE:** Ann von Gal/marketing
SOFTWARE: Adobe Illustrator **PAPER:** Fox River Starwhite Vicksburg **COLORS:** Two, match **CONCEPT:** By combining a rich red color and decorative initials to represent Von Gal Associates, the designers at Visual Asylum created a distinguished yet energetic stationery system for their client.

NATIONAL PHILANTHROPY DAY
celebrating San Diego's tapestry of cultures, causes and committed people

NATIONAL PHILANTHROPY DAY
celebrating San Diego's tapestry of cultures, causes and committed people

Honorary Committee
Ron Kendrick, Chair
Union Bank of California
Janine Mason Barone
The Fieldstone Foundation
Dr. Roger Cornell
Scripps Clinic
Murray Galinson
San Diego National Bank
Linda Katz
Community Volunteer
Phil Klauber
Community Volunteer
Judy McDonald
Parker Foundation
William Nelson
Scripps Bank
Darlene Shiley
Shiley Foundation
Deborah Szekely
Eureka Communities
Dixie Unruh
Community Volunteer
Elsie Weston
Community Volunteer

Planning Advisory Committee
Blair Blum, President, NSFRE
San Diego Hospice
Molly Cartmill, Chair
Sempra Energy
Manny Aguilar
Pacific Bell
Pamela Barnett
San Diego Blood Bank Foundation
James Brezo
San Diego State University
Tom Brunnhoelzl
Pacific Coast Catering
Anita Gomes
USIU
Joe Horiye
Asian Business Association
Jeanne Hunsaker
Sharp Healthcare Foundation
Ralph Inzunza
SDGGE
Julie Kalk
Qualcomm
Tim Larrick
National University
Jean Larsen
Children's Hospital Foundation
Chris LeeMaster
Osteopathy's Promise
To Children
Elizabeth Morgante
Grossmont Hospital Foundation
Ron Phillips
Hall of Champions
Kelly Prasser
Sempra Energy
Diane Prock, NSFRE
Complete Office Services
Madeline Progner
Union Bank of California
Charlene Pryor
The San Diego Foundation
Roderick Reinhart
Sharp HealthCare Foundation
Shannon Rice
Union Bank of California
Randa Trapp
NAACP

National Society of Fundraising Executives San Diego Chapter, Inc. 1644 Linbrook Drive, San Diego, CA 92111

STUDIO: Visual Asylum, San Diego, California **ART DIRECTOR:** MaeLin Levine **DESIGNER:** Joel Sotelo **ILLUSTRATOR:** Linda Helton **CLIENT/SERVICE:** San Diego Gas & Electric/utilities company **SOFTWARE:** Adobe Illustrator, Adobe Photoshop **COLORS:** Four over two, process **PRINT RUN:** 5,000 **TYPEFACES:** Hand, Matrix Script Ball **CONCEPT:** The designers at Visual Asylum say that the aim for this piece was to "construct a weaving representing philanthropic community contributions." **SPECIAL TYPE TECHNIQUES:** Hand creations.

STUDIO: Hollis Design, San Diego, California **ART DIRECTOR:** Don Hollis **DESIGNER:** Paul Drohan **CLIENT/SERVICE:** Rothschild Downes/architect **PAPER:** Appleton Utopia Premium Text **COLORS:** Four, process **PRINT RUN:** 400 **COST PER UNIT:** $0.50 **TYPEFACE:** Trade Gothic **CONCEPT:** "H + H Productions is the retail leasing arm of TrizecHahn Retail Development," says Don Hollis. "The purpose of the letterhead was to embody the spirit and history of Hollywood in a modern context, and it served to introduce new retail tenants (opposite of the revitalized Hollywood and Vine) to the spectacular new retail center and permanent new home of the Oscars."

STUDIO: slow HEARTH studio, Brooklyn, New York **ART DIRECTOR:** slow HEARTH studio **DESIGNER:** Sean Mosher-Smith **CLIENT/SERVICE:** slow HEARTH studio/art direction, design and photo illustration **SOFTWARE:** QuarkXPress, Adobe Photoshop **PAPER:** Finch, Pruyn **COLORS:** Two, black and match **PRINT RUN:** 2,000 **COST PER UNIT:** $1.00 per group of all five elements **TYPEFACES:** Impact (studio), Akzidenz Grotesk (address), standard bar code font (phone number) **CONCEPT:** For their studio's stationery, Sean and Katie Mosher-Smith say, "We tried to downplay the information on the stationery and integrate the image as part of the studio's design imaging." **SPECIAL TYPE TECHNIQUES:** "We thought that the use of the bar code as the phone number gave the stationery a modern, 'product' look." **SPECIAL PRODUCTION TECHNIQUES:** The metallic was overprinted to bury the black plate under a silvery powder.

Design Guys

STUDIO: Design Guys, Minneapolis, Minnesota **ART DIRECTOR:** Steve Sikora **DESIGNER:** Scott Thares **CLIENT/SERVICE:** Hest & Kramer/music **SOFTWARE:** Adobe Illustrator, QuarkXPress **COLORS:** Three, match **CONCEPT:** For Hest & Kramer, a firm which produces for film and television original music that sounds like radio hits, Design Guys created this dynamic stationery system.

all you have to do is ask JENNIFER RIGBERG where ideas are born, and she'll send you to the design studio located at 2801 cahuenga boulevard west in los angeles, california 90068. there, nestled against a lush hillside, work goes on long into the night in the service of these ideas. If you were to phone there at 3238505311 you would get a sense of how this is achieved. or you might receive a fax bearing the legend 3238506638. or e-mail from jrigberg@30sixtydesign.com. but any method of communication would doubtlessly lead to the same inevitable conclusion: this is where it begins.

30sixty design, inc.
2801 cahuenga boulevard west
los angeles, california 90068

www.30sixtydesign.com

30sixty design, inc
2801 cahuenga boulevard west
los angeles ca 90068
ph 323 850 5311
fax 323 850 6638

STUDIO: 30sixty design, Los Angeles, California ART DIRECTOR: Henry Vizcarra DESIGNER: Anna Kalinka PHOTOGRAPHER: Scott Hensel CLIENT/SERVICE: 30sixty design/advertising and design SOFTWARE: Adobe Photoshop PAPER: French FrosTone Iceberg COLORS: Four, process, plus one, match PRINT RUN: 10,000 COST PER UNIT: $0.1815 TYPEFACE: ITC Officina CONCEPT: For 30sixty design's stationery, art director Henry Vizcarra says, "The concept was 'This is where it all begins'. The inspiration was an old table that the studio uses for all pasteup work. It sits outside on a balcony off of the studio and is quite weathered and worn. What looks like a beautifully textured, computer-generated design is actually a manipulated photograph of this pasteup table." SPECIAL TYPE TECHNIQUES: Gaussian blur on text SPECIAL PRODUCTION TECHNIQUES: A fifth color touchplate of metallic silver was used so that the design looks as if it had been dusted with metallic ink.

all you have to do
born, and she'll s
2801 cahuenga bou
there, nestled ag
into the night in
to phone there

STUDIO: Sterling Design, San Francisco, California **ART DIRECTOR/DESIGNER:** Jennifer Sterling **ILLUSTRATOR:** Jennifer Sterling **CLIENT/SERVICE:** Levy Design Partners/architecture **SOFTWARE:** Adobe Illustrator, Adobe Photoshop **PAPER:** Fox River Starwhite Vicksburg **COLORS:** Three, match **PRINT RUN:** 5,000 **TYPEFACES:** Meta, Garamond **CONCEPT:** This elegant system uses embossing, a subdued color palette and duotones to convey the style and attention to detail of Levy Design Partners, an architectural firm.

STUDIO: Cahan & Associates, San Francisco, California **ART DIRECTOR:** Bill Cahan **DESIGNER:** Kevin Roberson **CLIENT/PRODUCT:** Boisset USA/alcoholic beverages **SOFTWARE:** QuarkXPress **PAPER:** Neenah Classic Crest **COLORS:** Three, match and glow in the dark **TYPEFACE:** Futura **CONCEPT:** With this stationery system for a microbrewery, Kevin Roberson of Cahan & Associates says, "We attempted to capture a bit of the spirit and importance of the historic Apollo mission. The bottle and simple graphics relate to the vastness of space. This system has been positioned to reflect high quality from a sophisticated microbrewery to counter the traditional branding trend."

STUDIO: Ricardo Mealha/Ana Margarida Cunha/Criação Digital, Lisbon, Portugal **ART DIRECTORS:** Ricardo Mealha, Ana Margarida Cunha **DESIGNER:** Ana Margarida Cunha **CLIENT/PRODUCT:** Uns & Outros/men's shoes **SOFTWARE:** Macromedia FreeHand **PAPER:** Couchet Mate **COLORS:** Four, match **TYPEFACES:** Clarendon, Aachen, News Gothic **CONCEPT:** This system was created for a new men's shoe brand, developed by two business associates who wanted to conquer a new market position. Ana Margarida Cunha says, "We focused on their target and decided to use sober colors, such as brown and gray. On the other hand, we wanted to use a casual image to create some distance from their competitors, so we decided to create an association with the well-known phrase 'What's your number?'" **SPECIAL FOLDS OR FEATURES:** The business card serves as a mini brochure that promotes the company's shoes.

STUDIO: Plazm Media, Portland, Oregon ART DIRECTORS: Joshua Berger, Niko Courtelis, Pete McCracken DESIGNER: Joshua Berger CLIENT/SERVICE: Waxman & Associates/renovation and construction in period style SOFTWARE: QuarkXPress, Adobe Illustrator, Adobe Photoshop PAPER: Fox River Quest Green COLORS: Two, match PRINT RUN: 1,500 CONCEPT: Waxman & Associates renovates old houses and creates new construction in a turn-of-the-(last)-century style. The identity was created to recollect this craftsman era aesthetic, according to Plazm's Joshua Berger. SPECIAL PRODUCTION TECHNIQUES: Offset and letterpress combination.

STUDIO: Two Dimensions Inc., Toronto, Canada **ART DIRECTOR:** Kam Wai Yu **DESIGNER:** Patrick Dinglasan **CLIENT/SERVICE:** Two Dimensions Inc./graphic design and advertising **SOFTWARE:** Adobe Photoshop, QuarkXPress **PAPER:** Rolland Motif Writing Pure White (letterhead), Neenah Classic Columns Duplex White (kit folder, business cards) **COLORS:** Three, process **PRINT RUN:** 5,000 of each item **COST PER UNIT:** CAN $4.50 (kit folder), CAN $3.50 (business cards, letterhead and envelope), CAN $1.50 (commercial courier envelope) **TYPEFACE:** Helvetica Condensed **CONCEPT:** According to Derek Armstrong of Two Dimensions, this stationery was inspired by the studio's award-winning corporate brochure, "Power," elements of which were borrowed to give the stationery a similar feel. "The colors (deep browns and orange) create a retro-styled leading-edge look, inspiring a feeling of warmth and maturity." **SPECIAL PRODUCTION TECHNIQUES:** "We used a nontraditional 1⅝" x 3⅞" (4.1cm x 9.8cm) size for the business cards," says Armstrong, "which is meant to convey our creativity, fresh thinking and willingness to challenge the status quo." **SPECIAL FOLDS OR FEATURES:** "We used a Velcro tab on the kit folder's fastener flap." **SPECIAL COST-CUTTING TECHNIQUES:** "In trying to exemplify the company's uniqueness and to distinguish it from the competition, you may find yourself overdesigning and may also forget about production costs. With the initial concepts, the costs on this job were already starting to skyrocket. To cut back, we changed the job into three colors, using only yellow, magenta and black, and we used yellow and black to create the illusion of green for the kit folder tab. We also cut costs by combining the kit folder and business cards on the same print run."

STUDIO: Effective Design Studio, Seattle, Washington ART DIRECTOR: Caroline Scull DESIGNER: Joy Rubin CLIENT/SERVICE: Harbor Properties/property manager for Site 17 Apartments SOFTWARE: Adobe Illustrator, Adobe Photoshop PAPER: Georgia Pacific Nekoosa Solutions (letterhead and envelope), SoDo Warren Lustro Dull (business card) COLORS: Three, match TYPEFACE: Helvetica Condensed CONCEPT: "Located in the urban, hip Belltown neighborhood of Seattle, Site 17 is a fun, funky new apartment building," says designer Joy Rubin. "We wanted to capture the atmosphere of the neighborhood, as well as emphasize the great location. The stationery design shows the site location from macro to micro."

typography

Type is to design as yeast is to bread—the stuff that gives it life (in both cases, with a few exceptions). This is truest of all of letterhead and business card design—they simply can't exist without the standard contact information. And there are limitations: for letterhead and business cards, legibility is key, so avant-garde type experiments and grunge fonts are to be considered skeptically, if at all.

The pieces in this section successfully walk that tightrope between being legible (and boring) and being trendy (and unreadable). They use type to communicate more than a name, address, and phone number: They use it to indicate the sort of people you will contact—and why you'd want to.

CHAPTER

STUDIO: Intersection Studio, Los Angeles, California **DESIGNER:** Greg Lindy **CLIENT/SERVICE:** Sugaroo!/music licensing **SOFTWARE:** QuarkXPress, Adobe Dimensions, Adobe Photoshop **PAPER:** Strathmore Script Bright White Pinstripe **COLORS:** Two, match **PRINT RUN:** 1,000 **TYPEFACES:** VAG Rounded, Helvetica Rounded **CONCEPT:** Greg Lindy of Intersection Studio says the goal of this stationery system for a music licensing company was "to create something that reflected the philosophy of the company, playful yet businesslike." The lettering and color scheme give the piece a retro feel. **SPECIAL PRODUCTION TECHNIQUES:** Die cuts.

9523 Lucerne Avenue Culver City, CA 90232
www.sugaroo.com

9523 Lucerne Avenue Culver City, CA 90232 t *310/842.9151* f 310/842.7393
www.sugaroo.com

STUDIO: Eg.G, Sheffield, United Kingdom DESIGNER: Dom Raban CLIENT/SERVICE: South Yorkshire Dance Consortium/dance promotion SOFTWARE: Adobe Ilustrator PAPER: Taffeta Ivory White COLORS: Two, match PRINT RUN: 10,000 COST PER UNIT: £0.03 TYPEFACES: DIN Mittelschrift, Trade Gothic CONCEPT: The idea behind this letterhead for a dance promotion company was, according to Dom Raban, "to create a letterhead that captured the radical nature of contemporary dance." SPECIAL FOLDS OR FEATURES: Metallic ink.

STUDIO: Eg.G, Sheffield, United Kingdom DESIGNER: Pat Walker CLIENT/SERVICE: Eg.G/design SOFTWARE: Adobe Illustrator, Adobe Photoshop PAPER: Taffeta Ivory White COLORS: Four, process PRINT RUN: 5,000 COST PER UNIT: £0.07 TYPEFACE: Univers CONCEPT: This stationery system for Eg.G plays off the name of the studio by including egg images on the back of the letterhead and the reversed statement "Eg.G [egg] is good for you" at the top left of the letterhead.

web.www.eg-g.com
email.info@eg-g.com

tel.+44 (0)114 276 8266
fax.+44 (0)114 249 4028

The Workstation
15 Paternoster Row
Sheffield S1 2BX
United Kingdom

Eg.G

Eg.G

The Workstation
15 Paternoster Row
Sheffield S1 2BX
United Kingdom

web.www.eg-g.com
email.info@eg-g.com

tel.+44 (0)114 276 8266
fax.+44 (0)114 249 4028

STUDIO: Sunspots Creative, Hoboken, New Jersey **ART DIRECTOR:** Rick Bonelli **DESIGNERS:** Deena Hartley, Rick Bonelli **ILLUSTRATOR:** Rick Bonelli
CLIENT/SERVICE: Sunspots Creative/graphic design, advertising and multimedia **SOFTWARE:** QuarkXPress, Adobe Illustrator, Adobe Photoshop **PAPER:** Neenah
Classic Crest Solar White Super Smooth **COLORS:** Three, black and match **PRINT RUN:** 5,000 **COST:** Printed by barter arrangement with local printer.
TYPEFACES: Roughedge (manipulated for Sunspots logo); Charlotte Sans **CONCEPT:** "Designing one's own identity is by far the most challenging project
to undertake," says Rick Bonelli. "We combined stylish yet easy-to-read typography with colorful block graphics of what we refer to as our company
colors of purple and green. A sophisticated custom logo with reflected light for *Sunspots* was designed to add intrigue and to avoid the obvious yellow
sun references that people tend to associate with the word. All complementary pieces to the system relay the clean bold look of our design philosophy."
SPECIAL TYPE TECHNIQUES: Typography was tracked throughout for a sleek, clean look. The typeface Roughedge was digitally manipulated in Adobe Illustrator
and placed into Adobe Photoshop, where lighting effects were applied. **SPECIAL PRODUCTION TECHNIQUES:** Corners were rounded on the two-sided business card,
the letterhead and the mailing label. **SPECIAL FOLDS OR FEATURES:** A mini quick-note sheet was designed with rounded corners to complement the letterhead.
SPECIAL COST-CUTTING TECHNIQUES: Colored vellum envelopes (purple and green) were purchased separately so a mailing label can be applied, sparing the
expenses associated with converting an envelope.

STUDIO: Modern Dog, Seattle, Washington **ART DIRECTORS:** Michael Strassburger, Robynne Raye **DESIGNERS:** Michael Strassburger, Robynne Raye
TYPEFACE DESIGNER: Michael Strassburger (Imperfect) **CLIENT/SERVICE:** Modern Dog/graphic and Web site design **SOFTWARE:** QuarkXPress, Adobe Illustrator
COLORS: Three, match **PRINT RUN:** 1,000 **COST PER UNIT:** $0 **TYPEFACES:** Trade Gothic, Marker Script, Frutiger, Imperfect (manipulated) **CONCEPT:** Robynne Raye
of Modern Dog says this stationery system for the studio was inspired by "cheesy mailing labels." **SPECIAL TYPE TECHNIQUES:** The logo font, Imperfect (designed
by Michael Strassburger of Modern Dog), was stretched in Adobe Illustrator to look three-dimensional. **SPECIAL COST-CUTTING TECHNIQUES:** Raye says they
talked the printer into a free job.

STUDIO: CO:LAB, Hartford, Connecticut ART DIRECTOR/DESIGNER: Richard Hollant PHOTOGRAPHER: John Soares COPYWRITER: Richard Hollant CLIENT/SERVICE: John Soares Photography/editorial, corporate and advertising photography SOFTWARE: Adobe Photoshop, QuarkXPress PAPER: Neenah Classic Crest COLORS: Four, process PRINT RUN: 1,000 COST PER UNIT: Total budget was about $4,000 to $5,000 TYPEFACES: Dogma, Bell Gothic CONCEPT: Richard Hollant of CO:LAB describes photographer John Soares as "the King-Daddy of Inventiveness. He's always trying something unexpected, like shooting portraits in a bowl of milk or projecting stuff or kicking tripods or lighting corporate execs with flashing Christmas tree lights. The outcome is consistently raw and emotional and always content based, while the process is unequivocably slapstick. We wanted to communicate John's irreverence and that he is at his best when he can play in the arena of subtext, when he can navigate the waters between what you want to say and what you *really* want to say." Hollant says of this stationery system that "each piece has a headline and image juxtaposition that speaks to a specific quality about John's style or practices. The business card deals with his inventiveness and alchemistic approach. The labels deal with his consummate professionalism and commitment to deliver a quality product—he may be wacky, but the job gets done on time and on budget. The letterhead lets you know that the entire world is his studio, which suggests that he's a location shooter, but then we foiled the ability to pigeonhole John by using a studio shoot to suggest his location shooting ability."

STUDIO: Prototype 21, London, United Kingdom **ART DIRECTOR/DESIGNER:** Prototype 21 **CLIENT/SERVICE:** Prototype 21/design **SOFTWARE:** CorelDRAW **PAPER:** Recycled paper and card stock, Fasson Permanent Crack-Back Plus (stickers) **COLORS:** Two, match **TYPEFACE:** OCR-B **CONCEPT:** This system for a London design firm is both minimalistic and futuristic. It saves its graphics for an array of versatile business card-sized stickers that the studio uses to promote its Web site.

STUDIO: Archrival, Lincoln, Nebraska CREATIVE DIRECTOR: Clint! Runge DESIGNERS: Ryan Cooper, Charles Hull CLIENT/SERVICE: Mill's Squeegee Fill Stations/convenience store chain SOFTWARE: Adobe Illustrator PAPER: Strathmore COLORS: Four, process PRINT RUN: 1,500 TYPEFACES: Decorated, King Richard, Gil Sans
CONCEPT: "Research indicated that the feeling of belongingness for today's convenience store consumer was missing from the convenience store experience," says Clint! Runge of Archrival. "There was no personal attachment to the stores for the general consumer. The Squeegee concept rose from the retro fill-station appeal toward youthful consumers and their Gen X preferences. The stations are quirky in style but serious in service. This identity is a part of a complete brand design including name, logo, stationery, cups, napkins, products, signage, interior design and uniforms. ■ We wanted the logo to keep in the tradition of circular gas logos, to embody a good-natured youthful fifties flair and to be trustworthy. Graphically, the squeegee is used in a literal fashion for added quirkiness and prepared as an illustration (as it would have been in the fifties). The colors, heavy outlines and typography follow in the concept of 'retro-flair attitude' for a Gen X appeal. ■ This identity system brings life into the new concept. The colors, shapes and typography add to that off-centered quirkiness that is embodied in the people who own the new Squeegee Fill Stations. These new stores are about personality and a fun experience. Here, they wash your car by hand and check your oil while talking to you about your snowboarding trip last weekend."

Concrete Design Communications Inc.

STUDIO: Concrete Design Communications Inc., Toronto, Canada **ART DIRECTORS:** Diti Katona, John Pylypczak **DESIGNER:** Diti Katona **ILLUSTRATOR:** Christian Northeast **CLIENT/SERVICE:** Blink Pictures/film production **SOFTWARE:** Adobe Illustrator, QuarkXPress **PAPER:** French Paper **COLORS:** Three, match **TYPEFACES:** ITC Franklin Gothic Book, Franklin Gothic Condensed **CONCEPT:** The designers from Concrete say, "The client has a wonderful sense of humor and imagination, so the inspiration came from a long conversation with the client. Our interpretation of clients' needs often come from talking with them."

The Kenwood Group

The Kenwood Group

Christina Crowley
President

75 Varney Place
San Francisco, CA 94107
Tel 415 957-5333
Fax 415 957-5311
crowley@kenwoodgroup.com

75 Varney Place, San Francisco, CA 94107 Tel 415 957-5333 Fax 415 957-5311 www.kenwoodgroup.com

STUDIO: Cahan & Associates, San Francisco, California **ART DIRECTOR:** Bill Cahan **DESIGNER:** Sharrie Brooks **ILLUSTRATOR:** Sharrie Brooks **PHOTOGRAPHERS:** various **CLIENT/SERVICE:** The Kenwood Group/event, video and interactive media production **SOFTWARE:** QuarkXPress, Adobe Photoshop **PAPER:** Fox River Starwhite Vicksburg **COLORS:** Four, process **PRINT RUN:** 5,000 **TYPEFACE:** Trade Gothic **CONCEPT:** "The Kenwood Group is a team of event, video and interactive media producers who uniquely position their clients through the stories they tell. The identity system was developed to reflect that process, each image telling a different story about what The Kenwood Group does. The deadpan directional sign was meant as a metaphor for the kind of guidance Kenwood provides its clients," says designer Sharrie Brooks.

Spatchurst Design Associates

STUDIO: Spatchurst Design Associates, Sydney, Australia **ART DIRECTOR/DESIGNER:** John Spatchurst **CLIENT/SERVICE:** Clock Hotel, Sydney/bar and restaurant **SOFTWARE:** Adobe Illustrator, QuarkXPress **PAPER:** OCM Brightwhite Wove **COLORS:** Two, match **TYPEFACE:** Peignot Demi **CONCEPT:** This stationery design uses nothing more than type to both play off the hotel's name and convey its style.

470 CROWN STREET SURRY HILLS NSW 2010

CLOCK'HOTEL'
CLOCK'HO

enquiry@clockhotel.com.au
TELEPHONE 02 9331 5333
FACSIMILE 02 9380 7966

470 CROWN ST SURRY HILLS NSW 2010

CLOCK'HOTEL'
CLOCK'HOTEL'

TELEPHONE 02 9331 5333
FACSIMILE 02 9380 7966
enquiry@clockhotel.com.au

CLOCK HOTEL GROUP PTY LTD
ACN 076 632 865

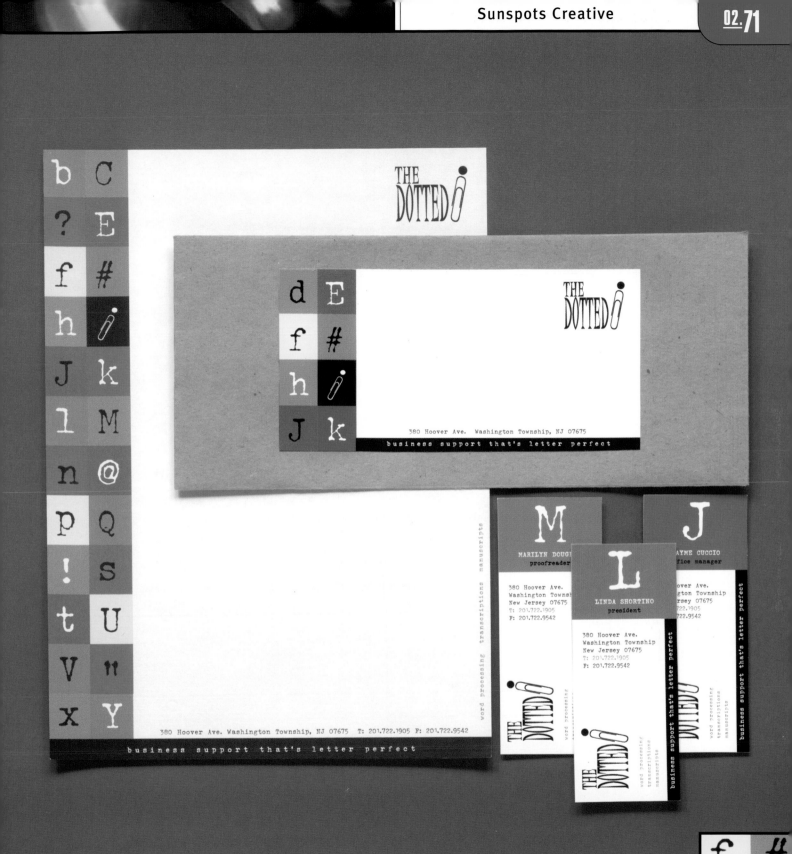

STUDIO: Sunspots Creative, Hoboken, New Jersey **ART DIRECTOR:** Rick Bonelli **DESIGNERS:** Deena Hartley, Rick Bonelli **ILLUSTRATOR:** Rick Bonelli **CLIENT/SERVICE:** The Dotted i/business support service **SOFTWARE:** QuarkXPress, Adobe Illustrator **PAPER:** Neenah Classic Crest White (letterhead), Kraft custom envelopes with side tie clasp **COLORS:** Four, process **PRINT RUN:** 2,000 **COST PER JOB:** $875 (letterhead) **TYPEFACE:** John Doe **CONCEPT:** "Business support service identity design is usually very bland, with typical clip art and basic typography," says Rick Bonelli. "We decided to give our client a bold and graphically simple but colorful look by emphasizing the alphabet in colorful blocks while using their logo for the letter i. Kraft envelopes give a very officelike feel to the whole system. The overall result for the client was very positive, with numerous compliments that their identity materials stood out compared to the daily influx of business mail received." **SPECIAL FOLDS OR FEATURES:** For the business cards, an unusual elongated (4¼" × 1¾" [10.8cm x 4.5cm]) size was used to emphasize the first letter of each cardholder's name. **SPECIAL COST-CUTTING TECHNIQUES:** Four-color labels were designed for 9" × 12" (22.9cm × 30.5cm) Kraft envelopes and no. 10 Kraft envelopes to save money and still allow for a colorful, tactile design.

Plazm Media

STUDIO: Plazm Media, Portland, Oregon **ART DIRECTORS:** Joshua Berger, Niko Courtelis, Pete McCracken **DESIGNERS:** Joshua Berger, Pete McCracken **TYPEFACE DESIGNER:** Plazm Fonts **CLIENT/SERVICE:** Xceptor Therapeutics/pharmaceutical genetics **SOFTWARE:** QuarkXPress, Adobe Illustrator **PAPER:** Champion Carnival White Smooth **COLORS:** Two, black and match, plus silver foil stamp **PRINT RUN:** 2,500 **TYPEFACE:** Roscent **CONCEPT:** "Xceptor will produce new pharmaceuticals modeled from DNA identified in the human genome," says Joshua Berger of Plazm. "*X* is a highly recognizable and elemental letterform. No company in biotech had built a franchise around the letter *X*. Since *X* reinforces the initial letter of the company name and is the company monogram, the symbol then reinforces brand identity. *X* and *O* represent unknown and orphan receptors in the biotech industry." **SPECIAL PRODUCTION TECHNIQUES:** Foil stamp trapped to litho custom ink color.

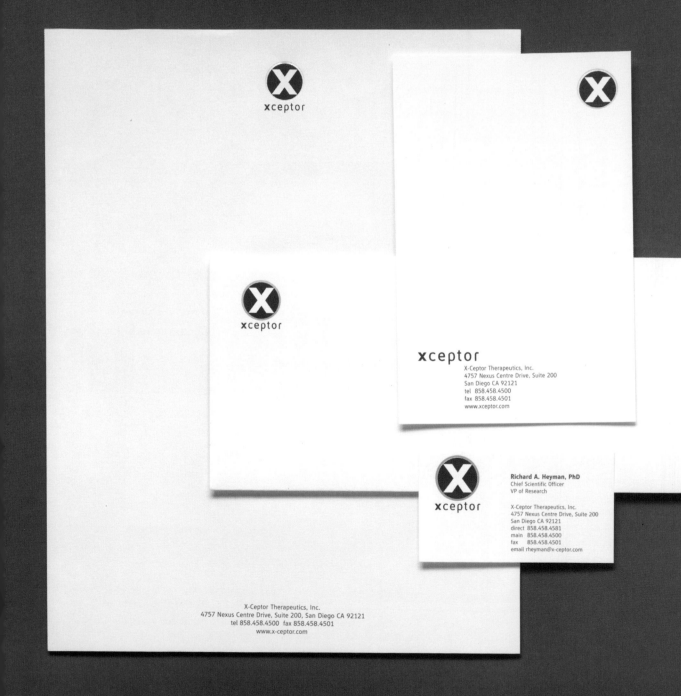

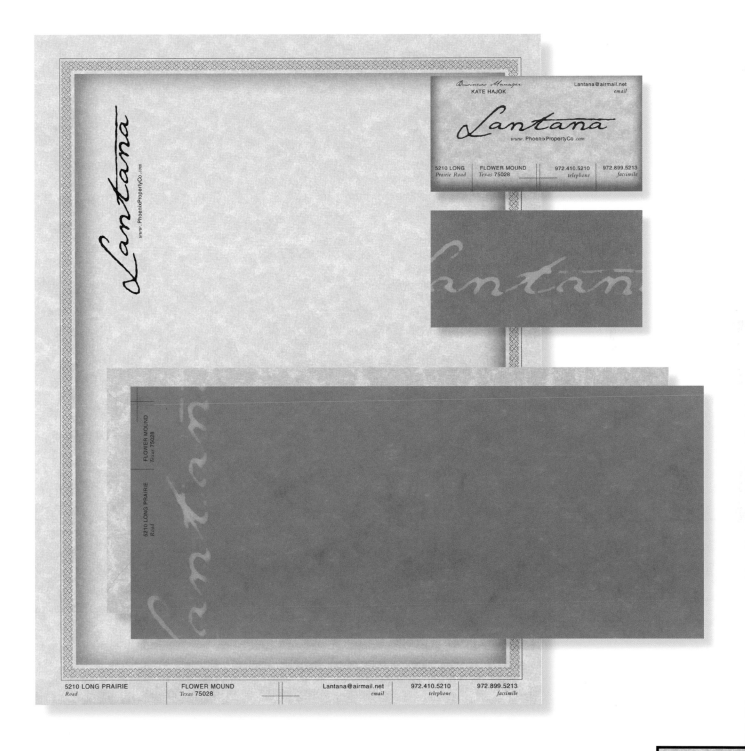

STUDIO: VWA Group, Dallas, Texas **DESIGNERS:** Bret Sano, Ann Thornton **CLIENT/SERVICE:** Phoenix Property Company/real estate developer **SOFTWARE:** Adobe Illustrator, QuarkXPress, Adobe Photoshop **PAPER:** French Parchtone Relic Gold **COLORS:** Two, black and match **PRINT RUN:** 2,500 **TYPEFACES:** Texas Hero (logo), Helvetica, Bembo Italic **CONCEPT:** Phoenix Property Company commissioned Dallas, Texas-based VWA Group to create for their multifamily Lantana property a stationery package to be used in correspondence with current and future residents. Designer Bret Sano says, "Marketing Lantana as a rustic lodge with modern conveniences was top priority, so the concept of mimicking official documents of the early West time period was approved. The completed design suggests old currency or stock/bond certificates, and it complements the clubhouse interiors as well as establishes the property's uniqueness. Details such as paper stock and metallic ink reinforce the concept." **SPECIAL TYPE TECHNIQUES:** "Using a mixed bag of standard typefaces like Helvetica created a 'nondesign' look and kept the focus on the logo. The Lantana logo was digitally manipulated in Adobe Illustrator out of the Texas Hero typeface." **SPECIAL COST-CUTTING TECHNIQUES:** While two colors were used throughout, the parchment stock acted as a third color and gave the pieces added richness and texture without requiring additional colors.

STUDIO: Tracy Smith Design, Pasadena, California **ART DIRECTOR/DESIGNER:** Tracy Smith **CLIENT/SERVICE:** Tracy Smith Design/graphic design **SOFTWARE:** QuarkXPress, Adobe Photoshop, Adobe Illustrator **COLORS:** Four over one, process, plus aqueous coating **PRINT RUN:** 20,000 **COST PER UNIT:** approximately $0.004 **TYPEFACES:** Futura, Good Dog, Monoline Script, Neuland **CONCEPT:** The design of this business card was inspired by "old postcards from the thirties and forties that I had lying around and a twelve-hour notice of free printing," says Tracy Smith. **SPECIAL PRODUCTION TECHNIQUES:** The miniature self-stick stamps were color output on a Canon color copier, and a rubber stamp was then used to hand cancel the "postage." **SPECIAL COST-CUTTING TECHNIQUES:** The printer had space on an existing job, so the card was run with that job, then trimmed off. Although there were over twenty thousand cards printed, Smith's only expense was film, the label stock for the stamps, and the rubber stamp—in total, less than $75.

STUDIO: bl_nk, San Diego, California **ART DIRECTOR/DESIGNER:** Dave Blank **CLIENT/SERVICE:** bl_nk/design **SOFTWARE:** QuarkXPress, Adobe Illustrator **COLORS:** Three, match **TYPEFACES:** Vintage Typewriter, Century Schoolbook **CONCEPT:** Dave Blank explains this business card design succinctly: "Hell, with a name like Blank, what else are you gonna do?"

The Management Innovation Team

5563 N. Via Girasol • Tucson AZ 85750
Phone: 520-250-5700 • Fax: 520-615-4053
e-mail: GillCons@aol.com

Gilliland Consulting

STUDIO: Boelts Bros. Associates, Tuscon, Arizona **ART DIRECTORS:** Jackson Boelts, Eric Boelts, Kerry Stratford **DESIGNERS:** Jackson Boelts, Eric Boelts, Kerry Stratford **CLIENT/SERVICE:** Gilliland Consulting/marketing consultation **SOFTWARE:** Adobe Photoshop, Macromedia FreeHand **PAPER:** Strathmore Writing **COLORS:** Two, match **PRINT RUN:** 2,000 **COST PER UNIT:** $0.40 **CONCEPT:** "The Gillilands are a husband/wife team that consults with Fortune 500 corporations in business management," says Jackson Boelts. "The flip-flop arrow is a symbol of the give and take of the information flow."

Inox Design

STUDIO: Inox Design, Milan, Italy **ART DIRECTOR/DESIGNER:** Mauro Pastore **CLIENT/SERVICE:** Daniela Quagliotti/food stylist **SOFTWARE:** Adobe Illustrator, Adobe Photoshop, QuarkXPress **PAPER:** Zanders Zeta White Hammer **COLORS:** Two, match **TYPEFACE:** Base Nine **CONCEPT:** The idea behind this system for a food stylist was to "let the personality of the client stand out. That's what makes her work special," according to designer Mauro Pastore. The original signature of the client (used in a manipulated form) symbolizes the taste and style that is a hallmark of the client's work.

Daniela Quagliotti
food stylist

Daniela Quagliotti
food stylist
t 0335 8248448
f 02 48003358

Via de Alessandri 9 • 20144 Milano (I) • P.Iva 12835260154

Via G. de Alessandri 9 • 20144 Milano • I

t 0335 8248448 • f 02 48003358 • Via Giovanni de Alessandri 9 • 20144 Milano • I • P.I. 12835260154

STUDIO: Kuester Partners, Minneapolis, Minnesota **ART DIRECTOR/DESIGNER:** Bob Goebel **ILLUSTRATOR:** Jack Molloy **CLIENT/SERVICE:** Faraway Productions/theater productions **SOFTWARE:** QuarkXPress **PAPER:** Strathmore Writing **COLORS:** Two, match **PRINT RUN:** 2,000 **TYPEFACES:** ITC Franklin Gothic Condensed, ITC Bodoni **CONCEPT:** "Evoking life on the island of Nantucket 150 years ago, the materials for this system draw inspiration from whaling journals, ledgers, books and other archival materials," says Bob Goebel of this system for a theater group. **SPECIAL TYPE TECHNIQUES:** The piece uses baseline shifts, inconsistent kerning and mismatched typefaces to replicate the look and feel of hand-set metal type. **SPECIAL PRODUCTION TECHNIQUES:** Illustrations are reproduced as black and orange duotones.

low budget

Unlike the designers in other sections—who were allowed the luxuries of die cuts, embossing or foil stamping to execute their ideas-the designers in this section had to work with less. Without snazzy production techniques, these designers' ideas were conveyed in their purest form and had to stand or fall on their own merits.

Without the option of expensive printing processes, a designer's true abilities are really evidenced—these abilities make the difference between something that looks desktop published and something that looks designed. In fact, just as the haiku or sonnet form can draw from a poet an idea that he or she would not have had otherwise, so can the limitations of budget draw the best from a designer—as we'll see in this section.

CHAPTER

Storm Visual Communications

STUDIO: Storm Visual Communications, Ottawa, Canada **ART DIRECTOR:** Robert Smith **DESIGNERS:** Kevin Kelly, Robert Smith **PHOTOGRAPHER:** Headlight Innovative Imagery **TYPEFACE DESIGNER:** Jackson Burke **CLIENT/SERVICE:** Storm Visual Communications/design communications **SOFTWARE:** QuarkXPress **PAPER:** Mohawk Superfine **COLORS:** Two, black and match **PRINT RUN:** 1,000 (letterhead), 1,000 (envelopes), 500 (business cards) **TYPEFACE:** Trade Gothic **CONCEPT:** Robert Smith of Storm says, "Our stationery system was expected to meet a number of challenges. As it must set Storm apart from other design studios, it would need to stand out in an environment of highly designed identities. It would also need to present the company in a professional manner and avoid being overdesigned. And finally, it would need to showcase the studio's approach to branding and marketing through design. ■ To achieve this, we developed a design strategy that would contrast the forceful, possibly chaotic name Storm with a clean and calm aesthetic. The typeface Trade Gothic was chosen for its clarity and classic style. Finally, dark, moody images of people in a storm were juxtaposed against a clean white paper stock. ■ The resulting message is that, through both our visual design and marketing strategies, we bring calm to the stormy, unpredictable and chaotic environment that is communications." **SPECIAL FOLDS OR FEATURES:** Printing an image on the back of the letterhead; printing on the inside of the envelope. (This required the envelopes to be printed flat and then manufactured.)

STUDIO: Sterling Design, San Francisco, California **ART DIRECTOR/DESIGNER:** Jennifer Sterling **ILLUSTRATOR:** Jennifer Sterling **CLIENT/PRODUCT:** Limn/furniture
SOFTWARE: Adobe Illustrator **PAPER:** Fox River Starwhite Vicksburg Cover **COLORS:** Four, match **PRINT RUN:** 180,000 **COST PER UNIT:** $0.50 **CONCEPT:** This set of
stationery systems for a furniture company conveys stylish simplicity, with the square, illustrated business cards giving this simplicity a twist.

Philip Fass

ART DIRECTOR/DESIGNER: Philip Fass, Cedar Falls, Iowa **CLIENT/SERVICE:** Eclipse Productions/film production **SOFTWARE:** Adobe Photoshop, Macromedia FreeHand, QuarkXPress **PAPER:** laser printer paper **COLORS:** One, black **TYPEFACE:** Frutiger **CONCEPT:** For this stationery system for a film production company, Philip Fass says that "the concept of an eclipse was interpreted through explicit imagery and concrete usage of type. The rules used on the stationery, card and envelope create structure and imply movement. They were also used in this way as a means of addressing the idea of variations on a theme, an idea at the core of film-making. **SPECIAL TYPE TECHNIQUES:** "The firm's name is interpreted in a concrete poetic way—type eclipses type." **SPECIAL COST-CUTTING TECHNIQUES:** "The files exist on the client's computer, so the main cost-cutting feature is that the client prints what he needs as he needs it. Since he doesn't need to take these pieces through typical production, this strategy 'eclipses' traditional printing."

Sushi.

Drama Queen
Seeks Audience.

SPVA 20
★★★★

619.235.8468
SPVA/20

M. B. Senkovič
direktor

w

wateko
d.o.o.

Meljska cesta 1
2000 Maribor, Slovenija
Tel.: 00386 62 22 879 90
Fax.: 00386 86 22 879 91

M. B. Senkovič
direktor

Meljska cesta 1
2000 Maribor, Slovenija
Tel.: 00386 62 22 879 90
Fax.: 00386 86 22 879 91

STUDIO: Hollis Design, San Diego, California **ART DIRECTOR:** Don Hollis **DESIGNER:** Paul Drohan **CLIENT/SERVICE:** Sushi Performance/nonprofit performance and dance theater venue **SOFTWARE:** Macromedia FreeHand **PAPER:** white cover **COLORS:** One, match **PRINT RUN:** 1,500 **COST PER UNIT:** $0.05 **TYPEFACE:** Helvetica Black **CONCEPT:** "Sushi Performance is known for pushing the envelope and bringing a much needed cultural diversity to the city of San Diego's East Village," says Don Hollis. For this teaser campaign, he says, "The cards were distributed in cafés, clothing stores, retail stores and dining locations where potential patrons live, work and visit. The point of the teaser campaign was to engage the viewer and to provoke thought and action. No logo or identification was placed on the bulk of the cards. Intrigue was the motivator designed to initiate a response."

STUDIO: Stojan, Pekel, Slovenia **DESIGNER:** Jure Stojan **CLIENT:** Wateko d.o.o. **TYPEFACE DESIGNER:** Stojan **SOFTWARE:** Macromedia Fontographer, Adobe Illustrator **COLORS:** One, match **PRINT RUN:** 500 **COST PER UNIT:** SIT 80 **TYPEFACE:** Wateko Sans **CONCEPT:** "A business card must be extravagant, in a sense, in order to make a long-lasting impression," says designer Jure Stojan. "However, the designer is limited to the card's standardized proportions: An oversized card would not fit in personal organizers and would then probably be discarded. We felt that using folding techniques not only overcomes this problem but also gives the overall design a sophisticated yet modern touch." **SPECIAL TYPE TECHNIQUES:** "The client also commissioned a corporate typeface, Wateko Sans." Special folds or features: The card is folded twice in the middle so that it conceals the company name and logotype. **SPECIAL COST-CUTTING TECHNIQUES:** One-color printing.

wateko
d.o.o.

STUDIO: Stoltze Design, Boston, Massachusetts **ART DIRECTOR:** Clifford Stoltze **DESIGNERS:** Cynthia Patten, Brian Azer **CLIENT/SERVICE:** Chelsea Pictures/New York production company specializing in commercials and independent films **SOFTWARE:** Adobe Photoshop, Adobe Illustrator, QuarkXPress **PAPER:** Champion Benefit Text Softwhite **COLORS:** Two, match **TYPEFACES:** Tape Type, Bureau Agency **CONCEPT:** The logo was inspired by the headline of one of the client's ads that read, "Why can't you be like everyone else?" **SPECIAL TYPE TECHNIQUES:** For this system, an existing font was modified so there was no repeat of the same letterform. **SPECIAL PRODUCTION TECHNIQUES:** Metallic ink for shadow **SPECIAL COST-CUTTING TECHNIQUES:** Many pieces were ganged to lower costs.

STUDIO: Modern Dog, Seattle, Washington ART DIRECTOR/DESIGNER: Vittorio Costarella ILLUSTRATOR: Vittorio Costarella CLIENT/SERVICE: Chicken Soup Brigade/annual HIV/AIDS fundraiser dance-a-thon SOFTWARE: Adobe Photoshop, QuarkXPress COLORS: Two, match PRINT RUN: 500 COST: Donated TYPEFACE: Akzidenz Grotesk CONCEPT: According to Robynne Raye, it was "hard to find a chicken-legged model willing to pose for the shoot"; therefore, this system for a charity dance-a-thon instead uses as its centerpiece an image that combines the photograph of a dancing model with exaggerated cartoon legs that play off the name of the event's sponsor, the Chicken Soup Brigade. SPECIAL COST-CUTTING TECHNIQUES: The designer specced a combination of basic black and yellow overprint to come up with a new color.

Spoon! Design

STUDIO: Spoon! Design, Toronto, Canada ART DIRECTOR/DESIGNER: Cris Jaw PHOTOGRAPHER: Eric H. Wang CLIENT/SERVICE: Spoon! Design/graphic design
SOFTWARE: Adobe Illustrator, Adobe Photoshop, QuarkXPress PAPER: Mohawk Superfine Ultrawhite Smooth COLORS: One over one, match PRINT RUN: 1,000
TOTAL COST: approximately CAN $700 TYPEFACE: Melior CONCEPT: "Lead type in a spoon. Mmm..." is how designer Cris Jaw describes the concept behind this
system for his studio, Spoon! SPECIAL TYPE TECHNIQUES: "The Spoon! logo was created by tracing old lead type bought from a thrift store," says Jaw. "The same
lead type was then photographed in the metal spoon for the stationery system." SPECIAL COST-CUTTING TECHNIQUES: "One over one, can't beat that!"

Stealing Time Editing Inc. T 416.597.8080
488 Wellington Street West F 416.597.8700
Suite 400
Toronto, Ontario
Canada M5V 1E3

_stealing time

Stealing Time Editing Inc.
300 Richmond Street West
Suite 200
Toronto, Ontario
Canada M5V 1X2

_stealing time

T 416.597.8080
F 416.597.8700

Greg Edgar

_stealing time _stealing time

Stealing Time Editing Inc. T 416.597.8080
300 Richmond Street West F 416.597.8700
Suite 200
Toronto, Ontario
Canada M5V 1X2

STUDIO: Concrete Design Communications, Toronto, Canada **ART DIRECTORS:** John Pylypczak, Diti Katona **DESIGNER:** John Pylypczak **ILLUSTRATOR:** John Pylypczak
CLIENT/SERVICE: Stealing Time/film editing **SOFTWARE:** QuarkXPress, Adobe Illustrator **PAPER:** Strathmore **COLORS:** Two, match **PRINT RUN:** 5,000 **CONCEPT:** The name
of the client was the inspiration for the design of this system. "Our little running man is made up of numbers; he's stealing time," say the designers from Concrete.

STUDIO: Super Natural Design, San Francisco, California **ART DIRECTORS/DESIGNERS:** Christie Rixford, Hajdeja Ehline **CLIENT/SERVICE:** Beige/architecture and design **SOFTWARE:** Macromedia FreeHand, QuarkXPress **PAPER:** Fox River Starwhite Vicksburg Tiara **COLORS:** Two, match **PRINT RUN:** 1,000 **COST PER UNIT:** approximately $1.00 per set **TYPEFACES:** Eurostile Bold ("Beige"), Futura (text) **CONCEPT:** This stationery system for an architecture and design firm called Beige bypasses the obvious by avoiding the firm's namesake color while suggesting its subtlety.

STUDIO: Boelts Bros. Associates, Tucson, Arizona **ART DIRECTORS:** Kerry Stratford, Jackson Boelts **DESIGNERS:** Kerry Stratford, Jackson Boelts **PHOTOGRAPHER:** Tim Fuller **CLIENT/SERVICE:** Fox Tucson Theatre Foundation/theater restoration **SOFTWARE:** Adobe Photoshop, Macromedia FreeHand **PAPER:** Fox River Recycled **COLORS:** Two, match **PRINT RUN:** 1,000 **COST PER UNIT:** donated **CONCEPT:** "This is a nonprofit foundation project to restore the 1929 Art Deco Fox Theatre in Tucson through donations from government and the private sector," says Jackson Boelts. "We updated the Fox logo and designed letterhead, posters, invitations and a lapel pin. We wanted to highlight the exquisite art deco designs of the theatre, which are still in excellent condition."

STUDIO: Miho, Pasadena, California **ART DIRECTOR/DESIGNER:** Miho **PHOTOGRAPHER:** Art Kane **CLIENT/SERVICE:** Art Kane/photography **PAPER:** Strathmore Cover
COLORS: One, black **TYPEFACE:** Helvetica **CONCEPT:** Of this system for photographer Art Kane, Miho says, "Art Kane was an art director/photographer and knew his art. He was more artist than art director or photographer, as his pictures show. His knowledge of a picture was legion, and his knowledge of the places in the world was legion. Naturally, I used his pictures as word messages. He was full of ideas about visuals. He died full of pictures yet to be seen."

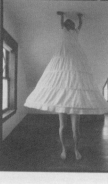
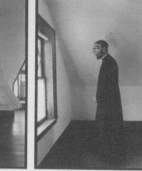

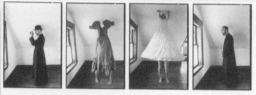

ART KANE 99 S. RAYMOND AVE., PASADENA, CA 91105 818 585-0047 FAX 818 440-9910

DEBBY KANE STUDIO MANAGER

ART KANE 99 S. RAYMOND AVE., PASADENA, CA 91105 818 585-0047 FAX 818 440-9910

ART KANE 99 S. RAYMOND AVENUE, PASADENA, CA 91105 818 585-0047 FAX 818 440-9910

STUDIO: Curry Design, Venice, California **ART DIRECTOR:** Steve Curry **DESIGNER:** Jason Scheideman **ILLUSTRATOR:** Steve Curry **CLIENT/SERVICE:** Curry Design/interdisciplinary graphic design **SOFTWARE:** QuarkXPress, Adobe Photoshop **PAPER:** Neenah Classic Crest Writing **COLORS:** Two, black and match **TYPEFACES:** Frutiger, Adobe Garamond, Bell Gothic **CONCEPT:** For this redesign of Curry Design's previous letterhead, which incorporated a dimensional *C* letterform along with the image of an eye, Jason Scheideman says, "Our concept was to express the symbiosis between vision and perception. We feel that good design transcends what we see and becomes part of our shared existence. It is the thought behind the vision that provides the depth."

STUDIO: NSD, Brussels, Belgium **ART DIRECTORS/DESIGNERS:** Jean-Marc Klinkert, Olivier Lamy **ILLUSTRATOR:** Ed Fella **CLIENT/SERVICE:** Beursschouwberg/state-supported avant-garde theater and performance venue **COLORS:** Four, process **TYPEFACES:** Helvetica, hand-lettering **CONCEPT:** Three years ago, Ed Fella was approached by NSD, a studio in Brussels, to hand letter a poster for Beursschouwberg, a theater and performance venue. They were so happy with the result that they approached him again to design their identity system. Fella, a design professor who doesn't design professionally anymore, says he told them he'd be willing to do the lettering, "but as far as the rest of the project, let the young local designers do it along with the production, paper, printing and all that stuff I'm retired from! I did the strip of lettering (in Prismacolor pencil as well as a black-and-white version) and sent it in a hand-addressed package to Brussels, neglecting to put the name of the country on it. (The lady in the post office did it, eventually). I didn't hear anything for a long while. Finally they called, all done, all printed, all happy. They asked if they could fly me over to Belgium to give a lecture at the theater and present the new logotype to the public. So I went. I had not seen anything of the project until I arrived there, and to my amazement there was the finished system with my logo in beautiful color reproduction with some set type and some handwritten lettering which I didn't recognize. They told me they got it all off the package! So it was mine, the postal clerk's and good old Helvetica on the complete letterhead and ID package."

PortalPlayer, Inc.
3255 Scott Boulevard, Bldg. 1
Santa Clara, California 95054
408.855.0830 Telephone
408.855.0841 Facsimile

PortalPlayer, Inc. 12020 NE 115th Avenue, Kirkland, Washington 98034 Telephone 425.825.1672 Facsimilie 425.825.1680 www.portalplayer.com

PortalPlayer, Inc.
3255 Scott Boulev
Santa Clara, Califo
408.855.0830 Tele
408.855.0841 Fac

STUDIO: Cahan & Associates, San Francisco, California **ART DIRECTOR:** Bill Cahan **DESIGNER:** Michael Braley **ILLUSTRATOR:** Michael Braley **CLIENT/PRODUCT:** PortalPlayer/portable, digital music technology **SOFTWARE:** Adobe Illustrator, QuarkXPress **PAPER:** Fox River Starwhite Vicksburg **COLORS:** Two over two, match **PRINT RUN:** 10,000 **TYPEFACES:** Futura Book (logotype); Avenir Book, Avenir Heavy (stationery) **CONCEPT:** "PortalPlayer has developed the technology that enables delivery of a complete digital media experience, including an all-in-one solution for MP3 players. This mark's whimsy captures the spirit and freedom of the revolution in personal, portable, digital music," says designer Michael Braley.

special techn

STUDIO: Independent Project Press, Sedona, Arizona **ART DIRECTOR/DESIGNER:** Bruce Licher **PHOTOGRAPHER:** Bruce Licher (business card) **CLIENT/SERVICE:** Independent Project Press/graphic design and hand-fed letterpress printing **PAPER:** basic laser printer paper (letterhead), French Dur-o-Tone Butcher Off-White (envelope), Hungarian Kraft (window envelope), Beveridge Placard (larger business card), Beveridge Buff Rainbow Bristol (smaller business card), Gypsum Board (note card), Spinnaker C1S Litho Coated Dextrine Gummed Stock (mailing label) **COLORS:** Three to five, match **PRINT RUN:** varied from 400 to 500 up to about 800 to 1,000 on the business cards **TYPEFACES:** Circular logotype: Jefferson Gothic ("Independent Project"), FC Helenic ("Press"), News Gothic Extra Condensed (address), Bodoni Ultra (postal code), Cheltenham Bold Condensed (street address); Business card: Venus Light Italic (name, "e-mail" on back), Bernhard Gothic Medium (title); Business card back: Spartan Medium (top two lines), FC Helenic (ampersand), Bernhard Gothic Medium Title ("Phone & Fax"), Record Gothic Bold Extended Italic (phone number), Venus Bold Extended ("Discfolio"), Grotesque Bold ("Home of," "compact disc & record packaging"); Letterhead, note card: Franklin Gothic ("Specializing in"); Envelopes, mailing label: Venus Light Italic ("Specializing in") **CONCEPT:** This letterpress system demonstrates the work of Bruce Licher's design and letterpress studio and it meets his goal of "having fun and doing something new and different" as well. **SPECIAL PRODUCTION TECHNIQUES:** The corners are rounded to make them friendlier. **SPECIAL COST-CUTTING TECHNIQUES:** Licher printed the pieces himself to avoid paying for labor.

STUDIO: Sterling Design, San Francisco, California **ART DIRECTOR/DESIGNER:** Jennifer Sterling **ILLUSTRATOR:** Jennifer Sterling **CLIENT/PRODUCT:** Sterling Design/design **SOFTWARE:** Adobe Illustrator **PAPER:** Fox River Starwhite Vicksburg Archiva **COLORS:** One, match **PRINT RUN:** 10,000 **COST PER UNIT:** $1.00 **TYPEFACES:** Garamond, Meta **CONCEPT:** This letterhead system for Sterling Design artfully uses tactility and attention to detail to convey an upscale image for the studio, while employing metal as a reference to the studio principal's last name. The metal laser-cut business card is both highly memorable and extremely durable. The rest of the system uses debossing and hole punches in unusual but subtle ways. For instance, the letterhead utilizes a perforated strip at the bottom where month, day and year of correspondence are indicated by punching holes on a row of numbers and part of the address on the envelope and the letterhead are debossed. The metal business card is mirrored by circular paper clips cut from the same metal, which are also echoed by small stickers the same size and shape as the paper clips. **SPECIAL TYPE TECHNIQUES:** Deboss, laser cut **SPECIAL PRODUCTION TECHNIQUES:** Metal laser-cut business card.

Thibault Paolini Design

STUDIO: Thibault Paolini Design, Portland, Maine **ART DIRECTOR:** Renée Fournier **PRINTER:** Graphics & Printing, Inc., Portland, Maine **TYPEFACE DESIGNER:** Lucas de Groot **CLIENT/PRODUCT:** Martha Roediger/sculptural woven artwork for private and corporate collections **SOFTWARE:** Macromedia FreeHand **PAPER:** Rolland Motif Curves **COLORS:** Two, black and match **PRINT RUN:** 2,500 **COST PER UNIT:** $2.06 per set **TYPEFACE:** FF The Mix **CONCEPT:** The look of this stationery system was inspired by the work of the artist client, says Renée Fournier. **SPECIAL TYPE TECHNIQUES:** "In the creation of the logo, type was converted to outline, and crossbars in As were removed. A red thread was made to weave in and out of the letters, completing the As." **SPECIAL PRODUCTION TECHNIQUES:** Emboss and deboss were used on the letterhead and business card. Custom outline dies were used on the letterhead and business card. The envelopes were printed flat, then converted for optimum ink coverage on flap. **SPECIAL FOLDS OR FEATURES:** "On the letterhead, a simple curve die cut at the bottom of the sheet becomes even more interesting when the sheet is letter folded, as it is printed in a solid special mix red on the back. Heavy ink coverage on the back of the letterhead also brings out the curve watermark in the paper, adding another layer of interest. The envelope front is printed with only a red thread, which stimulates curiosity. The envelope flap is printed with special mix red, and the thread is reversed out of the color, almost as if it was removed from the back and placed on the front. Also, when letterhead is inserted in the envelope, the dark solid printed on the outside of the folded letterhead enhances the curve watermark in the envelope." **SPECIAL COST-CUTTING TECHNIQUES:** An existing die was used for the emboss and deboss.

66 PEARL STREET | PORTLAND, MAINE 04101

207 828 8771 | FAX 207 828 8772 | MARTHAR@IME.NET

WWW.MARTHAROEDIGER.COM

STUDIO: Kuester Partners, Minneapolis, Minnesota ART DIRECTOR: Bob Goebel DESIGNERS: Bob Goebel, Jennifer O'Brien ILLUSTRATORS: Bob Goebel, Jennifer O'Brien CLIENT/PRODUCT: Parasole Restaurant Holdings/restaurants SOFTWARE: QuarkXPress, Adobe Photoshop PAPER: French Dur-o-Tone COLORS: One, match PRINT RUN: 2,200 TYPEFACES: Century Schoolbook, Cheltenham, Helvetica, HTF Champion Gothic CONCEPT: This system for a restaurant developer was meant to evoke "a stereotypical fly-by-night backroom import operation," says Bob Goebel. "It also incorporates art elements that carry forth the idea of 'street food from the hot zones': regional specialties from equatorial hot spots extending from the Caribbean across Latin America and the Pacific Rim to Southeast Asia and India." SPECIAL TYPE TECHNIQUES: "Using baseline shifts, inconsistent kerning and mismatched typefaces to achieve an amateur appearance." SPECIAL PRODUCTION TECHNIQUES: Address information is in the form of an adhesive sticker, the kind commonly seen adhered to the bottom of imported goods. SPECIAL COST-CUTTING TECHNIQUES: Address stickers could be used on a variety of items, thereby minimizing or eliminating the need for additional printing. To add to the eclectic look, four different patterns were run on the back of the letterhead by printing them all in a single pass on a large press sheet.

T U D I

Ave P501 Seattle,

MAIL info@form

DESIGN

STUDIO: Form Studio, Seattle, Washington **ART DIRECTOR/DESIGNER:** Jeffrey Burk **ILLUSTRATOR:** Jeffrey Burk **CLIENT/SERVICE:** Form Studio/graphic design **SOFTWARE:** Macromedia FreeHand, Adobe Photoshop, Strata 3D **PAPER:** Havana Perla Cover (business card), Strathmore Natural White Wove (letterhead, envelope) **COLORS:** Two, match **TYPEFACES:** Akzidenz Grotesk, Mrs Eaves, Clarendon **CONCEPT:** This system uses traditional and neotraditional fonts, a calligraphy-inspired logo and a die-cut and embossed business card to associate a feeling of quality with Form Studio.

F O R M S T U D I O I N C .

2900 First Ave P501 Seattle, WA 98121

TEL 206.448.0275 **FAX** 206.448.0277 **EMAIL** info@formstudio.com **WEB** www.formstudio.com

D E S I G N

F O R M S T U D I O I N C .

2900 First Ave P501 Seattle, WA 98121

JEFFREY BURK

TEL 206.448.0275 **FAX** 206.448.0277

EMAIL jeffrey@formstudio.com **WEB** www.formstudio.com

PRINT IDENTITY INTERNET

D E S I G N

F O R M S T U D I O I N C .

2900 First Ave P501 Seattle, WA 98121

STUDIO: Anderson Thomas Design, Nashville, Tennessee **ART DIRECTOR:** Joel Anderson **DESIGNER:** Roy Roper **PHOTOGRAPHY:** PhotoDisc **CLIENT/SERVICE:** Anderson Thomas Design/graphic design **SOFTWARE:** QuarkXPress, Adobe Illustrator, Adobe Photoshop **COLORS:** Four, process **TYPEFACES:** ITC Galliard, Triplex, Franklin Gothic **CONCEPT:** "Tired of uniform, simplistic collateral, we created personalized business cards with different icons appropriate for each designer and used the icons to tell a story on both the letterhead and envelope that blatantly stated our purpose and philosophy," says designer Roy Roper. **SPECIAL PRODUCTION TECHNIQUES:** The studio used a die cut which created a matching, unconventional shape for both the business card and letterhead.

STUDIO: Epoxy, Montreal, Canada **ART DIRECTORS:** Daniel Fortin, Maryse Morin, George Fok **DESIGNERS:** Maryse Morin, Daniel Fortin **PHOTOGRAPHER:** Anore Rider **CLIENT/SERVICE:** Café Melies/café **SOFTWARE:** Adobe Illustrator, Adobe Photoshop **PAPER:** Rolland Evolution **COLORS:** Two, match **PRINT RUN:** 2,000 **TYPEFACE:** Ghetto Prince **CONCEPT:** Daniel Fortin says, "Prior to joining with Montreal's mecca for the avant-garde, Ex Centris (a cinema/new media center), Café Melies was already recognized as the meeting place for Montreal's film enthusiasts. As a part of Ex Centris, I aimed at expressing Café Melies's warmth, the seething atmosphere of the *nouveau lieu* itself, while keeping in mind its references to the origins of cinema. I set out to do so with the help of a warm palette, an architectural Polaroid of its building that is also reminiscent of early prints, and an expressive font. By looking closely within the nonlinear dot emboss of the business cards and menus, one can also notice the principle of gathering being expressed here again."

STUDIO: Hollis Design, San Diego, California ART DIRECTOR: Don Hollis DESIGNERS: Don Hollis, Gina Elefante CLIENT/SERVICE: Chive/restaurant

BUSINESS CARDS: SOFTWARE: Macromedia FreeHand, Adobe Illustrator PAPER: 10 mil pressline clear COLORS: One, black (silkscreen) PRINT RUN: 1,200
COST PER UNIT: $0.20 TYPEFACES: Bodoni Italic, Trade Gothic CONCEPT: "Chive's positioning statement is 'cuisine moderne'; the thinking, design and food are
unique and tantalizing and were developed to parallel the architecture in a combined concept," says Don Hollis. SPECIAL TYPE TECHNIQUES: These business cards
display reversed letterforms and deconstruction; Adobe Illustrator was used to outline and edit the original. SPECIAL PRODUCTION TECHNIQUES: Silkscreen on clear
acetate SPECIAL COST-CUTTING TECHNIQUES: One-color, one-side printing.

RUBBER BANDS: SOFTWARE: Macromedia FreeHand, Adobe Illustrator COLORS: One, match PRINT RUN: 1,500 COST PER UNIT: $0.20 TYPEFACES: Trade Gothic Bold
Condensed, Bodoni CONCEPT: Hollis created these bands "to add a potentially 'interactive' element and color to a chic, refined dining experience—a splash of
fun. The primary objective was to provide something that couldn't get lost in a Rolodex or wallet and then later be forgotten. The bands are available in a vase
near the restrooms and in front by the greeting station." This special collateral does have its downside, however: "Watch out if you're sitting near the bar."
SPECIAL TYPE TECHNIQUES: Deconstruction and inverted letterforms from Trade Gothic.

Lodge Design Co.

STUDIO: Lodge Design Co., Indianapolis, Indiana **DESIGNERS:** Eric Kass, Jarrett Hagy, Jason Roemer **CLIENT/SERVICE:** Lodge Design Co./strategic, consumer-oriented image building through integrated marketing, writing and design **SOFTWARE:** Adobe Illustrator, QuarkXPress **PAPER:** French Dur-o-Tone Butcher, Kraft no. 10 envelope, aluminum **COLORS:** One, match **PRINT RUN:** 1,000 **COST PER UNIT:** $0.30 (letterhead), $0.18 (envelope), $1 (business card) **TYPEFACES:** Alternate Gothic No. 1, Trade Gothic No. 18 Condensed **CONCEPT:** Jarrett Hagy says that the goal for this system for his studio was "to achieve an industrial feel through choice of materials and printing processes in order to reflect our Midwestern work ethic and to create a strong, established look for our fledgling company. We also wanted to get as much attention as possible by utilizing the tactile nature of the letterpress printing, the embossed aluminum and special papers." **SPECIAL PRODUCTION TECHNIQUES:** The letterhead and envelope are letterpress and the business card is embossed and silk-screened aluminum. **SPECIAL COST-CUTTING TECHNIQUES:** "A label was used on the cards to personalize them with names, so the aluminum business cards could be printed in a higher quantity, reducing cost. One-color letterpress printing not only creates a more textural final product, but can be less expensive than one-color offset printing."

STUDIO: Segura Inc., Chicago, Illinois ART DIRECTOR/DESIGNER: Carlos Segura CLIENT/PRODUCT: [T-26]/custom and original digital fonts for Mac and PC use
SOFTWARE: QuarkXPress COLORS: Two, match (letterpress) PRINT RUN: 5,000 TYPEFACES: Tazor, Semafor CONCEPT: Carlos Segura says the idea behind this
letterhead for this font company was "the future of the world as we know it." SPECIAL PRODUCTION TECHNIQUES: Letterpress.

STUDIO: Blink, San Francisco, California **ART DIRECTOR/DESIGNER:** Scott Idleman **CLIENT:** Blink/graphic design, art direction, digital illustration **SOFTWARE:** QuarkXPress, Adobe Illustrator **PAPER:** Fox River Starwhite Vicksburg Tiara Vellum **COLORS:** Two, match **PRINT RUN:** 1,000 of each **COST PER UNIT:** $0.50 **TYPEFACE:** Alpin Gothic **CONCEPT:** Scott Idleman says that since the inception of his studio, Blink, in 1992, "I have been using a quasi—*I-Dream-of-Jeannie* motif of two eyes and a third eye in the center which has become the Blink logo. Originally, I portrayed this photographically with a female model dressed as a genie. I had used the photographed eyes in my stationery in the past with varying degrees of success. For this new stationery package, I wanted to strip down this whole motif to its most graphic state and yet use colors that would still allude to an exotic, magical past. I am often pleased to witness my clients holding the die-cut card up to their own eyes as if it were a small mask, thus transforming themselves into a genie if only for a moment." **SPECIAL PRODUCTION TECHNIQUES:** Die cut on letterhead and business cards **SPECIAL FOLDS OR FEATURES:** When the letterhead is folded to fit into the envelope, the solid orange tint on the back shows through in the eyes. **SPECIAL COST-CUTTING TECHNIQUES:** "I utilized a die shape for the letterhead and business cards that I had previously used on a promo piece," says Idleman. "Also, in order to avoid costly envelope conversions, I tried to maximize the printable areas of preconverted envelopes."

STUDIO: Hollis Design, San Diego, California ART DIRECTOR: Don Hollis DESIGNER: Paul Drohan CLIENT: Eye Candy (self) SOFTWARE: Macromedia FreeHand PAPER: white unrelated cover stock COLORS: One, black PRINT RUN: 5,000 COST PER UNIT: $0 TYPEFACES: Dogma, various CONCEPT: Hollis printed these satirical cards for himself "to make light of a term which demeans the design professions." SPECIAL COST-CUTTING TECHNIQUES: Printed on extra space at the edge of another print job.

STUDIO: delux design associates, Burlington, Vermont ART DIRECTOR: Keith Brown DESIGNER: Tim Clayton ILLUSTRATOR: Tim Clayton CLIENT/PRODUCT: Eight Loungewear/Frogirl Threads/men's and women's apparel SOFTWARE: QuarkXPress, Adobe Illustrator COLORS: Four, process, over two, match PRINT RUN: 1,000 each of three cards (first three employees) COST PER UNIT: $1.00 TYPEFACES: Loungebait, Mrs Eaves, Zero, DIN Mittelschrift CONCEPT: "The client, which was actually two companies, wanted one business card that encompassed both businesses with equal presence and recognition," says designer Tim Clayton. "The logos created for each business were almost perfect circles. Therefore, a round card was an effective solution that allowed the logos to stand on their own. Having the card spin open with the use of a grommet not only allowed another surface to house all of the pertinent information while keeping the logo highly visible, but also allowed the card to function as a hangtag." SPECIAL PRODUCTION TECHNIQUES: Die cutting of circular cards, both process and match printing.

STUDIO: David Schuemann Design, San Francisco, California **DESIGNER:** David Schuemann **CLIENT/SERVICE:** David Schuemann Design/graphic design **SOFTWARE:** Adobe Illustrator **PAPER:** Neenah Atlas Bond Ultra Bright White Light Cockle (letterhead), Appleton Lucence PF Gloss (business card) **COLORS:** Two, match **PRINT RUN:** 1,000 **COST PER UNIT:** $0.10 **TYPEFACES:** Minion, Serifa (letterhead address block), Neue Helvetica (identity, business card) **CONCEPT:** David Schuemann says that the aim for his studio's stationery was "to make it more impactful through use of embossing, microperforations and hand-punched holes that created a more tactile design. The ultimate goal was to create a stationery system that also functioned as a design sample." **SPECIAL TYPE TECHNIQUES:** Embossing of letterhead **SPECIAL PRODUCTION TECHNIQUES:** Microperforations and embossing on letterhead and waterless printing on business card **SPECIAL FOLDS OR FEATURES:** The business card folds so that it can be clipped onto letterhead as an added design element. The letterhead also features embossing, as well as an area where holes can be punched to identify whether the letterhead is a resume, cover letter or thank-you letter. **SPECIAL COST-CUTTING TECHNIQUES:** "The paper was generously donated by Neenah Paper, and much of the printing was donated or ganged with their permission."

STUDIO: McArtor Design Company, Des Moines, Iowa ART DIRECTOR/DESIGNER: Jason McArtor CLIENT/SERVICE: McArtor Design Company/graphic design
SOFTWARE: Macromedia FreeHand PAPER: French Dur-o-Tone Butcher White COLORS: One, match PRINT RUN: 1,000 COST PER UNIT: $0.63 TYPEFACES: Glypha
Black, Sedona Script, Courier CONCEPT: "The design of the total package evolved from the business card, which was created as a 'license' to design," says Jason
McArtor of his studio's stationery. "I wanted it to have the organizational feel of a driver's license so it would be easy for someone to find what they're looking
for quickly." SPECIAL COST-CUTTING TECHNIQUES: "Stickers and labels were gang printed and applied to envelopes, eliminating the need to custom print
envelopes while adding the flexibility of various stickers that can be applied to everything from presentation boards to promotional packets or folders. The
stickers offer endless possibilities. Also, everything was printed in one color, eliminating added film expenses, which add up in a short print run."

STUDIO: Willoughby Design Group, Kansas City, Missouri **ART DIRECTORS:** Ann Willoughby, Michelle Sonderegger **DESIGNER:** Michelle Sonderegger **ILLUSTRATORS:** various **PHOTOGRAPHERS:** various **CLIENT/SERVICE:** Willoughby Design Group/graphic design **SOFTWARE:** QuarkXPress, Adobe Photoshop, Adobe Illustrator **PAPER:** Crane's Crest Natural White **COLORS:** Two, match **PRINT RUN:** 25,000 **TYPEFACES:** Bernhard Modern, Weiss, Oblong, Helvetica Light **CONCEPT:** The goal behind this letterhead designed by Willoughby Design Group for their studio was "to customize our icon, the Willoughby W, for our individual clients, from classic conservative to whimsical and playful," says Michelle Sonderegger. **SPECIAL TYPE TECHNIQUES:** By modifying traditional fonts, "we put a twist on traditional calling card fonts," says Sonderegger. **SPECIAL PRODUCTION TECHNIQUES:** "We incorporated the application of individual stamps on each piece of letterhead. We also airbrushed the border of the business card and note cards to give them a vintage look. Our business card is presented in a glassine envelope to simulate the same type of envelopes used in stamp collecting, and each employee's individual signature is printed on the business card to imitate traditional calling cards." **SPECIAL FOLDS OR FEATURES:** "The closure of our letterhead envelope is located on the short end, a side-folded envelope."

ARISTEI Photographs

ARISTEI Photographs

1860 Obispo Avenue Studio E. Signal Hill California 90804 VOICE 562.494.2178 FAX 562.494.2179 E-MAIL aristei@earthlink.net

ISTEI Photog

VOICE 562.494.21

STUDIO: Direction Design, Los Angeles, California **ART DIRECTOR:** Teresa E. Lopez **DESIGNER:** Anja Mueller **CLIENT/SERVICE:** Sally Aristei/photography
SOFTWARE: QuarkXPress **PAPER:** Coronado Vellum (letterhead), Coronado Smooth (envelope) **COLORS:** Two, match **PRINT RUN:** 5,000 **COST PER UNIT:** $1.16
TYPEFACES: Franklin Gothic, ITC Franklin Gothic Demi **CONCEPT:** "Our concept was to display Aristei's work with emotion and intellectual balance," says art
director Teresa E. Lopez. "We decided not to use her photography but instead to make her logo a die cut of a picture frame in order to focus on that cunning-
eye behind the lens, focused on capturing lasting impressions." **SPECIAL PRODUCTION TECHNIQUES:** Die cut of a picture box on the cards and letterhead.

1110 north milwauk
chicago, illinois | 6

7 signals

STUDIO: Segura Inc., Chicago, Illinois **ART DIRECTOR/DESIGNER:** Carlos Segura **CLIENT/SERVICE:** 37 Signals/Web firm **SOFTWARE:** Adobe Illustrator **PAPER:** Fox River Starwhite Vicksburg **COLORS:** Two, match **PRINT RUN:** 2,500 **TYPEFACE:** Interstate **CONCEPT:** Graphically inspired by the search-for-extraterrestrial-intelligence movement, this stationery system for a Web firm sports an appropriately futuristic look. **SPECIAL PRODUCTION TECHNIQUES:** Letterpress **SPECIAL FOLDS OR FEATURES:** Die cut.

37 signals

37 signals

1110 north milwaukee avenue
chicago, illinois | 60622 | usa
t 773.862.0291 | f 773.862.1214
info@37signals.com

STUDIO: Binocular, San Francisco, California **ART DIRECTOR/DESIGNER:** Michael Fiore **CLIENT/SERVICE:** Rusty Reniers/photography **SOFTWARE:** Adobe Illustrator **PAPER:** Crane's Crest Natural White **COLORS:** One, match plus blind deboss **PRINT RUN:** 2,000 **TYPEFACES:** Futura, custom type **CONCEPT:** Michael Fiore of Binocular says, "Rusty Reniers is a very precise and artful photographer of modern architecture. Yet at the same time he employs techniques and equipment from the golden age of photography. The design needed to communicate this aspect of Rusty's personality while creating a feel that is like his work, clean and comtemporary." **SPECIAL PRODUCTION TECHNIQUES:** Letterpress printing was provided by Judith French, Full Circle Press, Grass Valley, California.

STUDIO: REVOLUZION, Neuhausen, Germany ART DIRECTOR/DESIGNER: Timo Wenda CLIENT/PRODUCT: Rebmann GmbH/interactive business cards SOFTWARE: QuarkXPress, Adobe Photoshop COLORS: Two, match TYPEFACES: Helvetica, OCR-A CONCEPT: This system was designed for a company whose product is business cards that are also CD-ROMs. REVOLUZION's design goal, according to Timo Wenda, was "to be modern, be interactive, be progressive"—and, of course, to demonstrate the client's business. SPECIAL FOLDS OR FEATURES: The business card is also a fully interactive CD-ROM.

FORTSETZUNG

HEBE

STUDIO: HEBE Werbung & Design, Leonberg, Germany **ART DIRECTOR:** Reiner Hebe **DESIGNER:** Achim Petroschka **ILLUSTRATOR:** Achim Petroschka **CLIENT/SERVICE:** HEBE Werbung & Design/advertising **SOFTWARE:** QuarkXPress, Macromedia FreeHand, Adobe Photoshop **PAPER:** Croxley Supreme Weiss Glatt **COLORS:** Two, match **TYPEFACES:** Akz, Gab, Ven, Akzidenz Grotesk BE Md, ITC Zapf Dingbats, CG Times **CONCEPT:** According to Reiner Hebe, "Our corporate identity represents the spirit of our agency or rather our working method: independent, courageous, classical and modern, creative." **SPECIAL PRODUCTION TECHNIQUES:** Die cut, second sheets are zigzag stitched with red thread.

STUDIO: Hollis Design, San Diego, California **ART DIRECTOR:** Don Hollis **DESIGNERS:** Don Hollis, Heidi Sullivan **CLIENT/SERVICE:** Interior Resource/interior design **SOFTWARE:** Macromedia FreeHand **COLORS:** Four, black and match **PRINT RUN:** 1,500 **COST PER UNIT:** $2 per set **TYPEFACE:** Bell Gothic **CONCEPT:** This letterhead system for an interior design firm uses the periodic table of elements "to convey the strategy, process and planning aspects of the company's services," says Don Hollis. **SPECIAL PRODUCTION TECHNIQUES:** Thermography was used to add emphasis to the logo. **SPECIAL COST-CUTTING TECHNIQUES:** "Perforation and multifunction usage helped demonstrate resourcefulness relative to planning. Two-sided printing created layers of discovery and reinforced the message of system solutions," says Hollis.

Clay L. Morton

750 Zorn Avenue #12

Louisville, Kentucky

40206 USA

Clay L. Morton 750 Zorn Avenue #12 Louisville, Kentucky 40206 USA

STUDIO: Choplogic, Louisville, Kentucky **ART DIRECTORS/DESIGNERS:** Walter McCord, Mary Cawein
ILLUSTRATOR: Walter McCord **CLIENT:** Clay Morton (personal letterhead) **PAPER:** Mohawk Superfine
COLORS: Two, match (letterpress) **PRINT RUN:** 1,000 **COST PER UNIT:** $0.10 **TYPEFACE:** Joanna **CONCEPT:**
"Clay acknowledges his dark—not to say wicked—side by allowing this sort of whimsical job to be
produced," say Walter McCord and Mary Cawein about this personal letterhead for client Clay Morton.
SPECIAL TYPE TECHNIQUES: Handset type, letterpress **SPECIAL PRODUCTION TECHNIQUES:** Letterpress.

Tayburn Design

STUDIO: Tayburn Design, Edinburgh, Scotland **CREATIVE DIRECTOR:** Bryan Hook **DESIGNER:** Domenico Romano **CLIENT/SERVICE:** Lesley McDonald/personal coaching **SOFTWARE:** QuarkXPress **PAPER:** Mirri H range, Accu-Cut Mirricard 300mic Silver (business cards), Classic Wove Ultra White Unwatermarked (letterhead) **COLORS:** One, match **PRINT RUN:** 500 **TYPEFACE:** Adobe Bauer Bodoni **CONCEPT:** Tayburn Design created this identity for Prairie, an Edinburgh personal coaching consultancy. According to Bryan Hook and Domenico Romano, "The name Prairie was chosen for the company as a place of wide horizons and limitless opportunities. The identity had to give an impression of individualism and personal attention. It had also to convey success, innovation and business effectiveness, as the company's target market is senior managers, professionals and business owners. The new identity and the stationery use various elements to achieve these aims. Hand fastening the business card to the paper creates the letterhead, symbolizing the personal attention and one-to-one approach provided by Prairie. Otherwise the paper is blank, representing the freedom that the writer has to make her mark. The reverse of the business card is reflective, conveying the idea of looking at yourself afresh. These elements combine to provide a unique and stimulating communication of the company's philosophy." **SPECIAL PRODUCTION TECHNIQUES:** Die-cut holes over *is.* **SPECIAL FOLDS OR FEATURES:** Cord is used to complete the concept on the card and letterhead.

STUDIO: Hollis Design, San Diego, California ART DIRECTOR: Don Hollis DESIGNER: various CLIENT/SERVICE: Hollis/marketing communications SOFTWARE: Macromedia FreeHand PAPER: Appleton Utopia Premium Silk COLORS: Four, process TYPEFACES: Glypha, Dogma CONCEPT: This set of business cards for Hollis employs a wide variety of color combinations and ties together images with unusual but related titles for employees (e.g., Don Hollis's card features an image of a fish on the front, and his title is listed as "chief angler"). SPECIAL PRODUCTION TECHNIQUES: Die cutting and vertical perforation are used to engage the reader and provoke conversation. SPECIAL COST-CUTTING TECHNIQUES: Printing is completed at the end of press sheets where space permits.

STUDIO: Plazm Media, Portland, Oregon **ART DIRECTOR/DESIGNER:** Niko Courtelis **PRINTING:** Crack Press **CLIENT/SERVICE:** Joint/editing
SOFTWARE: QuarkXPress **PAPER:** onionskin **COLORS:** Two, black and match **PRINT RUN:** 1,000 **TYPEFACE:** Olivetti Lettera 22 **CONCEPT:**
This stationery for an editing company is letterpress on onionskin paper. It uses pinhole perforations as a metaphor for editing,
with the pattern of the perforations interpreting the company name. **SPECIAL FOLDS OR FEATURES:** Business cards come in a rolling
paper-style case with ten individual cards glued inside.

STUDIO: Baseline, Victoria, Australia **ART DIRECTOR:** Betul Madakbas **DESIGNER:** Esther Fledderman **CLIENT/SERVICE:** Burnewang Mansion Reception & Convention Centre/reception and convention center **SOFTWARE:** QuarkXPress, Adobe Illustrator, Adobe Photoshop **PAPER:** Luste Cream **COLORS:** One, black plus foil stamping **PRINT RUN:** 3,000 **COST PER UNIT:** AU $1 per set **CONCEPT:** This system was inspired by Burnewang Mansion itself. **SPECIAL PRODUCTION TECHNIQUES:** Foil stamping.

STUDIO: Studio Voodoo, San Diego, California **ART DIRECTOR/DESIGNER:** Dave Blank **CLIENT/SERVICE:** John Schulz Photography/commercial photography **SOFTWARE:** Adobe Illustrator **PAPER:** Coaster stock **COLORS:** Three, match **PRINT RUN:** 3,500 **COST PER UNIT:** $0.03 **TYPEFACES:** Verkher, Clarendon **CONCEPT:** "After many late hours at the studio, we determined that this card would be essential for any art director," says Dave Blank of this commercial photography studio card that doubles as a beer coaster.

STUDIO: BBK Studio, Grand Rapids, Michigan **ART DIRECTOR/DESIGNER:** Yang Kim **CLIENT/SERVICE:** BBK Studio/graphic design and Web site development **SOFTWARE:** QuarkXPress **PAPER:** Fox River Coronado SST Recycled Cover **COLORS:** Two over two, match **PRINT RUN:** 250 **TYPEFACES:** Letter Gothic, Dotmatrix **CONCEPT:** Yang Kim says, "Our new personalized business cards were popular among our clients, and we got a lot of requests for full sets. So we decided to mail complete sets of cards. They were packaged together in a family picture, wallet-style foldout and housed in a tin box. We added a title card that read 'analog studio tour' and sent them to our clients." **SPECIAL PRODUCTION TECHNIQUES:** Thermography; tin and plastic sleeve by RG Creations.

STUDIO: Disturbance Design, Durban, South Africa ART DIRECTOR/DESIGNER: Richard Hart ILLUSTRATOR: Richard Hart CLIENT/SERVICE: Disturbance Design/design
SOFTWARE: Adobe Photoshop, Macromedia FreeHand PAPER: Bereg Magnomatt COLORS: Three, match (front); four, process (back) PRINT RUN: 500 TYPEFACES:
Trade Gothic CONCEPT: "The idea of doing a business card that doubled as a wallet calendar came to me one night in the bath—really," says Disturbance
Design's Richard Hart. "I had been trying to come up with something that would serve as a mini portfolio, showcasing both the studio's design ability as well
as our love for illustration; and somewhere in between wondering whether my toes were getting too hairy and whether it was really necessary to leave the
conditioner on for two to three minutes I thought, 'Hmm, a calendar that folds down to business card size with a different 'illo' on each section. Nifty!"
SPECIAL TYPE TECHNIQUES: "The word 'disturbance,' which runs across the front of the piece, was developed on the Mac using the original font from our compa-
ny logo and giving it a whimsical and slightly destructive treatment." SPECIAL FOLDS OR FEATURES: The piece is perforated so that each of the twelve cards can
be torn off; one can be kept in the recipient's wallet and replaced at the beginning of each month. SPECIAL COST-CUTTING TECHNIQUES: The piece was set up on
one sheet with several other elements of the company stationery to keep the costs to a minimum.

STUDIO: Sagmeister Inc., New York, New York ART DIRECTOR: Stefan Sagmeister DESIGNERS: Stefan Sagmeister, Hjalti Karlsson TYPEFACE DESIGNERS: Stefan Sagmeister, Hjalti Karlsson CLIENT/SERVICE: Anni Kuan/fashion design SOFTWARE: Adobe Illustrator PAPER: Strathmore Pure Cotton COLORS: One, match PRINT RUN: 3,000 TYPEFACES: custom CONCEPT: This simple but clever letterhead system features a logo that's only complete when the business card is closed, but the logo is also used in its incomplete form on other parts of the system. SPECIAL PRODUCTION TECHNIQUES: Laser die cutting.

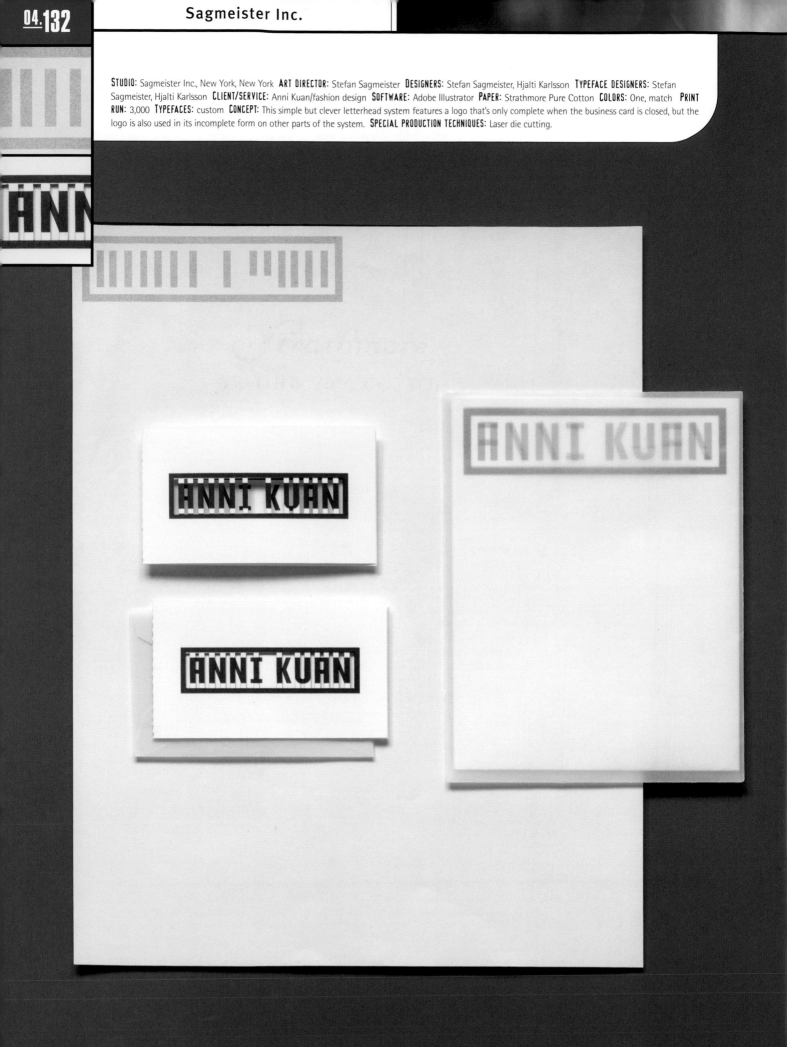

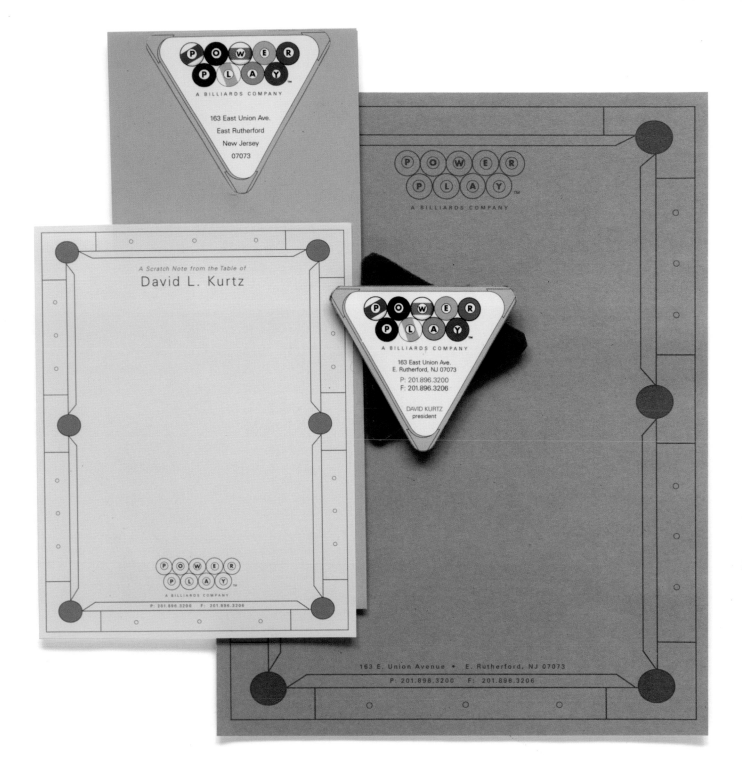

STUDIO: Sunspots Creative, Hoboken, New Jersey **ART DIRECTOR:** Rick Bonelli **DESIGNERS:** Deena Hartley, Rick Bonelli **ILLUSTRATOR:** Rick Bonelli
CLIENT/SERVICE: Power Play/billiards equipment manufacturer **SOFTWARE:** QuarkXPress, Adobe Illustrator **PAPER:** French recycled (green) for letterhead
COLORS: One, match (letterhead); four, process (business cards, labels) **PRINT RUN:** 3,000 **TYPEFACE:** Univers, Univers Bold **CONCEPT:** "The client is a new
manufacturer of billiards equipment," says Rick Bonelli. "We decided to give the client a memorable and unmistakable identity to shake up the existing s
porting goods buyers and their preconceived notions of the industry. Unique letterhead, with an actual pool table drawing on the surface and printed on
French recycled paper, gives a rough but playful feel. The hand-cut triangular business cards with felt backing enhance the design and the company's progres-
sive image." **SPECIAL TYPE TECHNIQUES:** Universe Bold was used inside the illustrated drawings of pool balls to spell out the company name. **SPECIAL PRODUCTION**
TECHNIQUES: "The business cards were hand cut in triangles produced only fifty at a time for the five employees of the company with the following technique:
A four-color business card was printed on label stock and then applied to a card stock. Self-stick green felt 8½" × 11" (21.6cm × 27.9cm) sheets were then
affixed to the back of the card and cut in a triangle shaped like a pool rack to simulate the actual feel of a pool table," says Bonelli. **SPECIAL COST-CUTTING**
TECHNIQUES: "One-color printing for the letterhead allowed us to elaborately design and hand-cut all business cards to help the client's budget. Application of
labels onto the light green tie-clasp envelopes saved the cost of custom-converted envelopes yet enhanced the colorful design of the whole identity system."

STUDIO: After Hours Creative, Phoenix, Arizona **ART DIRECTOR/DESIGNER:** After Hours Creative **CLIENT/SERVICE:** Bluespace/radical training for Fortune 500 leadership, working to integrate art, science, creativity and intuition into corporate culture **SOFTWARE:** Adobe Illustrator **PAPER:** Strathmore Grandee Bright White **COLORS:** One, match **PRINT RUN:** 1,000 **TYPEFACE:** Meta **CONCEPT:** "Bluespace itself is radical," says Russ Haan. "Since their goal is to help top business leaders see things from very nontraditional perspectives, we thought their card itself should be multidimensional and create its own space. Thus, the pop-up house format. And if you peer into the card's window, you get the company's mission statement, 'Who says we can't change the world?'" **SPECIAL PRODUCTION TECHNIQUES:** "This project took lots of engineering to make it easy to present the card flat and be able to turn it into a pop-up. Plus, the tabs all had to be hand glued." **SPECIAL FOLDS OR FEATURES:** "Pop-up construction, die cuts and scoring all over the place."

STUDIO: Bløk Design, Toronto, Canada **ART DIRECTOR:** Vanessa Eckstein **DESIGNER:** Frances Chen **CLIENT/SERVICE:** eyecandytv.com/Internet-based television network and new media content provider **SOFTWARE:** Adobe Illustrator **PAPER:** Cromatica yellow **COLORS:** One (on each piece), match/Pantone **TYPEFACE:** Trade Gothic **CONCEPT:** The artists at Bløk Design call this piece "simple, clear, democratic but undeniably BOLD!" The white-over-white plastic cards are meant to pull the reader into the content, reflecting the philosophy of a company that is aiming to build new narratives on the Internet. **SPECIAL PRODUCTION TECHNIQUES:** "We printed white ink over translucent plastic and built the translucent yellow envelopes to cover each card, creating a sense of uniqueness for each business card."

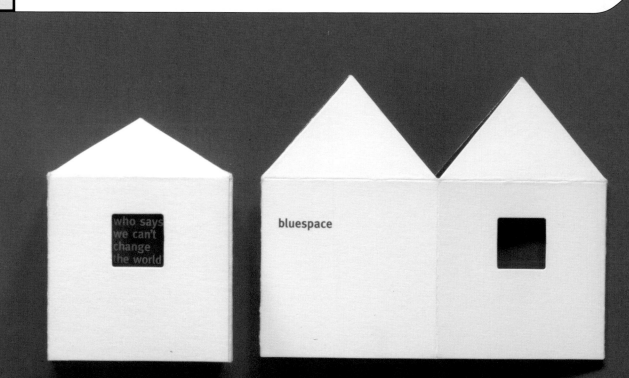

STUDIO: Tangram Strategic Design, Novara, Italy ART DIRECTOR/DESIGNER: Enrico Sempi CLIENT/SERVICE: Eliana Lorena/color and texture design SOFTWARE: Adobe Illustrator PAPER: Arjo Wiggins Conqueror COLORS: Two, match TYPEFACE: Frutiger CONCEPT: This system for a color and texture designer uses color and texture, but in an understated and unexpected way. SPECIAL TYPE TECHNIQUES: Embossed.

newenergy

STUDIO: Cahan & Associates, San Francisco, California ART DIRECTOR: Bill Cahan DESIGNER: Ben Pham CLIENT/SERVICE: NewEnergy/energy distribution
SOFTWARE: QuarkXPress COLORS: Three, match CONCEPT: This system uses a kinetic scribble to symbolize the energy distributed by the client.

ALEXIS H. TACIK
IG DEVELOPMENT MANAGE

NEWENERGY, INC.

UITE1900, LOS ANGELES,
787 F.213.614.9007 ATACIK

STUDIO: Binocular, San Francisco, California **ART DIRECTOR/DESIGNER:** Michael Fiore **PHOTOGRAPHERS:** various **CLIENT/SERVICE:** Binocular/advertising and design **SOFTWARE:** Adobe Illustrator, Adobe Photoshop **PAPER:** Crane's Distaff Linen **COLORS:** Five, match **PRINT RUN:** 2,000 **CONCEPT:** "Rather than just provide a literal illustration of the company name, here was an opportunity to demonstrate the company philosophy," says Michael Fiore. "As evidenced by the whimsical images on the backs of the business cards, a pair of binoculars can magnify your vision, bring distant objectives into sharp focus or change your point of view." According to Fiore, that's exactly what his studio does for its clients. **SPECIAL PRODUCTION TECHNIQUES:** Letterpress printing was provided by Judith French, Full Circle Press, Grass Valley, California. **SPECIAL FOLDS OR FEATURES:** A single die cut was used for corners and holes.

STUDIO: Bløk Design, Toronto, Canada **ART DIRECTOR:** Vanessa Eckstein **DESIGNERS:** Vanessa Eckstein, Frances Chen **CLIENT/SERVICE:** Atlas Pictures/film production **SOFTWARE:** Adobe Illustrator **PAPER:** Strathmore Ultimate White, Beckett Expression **COLORS:** Five, match/Pantone **TYPEFACES:** Univers, Trade Gothic, Franklin Gothic **CONCEPT:** "Atlas was in need of a new identity that would express the history of the company in the marketplace, yet be young enough to represent the new changes happening within," explains art director Vanessa Eckstein. "Clarity and subtlety through color, a typeface that feels like an old movie poster heading and a hole that seems like an old traveling ticket became the vocabulary of the system. It's a unique and memorable design to distinguish Atlas Pictures in a dynamic and ever changing market."

COPYRIGHT NOTICES

DIRECTORY OF DESIGN FIRMS

■ **Acrobat**
Liszta 2A/8
Gdansk 80-170
Poland

■ **After Hours Creative**
1201 E. Jefferson B100
Phoenix, AZ 85034

■ **Anderson Thomas Design**
110 29th Ave. N., Suite 100
Nashville, TN 37203

■ **Archrival**
The Apothecary
140 N. Eighth, Suite 50
Lincoln, NE 68508

■ **Baseline**
P.O. Box 2228
Sunbury 342g
Victoria
Australia

■ **BBK Studio**
5242 Plainfield Ave. NE
Grand Rapids, MI 49525

■ **Beehive design**
477 Richmond St. West,
Suite 308
Toronto, Ontario
Canada M5V 3E7

■ **Binocular**
300 Brannan St., Suite 403
San Francisco, CA 94107

■ **bl_nk**
4734 Bonnie Ct.
San Diego, CA 92116

■ **Blink**
326 Tarasita Blvd.
San Francisco, CA 94127

■ **Bløk Design**
398 Adelaide St. West, Suite 602
Toronto
Canada M5V 2K4

■ **Boelts Bros. Associates**
345 E. University Boulevard
Tucson, AZ 85705

■ **Cahan & Associates**
171 Second St., 5th Floor
San Francisco, CA 94105

■ **Choplogic**
2014 Cherokee Parkway #0
Louisville, KY 40204

■ **CO:LAB**
56 Arbor St.
Hartford, CT 06106

■ **Concrete Design
Communications**
2 Silver Ave.
Toronto, Ontario
Canada M6R 3A2

■ **Curry Design**
1501 S. Main St.
Venice, CA 90291

■ **David Schuemann Design**
850 26th Ave.
San Francisco, CA 94121

■ **dean hunsaker art + design**
2502 Dwight Way
Berkeley, CA 94704

■ **delux design associates**
19 Marble Ave.
Burlington, VT 05401

■ **Design Guys**
119 N. Fourth St., #400
Minneapolis, MN 55401

■ **Designaholix**
1114 S. Waterville Rd.
Oconomowoc, WI 53066

■ **Direction Design**
1230 S. Barrington, Suite 3
Los Angeles, CA 90025

■ **Disturbance Design**
15 Hammersmith Ave.
Berea, Durban KZN 4001
South Africa

■ **EAI**
887 W. Marietta St. NW,
Suite J-101
Atlanta, GA 30318

■ **Ed Fella**
California Institute of the Arts
School of Art
27400 McBean Parkway
Valencia, CA 91355

■ **Effective Design Studio**
501 E. Pine St., 3rd Fl.
Seattle, WA 98122

■ **Eg.G**
Swan Buildings
20 Swan St.
Manchester
United Kingdom M4 5JW

■ **Epoxy**
506 McGill St., 5th Floor
Montreal, Quebec
Canada H2Y 2H6

■ **Firehouse 101 Art + Design**
641 N. High St., Suite 106
Columbus, OH 43215

■ **5D Studio**
20651 Seaboard Rd.
Malibu, CA 90265

■ **Form Studio**
718 W. Howe St.
Seattle, WA 98119

■ **Gee + Chung Design**
38 Bryant St., Suite 100
San Francisco, CA 94105

■ **HEBE Werbung & Design**
Magstadterstrasse 12
Leonberg
Germany 71229

Hollis Design
344 Seventh Ave.
San Diego, CA 92101

Independent Project Press
Box 1033
Sedona, AZ 86339

Inox Design
Via Tarraggio 77
Milano
Italy 20123

Intersection Studio
4120 Michael Ave.
Los Angeles, CA 90066

Iridium Marketing + Design
134 St. Paul St.
Ottawa, Ontario
Canada K1L 8E4

Johnson & Wolverton
510 N.W. 19th Ave.
Portland, OR 97209

Kan & Lau Design Consultants
281F Great Smart Tower
230 Wanchai Rd.
Hong Kong, China

Kuester Partners
81 S. Ninth St., #300
Minneapolis, MN 55402

Lodge Design Co.
9 Johnson Ave.
Indianapolis, IN 46219

The Marketing Store
920 20th St., 2nd Floor
Sacramento, CA 95814

McArtor Design Company
850 40th St.
Des Moines, IA 50312

Miho
1200 Chateau Rd.
Pasadena, CA 91105

Miriello Grafico Inc.
419 W. G St.
San Diego, CA 92101

Modern Dog
7903 Greenwood Ave. North
Seattle, WA 98103

**Nielinger
Kommunikationsdesign**
Borsigstr. 5, Essen 45145
Germany

Philip Fass
1310 State St.
Cedar Falls, IA 50613-4128

Plazm Media
P.O. Box 2863
Portland, OR 97208

Prototype 21
Unit 23
Liddell Rd.
London NW6 2EW
United Kingdom

REVOLUZION
Uhlandstr. 4
Neuhausen 78579
Germany

**Ricardo Mealha/Ana Margarida
Cunha/Criação Digital**
Av. Env. Duarte Pachelo Torre 2 Pisa 2
Salas 9 x 10
Lisbon
1010-102 Portugal

Sagmeister Inc.
222 W. 14th St.
New York, NY 10011

Scott Wallin Design
520 E. Elizabeth St.
Pasadena, CA 91104

Segura Inc.
1110 N. Milwaukee Ave.
Chicago, IL 60622

slow HEARTH studio
295 Sixth Avenue #3
Brooklyn, NY 11215

Spatchurst Design Associates
230 Crown St.
Darlinghurst
Sydney
NSW 2010 Australia

Spoon! Design
781 King St. West, Suite 509
Toronto, Ontario
Canada M56 1N4

Sterling Design
5 Lucerne, Suite 4
San Francisco, CA 94103

Stojan
Pekel 32
Pesnica SI 2211
Slovenia

Stoltze Design
49 Melcher St., 4th Floor
Boston, MA 02210

Storm Visual Communications
70 George St., 3rd floor
Ottawa, Ontario
Canada K1N 5V9

Studio Voodoo
4734 Bonnie Ct.
San Diego, CA 92116

Sunspots Creative
51 Newark St., Suite 205
Hoboken, NJ 07030

Super Natural Design
674 Arkansas St.
San Francisco, CA 94107

Tangram Strategic Design
Via Negroni 2
Novara
Italy 28100

Tayburn Design
15 Kittle Yards Causewayside
Edinburgh
Scotland

Thibault Paolini Design
19 Commercial St.
Portland, ME 04101

30sixty design
2801 Cahuenga Blvd. West
Los Angeles, CA 90068

Thumbnail Creative Group
One Alexander St. #301
Vancouver British Columbia
Canada V6A 1B2

Tracy Smith Design
161 S. Madison Ave. #9
Pasadena, CA 91101

Two Dimensions Inc.
88 Advance Rd.
Toronto, Ontario
Canada M8Z 2T7

Visual Asylum
343 Fourth Ave., Suite 201
San Diego, CA 92101

VWA Group Inc.
5307 E. Mockingbird, Suite 600
Dallas, TX 75206

W2 Multidisciplines Design Inc.
126 York St., Suite 502
Ottawa, Ontario
Canada K1N 5T5

Willoughby Design Group
602 Westport Rd.
Kansas City, MO 64111

INDEX OF CLIENTS

INDEX OF DESIGN FIRMS

Are you on the edge?

If you'd like for your work to be considered for the next Creative Edge book, please copy the form below (or include the same information in a note to us) and send it to:

■ CLARE WARMKE
Creative Edge mailing list
North Light Books
1507 Dana Avenue
Cincinnati, OH 45207

or call Clare at 513.531.2690 ex. 549, fax her at 513.531.7107, or e-mail her at clarew@fwpubs.com.

Who knows—maybe you've got the edge we're looking for.

{ Please put me on the North Light design books mailing list. }

My name

Studio name

Address

City

State

Zip Code

Country

Phone

Fax

E-mail